INSIDE THE STUDIO

TWO DECADES OF TALKS WITH ARTISTS IN NEW YORK

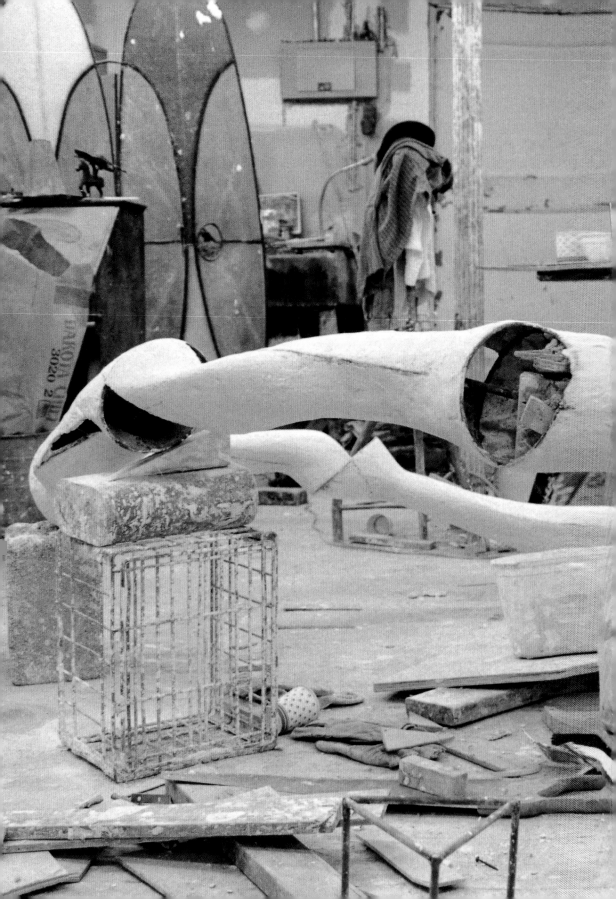

INSIDE THE STUDIO

TWO DECADES OF TALKS WITH ARTISTS IN NEW YORK

Edited by Judith Olch Richards

INDEPENDENT CURATORS INTERNATIONAL (ICI), NEW YORK

All of the artists' texts in this book are excerpts from transcriptions of audiotaped talks that took place as part of the annual ICI benefit series and "New York Studio Events."

This publication is made possible with the generous support of

The Bagley Wright Family Fund
Agnes Gund and Daniel Shapiro
Furthermore: a program of the J. M. Kaplan Fund
Douglas Cramer Foundation

Additional supporters are listed on page 295

© 2004 Independent Curators International (ICI)
799 Broadway, Suite 205, New York, NY 10003
Tel.: (212) 254-8200, Fax: (212) 477-4781
www.ici-exhibitions.org
Judd talk © 2004 Judd Foundation.
Mapplethorpe talk © 2004 Mappethorpe Foundation.

Library of Congress Catalogue Number 2004105137
ISBN: 0-916365-70-0

Judi Caron, editorial assistant
David Frankel, text editor
Bethany Johns, design
Photograph Credits appear on page 294

Printed in Canada

Distributed by D.A.P./Distributed Art Publishers
155 Avenue of the Americas, New York, NY 10013
Tel. (212) 627-1999, fax (212) 627-9484

Cover: Sandy Skoglund's studio. See p. 101
Back Cover: Oliver Herring's studio. See p. 205
Frontispiece: John Duff's studio: See p. 149

CONTENTS

ACKNOWLEDGMENTS

The creation of *Inside the Studio*, an exciting, rewarding, and enormously challenging project from its earliest stages, could not have been completed without the encouragement, generosity, and assistance of a great many people. First and foremost I am indebted to the more than two hundred artists who have generously opened their studios to the "New York Studio Events" program, and particularly to those who devoted time and thought to reviewing texts and searching for photographs for this book. It was a privilege to hear them speak and a pleasure to collaborate with them now in order to share their thoughts with a wider audience. I also want to express my appreciation to the many artists' assistants and gallerists who worked to track down images and crucial information.

Given the need to have some 140 audiotapes professionally transcribed, and the countless hours required to select texts and gather photographs, this was a costly project that could not have been undertaken without financial assistance. On behalf of ICI's Board of Trustees, it is my pleasure to acknowledge gratefully the generous grants awarded for this book, especially the substantial early support of the Bagley Wright Family Fund, which provided the means and the confidence to begin, as well as important additional grants from Agnes Gund and Daniel Shapiro; Furthermore: a program of the J. M. Kaplan Fund; and the Douglas Cramer Foundation. I also want to express our warm appreciation of the supporters who constitute ICI's "Insider's Circle." Having attended many of the studio talks that are excerpted in the book, the members of this group shared and supported my vision for the project, and served as a kind of cheering section throughout the production.

I was superbly assisted in this complex endeavor by Judi Caron, who worked on every phase of the production. *Inside the Studio* would not have been possible without her energy, dedication, professionalism, and care, and I am deeply grateful for her involvement. Judi and I had the tremendous good fortune to work with two exceptional collaborators, editor David Frankel and graphic designer Bethany Johns, who became crucial partners in shaping the book. David edited the selected passages with great skill, keeping each artist's voice distinct; he was also a patient and astute advisor to me in numerous ways important to the project. Bethany contributed her unique vision and intelligence to the production of this handsome volume, also graciously offering her input in the early stages of the project.

When I embarked on the planning of *Inside the Studio*, I asked a number of artists and members of ICI's Exhibitions Committee for their thoughts on several issues. The contributions of this informal committee were invaluable, and thanks are owed especially to Janine Antoni, David Reed, Irving Sandler, Fred Wilson, and Lynn Zelevansky.

ICI's dedicated staff deserves my deepest thanks for their continuous enthusiasm for the book, and for their patience and moral support during its production. I am particularly indebted to Director of Development Hedy Roma and to her staff Eileen Choi and Meghann McKale for their fundraising efforts, and to Sue Scott, Executive Assistant/Press Coordinator, for her wide-ranging assistance.

I also want to take this opportunity to recognize the leadership role played at the inception of the "New York Studio Events" and throughout its early years by ICI co-founder, executive director emerita, and trustee Susan Sollins-Brown. Her deep commitment to the program and belief in its unique educational potential were crucial to its success from the start.

Finally I want to express my thanks to ICI's Board of Trustees, whose excitement about *Inside the Studio* from the start was invaluable, and whose dedication to ICI's mission is a constant source of strength. The Board joins me in thanking everyone who played a role in bringing this book into existence.

Judith Olch Richards
Executive Director

Judith Olch Richards

Duane Michals says, "I don't believe in the eyes, I believe in the mind. . . . I'm not interested in what things look like"; for Haim Steinbach, "Art begins with the eye . . . what we know about the world through the fact that we can see." These opposite thoughts, both of them valid and convincing, give a hint at the richness and range of the nearly seventy texts in this book, all of them excerpts from tape-recorded talks delivered over the last two decades of "New York Studio Events," an annual ICI program of visits to the studios of prominent artists that started in 1981 and continues today. This unique archive of recordings, transcribed and shared here for the first time, constitutes a remarkable record of these artists' thinking at the time each talk took place. Hearing artists speak about their work, especially in their studios, adds unequaled dimension to our understanding; it is an invaluable experience and an exceptional privilege. *Inside the Studio* extends that privilege to the art audience at large, with results that are alternately inspiring, refreshing, thought-provoking, surprising, and humorous, and that are almost always revealing in some way.

The "New York Studio Events" program is a series of studio visits scheduled about a week apart, stretching over the spring months. The visits take place in the early evening, and the artist's talk usually lasts about an hour. Artists may discuss works that they present in slides or on video as well as works currently in the studio. During the visit the guests, averaging about thirty at each event, can ask questions about what they have heard and seen, providing an intimate experience of the artist's work and workplace.

The first studio event took place on a snowy day in February 1981, in the Financial District. It was a visit to the spare sixth-floor walkup studio of sound artist Max Neuhaus, the ICI staff transporting the folding chairs and refreshments up the narrow staircase, the adventurous guests following. The last event in the 2003 program was a talk on an unseasonably hot April day by sculptor Tom Sachs, whose storefront space near Chinatown contains a large but methodically organized array of his tools and parts, as well as a two-ton hoist left by the previous tenant, a machine shop. Over the years between, in enormous rough loft spaces, small living room studios, and almost every other kind of space and location across the city, the exhilarating memories of the talks have accumulated. The program's history has also become thickly embellished with extraartistic experiences: mundane mechanical failures of projectors and burnt-out bulbs have been joined by folding chairs collapsing under guests, clothing anointed with fresh oil paint, lots of fifth-floor walkups, occasional broken elevators and a good number of picturesque but dicey-looking, century-old manual elevators (essentially a floor with a mechanical device to hoist it), deliveries of refreshments gone astray, and more. The experience has also been punctuated by encounters

with nature—being jolted by a bolt of lightning hitting the roof just above our heads, wading through a flooded entrance hall to a studio on the river, wearing coats throughout a visit to an unheated studio during a snowstorm (in April!), and sweltering in early-spring heat waves.

ICI launched "New York Studio Events" as a benefit program to offer a valuable yet seldom available experience that would reflect the educational mission of the organization, which is dedicated to enhancing the understanding and appreciation of contemporary art. The program, which raises funds to support ICI's exhibitions, is planned each year to include artists who have attained substantial critical recognition and visibility and who have a wide range of viewpoints and aesthetic concerns; most have been included in an ICI exhibition. The aim is not to identify stylistic or conceptual trends, to reflect a curatorial viewpoint, or to illustrate any particular artistic direction, but to represent a broad cross-generational spectrum of approaches to artmaking today. (In its early years, along with visual artists, "New York Studio Events" included important composers, choreographers, and performance artists.) A list of the 208 artists who have participated in the program through the 2003 series appears on pages 292–93.

None of the talks is directed by an interviewer, moderator, or other professional. The artists are told beforehand that they can speak on whatever aspect of their work they wish. Their approaches, and the language they use, vary widely, from thoughts on their work's intellectual or emotional sources to discussions of formative artistic experiences, working processes and approaches to materials, relationships with art of the past, the current scene, and views on the day-to-day realities of the artist's life. Some speakers are funny, some entirely sober. Some address broad philosophical issues, some methodically review years of work chronologically, and some focus completely on new works present in the studio.

From one transcript to the next in *Inside the Studio*, then, the reader moves from one unique vision to a completely new one, from one universe to another. There is a chorus of ideas about a hundred different subjects. The talks include personal insights, philosophical reflections, stories, and discussions of the origins of the artists' practice, the evolution of their thinking, and the intellectual, psychological, spiritual, or even physical basis for the work. Some of the most inspiring comments reflect on basic questions: what is the source of creativity? What is a work *about*? Why does one choose to be an artist?

The formal concerns represented in *Inside the Studio* cover the spectrum of contemporary artistic practice. Many artists offer thoughts on the nature of painting, and both painters and sculptors comment on the use of color. Sculptural theories and practices are addressed by artists working in both traditional and unconventional media, and the talks include a rich array of reflections on the artist's physical relationship with materials. For Kiki Smith, "Each medium affords you a different experience. The physical manifestation of it is how meaning is constructed." Louise Bourgeois

Left: Fred Tomaselli speaking in his studio, April 16, 2002, during the "New York Studio Events" program that year
Right: John Currin speaking in his studio, April 10, 2002
Opposite: Tom Sachs speaking in his studio, April 15, 2003

observes, "Material is only material. It is there to serve you and give you the best it can. If you are not satisfied . . . you go to another material."

Artists as diverse as the conceptual photographer Vik Muniz and the painter Terry Winters remark on the nature of drawing, and on the part that it plays in their work. This medium is also central to Jim Dine, who notes, "I've tried through drawing to dissect the anatomy of my inner and outer world." A range of artists discuss their involvement with depictions of the human figure, including painters such as Chuck Close and John Currin and sculptor Joel Shapiro. And narrative content is addressed by artists such as painters Leon Golub and Amy Sillman, conceptual artist Fred Wilson, and photographers Tina Barney and Gregory Crewdson, who says, "Every artist has a central story to tell, and the difficulty, the impossible task, is trying to present that story in pictures."

A number of artists, including Golub, Jenny Holzer, and Steinbach, discuss the role that cultural or political issues play in their practice. Elaine Reichek explains, "What I'm trying to explore and unravel in these works is my own culture's history." Gender issues are among the concerns of several artists, among them Janine Antoni, Sarah Charlesworth, and Laurie Simmons. Meanwhile, R. M. Fischer, Charles Long, and Sachs discuss their involvement with images from the mass media and popular culture. A critical look at nature and landscape remains crucial to numerous artists, including video artist Mary Lucier, who states, "I . . . wanted to comment on how we perceive landscape, how we use it, how we both revere it and denigrate it at the same time." The conceptual and installation artist Mark Dion also deals with nature, but in another register: "My work is largely about the history of natural history."

Many artists note their involvement with other artistic disciplines, such as architecture for Vito Acconci, Donald Judd, Maya Lin, and Andrea Zittel; film for, especially, Douglas Gordon and David Reed; and poetry for Lesley Dill and Michals. A surprising number of artists speak of their struggle to reject the dominant theories of their art school education and to reconnect with the work they did in high school: for Judy Pfaff, Rona Pondick, and Sandy Skoglund this meant transgressing the strictures of Conceptual and Minimalist art theory, for Judith Shea and others it meant embracing "forbidden" figuration, and for others again it involved reconnecting with teenage

pursuits, such as, for William Wegman, drawing the Breck Girl. Several artists, such as Dotty Attie and Robert Kushner, describe the unexpected challenge they faced in teaching themselves how to use oil paints having developed their practices in the days when traditional art materials were disdained.

It's fascinating to learn from several artists how the place in which they grew up played a crucial part in shaping their concerns. Both Lin and Lucier mention the importance of coming from Ohio, as do Fred Tomaselli and John Duff in relation to Southern California, Barney in relation to Rhode Island, and, of course, Ilya Kabakov in relation to the old Soviet Union.

Many artists describe the central role that emotion plays in their work. Petah Coyne remarks, "I work with emotion and the shape comes," while Dill offers, "I want to make work about the emotional bath that we all live in most of the time." Others give surprising replies to the question of where their ideas come from: Jane Hammond often gets ideas for her paintings in dreams. Ross Bleckner, Robert Mapplethorpe, and Muniz, three artists with vastly different approaches, all call artmaking a kind of magic. And several artists speak touchingly about the place of trust in their vision, even when no ideas seem forthcoming: Susan Rothenberg discloses, "I've developed a real trust and a real need to paint. Or rather, I've always had the need but maybe I didn't always have the trust," and Smith says, "I put my total faith and trust in the deep part of my curiosity about things to take me where I'll go."

The talks in *Inside the Studio* explore many more issues, including the influence of other artists or cultures, the use of found materials, involvement with the hand-made, the museum as subject, communication with the viewer, the unity of fine art and applied art, and other topics ranging from the highly theoretical to the completely down-to-earth. One overarching reality, however, becomes clear after reading just a few talks: implicitly or quite directly, all of these artists define their lives and their work as inseparable, and a good number of them relate stories from their lives to illustrate this point.

Almost all of the talks took place in the artists' studios until the 1990s, when the program began to include a few talks in galleries during exhibitions of an artist's work. While still emphasizing the studio as the program's locale, this allowed the inclusion of artists showing their work in New York but living elsewhere, whether in the United States or abroad, as well as artists working outside the traditional studio.

The locations of the studios we visited, in parallel with the overall geography of artists' studios and living spaces in New York, shifted several times over the past two decades, pushed by the real estate market. In the early 1980s, most of the studios included in the program were large, rough, SoHo lofts, former warehouse and light-industry premises made into living and working spaces with sweat equity and offering

not the "loft living" that now symbolizes luxury internationally but a gritty, unglamorous life-style evolving from that in the cold-water flats of previous generations of artists. By the late '80s many artists had been priced out of SoHo, or had chosen not to live there, and were more often to be found in TriBeCa, the East Village, Chelsea, and various neighborhoods of Brooklyn.

Studio practice too has evolved since the start of the program, as more artists have become involved in new media, site-specific installations, and various other approaches to artmaking that require working almost anywhere but a traditional studio setting. There nevertheless continue to be artists who maintain studio spaces that they are willing to open to the view of interested strangers. Some of the participating artists are motivated simply by their wish to support ICI; some use the experience of speaking about their work in this intimate and protected context as part of the process of defining ideas and testing public response to new work.

Between 1981 and 2003, the "New York Studio Events" program included 208 artists or artist teams in 218 talks (some artists spoke twice). Out of these talks, ICI has created an archive of over 150 audiotapes. (During the first four years of the program, unfortunately, the talks were not taped; in later years some artists declined to be taped; others spoke brilliantly but the recorder malfunctioned.) Almost 140 tapes were of sufficient audio quality to be transcribed, of which we were able to include about half in this book. They were kept to a length that would allow the inclusion of a wide range of artists, and since the full transcripts average over 6,000 words each, excerpting them was often a tortuous process that meant choosing among equally insightful passages. The goal was to retain the "voice" of each artist speaking while offering a compelling and coherent text. After the editing was done, the texts were sent to the artists (or, in two cases where the artist has died since the talk, to the foundations representing them) for final approval.

The talks are arranged chronologically to reflect the fact that they took place over almost two decades. Especially when the studio visits date from a number of years back, it is important to realize that the texts reflect the artists' thinking at the time of the talk, and that their ideas and concerns have likely evolved since then.

The artists in this volume do not constitute a definitive group, and perhaps not even a representative one. Taken together, however, in their number and diversity, their talks form a portrait of the artist today, and an informal snapshot of the New York art world over the last two decades. They also offer an inspiring seminar on contemporary art taught by that most highly esteemed instructor, the artist. Why, when, how, and where a work of art was made—all these are clues to perception. While these artists will remain best known to us through their art, their words bring us a unique insight into the rich substance of artistic practice, a new depth of intellectual and emotional understanding of contemporary art, and a renewed appreciation of the role of the artist in our culture.

ARTISTS' TALKS

All of the artists' texts in this book
are excerpts from transcriptions of
audiotaped talks that took place as
part of the annual ICI benefit series
"New York Studio Events."

Born 1946 in London. Lives in New York City and Kingston, New York

JUDY PFAFF

Selected Solo Exhibitions
"Judy Pfaff: Neither Here Nor There." Ameringer/Yohe Gallery, New York, 2003
"The Art of Judy Pfaff: Sculptures Prints and Drawings." Elvehjem Museum of
 Art, Madison, Wisconsin, 2001
"Judy Pfaff: Round Hole Square Peg." Andre Emmerich Gallery, New York, 1997

Selected Group Exhibitions
"Corona de Espinhos." United States Representative, Bienal de São Paulo, 1998
Whitney Biennial. Whitney Museum of American Art, New York, 1987
"Vernacular Abstraction." Spiral/Wacoal Art Center, Tokyo, 1985

The color in my work has always thrown it into a funny kind of cartoon language. There's always something tense, and a little strange, going on; the color signals different kinds of things. I usually use color to make something lose weight, or separate from other images; I also use it emotionally. My tendency is for high-key color, which I think suggests a lot of things that I don't necessarily plan.

I get frustrated with how the art world locks you up—every piece I've ever done, the reviews tend to refer to the first review ever written and talk about "an explosion in a glitter factory," whether or not there's glitter or anything similar to an explosion. I got known as the person who did stick figures; I promptly stopped doing stick figures. In 1979 I'd been reading about my work being in bad taste, and it was making me crazy, so I went away to the Yucatan for a few days; and in the Yucatan the flowers were in bad taste, and the sunset was in bad taste, and all the fish were iridescent—so I came back raring to go. In the new work I used reeds, basket-weaving materials, and wire, with an image of weightlessness. The piece was called *Deepwater* [1980], and I wanted the experience of going down, psychologically down, as one walked across the space; it was seen as an aquarium. *Dragon* [1981], the next piece, was about fire. I thought it looked medieval, and it had a lot of black and gold and red and blue. My idea for it was to try to raise the temperature—to make it feel hot when you walked in there. I wanted to try to pick up this red (heat) and lace it through the installation. . . . But the patterns of fire and smoke had similarities to the patterns of water, and this piece too was seen as an aquarium.

The sculpture is always preceded by drawings, not schematic or direct drawings to translate into sculpture but drawings free of any pragmatic concerns. Then when I start making the sculpture, the drawings have taught me the new language, they've taught me how to cut the material, how to see the space, how to make the piece.

In Cologne, Germany, in 1981, there was a survey show of art since 1935 called "Westkunst." I think it was the first time Robert Longo, David Salle, Julian Schnabel, and artists like that were introduced to Europe. The Germans made this enormous new exhibition space within the convention center, the Messehallen. In the show there was Picasso and Kurt Schwitters and Joseph Beuys and Claes Oldenburg—hundreds of artists and virtually no women. It was Western art from 1935 to 1981 and there were no women in the entire show, or very few—I think I was one of two. And the work I showed there was seen as incredibly decadent. By the time I got back to Germany to take it down, it was basically destroyed—people just tore it, stepped on it, broke it. It was a horrible experience.

When I was in grad school the conversation was mostly about Minimalism and conceptual art. I sort of carried on a one-woman war in opposition to that. I didn't think sculpture had to be about mass, density, weight, and "truth to materials," or that a good idea necessarily made good art. It's hard to remember that dogma now, because the art world has really opened up. I thought sculpture could have illusion,

Gu, Choki, Pa. 1985. Installation at Spiral/Wacoal Art Center, Tokyo, 20 x 40' diam.

transparency, weightlessness, and color. I had come to sculpture as a painter so it seemed easy to bring a painter's language to the making of things and to think that in the making an idea could emerge.

None of my installations exists. It's been a real frustration in my life. I tend to work a lot, do a lot, and spend a lot of money on materials that I then sort of discard. And I never stay in one place long enough, or use one material long enough, to figure out all the technical problems—I'll work with a kind of paneling for a few months, then go to steel. Everything is thrown away, except for a very few objects from each piece that serve as souvenirs.

I was in the Venice Biennale in 1982. I got there three weeks early to begin, but none of the American shipment arrived until moments before the opening. The space for our exhibition was in an abandoned boatmaking building on the Giudecca. There was no electricity, telephone, or toilet. It was a mess, but it was Italian, and Italian messes are quite wonderful. I had nothing to do until the work arrived but fix the walls, so I stuccoed everything. I found windows that had been bricked up. The piece was called *Either War*: two wars had started in the world while I'd been waiting, and in that time of waiting an image of a chaotic Italian sensibility had emerged. Anyway, whatever it was . . . I thought it was real Italian. I made these cones, hundreds of them, in wood and steel; they reminded me of the Futurists. The cones were rigged above your head and produced the sensation of sound, overlapping, aggressive, political sound.

That same year I did an installation at the Albright-Knox Art Gallery in Buffalo. I love this place. The installation was in a room called the Clyfford Still Room. I began by cueing off a color palette that was very reminiscent of Still. When I'm installing, a lot of what happens has to do with the way the space feels, and here, being close to Still, I thought I might as well use a lot of black and orange. I have to get some sort of rapport as a way to begin. You went up the staircase and the image unraveled. It was very succinct, and worked formally in terms of the displacement of the objects, the sequencing of events, and references to that museum's great collection of Abstract Expressionism starting with Still.

I sometimes got sick after my gallery shows—they were very physical. After a show at Holly's [the Holly Solomon Gallery, New York] in 1983, I realized my process was just a nightmare, and I stopped: the show was up for about three weeks; it took me three months to make it. And I was broke. I made other small pieces that got me through the next year, and I thought, Maybe I should try to figure this thing out; throwing my work away is no way to live. The funny thing is that it was harder for me to make small works. Without the room as a container, I was lost on how to begin and what rationale to use. The work for a show called *Badlands* was the first that I thought was successful in being somewhat between those two states: not really a collage, and certainly not an installation, but with enough complexity, enough imagery, enough power to just exist as an object without me thinking it wasn't good enough.

I worry about the issue of how long the material will last. I care about it to the extent that I can—everything is primed as well as it can be, I don't make things to fall apart. I was helped by a visit to the Met, which has a lot of African objects in media like urine, straw, mucus, blood. I thought, "This survives? In a museum? Well, it looks good, and my work is physically stronger than that." Most of the materials are rugged, and I really work them. I also think, "I age, and my work will age." I do my best. But there's a lot of experimentation so there are a lot of mistakes. Now I fiberglass a lot of the joints so the wood glue won't come apart. And every year I have a demand to fix an old problem, but then I run into new ones.

If you ever see people walking through one of my shows, there's something more psychological and confrontational than not. I have trouble with art that's just in one emotional place. Most of the work I like is constructive, and is physically built or worked. I have a hard time with work that's basically conceptual. Even work that looks like painting but has a conceptual premise—a lot of that work seems cynical about painting.

If a piece gets too located, too specific, it's too much like the facts. I would rather something dreamed or remembered . . . a sensation of something coming into focus. I don't want anything to feel like fact. A lot of my work is like something or something else, but not exactly either. There are tons of references but you don't really identify them. I myself will think, "Oh, this looks like that place I went to ten years ago, five months ago, yesterday." It has that feel. Feelings have more layers and fewer facts. It conjures up more than it is.

Pfaff at Pilchuck Glass School, Stanwood, Washington, 1990

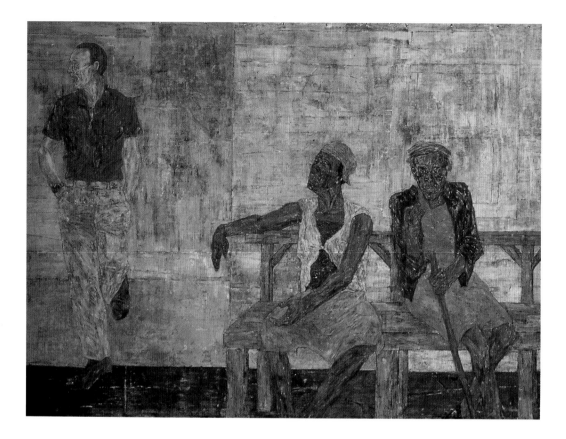

Born 1922 in Chicago. Lives in New York

LEON GOLUB

Selected Solo Exhibitions
"Leon Golub: Paintings 1950–2000." Irish Museum of Modern Art,
 Dublin, 2000 (traveling)
Third Hiroshima Art Prize (joint retrospective with Nancy Spero).
 Hiroshima City Museum of Contemporary Art, 1996
"War and Memory" (joint retrospective with Nancy Spero),
 American Center, Paris, 1994–96 (traveling)

Selected Group Exhibitions
Documenta XI. Kassel, 2002
"The American Century: Art & Culture 1900–2000. Part II: 1950–2000."
 Whitney Museum of American Art, New York, 1999–2000
"New Images of Man." The Museum of Modern Art, New York, 1959

I'm interested in the ways society is made to organize itself in terms of power. I've portrayed both victims and authority figures, even in the early days, in the '50s; these figures were all nude. Then, during the Vietnam War, I became self-conscious about my work. I conceived of these images as some kind of existential struggle, the figures were clashing with each other and so on, but they were clashing nowhere; the scene was bare and the figures weren't specified. In 1972 I painted *Vietnam (I)*, on the subject of the Vietnam War. I was very ambiguous about it. I couldn't make these soldiers run around naked. So in a sense my interest in situations of vulnerability or stress—certainly politics is a very stressful area!—led me to specific circumstances. What you get are representations of a violence that is very pervasive, we get it through the media continuously, we're surrounded by it. And one of my intentions is to surround you in a different way than you get surrounded by it through the public media.

This painting, *Two Black Women and a White Man*, is the last I completed. It's less aggressive than most of my work, less violent. There are two older women and one of them glances up at this white man. She glances with one eye, perhaps with a cast in it, so maybe she's not seeing with both eyes. This is a relatively typical subject of mine, dealing with political prisoners and what are called white squads or death squads. The torture of political prisoners died down in the nineteenth century, then reappeared in the twentieth century very widely.

The first phase of the painting is drawing. I use many photographs—for the head of one of these figures I might look at ten photographs, so it doesn't look like any particular person. I have literally thousands of photographs not necessarily dealing with these subject matters: men fishing, playing sports, doing this, doing that, and I transpose them. First I sketch in white chalk, then in brown chalk, then in black paint. White paint then coats the black, a kind of chiaroscuro effect, with contrasts of light and dark—it implies a generalized treatment of light and shadow and then color. Maybe I'll give a figure green eyes, a blue shirt, this kind of pants, various poses, various coloring. The colors are laid flat, each coat on top of the other.

So at the stage when the colors are all put on, underneath are all these other colors, lines, and so on. I lay the canvas flat on the floor on this worn linoleum, which starts to have an effect on the painting because of the bumps and everything else. (For the same reason, I often paint on this brick wall: when I rub the paint against it I get irregularities from the bricks. I like erosion and irregularity.) Then I soak an area of the canvas roughly two foot square in solvents. Most recently I've been using rubbing alcohol, which is the safest solvent to use—one uses it on one's body, after all—but in the past I've used very dangerous solvents. After the canvas has soaked for maybe a few minutes, I take a meat cleaver and scrape the paint off. A meat cleaver has something like a four-inch edge; the sculpting tool I used to use only has an edge of an inch or so. The scraping is a tedious process—often I've spent weeks

on it. I scrape the paint off and get back to various levels of the painting. Finally I touch up with a brush in various places.

I'm interested in the notion of the skin of the painting, which of course is the painting's surface. If you get close enough, you'll note in this final stage that the painting is largely porous. I scrape down a great deal, so there's very little paint left on the canvas. You can see right through to the canvas in some places, it catches light—the pores of the canvas come through. I make an association between that and our skins, which are translucent, or semitranslucent; they're made up of an infinite number of small pores, and they catch light in irregular ways, because of the way light spreads. And a canvas is made up of an infinite number of small pores in the way it's woven. In scraping it down, I remove most of the paint, but the paint sort of fills these thousands of pores. And it therefore catches light in more irregular ways than flat paint.

I'm married to Nancy Spero. We started out living in Chicago; I studied art history at the University of Chicago and then I was in World War II. I came back and went to the Art Institute of Chicago on the GI Bill. I finished there in 1950 and began teaching.

In 1956 to '57 Nancy and I spent a year in Italy. It was the first time I could really paint the whole time and didn't have jobs, and it felt good. Beginning in 1959 we lived in Paris. The point is we bypassed New York; we flew over it to Paris. We felt the atmosphere in New York would not be receptive to what we were doing. In 1964, though, after five years in Paris, we decided to come to New York. We've been here ever since, but I've always been known as a Chicago artist; only in the last three to four years did I become known as a New York artist. It took a long time. But being a New York artist is a special, intangible thing. It's only granted to you if there's enough interest in you among New York art circles—otherwise you're an outsider, in the sense that you're not acknowledged, even if you've lived here for twenty-five years.

To what extent are you inside and outside your work? You're both. In a way, the white man and the old women in *Two Black Women and a White Man* are me, not that I go around seeing myself as an old black woman. It does become more problematic, though, when whites represent blacks, or maybe when a black represents a white, given the tension that exists between blacks and whites. But the point is there are parts of me in that painting, maybe certain kinds of gestures. I am both the aggressor and the victim in many of these paintings. But then I would also say that *you* are both—because you're in this painting too. I make certain claims about the paintings that people aren't always willing to accept; one of them is that you're all in these paintings too. I try to document that if I can.

Visual arts have largely been turned into a comfort zone. There's nothing wrong with a comfort zone; we all need a little solace along the way. Nevertheless, the visual arts have become very strongly that kind of thing in the last seventy-five years or so.

Of course there are strong reasons why artists do the things they do, and their intentions can be subversive, in a kind of art sense, but the work becomes accommodated. Then also the only one of the arts that you can actually own is visual art, and that has something to do with the comfort-zone relationship: there's no reason why anyone would want to come home after a busy day and look at *Two Black Women and a White Man*.

But art hasn't always been a comfort zone. Often in its scale, often in its subject matter, it is a report on the nature of the society in which it occurs—about the way people act, the way they conduct their wars, the way they live their rituals, their religions, everything else. It tells you the way people look, the way they actually walk around. I'm interested in showing in our society—different versions of it—the way people look.

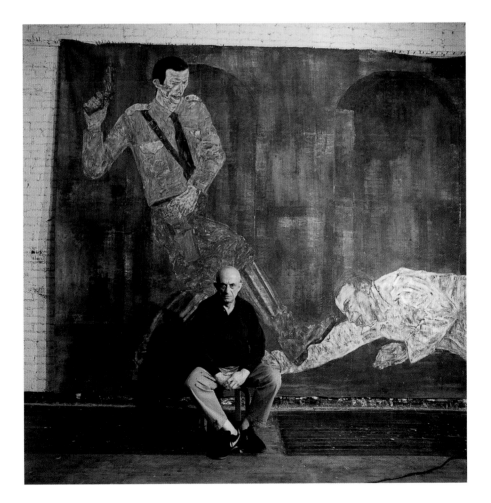

Golub in his studio, 1984

Born 1946 in Queens, New York. Died 1989

ROBERT MAPPLETHORPE

Selected Solo Exhibitions
"Robert Mapplethorpe: Photographs 1976–1985." Australian Center
 for Contemporary Art, South Yarra, Victoria, 1986
"Lady." Hara Museum of Contemporary Art, Tokyo, 1984
"Robert Mapplethorpe, 1970–1983." Institute of Contemporary Art,
 London, 1983 (traveling)

Selected Group Exhibitions
"The Heroic Figure." Contemporary Arts Museum, Houston, 1984 (traveling)
"Counterparts: Form and Emotion in Photographs." The Metropolitan
 Museum of Art, New York, 1982
Documenta VII, Kassel, Germany, 1982

I started taking pictures approximately fifteen years ago. I'd been studying painting and sculpture at Pratt Institute. Most of the people I've photographed are fairly good friends, or they were at the time, but now I work for magazines like *Vanity Fair* and *Vogue*, so I do assignments. But for years I worked only on my own, so there were people I met socially and eventually photographed. Sometimes I photograph people more than once, there's a second or third shooting. The important part for me, more important than the photographs, is the relationship I have with the people I photo-graph. I think there's two things: taking pictures, or making art, and then there's life. I would like to think that life comes first, and that though the art is what remains, the experience of the people, the communication in taking the pictures, is more important to me than the end product. Having an interesting life is more important to me than making interesting photographs. Hopefully I can do both.

I think the difference between the pictures that I take and the pictures that some-body else takes is basically my personality. I think I have a certain honesty about my life, and I think that somehow helps the subjects feel something that they might not feel with other photographers. There's a certain kind of abstract signature that runs through it all. Though I take quite a few varieties of picture, there's a certain way of seeing that's only me.

[When I started out,] I didn't really know much about what anybody else was doing, and I think that was a great advantage. I was more involved in the painting world and knew very little about the photography world. So I developed a way of seeing with the Polaroid, which is how I initially took photographs without knowing the history, and then I gradually learned the history. I think it was an advantage not to know too much. Often, photography people especially have this training, they've studied and they've seen too much, and they're always overly influenced by something else they've seen. It's important to know the history, but I think it was sort of an advantage to go into it without knowing too much.

Street photography doesn't interest me at all. I tried things, twice, but I felt so uncomfortable taking a camera out in the street—it's sneaky somehow. That's not my approach at all. I think some of the best pictures that are done that way are sort of people off-guard, and I just don't feel totally comfortable doing it.

I never did my own printing. I have a darkroom here, with great technicians, and I oversee the whole operation, but the actual darkroom work is actually not interesting to me—though the print quality is real important.

I'm pretty flexible: I think some of the best pictures I've taken were about the person saying, Gee, I'd like to wear this and I'd like to do this. When I get that out of people, it's great, but again it depends on the person. Some people are a little confused about what image they want to portray, so it's a matter of working it out together.

In the best of the photo sessions that I take, a certain kind of magic happens. I look in the camera and I look at the person and there's something happening that's

Thomas/Back. 1986. Gelatin silver print, 24 x 20"

sort of magical to me. And that's really what I'm after in photography. Again, that experience is more important than the end product, even though I get a rush when I see the finished product. But in a great photo session, I have this thing that happens that's about not knowing about time, not knowing about how much film you're taking—just knowing that you're getting great pictures. And that is really what interests me about photography. It can happen with still lifes too: sometimes I'll do five pictures in an afternoon and everything is clicking and I know that I'm getting good pictures. I basically know what I've done while I'm doing it. It's not something I see later; I know the picture while I'm taking it.

Ever since I started taking pictures, I've photographed sex of one kind or another. I actually started in Polaroids, which certainly adapts itself to that kind of photography. There are basically three groups of pictures that I've taken: pictures dealing with sexuality, still lifes, and portraits. I've always done that. And though maybe the types of sexuality or the kinds of people have changed over the years, it's a fairly consistent body of work. These people wanted to pose for these photographs. They weren't doing it to be in a magazine; it was the mid-'70s, the early '70s, and it was a certain moment when people would go to a crowd to exhibit themselves. Most of these people got prints afterwards—that was the exchange. I took a picture and they got a print.

The people in some of these severe pictures are not that odd really. Some of them are writers, some of them are art directors; they're not that abnormal. They just make it seem that way in the pictures. I was in a position to photograph these people. They were friends of mine and I was rather obsessed with the idea of doing a photo. It's almost like a documentary in a sense: even though they're formal pictures, I was documenting a certain life-style that I was very much a part of at that time. I felt like I was one of the few people who could really do that. People have done pornographic pictures forever, but most of the people who involve themselves in explicit sexuality aren't really artists. I don't like to call myself an artist—I think I'm a photographer first, and anyway that's for other people to decide—but I think I have a certain eye and a sort of edge on the whole thing. Also these were friends of mine, so it wasn't like some photographer coming in as a voyeur; I really kind of knew what the deal was. I think that shows up in the pictures. I'm not just an outsider coming in and taking pictures. The photograph becomes a document of a certain moment of a certain kind of sexuality in New York.

Nadar is probably the first and best portrait photographer. You can see that the subjects have a whole lot of respect for the photographer; you can see that they're on a one-to-one. They're not just being photographed. Of course it was the first time a lot of those people were photographed, but that comes through: they're just there, they're not giving attitude, they're standing in the presence of their equal. That's the greatness in Nadar. Man Ray was the one who kicked around photography in a way that it hadn't been kicked around before, so I guess he's the great twentieth-century photographer.

There never used to be a market for photography so there was no point in editioning things. I've been really strict ever since I took pictures, because I was coming at it from another angle: I never wanted to be a photographer, it just seemed like a good medium for me to work in, so I only really cared about the first print. I used to have editions of three; now I do ten. But I wanted to move on, and not think that I had a great picture that was taken ten years ago that everybody wants. Basically I keep on adding new pictures. If somebody really hassles me about getting a picture that was taken ten years ago, I can go back and find one and probably release it, but that isn't my approach. I care about the one I just took.

I've taken color pictures all the way through but I never set out to make color pictures until fairly recently. I think there are two kinds of color photographs: one that's really got color and one that's just about putting color film in the camera and doing a picture. I do both. Sometimes for magazines I back it up with color, but it's not really *about* color; I just put color film in. But when I do set out to make color pictures and that's the prime concern, in those cases the best pictures out of the shoot are the color ones, not the black and white ones.

If it makes a better picture by cropping, I crop. I don't see any point in saying I never do this—if I see something later that I didn't see, and it's a better picture, I go for it. But I try to take it all in the camera because you get a better print. You're using more of the negative. Since I'm not in the darkroom the whole time, my printer will crop and then I'll look at it and I'll say, "Well, let's try it this way." So I'll change it, hopefully for the better, at times. But I don't set out to do ten variations of the same thing. I don't really have strict rules. I think again photographers tend to do that: they kind of limit themselves by giving themselves these rigid formulas for doing pictures. I don't really have any.

Self Portrait with Dancer. 1974. Black and white Polaroid, 5 ¹/₈ x 4 ¹/₈"

Born 1950 in Gallipolis, Ohio. Lives in Hoosick, New York

JENNY HOLZER

Selected Solo Exhibitions

"Jenny Holzer." Neue Nationalgalerie, Berlin, 2001

"Jenny Holzer: The Venice Installation." United States Representative,
 Venice Biennale, 1990

"Jenny Holzer." Solomon R. Guggenheim Museum, New York, 1989–90

Selected Group Exhibitions

"The American Century: Art & Culture 1900–2000. Part II: 1950–2000."
 Whitney Museum of American Art, New York, 1999–2000

"High & Low: Modern Art and Popular Culture." The Museum of
 Modern Art, New York, 1990–91

"L'Epoque, la mode, la morale, la passion." Centre Georges Pompidou,
 Paris, 1987

I work a lot with electronic signs, and I find the hardware by looking through the phone book, calling people, and going to visit factories. Then I program the signs at my kitchen table. That's as close as I come to regular studio work.

When I was in graduate school in painting at the Rhode Island School of Design, I started trying to do public pieces. I wanted people to be walking along in the course of their daily lives and run into something they'd have to puzzle over, something with meaning. Unfortunately in *Beach Carpet* [1975] puzzling is about all that happened: people encountered a half mile-long piece of "found" blue fabric at the shore and went, "What *is* this?" So I only had part of my objective; people were confused and that was it. The piece did look like waves—maybe that was a minor poetic success.

I began to need to be explicit, to tell people things, but at the same time I never really liked narrative paintings. I never liked scenes of happy workers. I was stuck, because I wanted to make public work and I wanted to be explicit, but I hadn't figured out how, at least with painting. It was in this condition that I arrived in New York in 1977.

When I came to the city, I saw posters made by an anonymous person whose goal in life was to keep people away from vice in Times Square. He ringed the area with posters telling you that you'd get leprosy should you cross his imaginary safety circle. Before I noticed his posters, I had started a series of one-liners on most every subject in the world, written from many points of view. There were far-left lines, right-wing ones, good-common-sense sentences, all kinds of positions. I didn't know what to do with this writing: it wasn't poetry, it wasn't a novel. . . . I wanted to work outside, and after I saw Mr. Leprosy I thought he had a good practice. So I'd follow him, put my stuff on posters, and paste them in the streets.

Another thing around then was the New Wave music that had hit New York. There were great music posters, many done by artists. I think Mr. Leprosy and the music posters were what got me going. In my first posters, the one-liners are the "Truisms," and if you read a number of them there's something to offend almost anyone, and also something to agree with. I guess I wrote the "Truisms" because I'm curious about why people do what they do, and I thought that what they believed might explain their behavior. So I wrote these sentences thinking that truisms are a condensed form of belief. My sentences were meant to sound just like real truisms, but I composed them all.

An important fact about these street posters was that they were anonymous. Nobody knew who was saying these things; people had to wonder what was going on, and that gave them more to chew on. I put the posters anyplace posters could go around Manhattan. I skulked at three o'clock in the morning and stuck them up.

My first official public-art project was at Marine Midland Bank in 1982, and for a while I was happy because I was tired of sneaking around the streets and freezing. I thought, "Oh, this is wonderful. I can come inside, briefly." That happiness lasted

Truisms. 1982. Spectacolor electronic sign, 20 x 40' installation in Times Square, New York, organized by the Public Art Fund, Inc.

27

five or six days before the bank found one "Truism" that said "IT'S NOT GOOD TO LIVE ON CREDIT." The bank put the whole installation in the janitor's closet, and that was my introduction to legal public art.

At 1 Times Square in 1982 I got my first chance to use an electronic sign, which proved to be addictive. I think the Public Art Fund's occupation of that display has turned out to be one of the nicer public-art projects in New York, because it uses something that's there. It doesn't cost $10 zillion for steel, and it has an impact on a lot of people who filter through there every day.

On the occasion of the last presidential election [1984] I organized an event with a mobile unit, "Sign on a Truck," featuring the kind of electronic animated display you see in rock concerts or ballparks. We parked it in front of the Plaza Hotel and at Bowling Green Plaza. The sign had videos by a number of artists, and also featured interviews with people in the street, discussing not just the candidates but the issues that come up at election time—a time when Americans are willing to talk about politics, and what they really want to happen or not happen in the world. I thought this was a good moment to provide a platform for speaking, to give people a chance to express themselves, to see and hear themselves in a format as glittering as the ones offered to the incumbent. The project was an interesting political-art experiment, and it was helpful to me to start working again with video. Now I'm trying to make a number of fifteen-second spots for television. They'll appear in the midst of soap operas, or after the morning news.

With public-art projects there can be a lot of advance work and convincing to be done, which is okay, because it's an education for me and for everyone else concerned. If a piece is realized at the end of the talking, one that's not compromised by the negotiations, then it's worthwhile. I still find, however, that when you're doing official public projects you can have less control than when you're working in the street. This sometimes makes me delighted to work in art museums, where there's a history of hands-off tolerance. When I write a new text that scares me, I'm happy if it debuts in an art space so I can figure out what I think before I try it out on a general public. On the other hand, I still want to use mass media, for the same reason advertisers do: because you can reach so many people. Sometimes that's dangerous, sometimes the constraints can make for work as insipid as a breath-mint ad; I wind up with five dumb words and even I forget what I meant. But when you get a mass-media piece right, when you have the subject and the form down, it's great. It's so fast, anybody in the world can understand it in three seconds, and it's available.

It's nice that electronic signs are proliferating. Often there are blank spots in sign programs, which just end up filled with repeat advertising, and a lot of people are willing to have something different there—even art—in hopes that it surprises viewers. In Aspen they arranged for the ski signs to have my hard sentences between the "Ski Safe," "Ski in Control" notices.

I'm not a writer but I try to write as well as I can. I take time, because if you pack more into a piece, if it's reasonably well composed, if there's *x* amount of poetry and *y* amount of just-straight-to-it content, the message will be accepted or at least noticed. Right now I'm drafting a couple of long pieces that sound like laments; they're to go on the lids of sarcophagi. The new texts for television have to be much shorter—I want them to be fifteen-second spots that go wham-bam. Sometimes I preach in a text, and the piece says "Wake up," or "Snap into focus," and I have specific messages, a particular ax to grind. Other times I put out conflicting, terrible, expressionist content. The good stuff in life takes care of itself; we all know what to do with the good. It seems that the terrible stuff is what one must address.

I'm interested in art response, art criticism, so it's nice to be known in the art world; people will talk to me critically about how my pieces work, or don't. But this is very different from the way I want the art to function in the street. Outside the art world, the work should appear anonymously. I want two things out of life: I want input from people who know about art, and I want the possibility of changing people's minds in the larger world.

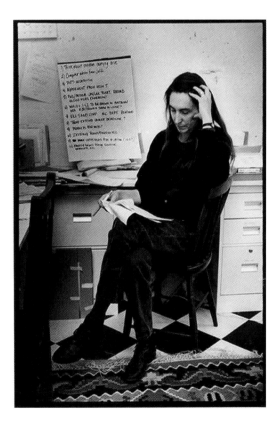

Holzer in her studio, Greenwich Village, 1994

Born 1953 in New York. Lives in New York

PETER HALLEY

Selected Solo Exhibitions
"Peter Halley: Paintings of the 1990s." Museum Folkwang, Essen, 1998
"Peter Halley: Painting as Sociogram 1981–1997." The Kitakyushu
 Municipal Museum of Art, Kitakyushu, 1998
"New Concepts in Printmaking: Peter Halley." The Museum of
 Modern Art, New York, 1997

Selected Group Exhibitions
"We Love Painting! Contemporary American Art from Misumi Corporation
 Collection." Museum of Contemporary Art, Tokyo, 2003
"Mythic Proportions: Painting in the 80s." Museum of Contemporary Art,
 Miami, 2001
"The Tradition of Geometric Abstraction in American Art 1930–1990."
 Whitney Museum of American Art, New York, 1992

I've always found myself drawn to geometric imagery. In the 1970s that interest took several directions. At first I was interested in geometry in primitive art—how primitive art uses geometric configurations to describe a relationship with nature, as if the circle or square had meaning as essential form. A little later I began to look at how geometry was used in early European modernism—Cubism and so forth. Finally I became fascinated by my own obsession with geometry. Why was I drawn to making geometric art, rather than using other kinds of form?

When I came back to New York in 1980, after living elsewhere for several years, I immediately realized that this vast urban, commercial, and industrial conglomeration is at basis a geometric configuration. Concurrently I lost any interest in the image of the human figure as a carrier of meaning. To me, the human body literally shrank in importance in comparison with the kinds of geometric systems on an architectural scale that I saw around me. My interest in postwar New York School art was also reawakened: specifically my interest in Barnett Newman, Frank Stella, the Minimalists, and the Post-Minimalism of Richard Serra and Robert Smithson. I began to think about what Stella had said about his paintings being ordered differently from European modernist paintings because of the social and philosophical differences between the cultures of prewar Europe and postwar America. Putting all this together, I began to think about the square.

There was one thing about Minimalism and geometric formalism that had always bothered me: I was never able to see these geometric forms as truly abstract in character. The idea of the detached signifier, the signifier without a signified, had always been difficult for me; to me, the square, or any other form, always had some kind of significance in the real world or in relation to other systems. If there is such a thing as post-Modernism—which is debatable—perhaps one way to see it is as a reaction to Modernism's concern with the idea of the pure signifier, or pure form, in the work of art. Post-Modernism is concerned with reopening signifiers to multiple levels of meaning.

Geometry also no longer seemed to me like a benign, universal, or ideal phenomenon. I reacted against the idea of geometry as Platonic form, the basis of a classical, timeless order. Instead I began to see geometry as a means of control and manipulation, as the dominant force in shaping the social landscape. I started to view the apartment, the office, and the street as essentially geometric configurations reflective of geometry's controlling functions. I wanted to find a way of visualizing this perspective on geometry in my work. To do this, I decided to make the square into a prison—to take a pure geometric figure and make it, first, into an image referring to a three-dimensional thing located in the landscape, and second, into an image of confinement. If I no longer saw geometry as ideal, I also no longer saw rationality, represented by the square, as particularly liberating, but rather as isolating and confining. So the square appeared in my work as a prison and later as a cell.

Red Cell with Conduit. 1982. Acrylic, Day-Glo acrylic, and Roll-a-Tex on canvas, 64 x 42"

If I began with geometry as alienation, with the square as prison, a space of enforced isolation, my perceptions soon began to change. Sitting at home in my loft, I was always aware of the physical isolation and social containment engendered by systems of industrial organization. Cars, apartments, even office cubicles are isolating situations. But the phone rings, there's electric light, there's television, there's radio. I began to realize that even though contemporary space is defined by physical isolation, it is also characterized by interconnections. Things come in and out—but they are all technologically mediated things. That's why the idea of the conduit—a supply line leading into the cell from underneath—came into my work.

The first paintings were single prisons. But *Freudian Painting*, from 1981, depicted two prisons, of two different sizes, side by side; I imagined a parent prison accompanied by a child prison—gallows humor I guess. *Prison with Conduit*, also 1981, is the first painting in which the underground conduit appeared. Looking back, it's clear to me why people found it pretty hard to tell that it was a prison with a conduit coming in from underneath; it wasn't clear as a representation, because there were certain things I couldn't compromise on. I couldn't paint a perspectival prison with electric lines coming in; the prisons, the conduits, and the cells had to remain generic forms. I was interested in the almost complete universality of this system of spatial connections in the contemporary cultural landscape. The conduits had to represent electric lines, *and* plumbing pipes, *and* anything else that might be directed into or out of the space. In addition, I wanted to use the language of geometric modernism to describe this system. I felt that modernist geometry and this social landscape were inextricably linked.

The first prisons and cells were white because the Roll-a-Tex–brand simulated stucco, which I used to paint them, was white. I was interested in using real-world materials in a way that borrowed from Minimalism. But in this Day-Glo red painting, *Red Cell with Conduit* [1982], I was thinking about the cells heating up.

While I'm always interested in the ideas that emerge from my work and that of other artists, I want to emphasize that my paintings usually come from intuitive, subconscious images, like a cell heating up or a cell glowing. How could I make the cell feel like it was glowing? The answer was Day-Glo paint. I didn't want a natural glow, or the kind of glow one sees in a Rothko. I wanted it to be a technological glow, the glow of radiation or a power plant, the glow of electricity.

In *Ideal City*, from 1984, I started working with the idea of connectivity in a broader way. I had begun to feel that this system of linear connections was also discernible in a variety of other social phenomena. It was visible in technology in the miniaturized scale of the electronic microchip. It also appeared, as an organizational space, in the flow charts used to map the bureaucracies of corporations and governments. But in the end, *Ideal City* also looks a lot like the face of a touch-tone telephone.

In *Yellow Cell with Conduit*, a painting from 1985, the spatial emphasis has changed: the iconography has become more abstract. The image here might suggest a television screen or a video game—the electronic world, not the built landscape. I was also becoming interested in computer animation, in which you can turn up a color simply by pressing a key on the keyboard. In this painting, I tuned up the color in the background—and as a result I got a much flatter, more diagrammatic space that had something to do with electronics. In fact the cell and conduit in this painting came very close to the idea of a microprocessor. The current is processed in the cell and moves on. I liked this configuration so much that, for the first time, I made a series of paintings that maintained the same configuration, changing only in color. I've always been interested in color as signifier—how color can be used to identify differences, rather than just as a means of emotional expression.

In the work of the last year or so I've pursued two very different directions. First, I've elaborated the cells and conduits. I began to think that one conduit wasn't enough; the contemporary landscape is characterized by *bundles* of parallel conduits—telephone wires, electric lines, and multilane highways.

Second, I became interested in the idea of an emptier space. In *No Man's Land* [1986] I eliminated the cell from the image. The conduit just runs along underground, it doesn't connect with anything. The space above is black; it's a landscape at the edge of town, emptied of activity. In *Three Sectors*, from 1986, the empty space is illuminated, as if the darkness had been replaced by a kind of dawn—not a natural dawn, but a sort of irradiated dawn of awful Day-Glo orange. The color shifts from yellow to orange to red. I wanted to take the spectrum out of the realm of color theory and emphasize associations with technology and corporate graphics. I've noticed that recently a lot of formalist ideas about color are being used in a corporate context. If you've ever seen the logo on a Manhattan Cable TV truck, you've noticed that there's

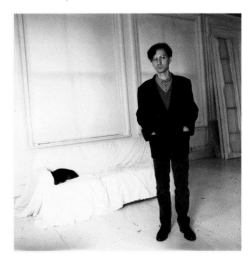

a sequence of yellow, orange, and red rectangles above a black rectangle. Lately transportation themes seem often to contain the idea of sequences of colors, and the colors are almost always warm hues.

The last painting I'd like to show you is *Two Cells,* also from 1986. Both cells have black Roll-a-Tex surfaces. They're close but not in contact. It's a return to the double-prison idea of *Freudian Painting*. The same themes keep coming up in my work, year after year. I hope they're expressed in different ways, but the themes don't change. They always seem to be there.

Born 1940 in Monroe, Washington. Lives in New York

CHUCK CLOSE

Selected Solo Exhibitions
"Chuck Close." The Museum of Modern Art, New York, 1998 (traveling)
"Chuck Close." Staatliche Kunsthalle Baden-Baden and Lenbachhaus
 Munich, 1994
"Chuck Close." Walker Art Center, Minneapolis, 1980 (traveling)

Selected Group Exhibitions
Venice Biennale, 2003
Carnegie International. Carnegie Museum of Art, Pittsburgh, 1995
Whitney Biennial. Whitney Museum of American Art, New York, 1991

I was a great student—the student everybody liked having in their classes. I was a chameleon: I could be Matisse one day and de Kooning the next. I ended up leaving graduate school without anything I wanted to do. I was in love with the idea of being an artist, I loved going to the studio, I loved the physicality; the problem was that I didn't like what I made. It didn't look like me. I couldn't find myself in it. Finally I realized it was sort of accidental that I'd ended up making what I was making, so I reassessed every aspect of what I did, every tool I used, every process, procedure, material, scale, color, black or white, thick or thin. If I couldn't guarantee that I was going to make anything interesting, at least I could guarantee that I wasn't going to make one more of those paintings. I was always told that I had a great sense of color, a great hand, and I made all kinds of wonderful shapes. So I threw away all the old tools and got a bunch of tools with which I had no personal history and no facility. I decided I was only going to use black paint on white canvas, which forced me to decide what it was I was going to do. Every mark on the canvas counted. No gesture could be some superficial flip of the wrist.

I was interested in the notion of alloverness, which I considered a typically American phenomenon of post-1945 painting. That meant I wanted to get away from the typical hierarchy of the portrait, which says that the eyes, nose, mouth, or what-ever are important and the other things aren't; I wanted to make paintings in which everything was equally important. I tried to find a tool with no fine-art connotations or art-historical baggage. The airbrush had only had commercial applications, so it interested me; it was also subtractive, in that it made a thin paint surface that I could scratch through, erasing it and manipulating it and taking it back off. I didn't want the paintings to be any more an homage to the airbrush than I'd wanted my earlier paint-ings to be an homage to the bristle brush.

After a number of years of working in black and white, I decided I wanted to bring back color. I didn't want to fall into the same old color habits, though, and one thing I had done away with in the black and white paintings was the need for a palette. So, for the few color paintings, I sprayed everything right on the canvas. When you have a palette, you're making decisions out of context: you mix your favorite color combinations over here and then superimpose them on an image over there. I needed to know how to break full color down into its component colors, so I made dye-transfer color separations that told me where each color should be and I would work from them. The results have this sense of alloverness, and of treating everything the same, since every piece of the painting is made with the same three colors, none of which you can see in its original form: the relative amount of one color over the next—more red than blue, more blue than yellow—determines the overall color, and their relative density determines how dark they are.

When I made the continuous-tone color paintings, all kinds of crazy color things happened that nobody saw because they were on top of each other and camouflaged

each other. Think of the metaphor of golf, which I believe is the only sport that moves from the general to the specific. Say you're playing a par four hole. On the first stroke you can't even see the pin; you just know it's over there somewhere. The second stroke is a correcting stroke. On the third stroke you hope to chip the ball onto the green and be in putting position, and on the fourth stroke you have to move someplace very specific. I wanted to make a painting in which I would approach each square as a par four square. And just to make it more interesting, I would tee off in the opposite direction. I know a square will eventually be a dull, orangeish brown, so the first stroke is purple. Then the second stroke has to correct like crazy because I'm going in the wrong direction; so now I make a red stroke on top of the purple. Now it's moving there but it's not orange enough, so maybe I'll make a yellow stroke on top of the red. It's wet, so it's going to pick up some of the color underneath—it's going to physically mix. Plus there are little pieces of the old color streaking through, so it shows where I was when I made the first stroke. I like to leave a record of where I've been. Then finally I've moved it to the right generic color, an orange—but it's still too bright. So the last stroke is a little dab of blue right in the middle that will optically mix, lowering the intensity down to the dull orangeish brown. Hopefully I come in within four strokes. Sometimes I come in a stroke early, and have a birdie; or I come in a stroke or two later and have a bogey or a double bogey. I can also have the aesthetic equivalent of being mired in a sand trap, and keeping on making stroke after stroke without getting anywhere.

One of the things about invention is, we have a notion that only one kind of thing is invention—you invent an interesting shape, an interesting color combination, an interesting edge. But that's just one kind of invention. For me invention is the invention of means, not the invention of shape; I decided to accept the shapes and colors and edges that happen in the photograph. One thing I've done over the years is recycle images that matter a great deal to me. I don't talk about the imagery because the imagery is self-evident. I don't paint commissioned portraits; these are my friends. Some images offer certain formal possibilities, and other issues as well; some have qualities that make them imminently recyclable. The only thing that stays constant is the iconography. I like having something stay constant so that I can explore all the other changes that I can put into it. I like painting faces because, first, you can make as many portraits as there are people, and I care about people. I don't care about grass, I don't care about trees, but painting people makes me want to hang in there and do what I need to do. I'm lazy, I'm sloppy, and I'm nervous, but I don't let myself wallow in my nature. I've constructed a situation that doesn't let me behave the way that's most natural. Resistance, difficulty, lack of ease, is very important. It gives an edge to things. You value things that don't come easily to you.

With paintings this big, you have a chance to rip the head loose from the context in which we normally see it, which of course is life-size. If you see one of these paint-

ings in a magazine or book, you can see the whole thing all at once. I want to make the painting so big that from an average viewing distance you cannot see it as a whole. That forces you to read it—to go from the flat surface to the image and back to the flat surface to see the marks across it, to view it from a distance and then walk up close enough so you don't even know what you're looking at. Those are the kinds of experiences that I've tried to build into the work.

I always wanted to make things that nobody else would be crazy enough to make. Richard Serra once gave me one of the great pieces of advice: "If you really want to separate your work from everyone else's, every time you come to a Y in the road, don't think about which way to go; automatically take the toughest route. Everybody else is taking the easiest one, so that will automatically separate you from whatever else is going on." I think there's truth to that. The prevailing wisdom is by nature ordinary thinking—it's simply what most people think ought to be happening. That doesn't mean it's what you should be doing.

I'm very much interested in trying to build something that's transcendent, something greater than the sum of the parts. The reward lies in knowing that these things have a certain life of their own. Like children, they're out there. They're representing me. People I've never met have been moved by them. In a sense, that's a little bit of immortality.

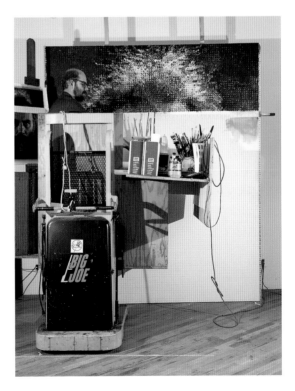

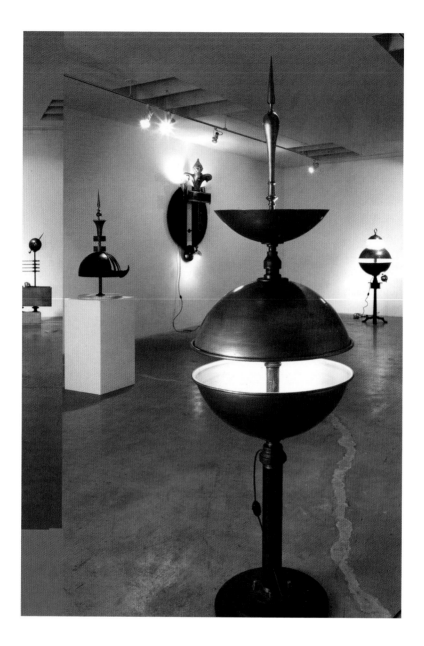

Born 1947 in New York. Lives in Brooklyn, New York

R. M. FISCHER

Selected Solo Exhibitions

Kansas City Sky Stations. Permanent public artwork, Kansas City,
 Missouri, 1991–94

"R. M. Fischer." Musée de la Ville de Toulon, 1984

"The Sculpture of R. M. Fischer." Whitney Museum of American Art,
 New York, 1984

Selected Group Exhibitions

"Threshold." Serralves Foundation, Oporto, 2001

Whitney Biennial. Whitney Museum of American Art, New York, 1987

"Between Science and Fiction." Bienal Internacional de São Paulo, 1985

My background in terms of art is based in Pop art and Minimalism, the art of the time when I was educated. But when I came to New York—in 1973, after graduate school—much of what was going on was considered Conceptualism. Artists were getting rid of the art object and dealing with ideas that were for the most part socio- logically based. Like them, I began making works where I used photographs and objects in combination, forcing the viewer to create a narrative. The photographs were often found materials, from sociology textbooks, psychology textbooks, or advertising, and the objects related to these things. But I felt I was putting myself in a corner by mak- ing work that seemed only to be able to be appreciated in a gallery setting.

Once I got out of art school, I came to think that placing yourself in the art-for- art's-sake box was an anti-inspired attitude. The art world wanted to keep itself in a small arena: "We're very special and you can't understand us." That's fine, I'm interested in in-house ideas too, but at the same time I always fought against that limitation. I grew up on Long Island and was a kid of popular culture, and I wanted to make an art that could reach out in many different directions at once.

I came upon the notion of using the lamp out of some of the conceptual work I was doing. A lamp would give the viewer a point of entry into the object—everyone knows about lamps, and design, and the objects of the real world. Taking such knowl- edge and abstracting it, I could play upon the viewers' preconceptions of that object, and perhaps of all objects in general that the viewer might have or live with. I could also question the position of the art object at this point in time. What is the function of the art object? What is the function of sculpture? Is it meant to be seen isolated in a museum or gallery? Or can it situate itself in the real world, as art perhaps functioned in the Renaissance? I wanted to ask where art situated itself in modern times.

I began the lamp works around 1977. At this point they were all made from found materials: street stuff, plumbing, pipes, ducting materials, secondhand lamp parts. The first installation included *Dinner Lamp*, *L.A. Lamp*, *Wired*, *Rustic Den Lamp* (which I thought should have been in everyone's den), and *Lobster Lamp*, which is eight feet tall. After that exhibition, at Artists Space, New York, in 1979, I decided that if I was really true to my belief that my art objects, or art objects in general perhaps, should be able to be seen and appreciated outside the art gallery, I would approach Bloomingdale's department store and ask if they would use them in their windows. To my surprise, they did. I was very excited about this, and I sent out press releases about how I was showing work both in galleries and in Bloomingdale's windows. I had an opening out on the street and I invited all my friends to wait for the press to show up, which of course they never did. But the "Home" section of the *New York Times* did a feature-length article on the work, a two-page spread, and what was most exciting to me was to be able to be written about in the popular press, to work myself outside the art world. I felt constrained by all the art-for-art's-sake ideas that were running around in Conceptualism and Minimalism. To be able to reach out beyond that was very exciting for me.

I hate to blame it on my father, but he's a manufacturer, a good businessman, and I remember as a kid going to his factory, which produced hair curlers. They had these Rube Goldberg devices to make this stuff, and he had display stands full of it and sold it to Woolworth's. So I think my interest in consumer objects and those kinds of things comes out of my background, in the environment of a middle-class manufacturer. I'm proud to have been brought up on Long Island, and I think that's in the work. I want it to be in there. I also wanted to make something that would be affordable to someone who might not be buying an art object, who might just be buying a lamp. So I made a multiple, in an unlimited edition, out of 16-millimeter film caddies. I was able to sell them out of Fiorucci's department store, in design and furniture stores, and in museum bookshops. It's an ongoing multiple, a generic object on a small scale.

As for art sources, a lot of this attitude comes out of the Bauhaus, and that notion of breaking down barriers and creating collaborative situations between various disciplines. Perhaps my work is a modernization of that ideology. It suggests that technology is not the enemy—that we control technology, that it can be a human thing. But the notion of technology in the work is already outdated in terms of what's possible; the incandescent bulb is actually an outdated mode. The world that we live in is in many cases the world of yesterday, yet our fantasies are of the future. I'm hoping to combine the known, the antique, a feeling of nostalgia, with a sense of the future and a hopefulness about some new form—not a frightening or intimidating form but a form that seems different, new, fresh, yet that we somehow feel comfortable with. The work has a kind of Flash Gordon–type sense of the future—an optimistic projection from our own world into what the future will be.

Ideas about religion and the inspiring object interest me. The power structure we inhabit is the corporate system, which has replaced religion in providing what we aspire to and what inspires us. The corporate images of our day are images of inspiration, and for me this is not a bad thing. It's just a change of God, in a sense; a change of the power system. I like that, so these objects give off a sense of the richness, the inspiration, the optimism, of the corporate system. At the same time, though, they hold their own ground and speak their own messages. The notion is to create something beautiful and modern yet subversive, something that undermines the very thing it was supposed to be, and that creates a dialogue both with itself and with the audience.

I want the pieces to continue to have a sense of use about them. Some include parts with obvious uses; some imply that in some unknown time and place this object had some function, not stated and perhaps not known. For the large piece Columbus [1984] I ordered parts from a Connecticut company that produced architectural details from original nineteenth-century castings.

I'm optimistic, and I feel optimism is an American attitude. My art isn't negative or about apocalypse or death or angst. I'd like it to be self-expressive, but I'd also like

it to be able to be read on a broader basis and in a cultural context. For me that means making it accessible and a pleasure to look at. At the same time, the work is obviously meant to be seen in an art context. Context has always been important to my work.

We're all used to seeing certain objects, and we're used to accepting things without noticing them. I hope my work makes people see things they're used to in a different way, and perhaps appreciate the physical world differently.

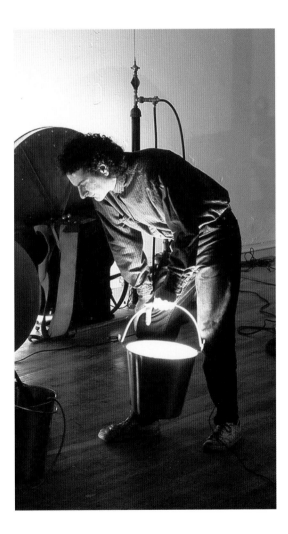

Fischer working in his studio, 1990

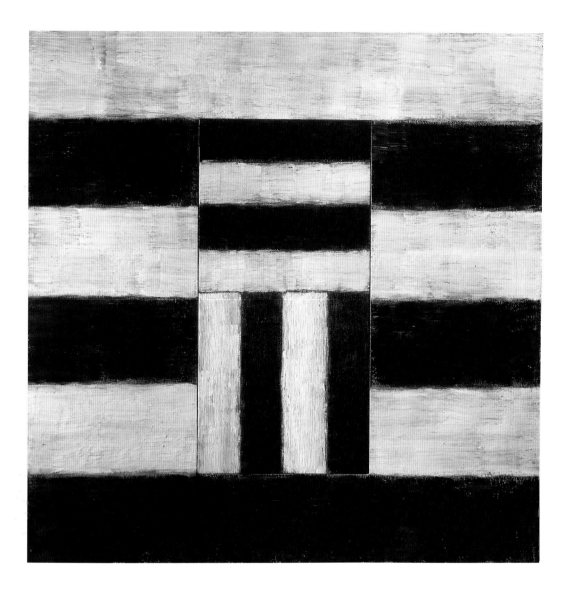

Born 1945 in Dublin. Lives in New York

SEAN SCULLY

Selected Solo Exhibitions

"Sean Scully: Wall of Light." Museo de Arte Contemporaneo de Monterrey
 (MARCO), Mexico, 2001 (traveling)
"Sean Scully on Paper." The Metropolitan Museum of Art, New York, 2000
"Sean Scully: Paintings, Drawings, Photographs 1990–2001." Kunstsammlung
 Nordrhein-Westfalen, Düsseldorf, 2000 (traveling)

Selected Group Exhibitions

"Color/Concept." National Gallery of Australia, Canberra, 2002
Bienal de São Paulo, 2002
"A Century of Drawing." The National Gallery of Art, Washington, D.C., 2001

In 1970, when I was an art student, I made a trip to Morocco. When I came back I was making paintings with cutout strips of canvas, because what you see in Morocco is material in colored stripes, long flat bunches of it made of thin strands of wool. They dye strips of material, then hang them over a bar to dry in the shaded heat. Then they use them to make rugs.

I'd been making calligraphic paintings; soon I got into making the grids. The way it happened was, I made an allover striped painting that was square. Then I turned it and did it again, and I ended up with a grid. That was the structure I used for about five years. It raises an interesting point: what has gradually happened over the years is that the band or bar or stripe has become the subject matter. It's the thing I address. For me, it replaces the nude, or the bowl of fruit, the thing you paint. There is of course light and space in these paintings, but I don't set out to manufacture light and space. What I'm doing is painting the stripe as the subject.

The other thing I think is important is that the work I've been doing for the last six years really isn't serial work. The structure is addressed over and over again, and there's a certain repetitive quality, but this isn't serial art. I'm not necessarily going to make ten paintings that deal with this as a formal issue, I'll do the thing I feel like doing.

So that makes these paintings actually somewhat different from the monotypes, which deal with pure experimentation. There I'm just shifting things around, and I'm open-minded and unassuming about the results. With the paintings that tends not to be the case. The painting has a personality, or a point of view, that has to realize its fullest potential. It's an emotional space.

Empty Heart [1987] is very symmetrical, but it's not a symmetrical painting. I wanted to make something harmonious and beautiful. The reason this painting is symmetrical is that I wanted to put something right in the middle that was different from what was around it in some interesting or provocative or poignant way. Since the inset panel is right in the middle, you have to look at it and everything around it at exactly the same time. In other words, the issue of symmetricality, in and of itself, is not particularly interesting to me. It's only interesting to me in relation to the way that I can put one kind of painting in the middle of another kind of painting. You have two paintings making up one painting, or two things making up one thing: that's the relationship that's of interest to me, not the notion of things being the same.

I've made lots of paintings where I've pushed forward some part of the painting, so those works have a real physicality about them, they're quite sculptural. Recently I've been making flat paintings, which has had a wonderful effect. It's amazing how, when you close up one possibility but subject the activity to the same kind of pressure, or apply the same sort of energy, as you did before, something else opens up. Painting flat has put more emphasis on color than on the drawing. The reason I did that was that the drawing in the three-dimensional works was somewhat limited by

the fact that they were three-dimensional. By not allowing myself that sculptural facet, I've made something more apparent to myself. I guess that's why the grid started to come back into the work, and why I started to paint the space. I should say, however, that painting space isn't very interesting to me. The issue of painting abstraction isn't space, it's subject matter, how that subject matter is addressed, and how that produces content.

Color is something real natural to me. I think about structure a great deal, but color is purely intuitive. I hadn't used green for a long time, and I got scared of it; so I made some green paintings, and I made friends with green again. That's very simple for me. What's interested me in painting ever since my trip to Morocco is the horizontal and the vertical. That, of course, goes back through Mondrian and other artists before him, but I feel that those two directions represent the two primary ways that we can see images. In all my paintings there's a horizontal and a vertical. Really what's happened with the paintings is that the grid in the early work has been pulled apart. If you put the horizontal and vertical sections back together, you reconstruct a grid.

Even though the paintings now are generally flat, I'm not saying they'll stay that way. There's something very moving to me about a surface that's extremely subjective and extremely real—something close to the sublime, something metaphysical in some way, yet extremely present. One of my big influences is Mark Rothko, whose space has enormous implications. But my paintings are more in the real world. The surfaces are more tactile and the seams between the different areas are very physical. So you have the opportunity to be in two worlds at the same time: you're looking at something concrete, something that has a body to it, but also has a spirit. I find that a complete experience. It's very true of Mondrian, whose paintings are resolutely flat yet have great aspirations.

The works on the wall now—monotypes I made at the Garner Tullis workshop earlier this year—were done with a kind of open-mindedness as to what they are, as I said earlier, whereas I want a painting to be much more opinionated about what its identity is. In a sense, these go back to interesting formal traditions, and are trying to open things up a little. I'm not really interested in what happens when you put this element next to that, I'm much more interested in meaning or consequence, but in these works that preference was temporarily suspended. These works have an element of curiosity that isn't usually there when I make a painting; when I make a painting I'm usually more interested in what it is. What is that as a painting? When I've figured out what it is, I try to make it as much what it is as it can be. When I feel I can't make it more what it is, it's finished. With these works on the wall I was more forgiving than perhaps I am with some of the others. But I think that for me that's a healthy thing—because my work, obviously, has a certain manic quality about it.

You may have noticed that every area in my work is filled up. There are no flat, empty passages, there's no in-between. Everything in my paintings is a fully realized thing, which is on top of another thing, which is on top of another thing. So they're

about compression, collision. They're crowded. I had a definite idea that the triptych *Black Ridge* [1984] would be about a figure compressed from each side, like a figure in a landscape—not in the landscape where we stand, since this is an abstract paint-ing, but still like a figure in a landscape that is exerting pressure on it. I began to paint the painting, and for some reason I painted it timidly, for me, everything being relative. And that became the subject matter of the painting: the way it was painted, the draw-ing, the color, the surface—everything was a little off. You know the way flowers sometimes grow out of a building? It was like that, and it was so beautiful that I left it. What was interesting was that the painting was made at a time when I'd made other paintings of this kind, so I was very sure in this area—yet I began to deal with the opposite of certainty. In another triptych, *The Traveler* [1983], which I did around the same time, one side of the painting is very sure of itself and the other side is not. When I make paintings like that, I'm completely beyond the point where I'm trying to make the painting work. That absolutely doesn't interest me. Of course I can make a paint-ing work; I've painted for twenty years. Not making them work is the beauty of it.

The final thing to say about the stripe is that it's debased by everyday imagery. It's all over the place—in the subway, everywhere. It might have had a slight shock value when Barnett Newman was doing it (not that that was the first time that form had been used), but to my mind that gets in the way. Painting a stripe is like painting an apple: when Cézanne paints an apple, you look at the painting and say, "Oh, it's an apple," such an ordinary thing; but the way he paints it makes it so wonderful, so moving. Jazz can be moving that way too: successful jazz musicians may choose a very simple melody, but then they improvise. And it's the sense of what the melody should be, or usually is, that makes what they do so poignant.

This brings me back to my point about not making things work. That's why I don't try to make the paintings resolved in a design sense: I just try to make them be as much as they can be.

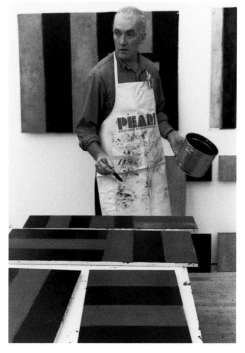

Born 1949 in New York. Lives in New York

ROSS BLECKNER

Selected Solo Exhibitions
"Ross Bleckner." Bawag Foundation, Vienna, 1997
"Ross Bleckner." Solomon R. Guggenheim Museum, New York, 1995 (traveling)
"Ross Bleckner." San Francisco Museum of Modern Art, 1988

Selected Group Exhibitions
"Jasper Johns to Jeff Koons: Four Decades of Art from the Broad Collection."
 Corcoran Gallery of Art, Washington, D.C., 2002 (traveling)
"In the Power of Painting." Moderna Museet, Stockholm, 2000
"Birth of the Cool: Amerikanische Malerei." Deichtorhallen Hamburg,
 1997 (traveling)

I think of making paintings as in a way like writing a book: I go from chapter to chapter. For me painting is thematic, not formal (in the sense of taking a single image and refining it)—although that of course is part of painting too. I think all painting has to do with a kind of libidinal energy. That relationship between what goes on consciously and what goes on unconsciously is often reflected in the way life becomes manifest in a painting.

I don't much distinguish between my more abstract paintings and my paintings that have more imagery, where I take an image of a chandelier, say, and use it as an idea about a certain artifice, a certain kind of life. It's something of a mystery to me how certain images come in, but I like to leave them as clues. They become expanded and contracted—they're most expanded in the abstract paintings and most contracted in the paintings of objects—but they really use the same set of ideas, they just go from being abstract into being still lifes. That's what I meant by a book: there's a narrative there. The narrative is basically how light changes.

I see the stripe paintings as diffuse in the way they don't really allow for an image to be constructed, which makes them more participatory. I like them to be confrontational. I don't really think of the stripes as stripes, I think of them as bars; they block one way of reading the painting. These paintings have an opticality in which what's in them seems to be behind them: it's as if there were something in there, but as soon as it begins to congeal into an image, it breaks up again. So the paintings are in a way disintegrating—they're the disintegration of my other paintings.

What's embodied in the dot paintings I think is metaphorically symbolic. The relationship between the literal and the symbolic is important to me. Obviously the image of an owl, or of a chandelier, is a more literal image. But a painting like *Fallen Summer* [1987], which has these snowflakes, turns things around: inside becomes outside, and nature becomes an artifice that gets used for culture.

I like paintings to have a certain relationship to landscape, but not to be landscape paintings. The place where light comes from is sometimes in back of the surface, sometimes in the painting, sometimes on the painting, sometimes in front of the painting. That question of where things are—sometimes they're more visible, sometimes they're *in*visible. That has to do with what's expressed and what's repressed, what's conscious and what's unconscious. The information we express isn't always the important information; a lot of things don't get expressed. These paintings try to address that idea of repression.

So that's why I don't see the abstract paintings and the images as being that different. They may be different formally, but thematically, getting from one painting to the other is more like a mutation. You take a certain possibility and mutate it so that what was an object suddenly becomes almost a condition, an atmospheric condition. Some paintings to me are like painting steam, or fog, and some, where they get very concrete, are like painting ice.

I've been talking about where I think images exist in paintings, the where and then the why. And as soon as you get to the why, you deal with "Why not?" So there are sometimes images that aren't images. Sometimes there's something you can see, sometimes there's something you can't see. Often what you can't see is as interesting or important as what you can.

As far as the shapes go, that brings me to another theme, which is commemoration. Most of the paintings I'm interested in, whether historical or contemporary, are to a certain degree commemorative. I think artists have to find ways to say things that are hard to say. Also, as soon as you make a painting your relationship to it changes, so there's a constant sense of loss.

I did two paintings, one saying "Remember Me," one saying "Remember Them" [1987], in which the idea of commemoration has to do with this shape like a memorial plaque. The way those snowflakes or bricks are built up from underneath—it's like they're there but not there. They're inside the surface. To me, the figurative element of a painting is really the surface, which is like the skin. And I often like to put things inside paintings, just like things are inside skin. Then what's on top decorates or rather embellishes what's underneath, which is where the tension really exists. The surface to me is like a skin, and there are places where I break through it, places where I paint into it, places where I paint on it, places where I paint in front of it, and places where I describe how I think I'm painting about it.

I'm very interested in glowing painting, painting that radiates. The work of a lot of my favorite painters—Rothko, Newman, Goya—has to do with things coming out from inside. That's part of what I'm doing with my paintings too: I put this little blob on top, which is just a piece of paint, but it describes this relationship of where things are and where they aren't. It sets up this whole illusionary space—but in some sense it's just the material of making the painting.

My experience of looking at painting involves a certain hypnotic effect. That idea generates images too: the methodology is ordered yet the effect is apparently disordered, out of focus, which makes it hypnotic. I needed to make very methodical paintings so that I could get them to have a kind of spacelessness, an endlessness, yet at the same time be paintings. The way these paintings disperse light—that's like the broadest parameter of how light disperses and then collapses. Then at some point as it's collapsing, it becomes an object, becomes embodied. I'm interested in painting light as an object. But it keeps collapsing, falling back into itself and becoming a dot. It's as if all the light from the object paintings ended up in the dot paintings. When I'm working on a group of paintings that's actually how I narrate the flow of energy through them.

For a while, what I've been interested in iconographically is using a very reduced image and seeing how much emotional range I can get out of it. Now I'm more interested in simply the painterliness of the paintings: there's this light from behind, there

are these shapes on top, there are things in the middle, they all vibrate together, and you can't really locate them. That's what holds my interest in them.

I think all painting aspires to things that painters shouldn't talk about. Not that they can't be talked about, they can, but these ideas of disembodiment, and commemoration, have to do with looking at the world over your shoulder in a way—speculating, not looking at the world directly but absorbing it, and trying not to reflect it but to transform it somehow through subjectivity. They have to do with the mode of transformation. In the world, my belief system is not that well constructed—I don't believe a lot in things like religion, for example—but in my studio it's different. So I test one against the other, and that creates a certain tension, which holds out a possibility of things being more spiritual. That's hard to completely embrace; I keep hold of a certain skepticism—but I do think good painting gives over to a sort of spirituality. I'm interested in my painting believing things that I don't necessarily believe in myself—to me it's all magic on some level.

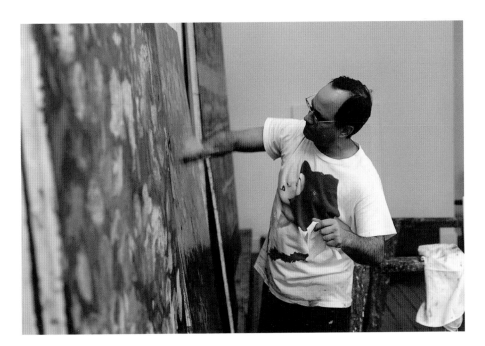

Bleckner in his studio, early 1990s

Born 1948 in St. Charles, Illinois. Lives in New York

GREGORY AMENOFF

Selected Solo Exhibitions
"Gregory Amenoff: Selected Paintings, Drawings and Prints, 1987–1999."
 Wright Museum of Art, Beloit College, Beloit, Wisconsin, 2000
"Thirty Views." Lowe Art Gallery, Syracuse University, New York, 1998–2000
 (traveling)
"The Sky Below: 18 Paintings by Gregory Amenoff." University of Tennessee
 Gallery, Knoxville, 1997–98 (traveling)

Selected Group Exhibitions
"Beyond the Mountains: The Contemporary American Landscape."
 Newcomb Art Gallery, Tulane University, New Orleans, 1999–2000 (traveling)
"Painting Abstract." Mount Holyoke College Art Museum, South Hadley,
 Massachusetts, 1996 (traveling)
"Parallel Visions: Modern Artists and Outsider Art." Los Angeles County
 Museum of Art, 1992

GREGORY AMENOFF April 26, 1988. Studio, TriBeCa

The work before 1973 is generic color field painting, much in the realm of what was going on with [Kenneth] Noland, [Morris] Louis, etc., all those Washington painters at the time. But these paintings that I started in 1973 are in oil and wax on canvas. Because I didn't go to art school, I didn't know about encaustic, so the wax is paraffin wax instead of beeswax. The works are highly layered; people likened them at the time to elephant skin, which greatly offended me, though now it seems kind of charming. These works were cumbersome and heavy, like tablets or slates. In some cases they involved separate panels, almost like an altarpiece. The linear elements were carved into the surfaces; the gold lines are real inlaid gold leaf. The visual elements are varied but minimal. I was preoccupied with moving from the left side of the canvas to the right, and with the space running across the surface. I was thinking about bridges, balanced structures that hang in suspension—things like that.

When you paint without color the way I did, there's really only one direction to go in. So I entered the world of color—not exceedingly daringly, but certainly there were some slight value shifts. As I brought a little more contrast and color into the paintings, the forms became more rigid and more geometric. Looking back, I can say that this was the way I was learning to paint, issue by issue—color, light, form, atmosphere, content, taking them one by one. We set up a lot of academies for ourselves, a lot of rules; the process of developing over time, loosening up and becoming free, is really the hardest thing to do.

In 1976 I stopped using the wax. One can fall in love with one's material too much, and it becomes a hindrance. Wax was just too seductive; sooner or later I had to get it out of the paintings, so I started working with just oil. At this same time the color was starting to get a little more adventurous.

I think all painters make paintings that may not represent their best work but are nonetheless pivotal in their development. That is, they discover something in a piece that represents a moment of realization. It might be color, it might be paint handling, it might be finally hooking onto a personal subject matter, or whatever else. For me, I remember very distinctly that this happened with a painting called *Pink Wish* [1976]. The way it's painted, with the gray field in the center, the way the forms emerge—I was almost watching my hand move. I'm not an athletic person, but the way I felt working on this painting is the way I imagine athletes must feel when they're operating at their peak performance level and almost marveling at how well things are working. Simply put, I remember getting a sense of coordination in this painting; I think that happens to all painters at various points. You get to walk across the meadow for a while. Then, unfortunately, there's another mountain ahead of you—it never really gets easier but there are fleeting moments of ease.

If you scratch any painter a little, you'll find someone who likes to decorate surfaces. Putting skins of color on surfaces, after all, is what we do. Some artists—Howard Hodgkin, perhaps, or before him Matisse—have elevated that decorative

sense to a high level, infusing it with content. For me, *Echo Pool* [1981] is a little cupcake. I use the word "cupcake" as in frostinglike paint, with hats off to Wayne Thiebaud. It's only maybe ten by twelve inches. I haven't done too many of these lately but six or seven years ago I did a bunch of them. It was a great release not to worry about trying to shake the world, just to enjoy decorating a surface.

Back in the early '80s my work had a polar sense: it would go from an outer-directed focus to a much more personal and internalized one. Examples are *Hinterland* [1984] and *After the Gauntlet* [1983], in which the forms are very similar but the second painting is much more internal and psychological, much more to do with me. The work still moves between those two poles, but I'm less concerned now with that outer sense and more involved with an internal one.

A couple of years ago, I felt like I was swimming in a sea of shapes. I wouldn't say the more organic nature of a lot of my earlier paintings has left the work, but I needed edges and less organic, more resistant shapes. I felt I needed things to bounce off again, and the forms started to feel arbitrary to me; it all seemed too amorphous. So some of the newer work has rectangles and edges appearing here and there, I suppose exemplified best by the big painting *Urania* [1987], which is probably the strongest painting I've made in a while.

I'm interested in a certain tradition, an American sensibility. I feel I can't escape that sensibility and have become more and more interested in it over the years. If the goal of painting over the course of a lifetime represents a process of trying to get more in touch with what you really have to say (and who you really are), then understanding my own "Americanness" in terms of my work is my charge. I'm a transplanted Midwesterner living in New York, and I'm very aware of that; I've never quite felt at home here. So the process of developing my work has been very much about trying to reach something that I think is undeniably very American, as opposed to European. There's something very fresh in a lot of those early American modernists, with whom, for better or worse, I suppose I've been associated to some degree—Arthur Dove, Marsden Hartley, and those painters. I think there's a wonderful tradition in that work that I would contrast with the European tradition coming out of Cubism, which was a movement that could not have come out of our hemisphere. Cubism and other early-twentieth-century movements are more connected to theoretical concerns; our experience in this country is much more direct and perhaps more guileless.

I have also found inspiration for many years in the work of untrained or outsider artists, or what some people I suppose would call folk artists. "Outsider" as an expression isn't as patronizing as some other appelations—it simply indicates that these artists are outside the academic and art-historical structures. Three of these artists in particular I think are very good: Bill Traylor, who made incredibly powerful and graphic images; Joseph Yoakum, who was very influential for the original Hairy Who group in Chicago, and who had a very inventive sense of form in landscape and a

phenomenal sense of space; and Martin Ramirez, whom I see as one of the greatest twentieth-century artists—of that I am convinced. Too often, I think, we've dismissed a lot of these artists as crazy or quaint or whatever. The directness, simplicity, and strength of art by self-taught artists can help us stay on track in what is otherwise a very limited art world.

I make a lot of sketches, small ink studies. When I find an image or form that starts to mean something to me, I throw it on the canvas and begin to develop a painting. I always start with a lot of structure. Lately it seems that the longer I think, the fewer images I get, and the more they mean to me. So I tend to exploit them, to move them into drawings and paintings and prints a lot more readily than I would have a few years ago. I'm more interested in how they change in those various mediums. You can't make a painting without formal concerns to make it work. The first duty of a painter is to make some kind of formal sense; otherwise you're not communicating. But formal concerns are a vehicle to get somewhere else.

North of Santa Fe there's a little village, very famous, called Chimayo, where there's a Catholic chapel that's at least three centuries old. It's a place where pilgrims come, regardless of faith or belief—there's a force there, a power, that's undeniable. The chapel is filled with incredible little Spanish *retablos* in all kinds of dark and black tones. I went there a few years ago, and I came back to my tent—I spend the summers in New Mexico—and did this drawing, *El Sanctuario de Chimayo* [1985]. I wasn't thinking about anything particular other than making a visual response to that chapel, but as I was making the drawing I felt as though I was almost "channeling" the image. From my point of view three years later, it's still one of the most connected images I've ever made. I'm still thinking about it and hope it leads to a new body of work.

Amenoff in his studio, c. 1988

53

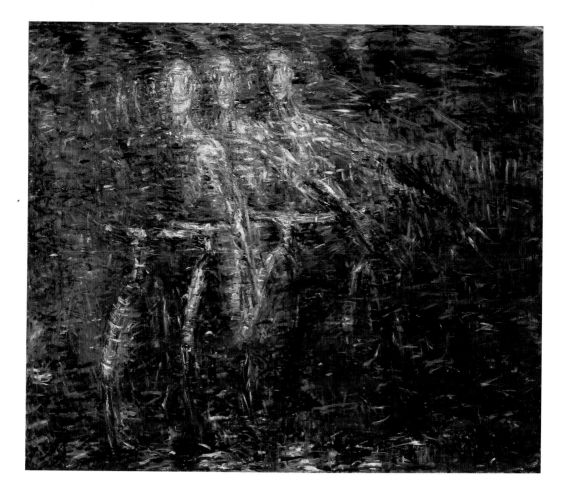

Born 1945 in Buffalo, New York. Lives in Galisteo,
New Mexico

SUSAN ROTHENBERG

Selected Solo Exhibitions

"Susan Rothenberg: Drawings and Prints." Herbert F. Johnson Museum
 of Art, Cornell University, Ithaca, New York, 1998–99 (traveling)
"Susan Rothenberg." Museo de Arte Contemporaneo de Monterrey
 (MARCO), Mexico, 1996–97
"Susan Rothenberg, Paintings and Drawings, 1974–1992."
 Albright-Knox Art Gallery, Buffalo, New York, 1992–93 (traveling)

Selected Group Exhibitions

Documenta IX, Kassel, 1992
Carnegie International. Carnegie Museum of Art, Pittsburgh, 1985
"Zeitgeist." Martin-Gropius-Bau, Berlin, 1982

I studied at Cornell, but I don't attribute too much to it. At Cornell I was just a goofy girl—I don't think I or anyone else there could have imagined that someday I would be here talking to you. It wasn't an ambition of mine to become an artist; I thought I'd be the muse of a famous painter. I think that I've grown into it.

After Cornell I took time off. I went to Europe a couple of times; I started a graduate program in Washington but didn't continue. Between the ages of twenty-one and twenty-five I sort of got lost. I drifted into New York with a suitcase and a skateboard in 1969 and ran into an architect I'd known at Cornell, who gave me the keys to his apartment one morning at seven A.M. Then in two weeks I found a loft. It was like New York was a state of grace: I'd come here a little orphan and I met Alan Saret and Gordon Matta-Clark, both of whom I'd known at Cornell. Suddenly I had a whole group of friends.

I was an early Pattern & Decoration painter, and what preceded the horse paintings that I first really got known for were checkerboard paintings divided by pencil lines so they were slightly out of sync. I did about eight of them and then threw them away; they were like wallpaper. But when I was starting to do the horses, I was dividing those, too, with pencil lines, and making the two halves a little out of sync; and I realized that even if I put the outlines of one of these divided horses *in* sync, a), it was antiillusionistic, which was the order of the day, and b), it was a surrogate self. In those days you couldn't make a figure painting if you were twenty-five or thirty years old, so the horses satisfied my itch for something real. They satisfied a desire to be formalistic and also to create a new space that you read from side to side, almost like a book, rather than in depth. So I started out both with certain very formal attitudes and with certain very intuitive feelings.

The horse paintings lasted roughly from 1974 to 1980. Since then I've been dealing with the human figure and with space and light. I do want the paintings to get quieter than all that Eadweard Muybridge–like movement I was playing with for a couple of years, though I'm glad I did those paintings. During the last 2 $^1/_2$ years I decided to address myself to a couple of issues I'd never really dealt with before, color and movement. The paintings I'd been doing were complex, they gave me a headache—every stroke was dependent on the next stroke and there was no clear space, no place to rest. I'd never really thought about color and movement. I found dancing and juggling to be the two vehicles I wanted to use content-wise to explore color. Then I figured that the color had to be doing something, it couldn't be static— I'm not interested in the Hans Hofmann notion of push-pull, I was interested in color only if it was going to do something new in my work.

What I'm trying to do now is find a quieter, simpler space, a more bodily experience. I'm interested in displacing things and putting them back together, in a way that's partly intuitive. I'm also interested in a more delicate juxtaposition of movement, line, and color. I don't think I could go back totally to black and white, or black

and sienna, but I am interested in a more limited use of color and in trying to find a slightly more buzzy, resonant space, such as in *Night Ride* [1987], than the shattered space in, say, *Pink Spin* [1987].

I mostly paint with the canvas stapled to the wall because I work the brush very hard. About three-quarters of the work gets done with the painting stapled to the wall, and then for the final process of finding where the tensions and spaces are, and when it all starts to feel right, it has to go on a stretcher, where it gets much more taut. I start by taking a lot from intuition and then I depend on composition, on building the painting's architecture. I use all the formal values of painting but it's not terribly examined, I just let it come. I'm finding more and more that it's coming out of drawing, which is new to me. Especially with the horses, I couldn't finish one painting before I wanted to do a permutation and take the next step—it was really serial. Now it's not; now the paintings have to be felt and visceral. They're also about doing figuration without relying completely on the figure.

I've never really considered drawings as studies. I used to do drawings usually when I had low energy, when I didn't feel like painting, and I was always afraid that if I really got into a drawing, and worked it as hard as I tend to work a painting, I would use up the idea. I'm changing my thinking now; I'm finding myself much freer in drawing, and making much broader gestures, than I'm able yet to do with paint. So drawing is becoming a learning instrument rather than something I do if I don't want to paint. I'm learning more from drawing now than I am from painting.

I was drawing in the studio one night, I started moving the charcoal around and it was a figure, and it looked just like what I thought Mondrian looked like from a few photos. It was also a very good drawing; my drawings are usually working drawings, searching drawings, rather than good drawings. I decided to turn this particular drawing into a painting. I also started to look at Mondrian more seriously than I had before. I realized how opposites can attract: I feel it to him, to Giotto, to Giacometti. Also to Matisse, Cézanne, Guston. There are certain artists who need to get to their true bottom line, but it's so clear in Mondrian, he's so clear and dedicated. I made a kind of romance out of that, but I also felt his loneliness, his isolation. Certainly that's a factor in many artists' lives; you spend so much time alone in your studio. Mondrian is a father figure for me, in an essential sense. He's more unlike me than someone like Giacometti; he's much more spare, much less irrational and emotional, and therefore I could go farther toward him than toward somebody more like me. There was a little bit of humor in my dealing with Mondrian, but not too much; it was very austere. It went on for a while, I did a little mental dance, and then it ended. But I had tremendous admiration for him from beginning to end.

When I walk into somebody's place where there's one of my paintings, I won't even look at it, I can't even see it, because I'll see the faults. I'll see with my 1988 eyes, not my 1976 eyes. I was told once that a 1983 painting was going to auction because

the owner wasn't happy with it, and through my dealer, Angela Westwater, we contacted that person and I offered to repaint it and said I wasn't satisfied with it either. He sold it anyway, but I was able to talk to the new owner, who offered to let me rework it. I did and he was very happy.

I don't read the art magazines any more, and art-historically I'm one of the most ignorant people you'll ever meet—I passed notes and slept and drank beer during my art classes. Whatever I know, it's because I've been fascinated by a painting, or by a museum—or sometimes by a book, but I look at the pictures and only occasionally read the text. I read a tremendous amount, but I read junk or modern fiction. I'm not an intellectual, to my shame, but I do learn sometimes by looking at other people's work. I really have learned a lot from Matisse, about hand and light, not overworking, placing the paint, being a little more casual. I get a physical sense from a painting: I experience the way it was painted, but it's not intellectual.

I never wanted to be a nine-to-fiver, and I seem to have made sure that I have no discipline in the studio. I want it to be a treat to be in here. Sometimes I take a detective novel and sit in here all day. I glance at the paintings, hoping they'll speak to me and make me drop the detective novel, but it's very irregular. On the other and, I don't believe in painter's block. I trust that there will be a dialogue; I trust that if it's not happening now, it will happen tomorrow. I've developed a real trust and a real need to paint. Or rather, I've always had the need but maybe I didn't always have the trust.

Rothenberg in her studio, c. 1988

Born 1949 in Pasadena, California. Lives in New York **ROBERT KUSHNER**

Selected Solo Exhibitions
"Robert Kushner: Seasons." The Montclair Art Museum, New Jersey, 1992-93
"Robert Kushner." Institute of Contemporary Art, University of Pennsylvania,
 Philadelphia, 1987–88
"Robert Kushner: Paintings on Paper." Whitney Museum of American Art,
 New York, 1984

Selected Group Exhibitions
Whitney Biennial. Whitney Museum of American Art, New York, 1985
"International Survey of Recent Paintings and Sculpture." The Museum
 of Modern Art, New York, 1983
"Drawings: the Pluralist Decade." U.S. Pavilion, Venice Biennale, 1980

I've done a lot of different things over the years. I've done pageants; I've always been interested in fashion and couture, so I did performances that were sort of parodies of fashion shows. I started making costumes in 1970, when I was first in New York, and I presented them in performance beginning in '71. Some of my designer friends took me to real fashion shows and I was just astonished at their dimensions, so of course I wanted to try to incorporate them into mine. I still think Balenciaga was the greatest sculptor of the '50s. I don't mean that humorously, I really think he was as good a sculptor as anyone working then, just with different materials. So those were my sources for the costumes and fashion shows. I did the last of them in '82, and I knew it was over, but I have the videotapes and they're great fun.

When I was fresh in New York, I was working a restaurant job and I didn't have to be there until eleven or twelve. So I'd wake up early and draw for two hours every morning. That process of learning new skills returned to me recently when I began to work in oils and realized I didn't know how to manipulate the paint. Oil is so resistant—to make it sing you really need to be comfortable with it. I had never been particularly interested in the struggle of the artist with the materials, all that Abstract Expressionist junk, but oil paint is a struggle. It doesn't flow—it's not like ink or acrylic. You have to get those stiff brushes, mash it around, sort of like turds. This came as a big surprise. Those of you who are painters may find that amusing because you probably went through it in school, but it was a new experience for me.

So I did a lot of small oil paintings, mostly of flowers and vegetables from my garden. I wasn't interested in changing my style, I was interested in trying to enrich the work's chromatic sense and deal with the more formal arena that the stretched canvas gave me. About nine months ago, those experiments suddenly came together in a series of paintings. If you know my work, this group of paintings is really a logical continuation. I look at it and I feel like this is the beginning of my mature work; I feel there's a sobriety and a depth. Yet I think the continuity is very clear.

Floral Decoration II [1988] is the first large flower painting in the series. It came right after I had read Georgia O'Keeffe's biography and was very interested in what she did, both with scale and with the intimacy of the flower. I've always painted flowers, but there was something very poignant to me in reading about her and thinking about her use of them. I always have flowers in my house. Anemones for me are always an homage to Matisse; I paint them a lot and he painted them a lot. Lilac always reminds me of Manet's late still lifes, when he was so sick he couldn't get out of bed. He painted the flowers his friends would bring, and it was spring so he painted white lilac. Of course he must have loved the color gradation that happens in the shadows of white lilac.

The basic idea that links all of these recent oils is the juxtaposition of lines with planes of color. The planes of color I internally associate with Léger, particularly late Léger, where he pared his Cubist program down—for example in *The Great*

Parade [1954], that huge painting where he's got a slab of blue and then figurative elements over it, with just enough of the figure delineated so that the black line jumps away from the blue. That seduces and excites me enormously.

So you have these planes of color and then the drawing. I'm a real addict of drawing, I love to draw—I look at good drawing anywhere I can find it, whether it's Oriental calligraphy, Matisse's drawing, Tiepolo, Watteau. . . . When the drawing is there, each line has be active and alive and felt and experienced and to tell you something that the other lines don't. That's a great drawing. Another range of drawing is the Japanese and Chinese poet-painters who intentionally adopted a consciously naive sense of drawing because it conveyed a depth of feeling and a conscious rejection of expertise. They didn't want to be confused with court painters, who painted everything perfectly; they wanted to have roughness and aliveness. That's what I'm trying for in my mind.

Each of these recent oil paintings is on two square canvases. What interests me about the double canvas is the way the image can be continuous on one panel and discontinuous when combined. I work on the canvases separately, then put them together, then separate them, then put them together, so there's a continual dialogue about whether the work is a unity or a duality. The color in all of these is so exciting to me, because working with oil paint suddenly gave me an insight into the color I'd always wanted my work to have. When I worked exclusively with acrylic, I could never get this intensity.

Once the background paint is dry, and I've figured out the relationship I want between the two canvases, I add the drawing and begin filling in to give the image the right balance between merging with the ground and being separate from it. There'll be places where just the line is enough to hold the volume, which is, I think, the essence of drawing: this simple line gives you the illusion of the entire body. That's the modern concept of drawing that Matisse articulated so well: you can put that line down and it's a leg, you don't have to shade it.

I almost always work flat, and I do all the drawing on the floor. I thin the paint down to a kind of milky consistency, like buttermilk—I dislike gratuitous drips. That's because my mother was an artist who trained with the realist school in the '30s, then wanted to be an Abstract Expressionist in the '50s: she really worked hard to get drips in, it was a challenge for her. But then she realized she didn't like them either.

Pink Rose [1988] here is one of the newest paintings in the series. Talk about transitional: it feels like it's moving in a whole new direction. Either you look and say, "Oh, those colors work," or, "Well, they don't work for me," or, "They're too pretty," or, "Color—who cares?" Many people don't. The trick to painting this way is, Does it still have the same excitement the fifteenth or twentieth or fortieth time you look at it? That's why, even though these paintings may look rather hasty, there's a tremendous amount of repainting in them. I did some of the painting on this work, thought about

it, then went out of town, then whipped out the canvas when I came back and said, "Yes, that's what I need to do." I don't do anything until I know exactly what I'm going to do. At the same time, I find that the excitement for me is working directly from the flower. I paint without preparatory drawings. Whenever I try to do a small sketch first and blow it up, something dies.

I'm constantly looking for habitual patterns. As soon as I find one I struggle to drop it, only to see that I've replaced it with another. That's what gives my painting life for me: I like to ask not just "What can I say?" but "What can I get rid of that's now become just a routine?" That kills the work, makes it dead.

People always want to know whether I'm going to return to painting on fabrics—I haven't done any for over a year. That part of my work lasted about fifteen years, which is a good period of my life, and it may return and it may not; but for the moment my primary work is in oil painting. I haven't changed my mind about decoration, though, which for me is an extremely positive word. I think some of the best minds in art history have made decoration, and certainly artists made decoration as part of their job all through the Renaissance and the Baroque. It's only recently that it has been made a pejorative term, by fans of Minimal art and Color Field painting, which from my point of view are extremely low-level decoration: they're flat expanses without much surface activity. I prefer a fuller field. I've always liked shiny things, always. As a child I had a little treasure box of rhinestones, along with pieces of fur; then when I was in college I began to analyze what I'd always liked, and to use it in my work. I did a lot of work with glitter. Two years ago I began to use real gold, mostly because I had a studio assistant who knew how to gild. All that stuff I had never learned.

Besides the oils I make a lot of drawings, but for the most part I retain them for my records. I'm continuing to make sculpture, and I really want to do opera sets—I want to do *Pelléas et Mélisande*, some of that really lush, late operatic material, because I can see it, I just know how to do it.

Born 1940 in the Bronx, New York. Lives in Brooklyn, New York

VITO ACCONCI

Selected Solo Exhibitions

"Vito Acconci/Acconci Studio: Acts of Architecture." Milwaukee Museum
 of Art, 2002 (traveling)

"Vito Acconci/Acconci Studio: Para-Cities: Models for Public Spaces."
 Arnolfini, Bristol, England, 2001

"Vito Acconci: Living off the Museum." Centro Galego de Arte Contemporanea,
 Santiago de Compostela, 1996

Selected Group Exhibitions

"Art, Lies, and Videotape." Tate Liverpool, 2003

Biennale of Sydney, 2002

"Into The Light." Whitney Museum of American Art, New York, 2001

My background was not art but writing; until 1968, '69, stuff appeared in the context of poetry. I treated the page as a literal space that I could move over—a space that the reader could move over. In other words I thought of the page as almost a minimal object. What interested me about writing were questions like "What makes you move from left margin to right? What makes you go from one page to the next?" Eventually, in my concern with the literalness of the page, it seemed like the only things I could use on the page were punctuation marks. I had driven myself into a dead-end. There had to be some leap, and that leap was into real space.

My work in an art context began in 1969. The big question I had was, "Now that I'm in real space, what gives me a reason to move in it?" The first pieces started with giving myself some reason to move. *Flowing Piece* involved a simple scheme: every day I'd pick out someone at random in the street and follow that person until he or she went somewhere I couldn't—home, office, car. So decisions of time and space were out of my hands; I was a receiver of somebody else's time and space.

In the late '60s a lot of artists were questioning notions of the unique object. To many of us, "unique object" meant "precious object." Another question arose from the fact that people talking about a famous artwork have often seen only photographs of it. So some of us started asking, "Where does the art reside? In that unique object, or in the photographs?" We were thinking about art as a system not so much of objects as of distribution. A newspaper reports an event that few people have seen; in the same way, there was no audience when I followed someone in the street—if anything, I was the audience of the person walking—but once the piece was done, it was distributed to others by means of talk and reportage.

Once I wasn't writing anymore, I could have picked some medium as a replacement for the page. But if I'd gotten to the point where the page didn't seem useful, I could probably assume that any medium I chose would eventually not seem useful. So I shifted the focus from medium to instrument—that is, to myself. The work began focusing on myself as an instrument of activity. The pieces this led to were self-reliant: I didn't need anything outside me, I needed only myself. Ordinarily art goes from the artist through the art object to the art viewer. But could I shorten those terms? Did you need that object? Could I go directly from me to you? I started to think of art as a presentation of self to others. How could I present myself? Maybe if I made myself vulnerable, there'd be more chance for the viewer to approach me.

I thought I was opening myself up to viewers, but soon I started to think that maybe I was doing the opposite. In retrospect it seems that what I really wanted then was to find some simple way to say "Hello" to viewers. But I didn't know how to make "Hello" make sense. I was a still point in these pieces; the viewer had to move in order to get to me. My work was falling into everything I hated about art—art as religion, artwork as altar, artist as priest. I had to *lose* that focus on myself. Instead of being a point that viewers were directed toward, what if I were a part of the wall or floor?

House of Cars #2. 1988. Junk cars, zinc coating, steel, wood, glass, and flicker sign, 13 x 16 x 35'

What if I wasn't seen? Thinking like that led to a 1972 piece called *Seabed*. Halfway across a gallery about forty-five feet long, the floor became a ramp that rose to about three feet high at the far wall. From opening time to closing time, from ten in the morning until six, I was underneath the ramp, under the floor, masturbating. I used the viewers as help—I could build sexual fantasies on their footsteps.

Once I wasn't seen in the space, another question arose: did I have to be there at all? Until then my work separated me from social systems in order to focus on the self. By the mid-'70s people had different notions of "self": self existed only as part of a social system, a cultural system, a political system. So my work should be part of those systems, not separated from them. In '74, '75, then, the pieces started to be installations, without live presence.

In making installations I took a given space and built a piece specifically for it; the piece couldn't exist anywhere else. If you do that, you're making no pretense that art is universal; rather, you're saying that it makes sense only at this particular place and time. After a while, it bothered me that the places these pieces were particular to were always galleries and museums. Was I adapting to the physical space of a gallery, or was I really adapting to an institutionalized frame of mind? Was I becoming an interior decorator for a gallery—in effect camouflaging its function as a store? I could never solve this question, so instead I started thinking of more portable, movable pieces. In the early '80s, then, a piece consisted of an instrument that was used by a viewer; the viewer's use of it made a shelter, made architecture. In 1981, for example, a piece called *Community House* was a long house, enclosed, with no way in, but outside it there were bicycles, and if you rode a bicycle it pulled out a section of the house, opening the house and making it enterable, usable.

I liked the usability of these pieces, but they lasted only so long as people kept the instrument going. I started to want a place that people could come back to. One or two pieces from 1983 have probably shaped most of the pieces since. These pieces gave people a ground, in two senses: ground as physical ground, and ground as a ground of convention. *Sub-Urb* started as a house about 100 feet long, with a conventional peaked roof. It was inverted so that the roof was on the bottom, and then the whole house was inserted into the ground. You stood at ground level and looked down into it. By moving panels on tracks, you could make a stairway available, and could go down into an underground house where there were rooms with animal shadows on the wall—as if there were a human world above and an animal world below. Each "animal room" led to a "study room," with words like crossword puzzles opposite a bench: close to the entrance, "evolution," and further in, "revolution"—close to the entrance, "father," and further in, "patricide"—outside, "soldier," and inside, "guerrilla."

When working in galleries or museums, I assumed that I could do anything to a viewer, because people entering galleries and museums are effectively saying, "I'm allowing myself to be a victim of art." But more recently I've assumed that pieces are

out in the world—the street, the subway, a train station. In that world there isn't an art viewer, there's only a casual passerby, who hasn't asked for art. I can't justify attacking the passerby, imposing on the passerby. Rather, I want passersby to find out things for themselves.

I've done a number of furniturelike pieces, spaces for one person, or for two or three. One kind of furniture takes off from conventional furniture. In *Storage Unit for Things and People*, for example, from 1984, when you pull out drawers on one side, it makes a seat on the other. Another kind uses materials that already have a function—aluminum ladders, for example, that become a lounge chair. A third kind of furniture becomes part of a room's architecture, like *Seat Thrown into a Corner* [1986], where a mirrored wedge shape fits into a corner; the person sitting in it disappears into the room's reflection. The fourth kind of furniture is made up of miniature landscapes; it brings the outside inside.

These pieces are practice for larger-scale pieces in public space, where my starting point is usually some notion of "house." A house in Western culture denotes privacy, ownership, the opposite of publicness. But what if you take a house, a convention everyone knows, and twist it, or turn it upside-down, or inside-out? *House of Cars* [1983] is an apartment complex made up of junk cars, stacked so that there's a single-story car, a mezzanine level, a two-story car. One thing that's disturbed me is that the piece is more of a playground than a house. A car is smaller than you are, so you have to bend to use it. So I did another version of the piece [*House of Cars #2*, 1988] that was more for grownups. If you place two cars together, bottom to bottom, you have a space approximately eight feet high—the size of a conventional room. This time the piece became more of a house; each unit is a conventional living unit—kitchen, bathroom, bedroom, living room.

The course of my work follows the process of a child growing up. First you're aware that you exist. Then you become aware that another person exists, and gradually that a whole mass of people exists. Eventually you start to realize that you can leave the room and the room still exists, even when you aren't there.

Acconci in his studio, 1988

A LETTER FROM MY FATHER

Born 1932 in McKeesport, Pennsylvania. Lives in New York

DUANE MICHALS

Selected Solo Exhibitions
"Duane Michals." Galéria mesta Bratislavy, Bratislava, Slovakia, 2003
"Duane Michals Unlimited 1958–2002." College of Visual and Performing Arts,
 University of Massachusetts Dartmouth, 2002
"Duane Michals: Mostra Fotografica." Galleria del'Arte Contemporaneo,
 Mestre, Italy, 2001

Selected Group Exhibitions
"Looking at Photographs." The Museum of Modern Art, New York, 2003
 (traveling)
"Revelation: Representations of Christ in Photography." Hotel de Sully,
 Paris, 2002 (traveling)
"Tempus Fugit: Time Flies." The Nelson-Atkins Museum of Art,
 Kansas City, Missouri, 2000

I don't believe in the eyes, I believe in the mind. I know that everything I talk to, everything I see, everything I hear, everything I register, is in my mind. I think that's very curious. Photographers are always photographing reality but they never question the nature of the thing itself. I'm not interested in what things look like; I'm much more interested in what things feel like. It's like reading a hundred love stories or falling in love: I'd much rather fall in love. It's direct experience. I don't believe in appearances anymore, and I keep going back to the notion that things are strange. We've divided life up into a very reasonable world that doesn't make sense. The minute you start paying attention to your mind, it all begins to unravel.

You know, everything is subject for photography, absolutely everything. It's not just pretty faces and moonrise and the sunset. Photography for most people usually means "observable fact," and if you don't believe in the facts, then you're totally out of business. What you tend to see is what you've been conditioned to see. Photographs are always looking for life in all the wrong places, without realizing that this is it. This is called being alive at this moment, the sixty years we're here on the planet. How do you make this tangible? How do you really touch things, really know they're there? I don't mean like driving in a car and chewing gum and listening to music in L.A. I mean really notice something's there. I never photograph sunsets and I never photograph moonrises. I'm not interested in what things look like.

Since I don't believe in appearances, I like to do portraits that have to do with what the person's about, rather than what they look like. I knew my mother and my father my entire lifetime, and not once did they ever reveal themselves to me. So I've never believed that portraits are what the person actually seems to be. How many people have you revealed yourselves to? What do you really know about yourself, in the first place, that you can actually say? Photographers are usually defined by their eyes but our real definition is our minds. What we believe to be true can become true.

I'm very interested in the nature of time. I realize that the minute I say "now," it's not now. When I was born, I was born now. (Believe me, I was not born yesterday.) When I was in high school it was now, when I was in the army it was now, and when I die I'm going to die now. But the minute I say "now," it's not now. That doesn't make any sense at all. Yet we always live on that edge, that moment, that sliver between being and not being.

I began to write for my photographs, not because I thought it was clever but because I was so frustrated with the photograph. *A Letter from My Father* [1964] is a picture I took of my mother, my father, and my brother. I began to write because I was trying to talk about what you cannot see in the photograph. To me the key word is "expression." How do you express yourself? Any way you do that is important. When I turned fifty I began to write poetry—well, what passes for poetry. A friend of mine said, "My God, you're fifty and you're going to write poetry. Isn't that a little bit embarrassing at your age?" I said, "The important thing is not that I would be a failed poet.

The greater failure is being afraid to do it, being afraid to make a fool of yourself, being afraid to risk. Because the moment you are, then you're through creatively in your life. You're absolutely through, and nobody cares. You have to care."

My father and I had a difficult relationship. I really don't care what he looked like; it was the legacy of our relationship that I wanted to talk about, not what he looked like when he was forty-seven. *A Letter from My Father* is inscribed,

> As long as I could remember, my father always said to me that one day he
> would write me a very special letter, but he never told me what the letter might
> be about, and I used to try to guess what family secret the two of us would at
> last share, what intimacy, what mystery could now be revealed. I know what
> I had hoped I would read in the letter. I wanted him to tell me where he had
> hidden his affection. But then he died and the letter never did arrive, and I
> never found that place where he had hidden his love.

So you see, I really don't care what he looked like. That wasn't important.

You know what's nice about getting older? You have a track record. When you're young you have no history. When you get older you can look back. It's like chicken soup: if it sits for three days it just gets better. As you get older, you collect all these layers of paint. Then you begin to see your track record. You begin to see your foolishness. You begin to see your patterns. In my case I began to observe that I had worked on the father-and-son relationship in many, many disguises. In a later piece concerning the father-son relationship, I wrote the following lines: "In my dream I saw the face of my unborn son, and he was fair and he called me 'Father.'" What's nice is to get to the point where anything you can say, if you have the nerve to say it out loud, you can. That is really nice. It only comes with time.

I like photographs to be unresolved. I think everything's a drama—my standing here is a drama, your sitting there is a drama—and I don't think photographs should tell you too much. Photographs should make you come to them. They shouldn't spill the beans.

You know how always in a dream, you believe you're there, and you are there, but you're really not there? I think that's incredible. I love dreams. I can't wait to go to sleep to find out what's going to happen next. If you die it's like going to sleep. I'm going to be crazy about it.

René Magritte [1965] is a portrait I did of René Magritte. In your lifetime you may meet three people who will free you. You may not even meet them, you may read about them, but whatever—anything that frees you—and Magritte did it for me. When I looked at his paintings, which are realistically, photographically painted, I found ideas that contradicted me, and I've never grown except through contradiction. My value to you is to say something that you really hate, or that really makes you

angry. You don't grow when you surround yourself with people who repeat everything you have to say. You grow through contradiction, and Magritte was wonderful for that.

Our lives, our faces, are constantly changing. I did a book in France called *Changement*, about aging and changing. I wrote an essay, and I talked about how the geography of my face had changed, and all the lines that had once been streams were now becoming rivers. The whole face was moving down like a glacier, back to the earth. But I like people to be flawed. The Japanese have a word for it when there's a perfect plate and then there's a slight crack. I like the work to be flawed. I find perfection boring. What makes us interesting is not our perfection, it's our imperfections. That's the only thing we ever share.

I've always made my living as a commercial photographer, but I have none of the apparatus of a business. I don't have a studio. (This space is rented.) I don't have an agent. I don't have a darkroom. Somebody does printing for me, and I have an assistant I use part-time, and I love it, because I have the freedom to do anything I want to do. That's really terrific. I practiced being poor for about thirty-five years, and I never got the hang of it. But the thing is, if you free yourself, then everything becomes possible.

People don't realize that we, and especially photographers, are our own definition. We're so indebted to Ansel Adams, but I'm not him—so why should my photographs look like his? But having them look like no one else's is the hardest thing to do. Photographs are so easy to make; that's why it's so difficult to make something else happen. You're either defined by a medium or you redefine the medium in terms of yourself. Of course, everybody's afraid. To be a human being is to be afraid. We're all like Frank Morgan in *The Wizard of Oz*—do you remember, he's behind the curtain, Toto pulls the curtain back, and he says, "This is the great Oz. Pay no attention to the little man behind the curtain"? Well, that's what it's like. We're the guy behind the curtain.

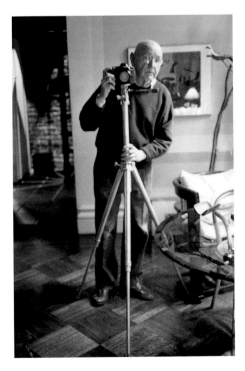

Michals at work in his brownstone, Gramercy Park, 2003

Born 1957 in Rehovot, Israel. Lives in Brooklyn, New York

HAIM STEINBACH

Selected Solo Exhibitions
"North, East, South, West." Haus der Kunst, Munich, 2000
"Haim Steinbach." Museum Moderner Kunst Stiftung Ludwig, Vienna, 1997
"Haim Steinbach." Castello di Rivoli, Rivoli/Turin, 1995

Selected Group Exhibitions
"Partage d'exotismes." Biennale d'Art Contemporain de Lyon, 2000
"Future Past Present." Venice Biennale, 1997
Documenta IX, Kassel, 1992

HAIM STEINBACH February 22, 1989. Studio, Greenpoint, Brooklyn

Growing up in Israel in the 1950s, I was very aware of American culture, the seductiveness of its products, the state-of-the-art cartoons and graphic design, '50s cars, rock 'n' roll and Hollywood films. Later I went to the High School of Art and Design in New York and was most impressed by European art at The Museum of Modern Art: Matisse, Picasso, Klee, and Kandinsky. In college in the early '60s, this art became a standard that I believed in and needed to understand further. By the end of the '60s I'd worked myself into a reductive mode, but only after thinking through Abstract Expressionism and seeing a lot of Minimal and Pop art. It was something uncanny and a slow process absorbing it all.

In 1971 I went to Yale, where, using a spray gun, I produced consistently flat, dark, square paintings with color bars along the edges. Afterwards I began to utilize linoleum as painting surface; I replaced paint with this cultural material. Linoleum is not neutral; it already contains patterns and designs, from Spanish tile to Italian marble to Colonial wood. People buy the design that confirms their sense of identity and taste. I would lay out the linoleum on a square piece of particleboard, then insert into it one or two triangular or rectangular shapes cut out from another type of linoleum. Sometimes the two patterns looked almost the same: a subtle white with a little gold crack in it, meant to suggest some kind of Italian glass, would abut another subtle swirly pattern imitating an American wall-to-wall carpeting.

It was a logical progression; the surface of a painting was replaced by a more or less traditional Baroque, Modern, Minimal, or simply vernacular "made-ready" surface (I use the term "made-ready" to distinguish the modus operandi of my own work with already existing objects from Duchamp's readymades). Beginning with some notion of pure painting, or art as art, I progressively worked toward the theory that you can't escape the cultural content of things, so why not deal with them? Why not start there? I began to see art as a cultural activity, something that comes out of a bigger framework and includes social and ethnological references. The next step was to recognize the different surfaces and forms of objects, everyday or otherwise.

I now found myself more and more involved with looking at things indiscriminately, suspending judgement, taking into consideration that any artifact is a beautiful invention that's worthy of my curiosity. Art begins with the eye, the sensory dimension of sight, what the eye sees, what we know about our world through the fact that we can see. The primary structure of the "thinking eye" has to do with the apprehension of surface and form, a process that is in effect philosophical. Having control over what we see is essential, and one has to take account of this perceptual and philosophical condition. I've always been interested in issues of art in society, in culture, in a political system; basically, in art that is not detached or removed from social reality. The content of things—what they mean—is very important to me. Still, art comes through the eye; I see something, I respond, and that's an idea.

When I find an object I always ask what it's called and how it's used. The gourds on the shelf in *Untitled (Wakamba gourds)* [1989], for instance, come from Kenya, from a tribe called the Wakamba, where they were used to store beer. You could say the piece was purely formal but it's not; it consists of a bunch of gourds that could have been sitting around that way, filled up with beer, in an African hut. They are a typology of objects, transformed and acculturated, that may seem mysterious in some way. When we say, "Oh, this looks like a formal, modernist piece, like Brancusi," that's something we bring to it. I doubt whether a man from the Wakamba tribe, or anyone without an art-historical background for that matter, seeing these gourds on this shelf, would say, "Oh yes, a successful artwork." The Wakamba man might wonder why I'd placed the gourds he uses for beer on this "other" support. And my answer would be that I devised a particular form or platform to memorize and memorialize the objects. There may be something ceremonial, of course, about building this shelf and present-ing things on it thusly; the work refers to the way we give place to things at home or in the museum, the way we conceive of furniture, choose certain styles, place certain objects on top, etc. There's a ritual there, a "look here" gesture, a history, a cultural tradition, a manner of speech. We follow the practice of building this kind of structure to communicate with objects.

I will use any object I can get my hands on, meaning that the object choice is open yet far from arbitrary. For a show in Naples recently, I did a piece using eighteenth-century classical marble scent vases with gilded goat-heads on their sides. I would put a Brancusi on my shelf if I could get my hands on one. Why not? It's presented on a shelf in a museum; why not put it alongside an everyday object, a very streamlined, simple object like the Philippe Stark toilet brush in The Museum of Modern Art gift store? I would juxtapose both those objects if they were accessible to me.

I like to refer to the shelf unit with objects as a model or paradigm, like an exam-ple of "how to." My shelves have an elementary geometrical shape: a triangular volume. That being so, they have a universal reference to a basic Euclidian structure. This particular form, or stratagem, which I arrived at through an evolution of the different shelves I've made, has turned out to be a useful vehicle for bringing about a game plan, which enhances a metonymical play. I always return to questions concerning the nature of an object and an "art" object: What is it? What does it do? How do we experience it? This triangular format came out of a theoretical speculation about the "aesthetic" object. If I'm going to talk about objects, how can I emphasize their struc-ture, their form and cultural identity, and at the same time enhance their dynamic properties? The shelf becomes a reinforcing place that underscores them as volume, as forms with weight, body, and shape, but also refers to the fact that they're not ideal forms. What is ideal? An object always has a color, a surface, something that refers to its material, its culture, and so on. So the shelf as a device invokes the very basic ethnological characteristics of the objects. It registers the form of presentation, this

triangular volume. But form has a surface, a cover, so I have to think about what skin to give it. I decided to use veneers and laminates. Most of them are plastic laminates, which means they're simulations; they usually imitate one material or another, they mirror. The shelf involves limitations but also possibilities, and in any case I'm interested in limitations. I'm happy to work within a basic structure, like composers creating an infinite score within those five simple bars, or chess players executing endless strategies on a fixed grid.

With the "made-ready" objects I can go anywhere I want to. I'll take anything, selecting, editing, and choosing. But then, with the geometric shelves, other ramifications come into play. Of course there's uncertainty and unpredictability, a subjective intuition, and, as with John Cage, a philosophy of chance as something that always exists in spite of our understanding of given, established orders of things. And yet, at the same time, there's an inherent accountability for structure. Similarly, I could have found a way to attach the objects to the shelf, but I have chosen not to do so; they can always be separated from it and rearranged. I provide specific instructions about how to place them, as well as a photograph, but they're not permanently fixed—and that's a very important aspect of the work. They remain contingent on one another and this tempts viewers to intervene, to want to disrupt the order. It leaves them with a certain feeling of doubt about my decisions, and it's as if the space I'm in were projected onto them. A decision has been made, yet it does not seem final, leaving viewers with a sense of their own accountability.

People respond in various ways, and touching the objects is not an uncommon reaction. I don't really want that, in that I want the works to last; but people want to see whether these are real objects or whether I made them, as if the pots in *ultra red* [1986] were made out of some kind of hand-formed balsa wood and painted to look like real pots. So viewers want to tip the lid to find out whether it's actually a lid, and that kind of response is natural to the work's philosophy.

I read Sartre, Camus and Robbe-Grillet in the '60s when I was in France, and certain questions of being and essence have been very important to me over the years. I've never really been studious, though, or anything approaching a scholarly reader of this material. So when I talk about philosophy, I'm talking about the basic questions I've always been raising.

Steinbach in his studio, c. 1988

Born 1911 in Paris. Lives in New York

LOUISE BOURGEOIS

Selected Solo Exhibitions
"Louise Bourgeois at the Hermitage." State Hermitage Museum,
 Saint Petersburg, 2001–2002 (traveling)
"Louise Bourgeois: The Locus of Memory." United States Pavilion,
 Venice Biennale, 1993
"Louise Bourgeois: A Retrospective Exhibition." Frankfurter Kunstverein,
 1989-90 (traveling)

Selected Group Exhibitions
"The Body Transformed." National Gallery of Ottawa
 (installed in La Cité de l'énergie, Shawinigan), Quebec, 2003
"Surrealism: Desire Unbound." Tate Modern, London, 2002 (traveling)
Documenta 11. Kassel, 2002

I am kind of a recluse, and I do not need to go on and on, faster and faster, and I do not need to show my work, and I do not need to explain it. If the work doesn't talk to you, just relax. Do any of you have to define yourself? It is very difficult to define yourself. It is even *more* difficult to reveal yourself.

I am not interested in other artists. I do enjoy certain artists immensely, but it is a pleasure that doesn't relate to my work. In fact it is really a holiday for me when I go see a show.

I have an open house on Sundays, anybody can come. But I have discovered they want me to criticize their work. Well, this is ridiculous. I rack my brain to criticize, I make constructive criticism, and they cry because they don't want to be criticized—they only want to be loved and encouraged. But that is not possible, you cannot encourage everybody. I can spend hours talking about their work, but they cannot ask me to love it, and sometimes I do not. I cannot commit myself to saying I love something I do not love. I do appreciate these afternoons, but at the end of the afternoon I can feel like a failure. I feel that all these people came for something they did not get. People ask too much; they want me to encourage them to become Picasso—the sky is the limit. This is what I see in the students: they want the show and publicity and the big sale, and there is no end to it. This reminds me of a fairy tale: a child wants to leave home, to forget about home, and he runs in the woods until six o'clock. Then he wants to come home—but he cannot retrace his steps.

This idea of selling, it's new. In the past, artists made work, they had shows, but then they took the art back home—nothing was sold of course. Naturally that happened to me. A lot of artists gave up, but it was a fantastic experience for the artist to see the work far away from the studio, in exhibition.

I remember when Stuart Davis became successful and had a show at the Modern, he said, I can never paint again. And it was true. I don't know what kind of syndrome that is but a lot of artists cannot stand success. But they cannot stand failure either . . . so you might say that art is an addiction you cannot control.

Material is only material. It is there to serve you and give you the best it can. If you are not satisfied, if you want more, you go to another material. Marble is interesting for me because it proposes a fantastic resistance, and at the same time it is fragile, it breaks. You want one thing and you get something else; you want something too much and you break the stone. The resistance of marble is like the resistance of people when you try to seduce them and they don't want to be seduced. Whatever you want is the basis, but you have to adjust.

The romance of materials is absurd, an academic notion. The material is just what it is; it is not an end, it is just a means to get to something. It has to serve you. The end is when you have achieved what you really want to say. Whether you have been

Untitled (with foot). 1989. Pink marble, 30 x 26 x 21". Collection Corcoran Gallery of Art, Washington, D.C. **75**

understood, or whether you understand yourself—that, not the material, is the end. I want to say something. I want something that I cannot quite define. What I have is not precise enough to define what I mean. I want to be understood.

I was not influenced by the Surrealists. I knew them because they were of a certain age group, my parents' age group really, so I saw them when I was in school in Paris; they lived on rue de Seine, they had a gallery there, and I would stop in and talk to them. I was a kid from school, but I came into the feeling that I was much better than they were. It was my first experience of reacting against a group. I was very happy at the time to have somebody to go against. It was like the marble—the resistance it offered made me feel stronger.

At the same time as the Surrealists, about 1932 to '33, what was interesting to me in Paris was Art Deco graphic design. Art Deco was really what I liked. Those artists influenced me, not by what they said but by what they did. The Surrealists were extremely self-concerned and what they were most interested in was their presence, their demeanor, their talk. They were not concrete. But the Art Deco people, who came from modest backgrounds, were very formal and their forms were very pure. So it was A. M. Cassandre and Paul Colin who interested me, and there was a very important show of them in 1925, whereas the Surrealist show in 1936 was really a political show.

The thinking and the preoccupations of a man are really different from the thinking and preoccupations of a woman. This is obvious, we all know it. And I am a woman, so whether I want to be or not, I am part of the feminist movement. But my husband was much more of a feminist than I am. (Why? Because his mother was a feminist and he wanted to top her on that subject!) I would be interested in listening to a man who objects to feminism, I would be interested in his arguments. What is wrong with that? What you should do to be a good woman I never did discover. Never.

Even though I'm only interested in the work I do tomorrow, I do not destroy my past work. I'm not interested in it, but it lives there all by itself, gathering dust. The dust that has gathered over all this work—we can remove it and say, "This is a show of the '50s." It is very nice to face the past. It was not that bad.

The feeling of creating is really your fight against depression. The thing is not to get depressed, which is not interesting at all; the thing that is interesting is to get out of depression, and the way to get out of depression is by having a couple of bright ideas. It really works. Of course it needs discipline, but that is really what is in back of the work. It is like saying, Tomorrow is going to be beautiful. Why say that? It is ridiculous—tomorrow is going to be just like yesterday—but somehow something clicks somewhere, and you think, "This time I'm going to make it." But if you are a sculptor you have something. The work is there; it talks back to you.

I have a very tiny life. I am very concentrated; my art is so precise and every day is the same. The discipline, the routine, I do not mind them. I don't take vacations; I don't enjoy them. To go to Europe—there is nothing there. Europe has no wonder for me. What does have wonder is having a challenge that is difficult to meet.

I am interested in the New York subway, in taking the subway and how people go to work in the morning. I wonder how they don't fall on the tracks, I wonder how they all get to their jobs, I wonder why the subways are deserted at five minutes past nine, I wonder how all these people function. I don't say they're happy but they still arrive. To me this is a wonder. On Atlantic Avenue in Brooklyn, for instance, you have people from all over the world in the subway before nine. They tolerate each other. Some people look at other people. I don't say they all smile, but it functions. This is wonderful.

Bourgeois in her Brooklyn studio with *Sail* (1988), 1988

Born 1935 in Cincinnati, Ohio. Lives in New York and Paris

JIM DINE

Selected Solo Exhibitions
"Jim Dine Drawing." National Gallery of Art, Washington, D.C., 2004
"Jim Dine: Paintings Drawings and Sculpture 1973–1993." Boras Konstmuseum,
 Sweden, 1993–94 (traveling)
"Jim Dine Retrospective." Isetan Museum, Tokyo, 1990 (traveling)

Selected Group Exhibitions
"Les Années Pop." Centre Georges Pompidou, Paris, 2001
"Out of Actions: Between Performance and the Object, 1949–1979." Geffen
 Contemporary, Museum of Contemporary Art, Los Angeles, 1998 (traveling)
"Future Past Present." Venice Biennale, 1997

In art school I was not aware of draftsmanship. I wasn't even aware that I *was* a draftsman, or had an aptitude for it. I was trying to paint. But toward the end of my stay in the school—the School of Fine Arts at Ohio University—a man called Fred Leach became its head, and he was interested in master drawings and spoke on them. I looked at them very earnestly, began to draw, and suddenly got involved with draftsmanship.

I made some rather accomplished self-portraits but the rest wasn't very good. Some drawings of my wife at that time are actually terrible—they weren't well observed. I was more interested in making the piece than in observing. I believe I must observe closely to train myself.

At any rate, that's when I started to think about drawing a lot. But I never really sat down and drew specifically to train myself until 1974, when I went back to the figure, as it were. I was already involved to a point, but at the end of the '50s and into the early '60s I was just making drawings like harvesting radishes. I was always drawing; I never thought about what my goal was. I'm a very obsessive person. I believe I'm put here to draw and to paint because it's all I can do. It's the only thing that gives me pleasure. For me, it's a vacation every time I go to my studio. If there's pain at all, my pain is in making things work. I've always had the confidence, whether I knew it or not, that I could make something work.

I'm never satisfied, though—I'm not satisfied with the end product until it's taken away. I keep on messing with it. I really appreciate those stories of Bonnard sneaking into museums with oil paints to work on his paintings. There are things I could fix right now. In the early 1980s I became more comfortable with my ability to achieve what I want to achieve. I realized how the experience of those six years of solid drawing, from 1974 to '80, gave me a foundation. Drawing goes into everything I do now.

I'm interested in a drawing being a living object. I want people to see my working processes. Giacometti's constant changes, not in his drawings so much as in his sculpture, the way it was corrected and corrected—those were about drawing too. He gave himself a rather simple task in terms of imagery so that the work could be constantly corrected. I've tried to limit my subject matter too, although I've been expanding my body of images more rapidly in the past ten years.

My oeuvre contains two distinct bodies of drawings: drawings that simply accompany my painting and sculpture, and drawings precipitated by the figure. My best drawings before I started to make figure drawings are the big tool pictures from 1974, at The Museum of Modern Art. If I had ended there I would have been quite proud of myself. But once I started to draw the figure, I realized that up to then I'd been dealing with a much easier problem. Drawing living flesh, and observing and reinventing the figure, are harder and bigger tasks than dealing with specific objects that you know about, like a hammer or a saw. The tools were drawn very dumb, you know— deadpan, in the sense they're shown straight up and down. There's no illusion of

space. You can look at a handle all you like, but it's not the same thing as looking at your hand. Everybody's hand is different, for instance, and everyone's hand changes every minute.

At one point I looked to Giacometti for inspiration, at another to Van Gogh. Matisse is a constant beacon. They're always there for me. I'm very sure that I come from a long line of draftsmen. I looked for a long time at Ingres: I couldn't believe it, I still can't sometimes, not that I even always like it but it's technically amazing. The observation of distortion is so weird much of the time, it's like collage—many of the figures seem stuck on.

Not until I got into printmaking and learned about etching was I able to look at Rembrandt at all. I don't think I'll ever be able to do anything like his work, or Van Gogh's, but I didn't really understand Van Gogh until the mid-'70s, when I became so intent on looking at the figure. With the exception of Ingres, I'm most drawn to expressionist drawing. I'm from a very Northern European expressionist background. Some of my generation aspired to a de Kooning-esque existence, at least I certainly did. De Kooning is in one sense a figurative artist; he just didn't want to say so at the time. He's a romantic figure, and he's a European who Americanized himself. He's called an Abstract Expressionist, but he actually represented a figurative expressionist genre that derived from Gorky—a genre to which I aspired. It came out of Europe and out of Picasso. Some of my drawings are action drawings, one would say.

In the drawings after Van Gogh, I felt, I don't think unreasonably, a tremendous responsibility and fear. I always feel a tremendous responsibility to make something work. It's the most difficult thing you can do, to put yourself up against Van Gogh. I had this facility and it was all up to me—I hoped I had the so-called Midas Touch. There was always the possibility of failure. They are somewhere between abstraction and realism, these drawings, fragmented abstraction from a figure. I tried to reinvent the figure through Van Gogh, using Van Gogh as a still life. His drawings are so charged. I felt like I was in control but I had to take certain chances. With most of them I would make the drawing, then throw ink and paint at it, obliterate with the sander, and go back and do the same drawing again. The process was succeeding and then destroying, and leaving the pentimento of destruction. I love pentimento, I like to show my tracks.

I quit on a drawing before the paper is totally gone physically. That's one of the ways I quit; another is I lose interest. The drawing becomes too much for me—too much of a good thing, sometimes—but you stop when your mind blocks up.

For me, now, the only thing that distinguishes a drawing from a painting is that it's a work on paper. You expend the same energy, you use the same materials. The only difference is that oil paint on canvas is handled differently. I'm much more risky technically on paper because oil paint on canvas is so fragile. I like to buy industrial paint and car paint and spray paint. I take the valve off, shove a nail into it, and it

shoots like a volcano. It's a very exciting thing to do, and it obliterates things like an eraser. You can block things out this way. I wouldn't use it on canvas because it would crack, but I feel it can be controlled on paper. The paper I use is tough, and the colors sink in. They don't sit on the surface and form a gloss that could crack.

There are times when I long to sit and make careful pencil drawings. I do that when I make botanical studies and in self-portraits, but frankly I'm just too impatient for all that. I'm too ambitious for my art to make a bigger statement. I go where my romance takes me. I'm waiting for the moment when I can sit, I yearn for the precision in Picasso's pencil drawing, but I don't sit still long enough.

The other day I was making a painting of my wife, Nancy, that I've been making as a drawing as well. And as I was sitting there looking at her I said to her, "You know, I can't think of anything I'd rather do." To be able to observe someone, and to feel I am seeing totally clearly, is the most pleasurable, privileged thing. Some days I just cannot put my hand and my line together, but there are days, like the day I was speaking of, when as I was looking at Nancy I saw everything I wanted to do right there.

If drawing is either the projection of the artist's intellect or the artist's most intimate confessional marks, then I hope my drawing is both. I've tried through drawing to dissect the anatomy of my inner and outer world. This world is a mixture of magic and reality, of contemplation and of sharing emotions and ideas. I am on a lifelong journey to express my feelings about this world and myself in it. The subject matter is essentially me, and exists as examples of my feelings and the channels through which they pass.

Dine in his West Village studio, 1987

JOEL SHAPIRO

Born 1941 in New York. Lives in New York

Selected Solo Exhibitions
"Joel Shapiro on the Roof." The Metropolitan Museum of Art, New York, 2001
"Joel Shapiro:Skulpturen 1993–1997." Haus der Kunst, Munich, 1997–98
 (traveling)
"Joel Shapiro." Stedlijk Museum, Amsterdam, 1985 (traveling)

Selected Group Exhibitions
"MoMA 2000: Open Ends." The Museum of Modern Art, New York, 2000–2001
"Afterimage: Drawing through Process." The Museum of Modern Art, New York,
 1999–2000 (traveling)
Documenta VI. Kassel, 1977

The most recent piece in this room, the piece in back of you, is the one that looks like it's leaning over. It's structurally problematic and unresolvable, which is interesting. You have ideas about form and how to translate thinking into form, and then you actually have to do it. This might be one reason why I draw: in drawing you're not really confronted with the structural or physical problems. But whenever you're making sculpture, aside from having an idea, which after a certain period of time is almost inevitable, the issue is literally getting the piece to work, getting it into the world. How do you keep this thing in the air? When you make sculpture, you're constantly confronted with problems of gravity, material, and form. It's very difficult.

I like this piece, but I feel, and probably many artists do, that as soon as you make something you immediately distance yourself from it. You begin to analyze the work and the form, and you recognize the limitations in how you handled the concept. I imagined this piece as very figurative. It looks very abstract, and it is, but I was interested in the figurative scale of the piece. It's sort of body size; if I laid down next to it you'd see that it somehow refers to a human torso. But having done the piece, I thought, "Look, the only problem with this is the fact that it's so dependent on architecture." I want to remove it from architecture so it will have its own life independent of wall, ceiling, and floor. That may be a resolution, or some direction like that.

I have a scale model here for a sculpture that'll be twenty feet tall and will go into the Bedford Courtyard at the Hood Museum, Dartmouth College. A commission is an interesting problem, if it's good architecture: instead of dealing in the private world of your studio, where you make things according to your own needs, all of a sudden you're confronted with making something in relationship to another being and a larger space. It's challenging, and I'm excited by it. I want this piece to be very linear and to have a sense of engaging every aspect of the courtyard, reaching out, reaching around. In a sense, it'll almost cascade down the balustrade. Of course the problem now is how to build this thing.

I think the problem in large sculpture is how to retain your own self in the work. The process can be very removed from you. Very few sculptors work successfully in large scale; Alexander Calder I think is one, because he was always able to instill this childlike, playful quality into the work, regardless of its size. He had enough command to see that through, and he didn't relegate the work to somebody else.

You have the germ of an idea and you do a little sketch in wood. Then it evolves. You go to the space, you build a model, you think about the model, you think about the space. You come up with a solution, or a few of them, and then you have to realize the solution in the world. It's one thing to work in terms of the germ of an idea; the next step is to make it larger. There's always risk involved, it may not work. I've already reduced the height of this Dartmouth piece, it was to be twenty feet and I thought that would be overwhelmingly aggressive—I went back to the space, and the piece would have looked like it was leaping through and beyond it. So I chopped

it down a little just so it had some sense of place. It'll be bronze. I'm making the pattern out of fir, and then I'll cast it.

I think this small chair piece [Untitled, 1973–1974] is very magical. These small pieces are about magical thinking. They insist on themselves. The chair is particularly effective because you have this reduction of scale but you're forced to confront it on the artist's terms. I made this piece during a time dominated by protests against the war in Vietnam. When I began to structure things, just to join three pieces of wood was a real willful act. To take five pieces and turn them into a chair, or make them into a house, was a real willful gesture. I think I made them very small because that was the size that I felt comfortable with and that I felt was necessary in order to externalize my own interior thoughts. I guess as I matured and got some distance on it, I decided I really wasn't interested in being that manipulative, or insisting that somebody enter that world—I wanted work to function more in the real world, more in the perceived space, more in the present. The small pieces are really made based on the size of a thought, or the size of an idea. Twentieth-century art is or should be about something real. I think the struggle of the century is the struggle for work to be real, not to be mimetic, not to be pictorial, but to be about the real world, to be its own real issue. The only way to deal with a commission, like this Dartmouth piece, obviously, is to confront what's really there, confront the real space, respond to its actual size, its actual volume. It's very different from some notion of just making a giant sculpture and sticking it in the space.

Right now I'm included in a show at the Whitney, on sculpture from 1965 to 1975 ["The New Sculpture 1965–75: Between Geometry and Gesture"]. The late '60s were an exciting time to work. Compared to what's going on now, that show, that world, seems much more adventurous. My work is definitely in the show because of its referentiality; my language now is more literary, and more figurative. Back then my studio was covered with piles of clay. I had all kinds of ideas: I was trying to find a more internal space to work from, more personal and intimate. The work was different from Minimalism: it wasn't based on absolute, preconceived notions about what was right and what was wrong, it was more an articulation of an internal dilemma. I thought that the psychological could be a viable way of establishing form and dialogue.

My pieces aren't patinated, they come out the way bronze comes out. Sometimes I'll patinate a piece, but I have this idea that patinas are really about masking something rather than revealing the making of a piece. Sometimes the way the metal comes out, even though it's structurally sound, is quite irregular, and the irregularity is absolutely interesting. Other times it's less interesting, but even so, I like the life of the piece's making to manifest itself in the surface. I'm not interested in the unification of the piece, making it look like one solid object. I want it to have some irregularities of light and reflection. Wood has an intimate quality that's very moving; when you cast it in bronze, to some extent that's lost. Some pieces *should* be in wood, but once a

piece begins to get large, wood makes no sense. You can't even join it together without adding all sorts of supports and crutches.

The reason I draw is that you don't have to join things together. It's very easy and immediate, and it occurs in its own world, not the real world. The problem with sculpture really is its existence in the physical space we occupy. That's the problem that sculpture has, not only in terms of its credibility but also in terms of its physical life. I might discover things in drawing that I don't remember until years later in sculpture. You have problems articulating your thoughts in drawing, but you don't have the gravitational, physical problems of making sculpture—which, by the way, are some of the most interesting aspects of making sculpture. Drawing keeps me busy until I'm ready to jump into sculpture.

Any time you're dealing with abstraction, it's a problem. Even artists find the meaning of abstraction a problem. How do you deal with the notion of materiality, and how significant is it? There's a real conflict there. With this sculpture [Untitled, 1987] I think the thought is very abstract. When I snapped the arms off that piece and stuck them under the head, I wasn't thinking I wanted to do something about immobility. That becomes the language I might use after I make the piece and see what I've done; I don't have that kind of concept prior to a work, it's really a critical language based on my analysis of the work after making it. I know what every piece is doing, I have a real intention, but the intention isn't answered until the work is realized. Otherwise I wouldn't work. You really do have to look at what you've done— you have to know what you've done. I don't think artists are excluded from needing to understand how and why they behave.

Born 1949 in New Haven, Connecticut. Lives in New York **CARROLL DUNHAM**

Selected Solo Exhibitions
"Carroll Dunham." The New Museum of Contemporary Art, New York, 2002
"Carroll Dunham: Paintings and Drawings 1990–1996." Guild Hall,
 East Hampton, New York, 1996 (traveling)
"Carroll Dunham." Artists Space, New York, 1981

Selected Group Exhibitions
"Fabulism." Joslyn Art Museum, Omaha, Nebraska, 2004
"American Art of the 80s." Museo d'Arte Moderna e Contemporanea
 di Trento e Rovereto, Trento, 1992
Whitney Biennial. Whitney Museum of American Art, New York, 1985

I think about two kinds of ideas now in terms of the construction of the paintings: there's a shape—a dominant motif or character—and then there's the space around it, the space it inhabits, which can have different characteristics. *Fourth Pine* [1983] shows clearly the interaction between the two, in that the space and the motif are more or less completely a result of the patterns in the ground, which is a plywood panel. The figures in the grain of the wood dictated to some extent what happened when I went to work on it.

At this point I was using pieces of wood as they came from the manufacturer. Later I started to juxtapose different types of wood and to use fancier stuff, veneers made for architects and furniture people: I was designing the surface of the panels before I painted them. I cut up different veneers and attached them to panels. Then I went to work and tried to respond to what was there. I thought of something coming out of me and going toward the panel, and something coming out of the panel and going toward me. Whatever the result was, that was the artwork—the place where my feelings and ideas met the materials that I needed to realize them.

At some point I began to think that I could make the arrangement much simpler. *Body of Knowledge* [1987] is just a shape and the wood around it. The space that the wood suggested is given over to this shape, this inhabitant, which is fairly typical of the family of forms that I was drawing at the time—it's mainly based on arcs, the idea of trying to paint curvature. What was striking to me about this work was its simplicity, and the idea that I didn't have to worry so much about filling the painting up.

Around 1987 I felt I had reached the end of something. I had been working for over seven years on these surfaces, this idea that I should follow the materials until they reached their own conclusion, and I began to feel that some corner had to be turned. I'd been making these works as vertical rectangles, and I got the idea that I should try something horizontal. I've always been interested in how these basic conditions affect what one's looking at; horizontality would make an important difference, and I started to think it might help me to turn that corner.

Untitled [1987] represents that turn, and also represents the end of my being able to work on things where I was thinking about filling up space. It's full of shapes, which I developed in response to the surface, and to different things I'd figured out to do with painting and drawing. The important thing about it, though, was that in trying to find a way to fill this horizontal space, I found a shape I'd never drawn before—the asymmetrical, pointed shape hanging from the top edge. I drew it in a doodle and put it into the painting, and it seemed to allow the painting to be finished somehow. It fell nicely into the painting's family of shapes, and seemed to augment them. At the same time, I felt I'd reached a kind of wall: I just couldn't stand to look at any more wood veneer, and I couldn't stand to think about filling up the space with these colored shapes. So I started to try to think about a way out, or past. One doesn't escape, one just goes past, or through. I settled on this shape. I started to draw it and

Shape with Points. 1989–90. Vinyl paint, acrylic, and pencil on cotton, 66 3/8" x 7' 3 7/8"

its variants a lot, turning it upside-down and sideways, and trying to think of things to do with it. It became the basis of everything I'm still working on now. The shapes based on arcs, on ideas of circular contour, had had a kind of softness; they had no points, no sense of armor. And this shape got me excited because it was so asymmetrical, it involved curvature but points as well, and it involved very different speeds of drawing and ideas of personality within its different parts.

A strong characteristic of the wood veneers I'd been using was that they absorbed light and functioned as a color. But I'd begun to work on lithographs and etchings, and in the process I realized that what I was most attracted to about paper was that it's a surface that gives off light. I was interested to try to bring this idea of light as ground into my painting, so I took my plywood panels and covered them, not with wood veneer, but with paper, a museum-mat-board-type stuff—a bright white surface that's beautiful to draw and paint on. It took a long time to understand how to make these works. The way I set them up was very like the way I'd set up my previous paintings: I began and worked on a group of them at a time, and saw them through to what seemed like the point when they were all finished. A lot of drawing was involved, and a lot of the materials one associates with drawing: pencil and charcoal. That was part of not wanting to get too fancy or complicated with color. I wanted to be willing to do what came to mind, but I didn't want to do it in a way that would involve complicated color relationships—I wanted to do it in a way that would involve space and light.

The use of the wood panels and everything that led me to them had had to do with an ambivalence about painting in the first place. I didn't like most painting I saw, and I *really* didn't like most painting I saw that was made in the traditional way of paint on canvas on stretchers. I saw so many conventions, so much rhetoric, that I couldn't see a way to use. At the same time, the idea of the flat pictorial rectangle— the idea of making a picture—seemed so basic to human activity that I was compelled by it, and I started to think about ways I could take that condition apart without giving in to it. So everything I've talked about so far involves a certain amount of ambivalence or confusion on my part about the whole idea of painting in the first place, but *Yellow Shape* [1989] is the first painting I finished that I thought was an acceptable-looking thing—a thing that looked like what I meant. I'd simplified the terms of the situation to the point where I could feel I was being clear; now I had to start to bring back some of the things I'd been disenchanted with in the group before and try to synthesize. So this painting came out of a long period of six or seven months of really being unable to make a painting. Instead I was just experimenting, thinking about what the work would be, trying different kinds of paint, looking at a lot of really awful surfaces and things that looked like a million other paintings I'd seen, and finally coming to a point where I thought I could imagine what kind of painting I would try to make.

By the time I finished the colored shapes, I realized that I'd kind of made my bed: if I was going to work with lightness, scale, and all the things I've been talking about, painting on stretched canvas was such a straightforward way of doing it that I really had to give up on all these problems and just try it. That gave me a whole new range of things to work with based on the idea of absorbency—how canvas deals with material, as opposed to how wood panels do. So, in *Untitled* [1989], I painted on unprimed canvas. It behaved like you're painting in ink or watercolor on paper, bringing up the issue of colors mixing and bleeding into one another. That seemed to raise a whole other set of issues about the emotions one would bring to looking at it.

The influence of printmaking is very big in all these works. Something that's gotten to be very interesting to me about printmaking is the fact that it has no surface to speak of, no physicality: it's a molecule-thick layer of ink laid on top of a piece of paper. But that molecule-thick layer of color can carry an enormous amount of information in enormously varying ways. And that's been my idea in these works on canvas—the idea that the surface is an optical condition, not a physical one. If you look at these paintings close up, there's really no relief. There's no buildup. Also coming from printmaking is the idea that color is not something one mixes so much as something one deals with in layers.

It's very important for an artist to go with what he feels he wants. At this point, the way I'm working on these things has to do with being willing to really look at what I want to look at, and to try to censor myself, or to think about taste, as little as possible. I don't even really want to think about content. I have the idea that any color is as beautiful as any other color, so in these paintings I try to work with the idea that anything is as interesting as anything else.

Born 1944 in Bachrus, Ohio. Lives in New York City and Cocheton, New York

MARY LUCIER

Selected Solo Exhibitions
"Mary Lucier." Weatherspoon Art Gallery, Greensboro, North Carolina, 2001
"Mary Lucier." The Museum of Modern Art, New York, 1999
"Mary Lucier." San Francisco Museum of Modern Art, 1995

Selected Group Exhibitions
"Into the Light: The Projected Image in American Art, 1964–77."
 Whitney Museum of American Art, New York, 2001 (traveling)
"Illusions of Eden: Visions of the American Heartland."
 Columbus Museum of Art, Ohio, 2000–2001 (traveling)
"Video Cultures." ZKM Museum fur Neue Kunst, Karlsruhe, 1999

In 1983 I did a video installation called *Ohio at Giverny* in which I developed a partic-
ular notion about the garden. I worked on the idea for three years in a series of pieces,
whittling away at what I felt was the function of the garden in contemporary life, the
meaning of the garden in art, and how those ideas could come together and either be
useful or play themselves out in terms of our relationship to the environment that we
live in. What I observed in *Ohio at Giverny* was that Claude Monet, painter and master
gardener, created for himself a perpetual refuge, an endless loop, in which he lived
and worked for the rest of his life. His garden fed his palette and his palette fed the
garden in an endless, infinite capacity—yet also served to wall him off in some way
from the rest of the world.

Around the same time I was also looking at how certain nineteenth-century
American artists took it upon themselves to re-create a little bit of paradise, a little
personal utopia. Frederic Church did that at Olana in the Hudson Valley. I was inter-
ested in people actually living in a spot that becomes their motif and their muse, their
eternal subject—artists drawing sustenance from a site that is in itself a work of art,
resulting in a constant interplay between the place and their life's work. I conceived
the notion of going to Giverny and re-viewing these motifs that are so well-known in
Western art, and of creating a kind of personal journey out of the American encounter
with European art.

I also wanted to use these motifs as a kind of a hook for my own personal jour-
ney from Ohio, my birthplace, to France; and, in doing this, to try both to understand
something about the challenge presented by Europe to an American artist and to
create a kind of homage, not so much to Monet as to the act of working with light,
which of course is the basic substance of video. (This work was also, on a personal
level, an homage to my American uncle and his French wife, who was killed in a train
accident near Versailles.) I was interested in Monet's use of light, something way
beyond the canvas and beyond the material—something that video could share with
painting, that could say something to us about both landscape and interior states of
being. And in *Ohio at Giverny* I was particularly interested in the fading of the light as
Monet became blind, as he aged into the 1900s—how he obsessively repeated certain
motifs, and how his work became more and more abstract. So *Ohio at Giverny* is also
a journey from the representational to the abstract, from a simpler, American origin
to a kind of "decadent" European art history, from youth to old age, from birth to
death, and so on. This was my initial interest in the idea of the garden, and I contin-
ued to develop it over the next few years after *Ohio at Giverny*—in *Wintergarden*
[1984], followed by *Wilderness* [1986], and then in *Asylum* [1986/89].

Now in *Ohio at Giverny*, as in much of my work, there tended to be no featured
people. There's no protagonist, no literal narrative, no spoken words. Yet I do think
of these pieces as narrative—a kind of multiple-channel pictorial narrative—in which
picture and sound are edited to create a subliminal story. The work is not an explicit

text that you can interpret literally, but, if you're willing, it can take you from where you are to someplace else, and suggest a variety of meanings and even adventures. You see the image literally dissolve, from the representation of the water lily to the abstract marks or strokes that suggest Monet's brushwork in his later paintings, and to me this tells a lot about the history of modern art, how the representation of the object becomes transformed into pure light, color, and movement. This is something that video can do, essentially and beautifully and in a few seconds. And in doing that, it has the capacity to recapitulate the development of the last century of modern art.

The idea of the natural and the artificial is also at work in *Wilderness*, which again deals with an idea of the garden but in this instance it's more the Garden of Eden, the original paradise. *Wilderness* is about the nineteenth-century American view of landscape, how it made the landscape a commodity, and how it came about at a time when the landscape first began to be seriously threatened by industry. In a way, nineteenth-century painting functioned the way television functions for us today. This aspect of the idea of the garden becomes divorced from the more intimate sense of a garden that you would have found at Giverny, or in a formal Japanese garden as in *Wintergarden*.

All the works I'm referring to are on some level about decay, about death. The journey that occurs in all of them is from the fresh to the moribund. I also wanted to comment on how we perceive landscape, how we use it, how we both revere it and denigrate it at the same time; on how the medium that delivers the landscape to us was once painting but now is television; and at the same time to evoke a sense of the loss of what once was. *Asylum* for me is about the fact that the garden as a private refuge is no longer possible. It may seem a truism yet I think it's kind of a startling reality that World War I took place while Monet lived at Giverny; you'd never know it from his work. There was once a way of insulating oneself from the so-called realities of the world that I think is no longer available. In this cycle of pieces I was intrigued by the use of the garden as a utopian or escapist haven, as a refuge from the world, and in the apparent breakdown of that function. In *Asylum* the garden is presented as an exhausted icon. It no longer operates. You have to find your shelter somewhere else, because there's no escape from Three Mile Island, there's no escape from Chernobyl. There's no longer that place you can go to that is of your own creation, that can shelter you from the true process of decay within your lifetime.

Still, obviously, if the garden is itself about decay, it's also about regeneration, about birth and death and renewal. I think that its function in human life is to serve as a reminder of these cycles, and to give us a sense of power and control over things we actually have very little control of. But in *Asylum* we see those things as having come to an end. The garden simply ceases to function; there's no asylum really. And in the installation you kind of gravitate—I do, anyway—to this room, the "toolshed," as the place that seems to feel comfortable, yet it has its own peculiar, ominous under-

tone that eventually repels you as well, and drives you out, making you feel that there's no place where you can permanently be at ease in this space, where you can take shelter. So ultimately you come back to the image in the video, and to the sound on the tape, which permeates the entire space—and there's no escape from that either. And the rubble on the floor, which is site-specific to the installation locale, is a counterpart to the rubble you see in the shed and onscreen. These are all discarded objects, which have ceased to function in the ways they were intended to function. The old toolshed contains them as though it were a museum of rust. The patina of age that forms on these objects lends them a kind of beauty, whereas the patina that forms on the pile of rubble on the floor is one of ugliness—but the line between the two is really very thin.

The piece I'm working on now, *Noah's Raven*, will have a more ecological thrust. I'm traveling to a number of different environments—the Brazilian Amazon, Alaska, the Midwest. I've been shooting in oil refineries and steel mills, and I'm also trying to say something about women's cancer scars in the same project. I'm trying to make the figure read as part of the landscape, and then somehow help the viewer to get a feeling for the landscape as an integral part of one's own body. Because one thing I have

noticed in contemporary art, and in contemporary thinking, is that there seems to be a belief that you can make work either about "landscape" or about "the figure" and social issues but they cannot be connected. I don't for a minute believe that's true; I think they're absolutely connected, and in this new piece I'm going to try to say that any injury to one is equally injurious to the other.

Lucier shooting on location in the Brazilian Amazon, 1991

Born 1944 in Los Angeles. Lives in New York

ALLAN McCOLLUM

Selected Solo Exhibitions
"Allan McCollum: Natural Copies." Sprengel Museum, Hannover, 1995
"Allan McCollum." Serpentine Gallery, London, 1990
"Allan McCollum." Stedelijk Van Abbemuseum, Eindhoven, 1989

Selected Group Exhibitions
"The Museum as Muse: Artists Reflect." The Museum of Modern Art,
 New York, 1999
"L'Informe: Mode d'emploi." Centre Georges Pompidou, Paris, 1996
"A Forest of Signs: Art in the Crisis of Representation." Museum of
 Contemporary Art, Los Angeles, 1989

I've always been interested in the distinction between the unique object, such as the artwork, and the mass-produced object, such as something industrially produced. I've always felt that the distinction we make between the two isn't as understood as it could be. Our understanding of uniqueness is only arrived at by comparing the unique object to an object that *isn't* unique. So it might make sense to say that the unique object is *created* by the mass-produced object. The problem in these distinctions interests me.

The "Constructed Painting" series, of 1969 to around 1975, for instance, resulted from my thinking about what might determine the identity of an art object in this context. I was influenced by the quasi-critical distinctions art writers used during that period, and I tried to turn them into a kind of mass-production system. The works were made from standardized canvas or paper shapes that I would make by the hundreds, sometimes by the thousands, and glue together using various task-oriented systems, making repeated patterns, like complicated tile work. So one wasn't able clearly to say whether or not these were art objects: they weren't exactly produced the way art objects were, but then again they sort of satisfied the conditions one thought of for a formalist artwork, all lines and edges, all self-referring. They became, in my mind, surrogate artworks.

I continued to develop the idea of an artwork as an imitation of an artwork. I began to question where that investigation might lead: I wanted to understand what an artwork was in terms of the other objects in the world. To the degree that I was interested in definitions at all, I became more interested in the more anthropological definition of an artwork. I mean, if one imagined a continuum of paint being applied to a surface, and at one end of the continuum is a fire hydrant and at the other end is a de Kooning, where in that continuum would one find the brush-mark that you weren't quite sure was an art brush-mark or a coating? I found this a scary sort of place. I was interested in a painting that you weren't sure was an artwork or not. I then realized that an artwork is largely something that fits in a categorical place where we expect to find artworks. There is a system of objects, in a sense—objects that are chairs, objects that are food, objects that are pets, objects that are paintings. And artworks achieve their identity by occupying a place in that system.

To investigate this I decided to come up with an art object that functioned like a sign for an art object. When I tried to think about a painting, I could only think of, say, a Picasso or Cézanne. No neutral image of a painting that was just a painting would enter my mind—so I decided to try to paint that painting. I wanted to promote a distanced view of an artwork, so that one might be able to think of it as an object in a world of other kinds of objects, like chairs and tables. I did a series of experiments in 1977, '78, trying to come up with a sign for a painting. The series' title was "Surrogate Paintings."

During this period I had a job as an office cleaner uptown. Every night while I was cleaning the offices I would look out the windows and notice things in apartments

Over Ten Thousand Individual Works. 1987–88. Enamel on HydroCal, each object unique, each 2" in diam., lengths variable. Installation view

in the faraway buildings that I immediately knew were artworks on the walls, but they were so distant I couldn't see any details beyond that. So part of my thinking was, How do I know that's an artwork? And obviously I knew because not only was it not a couch, but it had a frame, a mat, and something within the mat. I began to realize that this was the vocabulary one used when one identified a painting. And in the end, that collection of features was what I decided on—the frame, the mat, a window in the mat, and something flat and rectangular and anonymous inside the window—all of which, taken as a whole, could function as my sign for an artwork.

In a show in 1979, I put eighty of these "Surrogate Paintings" together in a cluster. It was hard to deny that there was something a little off about these works: they weren't exactly paintings, they were objects that *represented* paintings. I decided that maybe if I started giving them a black center, and articulating the frame with a slightly different color, I might make it more explicit that they weren't little Minimalist sculptures but signs representing paintings. One problem I had during this period was getting people to recognize that the frame and mat were parts of the work. It was almost impossible for people to understand that; they would point to the center and say, "Oh, this is the work here." At first I tried to counteract that by making the whole object monochrome, but in the end I had to come up with a technical solution: I took twenty of the "Surrogate Paintings," made molds from them, and began to cast them in plaster. Once I started doing that, I was able to make a lot more of them in less time—it had taken days to make them out of wood. So I was able to produce larger, more dramatic installations, and also to solve the question anyone might have as to whether or not the frame was part of the work. Once they were solid plaster, that question vanished.

In 1980, when I was designing the first "Surrogate Paintings," I decided also to devise a kind of sculpture that could function as a sign for a sculpture. So I began collecting different kinds of vases, and taking pictures of vases I saw on television. A vase is a symbol of civilization, or spirituality, or mortality, or femininity, or creativity—there's so much symbolism there. By casting vases solid, I developed a series that I called "The Perfect Vehicles." It was meant to evoke the kind of response one has to an object that one imagines might carry a transcendent meaning. These works, I decided, would start out with a neutral sort of presence, lacking in specific meaning. Over the years, though, they would develop an exalted presence. Sometimes when I look at them I feel they're functioning like spiritual vehicles. I think that will continue as time goes by.

In 1987 I began a series called "Individual Works," which addressed the notion of the unique versus the mass-produced object probably more than any other series did. I developed a system for producing thousands of little plaster shapes, about the size of your hand, each one being completely unique. My inspiration was those little objects by Steuben or Fabergé—objects with no purpose except to be symbols of value. I thought it would be interesting to operate as an artist who saw no distinction

between a plaster souvenir and a Fabergé egg. What kind of object might I design if I didn't recognize that distinction? I was also interested in why we divide up the world of objects into categories of, say, the mass-produced object, which is common and interchangeable, and the rare and unique object. It occurred to me that it would be simple to mass-produce unique objects if one just decided that that was what one wanted to do. I felt the reason for not doing that must be ideological: we must enjoy this system in which there are many interchangeable objects and a few priceless ones. In a sense, this must reflect our view of the social world: the way we like to think of some people as special and others as expendable. I mean obviously it's ideological, not technological, because I could produce this system pretty easily, and I'm not an industrial designer, I'm not a production engineer—I just worked in my kitchen with little things I found in hardware stores and supermarkets, flashlights and doorknobs and bottle caps and stuff like that, and I made a point of never using a computer or anything complicated. I made molds in my kitchen, then made casts from those molds and developed a vocabulary of shapes. I had tables filled with these little parts, and I chose ones that I liked best. I've made enough molds at this point to produce about 45,000 unique objects. I've so far produced about 25,000.

We have a hard time coming to terms with huge numbers. When we think of a huge number of objects, it's comforting to imagine that they're all alike. But to imagine a huge number as all different—to think of a people we're at war with, for instance, as all unique individuals—is painful. To make distinctions among huge quantities of things we've been thinking are the same, to suddenly have to look at them as unique—this is a painful disruption of our way of perceiving the world. So having all the objects in "Individual Works" in front of us makes us go through this battle. There are over 10,000 unique objects here—does it matter that they're unique? Are they symbolic of the world as a whole, because all people are unique? Or would I prefer to think of people as not unique? This series triggered a lot of that kind of moral consternation.

McCollum in his SoHo studio, 1989

SANDY SKOGLUND

Born 1946 in Weymouth, Massachusetts.
Lives in Jersey City, New Jersey

Selected Solo Exhibitions
"Enchanting the Real." COPIA, The American Museum of Wine, Food,
 and the Arts, Napa, California, 2004
"Breathing Glass." Museum of Contemporary Arts and Design, New York, 2000
 (traveling)
"Reality under Siege." Smith College Museum of Art, Northampton,
 Massachusetts, 1999 (traveling)

Selected Group Exhibitions
"Visions from America." Whitney Museum of American Art, New York, 2002
"An American Century of Photography." International Center of Photography,
 New York, 1995–2002 (traveling)
"Almost Warm & Fuzzy: Childhood and Contemporary Art." Des Moines Art
 Center, 1999. Coorganized with Independent Curators International (traveling)

I went to the University of Iowa for graduate school. Now the Midwest, I would say, has never been that cerebral in its overall view of art, so when I came to New York, in 1972, I was completely overwhelmed by the atmosphere of Minimalism and Conceptualism. The essential question for me became how to get back to image-making; being a Conceptual artist for most of the '70s had left me with a feeling of emotional bankruptcy.

So in 1978 I looked around at images and I decided that I wasn't going to judge them by whether they wanted to be art, or tried to be art, or what their supporting apparatus was. I was just going to look at images, period. And commercial photography hit me over the head. I had never studied photography, by the way; I got my master's in painting. One thing that hit me was that these images were really trying to communicate something to the viewer. The other thing was the relationship between what's shown and the controlling system *outside* the image. If you could see a photograph of what it took to make an advertising photograph—things you don't think about, like the photo assistant carefully arranging the meatballs—the degree of unnaturalness would be astonishing. Yet it produces an image that looks natural, and is orchestrated to provoke basic emotional responses.

A position in the avant-garde then was to avoid using high craft. I decided to inject high craft: to use the skills and language of commercial photography within the fine-art context, which I thought would reverse both things, turn them inside out. *Peas on a Plate* [1978] is a straight picture of peas on a plate. It has the craft of commercial photography, but all the artifice is clear: the plate is on a patterned surface, and you can see that they're arranged.

Around 1980, when I did *Radioactive Cats*, I was thinking about the difference between the made object and the found object. I felt, again, that I wanted to stay in touch with an emotional center. That meant that instead of going to Woolworth's and finding cutesy things there, found objects, to do these cats, I would make them myself. Then, having made them, I couldn't throw them out. So it was as if a new sort of art form happened for me, or to me, through my investment in the process of making the sculptures.

Revenge of the Goldfish [1981] took at least six months. It was really grueling. I was scheduled to have a gallery show, and I wanted to do a piece specifically for the space. I enrolled in a hand-building pottery course and made the goldfish by hand, in painted low-fired white clay. There were about 130 of them. What I feel most comfortable with in these large installation works is this pushing of control to the point of mania. In fact I like to do the entire installation myself as much as possible; of course I work with assistants, but I also like to make the installation first in the privacy of my studio, as opposed to doing it first in a museum or gallery and bringing the camera in. In the photograph *Revenge of the Goldfish*, every fish is placed for the camera—for how it looks through the camera lens. That's really what I like to do with the photographs,

which basically, for me, are an equivalent to the installation. I think I'm really fortunate to be an installation artist who is heavily invested in photography: I don't have the emotional problems with the loss of the work that some installation artists have. The photographs wouldn't exist without the installation, so the installation is necessary for the photograph; but at the same time, I think I'd kill myself if I only did installations. There's something deeply tragic about doing work that you know is temporal.

With *Maybe Babies*, from 1983, the idea was once again to learn something new, which this time was mold-making and traditional sculpture. The figures are sculpted out of my head, but I began by taking sketchy photographs of friends' children, buying books on child-rearing and age development, and plastering the walls of my studio with this material.

An interesting thing about work that goes out and has an audience is that there's a discrepancy between what you think or intend and how it's perceived. Also, of course, the way things are perceived changes through time. When I did *Maybe Babies*, there was a lot of nuclear fear, and the piece was seen as a post-nuclear-holocaust image. The babies, being blue and purple, were seen as bruised. I found that astonishing. To me the thing had a certain content based on the babies, and the way I sculpted them, and there's certainly a somberness to the black; but I never saw the piece as having anything to do with nuclear anything, and I certainly didn't choose the colors to look bruised. Rather, I chose them for having just come out of the womb, and for crossing back and forth between blue and pink for male and female. To me this is an existential piece. But "baby" to Americans is charged content, particularly with the prolife thing: another interpretation of this piece has had to do with abortion. Where do you see that? And if you do see it, is it pro or con—I mean what is it saying about abortion?

Do I want an image to be sweet or sour? Do I want it to be hard-hitting and nasty or more forgiving? Partly because I have so much time to think while I'm making the sculpture, I do a lot of objective analysis. From there I'll go into the colors. In *Revenge of the Goldfish*, for example, there's bright orange and turquoise blue. I wanted the image to be highly charged, to have sexual overtones. The people are a mother and her son. She's lying in bed and he's sitting on the edge of it. Why fish? Well, just the planes and shapes, and the subconscious stuff we all engage in. They could have been green fish or brown fish. For me there's this fine-tuning of the relationship between what's natural or expected and what's not too much farther beyond that. I meet people who always use the S word, you know: surrealism. But I think real life is surreal, at least in the United States.

I'm not working on large installations right now; I'm taking a breather for a month or two, because I've had these desires for years to use food as material. For *Spirituality in the Flesh* I covered the figure with hamburger. The idea has to do with

photography and death: photography stops things. I mean it stopped the meat at a particular moment in time. If I'd photographed this figure two hours later, it would look entirely different, and of course the next day it would have looked *really* different. But it's a straight photograph. The series also includes *Body Limits*, in which the figures have bacon all over them. I've spent the last week lighting, testing exposures, testing how the light falls and flows. I'm interested in the way these "clothes" take on a life of their own; that happens through the photography, the lighting, these technical things. I'm also intrigued by the way the figures lose a sense of embodiment: you're not quite sure whether you're seeing a real person or just a sculpted thing.

American artists are very audience oriented and I feel that way too. But what interests me is a broad emotional thing—I don't need the audience to understand exactly the whole content of my intent. To surprise or shock somebody: that's a big thing today, a really big thing. I guess that's what my strategy is.

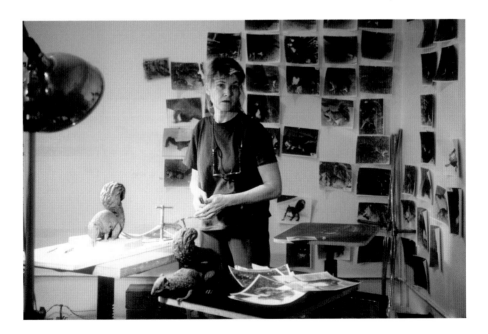

Skoglund in her studio, 1991

Born 1938 in Pennsauken, New Jersey. Lives in New York

DOTTY ATTIE

Selected Solo Exhibitions

"Pierre and Lady Holland: A Suite of Drawings by Dotty Attie." Smith College
 Museum of Art, Northampton, Massachusetts, 1999

"Dotty Attie." Montclair Museum of Art, Montclair, New Jersey, 1992

"Dotty Attie." Greenville County Museum of Art, Greenville, South Carolina, 1990

Selected Group Exhibitions

"Imprint." The Print Center, Philadelphia, 2002

"About Face." The Museum of Modern Art, New York, 2001

"American Identities: A New Look." Brooklyn Museum of Art, New York, 2001

All of my work consists of fragments of mostly eighteenth-to-nineteenth-century European art. What I'm trying to do is to show how an artist's life is really essential to his work. His work is really about his life's experience.

People who appropriate in the sense that it's come to mean are really appropriating from popular culture, commenting on popular culture, and being critical of it. I don't consider myself critical of my sources. I really *like* my sources. But I'm definitely looking at them from a post-Freudian twentieth-century vantage point, which makes a difference.

When I was a student, at the Brooklyn Museum Art School, I worried about what I was going to do when I left. I've always been a referential artist; I've always had to work from something. I've never worked from my imagination. So one day one of my favorite teachers started talking about an artist who painted from photographs. I didn't know such a thing was allowed; this was 1959, and I came out of a Philadelphia art school where it was considered very retrograde to do anything but work very large and loose, which I always had trouble doing.

As I said, I always painted *from* something, and I was never particularly interested in painting still life. I like to paint people, but I didn't feel comfortable hiring and painting from a model. I wanted material that I could comfortably use myself. Photographs really seemed the answer for me.

Around that time I got married and had two children, and it became really hard to work. I was going to my studio, which has always been in this house, and just doing what I knew I *could* do during the short time my kids were with a babysitter. I was feeling terrible about my work, and not very interested in it, but I wanted to do *something.* At one point I felt really desperate. I guess I was about thirty-three or thirty-four at the time, and I thought, "If I don't do something soon my whole life is going to pass me by." So I took a month off and went to a lot of galleries and museums. And I saw some drawings by an artist named Marvin Hardin at the Whitney, they weren't small drawings but they had very small images in them. I had drawn all my life until I got to art school, so I decided I'd try to go back to drawing.

Around 1970 a friend called and said, "Would you be interested in being in a cooperative gallery?" And I said, "Well, I'm not *incredibly* interested in being in a cooperative gallery," but I wasn't doing anything else in terms of a career, so. . . . A friend of hers—Barbara Zucker, who was interested in starting a cooperative gallery—came over to my house. She liked my work. Six of us formed a core group, and four of us decided we would go and find the other fourteen, because we needed twenty to start our gallery. So for about three months we went to various people's studios and looked at their work and decided whether or not they would be a member of what would become A.I.R. And I started feeling really uncomfortable because everybody was doing conceptual art. *Nobody* was doing figurative art certainly, and nobody was copying from the masters. As a result, I was anxious about how people were going to relate

to my work, and I started making drawings and then destroying them in some way. I did a number of those, and they were in my first show at A.I.R.

After that show I started feeling paralyzed. I was having a really hard time working, I didn't know what I wanted to do, but I had to be in a group show at the gallery, so I decided I'd just execute something. My idea was to make lots of little drawings about two inches square and tape them on the walls like postage stamps. When I'd done ten or twelve of them I saw it was a story. I hadn't intended to make a story, but I really liked the idea and I started looking through all my books and things for images that would advance the narrative. This was my first narrative piece.

People always used to say, "Don't you want to make a book?" I never have, but I like to have long extended projects—I like to go down to my studio and know I've got something to work on and not have to worry, "What am I going to do today?" At the same time, I like to be able to see a result immediately. So this was perfect, because I could feel good about each drawing but at the same time it might take me months or even a year to finish the whole group. So it worked out great.

I would have an idea, a feeling I wanted to get. Then I'd start making the drawings, and I'd choose images that I thought had some relationship to my ideas and the feeling I was reaching for. I'd make many pages of drawings and put them in a drawer. And then, when I felt I had enough drawings, I'd start cutting them up and putting them together and writing text to go with them. I took sentences for my first piece with text from *The Story of O*. I never could find any text I liked as well; writing was very hard for me, I'd write a sentence and then I'd look in the thesaurus and change every single word. But eventually it got a little easier.

Then the very last thing I'd do, and this was after the drawings were framed, would be to put everything together. I never knew which drawings would go with which sentences until the very end, and then often I'd have to make a few drawings, eliminate others, write a few more sentences, and stuff like that. That was the more creative part maybe. The other part was just very labor-intensive.

I drew for about fifteen years, and it was very suited to my personality, but after a while I felt as if I were going into my studio and sitting down and doing the same thing again and again and again. I started describing myself to my friends as a gerbil: just cranking out one drawing after another. It got to be impossible to stay at my drawing board: I'd go down to my studio and sit down, and then I'd get up and get something to eat, then I'd sit down again, and then I'd get up and see if the mail had come. So I eventually decided, it took me a while, but I decided I had to change in some way and I thought what I'd do was paint. This was a total trauma, one of the most traumatic experiences of my life. I always thought that when my work changed it would evolve, or I'd get interested in doing something else, but that really wasn't what happened. What happened was, I just got bored with doing the drawings, and I didn't know what else to do, so I started painting.

At first I couldn't believe how horrible a painter I was. I had such good control over my drawings but I just couldn't paint. I'd go to my studio and paint all day long and at the end of the day I'd have this terrible-looking mess. It was very, very depressing, but I felt I had to just continue and try to do something. It took about nine months before I did one painting that I liked, and this one, *Untitled* [1987], is the one.

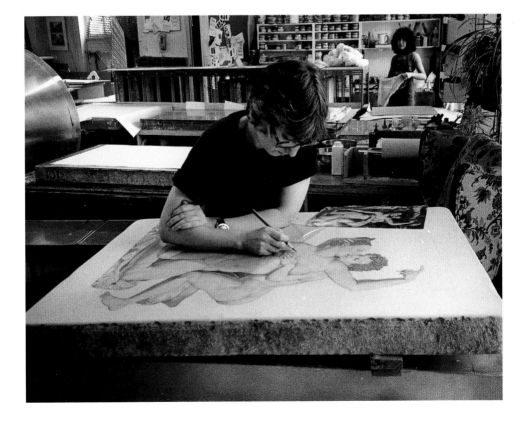

Attie at Solo Press, Murray Hill, New York, early 1990s

Born 1943 in Holyoke, Massachusetts. Lives in New York

WILLIAM WEGMAN

Selected Solo Exhibitions
"William Wegman: Photographic Works: 1969–76." Fonds Regional d'Art
 Contemporain Limousin, Limoges, 1991
"William Wegman: Paintings, Drawings, Photographs, Videotapes."
 Kunstmuseum Luzern, Lucerne, 1990 (traveling)
"Wegman's World." Walker Art Center, Minneapolis, 1982 (traveling)

Selected Group Exhibitions
"The Last Picture Show: Artists Using Photography, 1960–82."
 Walker Art Center, Minneapolis, 2003 (traveling)
Documenta V. Kassel, 1972
"When Attitudes Become Form." Kunsthalle Bern, 1969

I didn't always work with dogs but that's what I am known for. In my retrospective at the Walker Art Center in 1982, only about one in twenty photo pieces had a dog in it. But that's what was memorable, I suppose. It didn't help that the museum banner for the show was in Purina checkerboard.

However, from the works in that show you could see that I had gone to art school because painting and sculpture ideas show up in the photographs, videos, and drawings. In art school, photography was just about the only thing I didn't study. My background is painting. I didn't make my first photo piece until two years after grad school, while I was a visiting artist in sculpture at the University of Wisconsin. I like dogs but I'm not really a dog person. I got Man Ray for my wife Gayle in 1970 when I moved to L.A., and I immediately began using him in my work. He was supposed to be just a pet but he kept hanging around me while I was working and it was inevitable that he got into the frame.

My first response to him in my house, he was a trembling six-week-old puppy, was to take his picture. I guess you do the same with a baby. He looked like an old man and he was sitting in a ray of light. Man Ray! In one of my first videos with him I poured a puddle of milk on the floor and recorded him lapping it up. Then I got the idea to set the camera down on the floor and pour the milk out away from it from my mouth and then let him lap it up back to the lens. He developed an attraction to photo and video equipment. He carried the microphone around like it was a bone. Most of the pieces with Man Ray were born out of his natural inclination to retrieve and to keep an eye on me. He loved to work and for most of his 11 1/2 years he was my primary inspiration. He always seemed to fit into whatever I was thinking about in terms of art.

These early pieces at the time seemed just barely art, and that appealed to me. The idea was to make something out of nothing, especially to make something that had nothing to do with art. They could be about almost anything so long as the subject wasn't a hot one: no art theory, no science, politics, sex, or violence. I was following Marshall McLuhan's words about the media and was influenced by Glenn Gould's ideas about recording. I was a big fan of Bob & Ray's radio pieces, I loved their deadpan style. I was not a Lassie fan. In fact by the late '70s the whole dog thing started to get to me.

In 1978 I decided to not work with Man Ray as an act of self-discipline. I didn't want to rely on him. Man Ray hated not working, though. He would come into my studio, see me drawing or working on photographs, and just slump down at my feet with a big sigh. Fortunately for both of us the year ended. Polaroid had invented a new camera, the twenty-by-twenty-four, and I was invited to Cambridge, Mass., to experiment with it. Naturally I took Man Ray and we were working again.

The studio was very unlike mine—big camera, lights, a real professional photo studio. I had to get used to working around a lot of people. There always seemed to

Vacation Land (Hardly Boys: Jo and Frank Hardly in Sailboat). 1993. Color Polaroid, 24 x 20"

be tour groups coming through to see us or the camera process, which is pretty interesting at first. Somehow I was able to work in this circus environment and that was very new to me.

Man Ray died in 1982. We worked right up until the end. I was devastated when he left. I didn't get another dog for five years, I had no interest in working with another dog. I got Fay as a pet, not a model. That job seemed to be finished with Man Ray. But Fay had other ideas. "Aren't you Bill Wegman, the dog photographer?" So I took her to the Polaroid studio, which was now located in SoHo, a few blocks from where we live. Fay thrives on the work. For her, working is a necessity. She is very different from Man Ray, more vulnerable and feminine, lighter in tone and more reflective to color. It shows up in the photographs the way the light gets modulated. Her surroundings inhabit her in a way. Fay's body is more lithe than Ray's. She has this intense coiled-up energy. She likes the poses to be a little difficult. Man Ray had repose. He just was.

When Fay had puppies I got to see how very different their personalities are. Batty is comic and sweet and possibly forlorn. Batty is Cinderella to Fay's evil stepmother/fairy godmother. Fay is Garbo, Batty, Carol Lombard. Batty always makes me smile. Chundo is princely, Father knows best. Crooky is perky. Sally Struthers. These characters have led me to make works for children.

There's about a six-year gap between the last picture of Man Ray and the first of Fay. That's when I started to paint again. For years I wanted to paint but was afraid to. Since my grad-school days I had made such a big to-do about the end of painting. My last painting looked like a glow-in-the-dark Frank Stella, 1960 style. I went on to Minimal sculpture and conceptual/performance art. See any *Artforum* magazine from 1966 to '69 and you'll know where I was at. For me painting was ancient history.

My drawings fit in my manifesto. As long as they weren't considered "objects" it was okay. In making these works there was a sense of relief: no equipment to drag into the studio and set up. No props or lights or electronic stuff to figure out. I could just go to work.

In these first drawings, which were all made on typing paper using a #2B pencil (the most rudimentary method and material I could think of), I had an idea to sabotage style. I could be Thurber. I could be Chester A. Gould, or Matisse, or Norman Rockwell. I thought of it as a strategy to subvert anticipation, to sneak up on the viewer.

With painting there is a lot more baggage. Style isn't so much an issue, it's more a search for a suitable subject. Painting has so much weight. A painting may take two or three people just to pick it up and haul it away. With drawing you just turn the page and it slips out of sight. Clipper ships are suitable subjects. What else? Bottles, guitars, nudes. . . .

In my painting I couldn't pick up from where I left off, Day-Glo Stella. So I went back to my high school days for inspiration, to a time before I learned all that other

stuff that led me astray in art school. Back then I dreamed of one day having the job of illustrating the Breck Girl as seen in almost every magazine ad in the '50s. She was so beautiful that only the best artist would get to paint her, I was sure. I had made more than one pencil sketch of her in when I was fifteen or sixteen. In art school I learned not to concern myself with her. In my return to painting I thought she might be the right subject, so I painted her and included some other simple things that for me represented innocence: a log cabin, my class picture, and a letter from me describing the painting, ending with the sentence "I am more than happy with it."

I raided a Jon Gnagy how-to-paint book for other ideas, changing his compositions slightly. My biggest source was my favorite boyhood encyclopedia, *The Book of Knowledge*, which as a child I was often daydreaming with. These paintings really reflect my childhood. I was obsessed with my bedroom wallpaper. Why wasn't the pirate's mustache on the pirate? Why do the sails on the ship float in space, disconnected from the mast ? These questions still drive me today even though I know the answers.

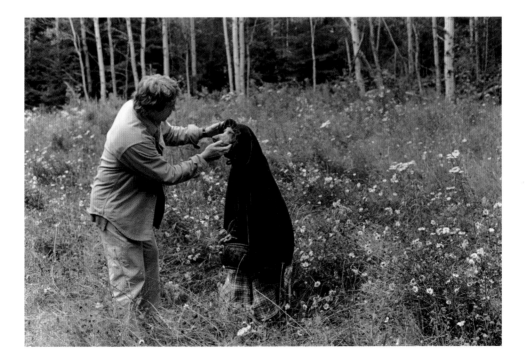

Wegman with Batty, 1992

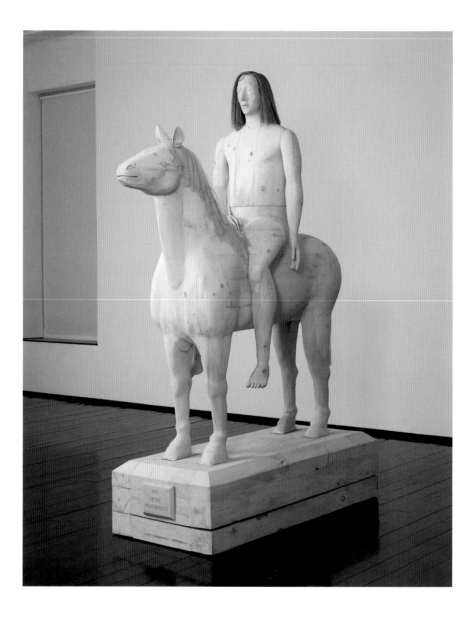

Born 1948 in Philadelphia. Lives in New York

JUDITH SHEA

Selected Solo Exhibitions
"Judith Shea: Monuments and Statues." Whitney Museum of American Art
at Philip Morris, New York, 1992
"On a Pedestal. Judith Shea: 'Public Goddess' and Other Works."
Laumeier Sculpture Garden and Park, St. Louis, Missouri, 1991
"Horizons: Judith Shea." Nelson-Atkins Museum of Art, Kansas City,
Missouri, 1989

Selected Group Exhibitions
"Twentieth Century American Sculpture at the White House." Exhibition V,
The First Lady's Sculpture Garden, The White House, Washington, D.C., 1997
"Art and Fashion." Guggenheim Museum SoHo, New York, 1996
"Ideas and Objects: Selected Drawings and Sculpture from the Permanent
Collection." Whitney Museum of American Art, New York, 1994

Inside Venus [1990] roughly replicates the Venus de Milo—except that she has an extended arm and she's holding a dress. For me, this piece brought together qualities of my earliest work, which was in cloth, and my work in bronze. These pieces are a continuation of my interest in the kind of sculpture that I was essentially taught not to look at, without that being said in so many words. I was an art student in the late '60s and early '70s, the height of Minimalism, which in a sense was the high point of modernism—or the endpoint of modernism, let's say, the end of a whole notion of thinking about a reductivist, abstract approach to form. The kind of statuary that one of my favorite art historians, Robert Rosenblum, has discussed was essentially not shown to us, as if it would somehow ruin our vision. But I somehow found my way to this work, initially through books and then through travel, and I thought, "This kind of statuary is actually so rich in ideas and technical devices, particularly for sculptors."

Monumental equestrian statuary usually honors or is a memorial to a figure known for heroic accomplishments, often military, sometimes political. To the modernist ethic or aesthetic, I would say, it's the most taboo form. I went to it immediately. It was the one I most wanted to tackle because, in my natural, quiet perversity, it was the most thrilling one to wrestle with. This horse piece, *No More Monument* [1992–93], is meant to be the antithesis of that kind of statuary and what it's meant to portray. Part of why I was trained not to look at that kind of work is that it really isn't appropriate to how we are, psychologically and emotionally, in our times. If you think of what's truly monumental in our aesthetic experience, it's probably the gigantic talking heads on a movie screen. There are gigantic monumental paintings too, but if you're working with the figure, and you're working with the kind of emotional content that I'm interested in, gigantic abstract paintings don't say enough. Neither do gigantic abstract sculptures—or rather they have power and meaning of a different sort. I consider sculpture the dinosaur of art forms at this point. In a perverse way, that's just why I stay with it.

So gigantic talking heads on a movie screen have good narrative ability and are truly monumental. At one point I found myself analyzing, "What is it about them? What are they doing?" I did a lot of thinking and reading about that, and about how you can turn on your TV in the middle of any day and see Americans sitting being interviewed by Oprah, Phil, or Geraldo, and essentially telling all. This is what we care about; this is what we're capable of in our postpsychoanalytic period. There's no code by which all of us live, so we can't use metaphor much any more to communicate. Then how do you take equestrian statuary, an essentially nineteenth-century motif and form, and get out of it a post-twentieth-century narrative and emotional meaning?

I would describe these recent works, in a simple way, as unheroic monuments. That was the task I set for myself. Essentially I started out with this guy, a sort of businessman at the end of the twentieth century. That figure depicted more of the essence of living in our times than a military hero would. In the piece called *Post Balzac*

[1990], for example, my thinking was, "If Rodin's Balzac represents a late-nineteenth-century optimism of what the twentieth century could bring—a writer—then my piece, for me, represents what we feel at the end of the twentieth century." We feel the opposite: not totally pessimistic but existential. We've begun to destroy our actual physical world. All the technological promise of the twentieth century brought with it tremendous problems that we now have to address.

So the notion of an equestrian statue with a businessman on it seemed interesting to me as a starting point. But then I felt that the businessman was too limited. I was very interested in the idea that this was a male rider, not a female one. I was also reading literature about the idea that it was time for a men's movement, which was to be about emotional issues rather than business networking or whatever. I started thinking much more compassionately about the notion of depicting a man not as heroic but as in transition, perhaps wounded by having striven for goals that now are in transition themselves.

The female hero in *Object* [1991] is doing it differently. As a woman, I think, we traditionally make ourselves like objects in a certain way. More than men, we change ourselves if we don't feel beautiful enough. Putting on a face—in a certain way that's like making art. When I was working on these pieces I had just begun to work with heads. For some of them I make clay studies first, so you take a lump of this clammy stuff and work and work and work; or else you take a block of wood and you cut and cut and cut. Then suddenly somebody's looking back at you. It's a very peculiar experience. Are you going to make it beautiful? If so, by what standard? Do you want it to look like somebody you know? It's not exactly a portrait, but what figurative art so often gives back is the presence of a person. It's this funny thing, it's an object but it's a representation of a being. There's a kind of overlay. So those were the thoughts and feelings that made this piece. Again, I liked the irony of putting her on a pedestal, in the tradition of monumental or portrait statuary. In that tradition, I was wondering who she was like in the female realm. I thought of the Statue of Liberty, another woman on a pedestal; of Joan of Arc, a female equestrian; of Venus and of Nike. Again it's this overlay of twentieth-century thoughts and feelings and nineteenth-century or classical sculptural devices.

After I made this piece, I felt sure that there was a male version of the sentiment, but that obviously it needed to be different. For a woman, the riskiest way to request love or approval is essentially to say, "I'm not an object; there's more to me than that." For a man, it's to say, "I'm not a hero; I'm a human being, and I'm more vulnerable than the role that's been handed to me." So this is how *Him* [1992] came about. I think the risk is grander for a man, in a certain way, because of how we've all been raised and trained. So he's got a grander pedestal, and it reeks of tradition. It's a Doric column that I had fabricated by a column company. I felt that the taper of the Doric gave it anthropomorphic qualities. It's my dream to complete my obsession with nineteenth-

century statuary with a kind of rotunda of statues, not politicians but the characters that people our world, whether they're accurate portraits of particular people or more the people who carry the qualities of what we live through in our time.

Artist [1992] is really my interpretation in a more general way of some of the experience of being a woman today, and particularly a woman artist, and particularly a sculptor. The hands are probably the most obvious symbols in the piece. One hand is open, for the receptivity that's needed to be an artist. You have to be receptive to the world around you to understand and interpret it. The other is clenched, which is about the determination you also need. The dress is very female, somewhat sensual, tight fitting, whereas the head is bald, as if exposing the brain, and representing clarity and efficiency. I made her barefoot, which is about being human and earthy.

A lot of artists are working with the idea of breaking down the existing gods and goddesses, the pantheon of sculpture, whether in the recent or, in my case, the farther past. I came to this not out of a desire to tackle that particular issue, or to be perverse. It was more an outgrowth of the fact that I had three simultaneous educations. I studied fashion design, then rejected that field. I began working for a BFA at night, and I had a job during the day at the United Nations, working with folk art. So finally I have this three-tiered education . And I learned to love folk art, which included clothes, textiles, carvings, and everything else on an equal plane, at the same time that I was studying art history and beginning to meet contemporary artists. I was always pondering, "Why is one considered fine and the other something else? Where do those lines get drawn?" So I didn't have that kind of stratification in my mind. Ultimately that was an asset for me. And making these works is so much like doll-making, which was my earliest artwork. In an emotional way, they go back very far, and include so many of the things I've done.

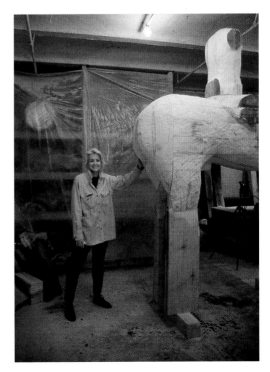

Shea in her SoHo studio working on *No More Monument*, 1992

Born 1950 in Bridgeport, Connecticut. Lives in New York

JANE HAMMOND

Selected Solo Exhibitions

"Jane Hammond." Weatherspoon Art Museum, University of North Carolina,
 Greensborough, 2003
"Jane Hammond: Backstage—Secrets of Scene Painting." Whitney Museum
 of American Art at Philip Morris, New York, 2002
"Jane Hammond: The John Ashbery Collaboration, 1993–2001." Cleveland
 Center for Contemporary Art, 2001 (traveling)

Selected Group Exhibitions

"On Paper: Masterworks from the Addison Collection." Addison Gallery
 of American Art, Andover, Massachusetts, 2003
"Picturing the Modern Amazon." The New Museum, New York, 2000
"Anxiety and the Irrational: Selections from the Permanent Collection."
 Whitney Museum of American Art, New York, 1995

JANE HAMMOND March 22, 1993. Studio, SoHo

One of the things I think is confounding and difficult for an artist, or that I've found so, is that there is a certain pressure on you—I don't mean a commercial pressure but a sort of aesthetic pressure—to formulate something you might call a style. Usually this thing that we call style has to have a certain focus about it, and therefore by definition a kind of narrowness. And I think, on a dumber and more pragmatic level, that one of the things I saw around me in the mid '80s in New York was an increasingly narrow definition of style. I would go to galleries and I would see what I felt were ten versions of the same painting. Then a year or two later I'd see a little tiny variation. A lot of these people were making work that I was interested in, and that I thought was a valid way to paint at the time, but I would say to myself, "How do you stay in the studio every day and make these stripes all day long, or make this gray rectangle that's a little bit over to the left with two dots next to it?" How do you keep art, which is supposed to be open, investigative, exploratory, risky, deep, complicated—how do you keep it that way and at the same time formulate a style?

The artists I'm most deeply in love with are people who are particularly open: John Cage, Duchamp. Duchamp would ask a question with a work of art, and once that question was asked he'd leap to its obverse, or to a totally different question. So one work wasn't a refinement of the work that came before it, or a variation; sometimes it was a complete contradiction. Even the readymades Duchamp made only twelve of, he didn't make a lifetime practice of them. But you're supposed to have a style, and there's a contradiction, in my mind, between style and art. I think one of the things that's interesting about art is that it holds all these aspects of yourself: your intellect, your autobiography, your emotional life, your sense of humor. It holds all these things about you, half of which you're helpless to keep out of it.

I've always been interested in information. When I went to Mount Holyoke I went to be a scientist. I didn't have a deep interest in art. I came from a conservative family. Also I thought that art was about replicating the appearance of things, and I was never interested in that. But I've always been interested in factual information. When I was a kid, I made grids on our property with stakes and string, the way a surveyor would mark off land, and I'd identify everything inside the grid, like rocks and trees, and grubs and birds, and list them in notebooks. I spent a lot of my childhood with my grandmother, and she and I would collect things like shells, only we'd go to the beach at four in the morning with flashlights if low tide occurred at that time. And we'd press four-leafed clovers in dictionaries, things like that. This whole idea of selecting, reaching out, and bringing all these things together, this notion of collecting, was very appealing to me. I've also always been interested in associative thinking: I'm interested in the nature of language, and in the relationship between language and consciousness itself. Out of all of that has developed this body of work.

The trouble with speaking on your work is the better you are at that, the more logical you make the work's development seem, and it's only a quasi-logical thing, slow

and somewhat organic. Anyhow, in about 1985 I noticed that I'd been making work using a lot of different information culled from a great variety of sources: bee-keeping, medieval literature, magic, children's drawings—smart, dumb, Eastern, Western, adult, child, science, art, pseudo-science, etc. I had this burgeoning antistyle notion in my mind, and this interest in language, and I was taking in all this information, and I decided that what I was going to do was figure out some way to have a system instead of a style. So I kind of mentally drew a circle around 276 pieces of information. Some of these things you might want to call images, but some are things we don't have a word for, they're very abstract, and they fall into a variety of categories. I chose 276 things from different places, largely things I had already been using less systematically for a while, or that I had in the house in folders and Xeroxes. I supported myself for ten years by teaching in Baltimore three days a week while I still lived in New York. The two nights a week that I spent there I would spend in the library at the school. I would read through books and Xerox them. I don't know if I would have done that if I'd been independently wealthy, or if I taught down the block from home, but that's what happened.

So I decided I'd have these 276 pieces of information, and intuitively I knew that I'd have this circle of things and I would let it radiate out in a lot of different ways. Intuitively I also felt that there had to be some other parameter; so I said to myself, I'll restrict the palette, and I chose red, orange, yellow, blue, black, and white. And then I said to myself, I'm going to take these 276 pieces of information and these six colors, and I'm going to let myself make any kind of painting I want. So if we were to take a walk together through an imaginary museum, and you were to see every painting I've made out of this system, you would see paintings that you would swear were completely nonobjective, paintings that were completely simple, paintings that were wildly complex, paintings including words, paintings with only words, paintings without words, paintings with flat space, paintings with deep space, paintings with figures, paintings with no figures, geometric paintings, squishy, messy paintings, etc.

There's nothing magical about 276. I'm not into numerology. Intuitively I knew that what I was after was some kind of recombinative structure, like DNA, and I think I knew that if I had twenty images it would repeat too patly and it would seem too simple, and if I had 4,000 images it would appear like chaos for the next ten years of my life and I wouldn't be able to deal with it. So maybe 276 was about the right order of magnitude. In the beginning I felt like I was the architect or the policeman of this system, and I was extremely self-conscious about it and wrapped up in it. After two years, I felt like I could think in these terms.

I only make paintings when I have ideas for paintings. I have no notion how these ideas come; they literally pop into my head, like a slide in a projector. Even though I have this system, I rely on this intuitive starting point. In the case of this painting with the man in underwear and the burning snowman [*Untitled (156, 251,*

121, 116, 55, 227, 231), *1993]*, I was literally lying in bed in a hotel in Milan and I pictured this painting. That doesn't happen to me twenty times a day, and I wouldn't even want to say out loud that it happens to me twice a week, because maybe God would punish me, but it does happen every once in a while, thankfully—often enough that it keeps me working.

When I start the painting, I don't ever know what the meaning is, I don't know why it's important, I just come to trust that the things that occur to me at night while I'm lying in bed are real. I say to myself, "This is a painting idea," and I find my glasses and kind of drag myself up and make some notes about it. In a fascinating and ever deepening process, what happens to me is, as I make the painting, or after I finish the painting, or sometimes a month after I finish the painting, I realize why the idea came and what the painting is about. I wouldn't get that insight if I didn't make the painting, so the painting, for me, is a process in which I get to access something that I couldn't access but for painting it. Painting is like a tool for self-knowledge. Maybe it sounds kind of corny to say that today, but that's how I see painting.

Hammond in her studio, early 1990s

Born 1928 in Excelsior Springs, Missouri. Died 1994 in New York

DONALD JUDD

Selected Solo Exhibitions
"Art + Design: Donald Judd." Museum Wiesbaden, 1993
"Donald Judd: Architecture." Westfalischer Kunstverein, Münster, 1989
"Donald Judd." Whitney Museum of American Art, New York, 1968

Selected Group Exhibitions:
"Qu'est-ce que la sculpture moderne?" Centre Georges Pompidou, Paris, 1986
"Critical Perspectives in American Art." American Pavilion,
 Venice Biennale, 1976
"Primary Structures." Jewish Museum, New York, 1966

I've had this building for a long time, it's hardly ever had so many people in it. This floor has had exhibitions by myself and by other artists. Ordinarily this is sort of a casual studio, things coming in and going out. The upper floors are partly studio, partly living, so it's a studio and a living space, but I also consider it sort of the last gasp of the situation in New York with Jackson Pollock, Barnett Newman, Mark Rothko, and all those people, and then of my own generation. The whole building is intended to stay exactly the way it is forever. When you see what's happening to the SoHo area, and what they're doing to the buildings, this building I think is important as an example of something serious done in its own time. So it's intended to be this way. The building was built in 1870—the architect was Nicholas White—so it's a little bit earlier than most of the buildings down here. It's also the only one by Nicholas White.

I have a number of architecture projects in Europe. I take it for granted by now that I've settled in as an artist, but the architecture is relatively new, and is becoming very serious, with a wide scope. I'm the coarchitect on the new part of the railroad station in Basel, I'll probably build an archive and office for a new museum in Austria, and so on. (The railroad station, of course, comes with a developed architectural firm; they have forty people full-time on this, plus there's a whole other firm. I worked on the building I have in Switzerland with a young architect there, so he did a lot of the work on the spot and in relationship to the carpenters and plumbers. In Texas, a lot of people have their hands in it.) So the architecture's a serious enterprise, the writing is a serious enterprise, and so, of course, is the art. The architecture came about in a very natural way, very early on. Furniture to me is part of architecture, and the furniture I've made came about partly in relation to the installation of the art, partly because there was no way to buy anything I wanted to have. I made the first pieces for myself, in [Marfa,] Texas, because there was nothing whatsoever to buy, and it slowly developed in a very normal way. There's a lot of different kinds of furniture now: metal furniture, very well-made wooden furniture, well-made but cheaper plywood furniture. I don't like anybody else's furniture now, but I do have a lot of Reitveld furniture and Mies van der Rohe furniture and Breuer and Hoffman.

History's constantly warped by various people; I thought Ad Reinhardt and Barney Newman were a little excessive in worrying about history, but if you've been around awhile you do see bizarre histories, and then you get irritated. Actually I was almost the first person to use color in so-called "sculpture." John Chamberlain is prior in some way, and there are various connections that could be worked out, but I assumed my work would have color. I never thought otherwise, because I was a painter; I had no training in chopping marble or wood or anything, and always thought that was probably a horrifying thing to do. I think color is very important, and it's been very important to a lot of artists. It's a very, very big aspect of twentieth-century art, one of the biggest developments, though it's ordinarily not thought about very much.

Untitled. 1992. Purple Plexiglas and stainless steel, ten units, each 6 1/8 x 27 x 24", overall installation 10' x 27" x 24"

So color has always been very important to me—my work began colored. And it's not that these works don't have color, it's that they're just one color. As far as being sensuous, to me that's dividing something, taking one aspect. Philosophically I'm very much against the division of thought and feeling, and to use an adjective like "sensuous" is to me already splitting it up. As far as being sensuous in an ordinary way, that's just fine. That always is. But the early ones had lots of color and they still do.

I've said this one million times and I hope the recording is working to hear me say it one million and one: "Minimalism" was a derogatory term that someone coined. Barbara Rose gave "ABC" a try, and that was derogatory. The "Primary Structures" term was not meant to be derogatory, but it was very misleading: there is no such style and there was no such group. It's very easy to find out there wasn't a group. I hardly knew Robert Morris; I met him in March or April maybe of '63. I had a show at the end of that year, so I didn't have anything to do with Morris's work. Also his work comes out of Duchamp. I knew Dan Flavin for about a year prior to that and I didn't know him well. And there was no discussion. There was no group. Sol LeWitt is many years later. Carl Andre I met because he was a friend of Frank Stella's, but he told me on the street, walking along, that he carved things out of wood, and at that point he was also flirting with my then wife, and I stopped listening to Carl. Three or four years passed before I had any idea what he was doing, when he finally had an exhibition.

That's the so-called "Original Minimal." Since then, half the world has become Minimal, but that's just more publicity. Now Stella's considered a Minimal artist, and so are a whole bunch of painters—so in no way was it a group. These people didn't know each other. The idea of a Minimalist movement is a very careless falsification of the history. At any time you're going to have certain correspondences between the best artists, which is ignored, too. People don't talk about that and that's a legitimate thing to write about; you can say there are certain things in common between me and Claes Oldenburg, say. But I naturally feel I'm an independent artist, and I don't like suddenly disappearing into some group that I consider to be nonsense.

To make more pieces, we have to sell pieces. I would like to keep everything except for the fact that in my case, if you think about one piece, you've thought about a dozen, and it would become preposterous to keep all of them. So there is a natural overflow, but basically, except that we need the money, I'd prefer that these works were in Texas. Well, the art business is not so good now, and the happy thing about that is you get to keep more pieces. So I have a lot. I have almost all the first reliefs, almost all the paintings . . . almost all of the first three-dimensional pieces are in Texas because no one was interested in buying them. And I'm, as usual, worried about the rent and such things, but now we have them and they're permanently installed in Texas.

Being an empiricist, I'm a little down on ideals. I never understood perfection, and I'm still trying to figure out what "pure" means—they jumped on Ad Reinhardt

for being "pure," and I've never understood what "pure" was. I think it's a very strange word. It's something that needs to be traced. Elaine de Kooning wrote an article against Reinhardt calling him "Mr. Pure," and I don't know—is she "Ms. Impure"? People are very free with the word and I don't really quite know what it means. I suppose it comes out of Plato.

I probably have a pretty definite philosophy and I take philosophical ideas, political ideas, social ideas perfectly seriously. And as you can see, for thirty or forty years, the ideas in my work haven't changed too much. And that's what I intended in the first place. I wanted something that would develop naturally without being forced, and it changes on its own or as I go along. I don't expect a great contradiction at some point. There won't be a big revelation and I go to Rome and meet the Pope.

Judd's first-floor studio, 1993

Born 1949 in Brooklyn, New York. Lives in New York City;
Ancram, New York; and Geneva, Switzerland

TERRY WINTERS

Selected Solo Exhibitions
"Terry Winters/Printed Works." The Metropolitan Museum of Art, New York, 2001
"Terry Winters." IVAM Centre Julio Gonzales, Valencia, 1999 (traveling)
"Terry Winters." Whitney Museum of American Art, New York, 1992 (traveling)

Selected Group Exhibitions
"New York Renaissance from the Whitney Museum of American Art."
 Palazzo Reale, Milan, 2002
"Celebrating Modern Art: The Anderson Collection." San Francisco Museum
 of Modern Art, 2000
"The American Century: Art & Culture 1900–2000. Part II: 1950–2000."
 Whitney Museum of American Art, New York, 1999–2000

TERRY WINTERS April 14, 1993. Studio, TriBeCa

I was drawing a lot last fall, and at some point I decided to use the drawings as a way to generate paintings. My drawings and paintings have always had a relationship, but I thought it was important that the drawings were the drawings and the paintings were the paintings—I tried to avoid that classical activity of turning a drawing into a painting. Paradoxically, though, I found that using the drawings to structure the paintings, or as blueprints in making the paintings, freed the paintings to be more themselves. I could concentrate more on aspects to do with color and material that I felt were particular to painting itself. *Event Horizon* [1991], for example, came out of a very small ink drawing. It was a surprise to me that the drawing freed me up to take the paintings in directions I had always thought about but somehow couldn't quite manage to do.

One quality I was made aware of by looking at the recent show of my work at the Whitney ["Terry Winters," Museum of Contemporary Art, Los Angeles, and Whitney Museum of American Art, New York, 1992] was how I was taking structures that interested me and trying to see how they could function within the painting. Something about the experience of that show made me realize that my relationship to those structures, to that kind of imagery, was now as much a part of my vocabulary or syntax as was my sense of the way that I wanted to use material. Painting has a peculiar characteristic of being made out of raw material that has no features. The way that material is pushed around, and somehow crystallizes on the surface of the canvas or paper, is one of the magical aspects that painting possesses.

In any case, having worked with these drawings from the fall, I decided to use some drawings I made last spring as a basis to develop other works, whether drawings, prints, or paintings. Each drawing is really done to be a drawing, but within the drawing some other aspect might need to be revealed or exposed. There's something about transcribing a drawing and changing it into a painting. Subjecting it to different stresses of material and color ends up revealing aspects of meaning that were contained in the drawing but only get exposed through the process of making them into a painting. I began to see the drawing activity as a way of excavating or engineering form. It was a place I went to design images that seemed to have some significance for me, that functioned as a kind of hieroglyph. The process of transforming those images into paintings ended up bringing out characteristics of the images that I wasn't aware of in the drawings themselves. I began to see the process of making paintings in relationship to drawings in almost a computer-graphics sense, the way that computer visualization systems can bring out hidden possibilities contained within an image. I felt that I was turning the dials and seeing what kinds of meanings were unleashed through the process of making the painting. It seemed a new way, and at the same time a very classical way, to push the imagery further.

This past summer I did a group of fifty-six drawings over twelve days, all on the same cotton-and-banana-leaf paper but done with pencils and graphite sticks of

different degrees of hardness or softness. They were done as a problem of addition, in the sense that I just kept drawing—I made no erasures, I just kept trying to push the images further until the drawing had a sense of completeness for me. So some of these images became very dense, even almost completely black over the entire surface.

I'm now working on paintings coming out of this group of drawings. I take aspects of either one or many of the drawings, sometimes combining a number of drawings in one painting, trying to push the imagery I developed last summer and see what happens in opening these forms to a more arbitrary range of color and a wider range of material. Like in the painting *Swap=diagram*, shifts of emphasis take place through this transcription that I could never have predicted. Having the drawing as a blueprint has let me open up my relationship to these pictures.

I'm trying to work intuitively, irrationally or *a*-rationally—in a preconscious way but within a theoretical framework. I want to build a structure within which I can do the real work, which isn't rational. I think there's a compulsion to picture something, to figure something out by making a picture of it—which is where there's an affinity with outsider art. On some level everyone making art has to get in touch with that drive, because otherwise there's really no reason to do it. I don't think you can construct a very civilized idea about this activity that can sustain you on a day-to-day level. It has to come from someplace inexplicable.

I'm taking in information, synthesizing it, and putting it out. Everything starts from something specific that's seen. Then it gets respecified through the activity of making the painting and the drawing. I have a lot of source material—photographs, drawings, things I've found in books. These aren't things I make up, but in some way they end up being products of the imagination: I take in primary and secondary source material and somehow collage it all together, through my own thought process and through the activity of making the work. But it's more synthesized than it used to be; the relationship to the outside world has become more difficult to make out. It's harder to graft a simple kind of meaning onto the pictures now, they seem more declaratively invented. Whereas some of the earlier work now seems to me more analytical.

I've always had an interest in process, in the making of things. At one point I was making my own paints, figuring out things about their elementary structures. My interest in structures also had to do with primary or elemental units. Although I wasn't trying to depict those things, the forms of the paintings had analogues to structures on a microscopic or a macroscopic level.

Arthur Dove and Georgia O'Keeffe and that whole group of American abstractionists weren't people I ever looked at. I was more a New York kid who grew up in The Museum of Modern Art, I thought it was all Picasso and Matisse. The Abstract Expressionist generation, and how, through European art, they came to a very physical representation of mental form, is really the place I discovered things, more than earlier American examples. They were the first American contemporary artists I was aware

of, before I was even in high school. There was something about their achievement that everything needed to be measured against in terms of its scale and ambition. I think that's still true for anybody making paintings. The kind of declarative space that Pollock, Newman, and de Kooning invented, where there's a one-to-one relationship between the viewer and the painting, seems particularly American. And it's still, I think, the condition of painting. I know the art world is based on there being some kind of turnover of the cultural mill each season, but these are still new ideas; we're talking about something that's only forty years old. Abstract Expressionism came to a really new conception of space, the way we perceive space, and the psychological meaning of form.

The condition of artmaking now is such that there are many ways for people to work. That seems healthy to me; it's good that there are people doing film or video and installation art, as well as painting and sculpture. Forty years ago most artists were making painting and sculpture. Now there's a wide range of avenues that people can explore in order to say different things.

It's difficult to argue with people who want to turn art into problem-solving or criticism, but for me, while those things have very valid applications, they don't really belong to the process of artmaking. I'm not particularly interested, either, in the kind of expressionism or neo-expressionism whereby the image functions only as an extension of somebody's feelings. Things seem more complicated to me than that. Although the artwork is an outgrowth of one person's particular vision, the work that continues to hold interest for me somehow suggests larger territories. That's still the only way into whatever this mysterious place is that I want to get to, through an individual. I guess I think of expressionist art as a place where the artist is too present. I tend to like art where the viewer is left with his own experience of the work.

Drawing is a very private excavation of form. Painting is both more public, or more socialized, and more physical. But for me it all starts in drawing.

Winters in his studio, 1991

Born 1945 in New York. Lives in Watch Hill, Rhode Island

TINA BARNEY

Selected Solo Exhibitions
"Tina Barney: Les Européens." Rencontres d'Arles, Arles, 2003
"Tina Barney." Museum Folkwang, Essen, 2000
"Tina Barney." The Museum of Modern Art, New York, 1990

Selected Group Exhibitions
"Stepping In & Out: Contemporary Documentary Photography."
 Victoria and Albert Museum, London, 2002
"Making It Real." Traveling exhibition organized by Independent
 Curators International, 1997–98
"Family Lives: Photographs by Tina Barney, Nic Nicosia, and Catherine
 Wagner." Corcoran Gallery of Art, Washington, D.C., 1994

I grew up here in New York City and married at twenty. When I was twenty-eight I moved to Sun Valley, Idaho, with my two sons and my husband to start a new life. I was already very interested in photography; I'd started to collect in the '70s, when not many people had done so. I moved out to Idaho thinking I'd left art, culture, and everything else behind, except for skiing. But there *was* an art center in Sun Valley, and that's when I started learning how to take pictures and print them, and learned about photography's history.

I noticed a big difference between Idaho and my life back in New York City. I was terribly homesick. I took most of my pictures when I came back to Watch Hill, Rhode Island, in the summer. I missed everything about summer, the East, tradition, etc., and I started making black and white photographs that I printed myself to mark this place that I was so fond of and missed so much. The architecture of the houses, both outside and in, was very important to me. So I went around with my 35-milli-meter camera just recording this place that I realized is very special.

There were traditions; you'd hear stories. My children's grandmother would talk about a soda fountain where my husband went as a child. Now I was bringing my own little babies to this very same place. Even though I was quite young, I realized there was something about these traditions and rituals that did not exist in the West. The people from Idaho, and the Californians I met, would ask about these traditions because they didn't seem to have them themselves. They were really surprised that I'd go back to the same house every summer.

So I also started taking pictures of ceremonies and rituals that even today, twenty years later, are exactly the same. This tradition of taking down the American flag—I just think it's wonderful that people make that effort. (I also was influenced by Robert Frank, who had the American flag in many of his photographs.) I would cut the heads off people in my photographs because I didn't want these pictures to be portraits but rather to be about the gestures, attitudes, the spaces between people. I also thought about the gestures characteristic of the East Coast, that perhaps came from going to prep schools where everybody put their hand in their pockets the same way.

In 1979 I started printing in color. My sensibilities for color were inborn—they're very much East Coast colors. I also thought about the structures of the photographs, and I looked at the Italian and Flemish painters.

I was interested in the relationship between children and adults, and the respect or disrespect between them. At the time I felt the American family was disintegrating; subconsciously I was obviously thinking of my *own* family. I was very concerned about that, and wanted to bring families closer together. Without realizing it, I was separat-ing the picture down the middle structurally and having a kind of diptych. There was a narrative I had in my mind. For instance, in *Sheila and Moya, Hawaii* [1980], the tree down the middle was important to me. The child is in the middle, the father is looking away from the mother, the mother is walking away from the father. I was thinking

The Trustee and the Curator. 1992. Chromogenic color print, 28 ¹/₂ x 36 ¹/₄" 127

a lot about the indifference of husbands toward wives, and the child down the middle, splitting that problem. I thought about the nest, how families come to the beach and search around to find their own little space.

Each year I would explore a new subject matter. I was still living in Idaho, but I would come back east and I started thinking about the upkeep of the house. I was always amazed that people keep fixing up their houses, and I thought that maybe the upkeep of the house tends to keep the family together. The family may be growing apart, but the wife might say, "Oh, honey, don't you think we should paint the room?" That activity may keep them together. So I started photographing the interiors of the houses I knew because I thought they were beautiful. I just had this feeling they had to be photographed.

It was around this time that I started putting my camera on a tripod and making the photographs bigger. I had to start photographing the people who belonged in these houses. It took a lot of courage to put people in the pictures, a lot of presence. To this day I need a bit of courage to do it. I began using a four-by-five-inch negative because I wanted this beautiful quality when I enlarged my photographs.

I guess, as an artist, it just takes time to come to the point where you have a specific thing in mind. In 1982 I made *Sunday New York Times*. I knew this family well; they were interested in photography and they were also great hams. And I just walked in there—I knew they hung out on Sundays reading the Sunday *Times*. Again, the palette is very much a part of my style, and also the spaces between people and how they relate to each other. I knew I wanted the father at the head of the table, but I wasn't directing very much, it was something that just didn't enter my mind. I directed only in the fact that I said "Hold still." (I was using long exposures at this point because I wasn't using any lighting except daylight.) And sometimes I might say, "Can you bring your feet out, Mark, and touch Tim's feet there."

In time I slowly started directing, saying, "Look at the camera, get on the phone." I started having fewer people, making more decisions—where the camera was, its height, how to bring the eye into the work. I wanted to have more eye contact, or more expression, from the subjects in my pictures—more of a narrative about their feelings, how they felt about each other.

I began to think more about directing people, controlling them. When I shot in a room colored apricot peach, I thought, Why not ask the mother and daughter if they had clothes that color? I also thought about sociological connotations—how the mother and daughter happened to have the same color clothing because, of course, Calvin Klein made clothes that color that year, and everybody ended up in the same thing. But there was also the fun idea of having them look like they're on the same team.

In 1989, I realized it was time to put myself in the pictures. That was a big decision to have reached. Just formally, what do I do? Where do I stand? Now I have to start acting like the people I've been telling what to do. Plus I have to think of

all the technical stuff, run around—but basically the most important question is, What am I doing here? And what do I want to say that's not forced and controlled? And I decided to show the cable release in my hand to show that I was taking the picture at that very moment.

My teachers were all the best photographers in America—and they were *terrible* teachers. I'm amazed I didn't get discouraged. But I would go back to Rhode Island every summer and take pictures the whole summer. I didn't realize that was happening, but when I looked at the work I did in Idaho, there was nothing there. Idaho was foreign. The colors were foreign to me. There was no age. There was no quality of texture. I didn't realize this for a long time, but there was nothing there I could relate to. And I realized that this home in the East, this background, this history that I had, was unique.

Making these photographs took a lot of courage. I remember a friend at the time said, "Do you realize what you're revealing, this private life?" At first I never thought the public would see it, and then, as the work got more and more recognized, I just kept on doing it.

Barney at work on location, 1999

Born 1930 in Falenty, Poland. Lives in Warsaw **MAGDALENA ABAKANOWICZ**

Selected Solo Exhibitions
"Abakanowicz on the Roof." The Metropolitan Museum of Art, New York, 1999
"ARC." Musee d'Art Moderne de la Ville de Paris, 1982
Polish Pavilion, Venice Biennale, 1980

Selected Group Exhibitions
"A Century of Sculpture: The Nasher Collection." Solomon R. Guggenheim
 Museum, New York, 1997
International Exhibition for Contemporary Sculpture, Fujisankei Biennial,
 Hakone, Japan, 1993
"Kunst Wird Material." Nationalgalerie, Berlin, 1982

I'd like to concentrate on space, an important part of my work from the beginning—maybe because I *had* no space, maybe because space meant freedom.

Butterfly [1956] was one of my first paintings after I finished my studies at the Warsaw art academy. It was enormous, about twelve or fifteen feet. Poland then was not repaired after World War II and the Communist takeover. It was a nervous time for me—I felt as if I were looking through a window to a strange reality, a different reality from everyday life. *Butterfly* is flat but I see it as my first environmental work. *Fish* [1956] belongs to the same series; it too is very large. It was never framed, because there was no space—I had no studio—so I made things that let me develop my dreams but that I could roll up so that they occupied no space.

My first works in space were three-dimensional woven pieces. The flexibility of the material was very important for me, and its reaction to wind and sand. The works were called "Abakans" after my name, and because nothing like them existed in the art of that time. This was the period of Minimal art, Conceptual art, and Pop art, so the "Abakans" were a protest against all the established tendencies. They reflected a need to express in an absolutely personal way, without following any trends, rules, or precedents.

These works were extremely important for me because of the special way of existing in my country: the enormous lack of living space. I had no studio so I developed my ideas in exhibitions. The exhibition room then became a space to meditate, like a still ceremony, a place where I could develop my vocabulary and what I had to say.

I traveled with my exhibitions around the world, to Australia, Japan, South America, many European countries. My first exhibition in the United States was at the Pasadena Art Museum [now the Norton Simon Museum] in 1971. I used woven material because of its inherent qualities, as I said, and also because I could roll it like a carpet, then develop it into an enormous and powerful sculpture and exhibition. At the same time, the pieces became personalities. They became a world in themselves just *because* they were an expression of a soft material, were something that couldn't be repeated by any other technique. But in art there is nothing to follow and everything to discover. I had to move away from the "Abakans," I couldn't continue to produce them. They were my statement, then I moved forward—different scale, different material. I had begun to explore my first casts of human beings. Groups followed, then big crowds.

The crowd of people—the expression of the human body in a group, in a quantity—became a problem I explored for many years. My life was made, was formed and deformed, by wars and revolutions, by the worship and the hatred of the masses. Finally these masses became like an obsession in my work. This was before the liberation of the socialist countries, and the work was seen as a critique of Soviet power behind the Iron Curtain. I had more than a hundred thousand visitors to an exhibition at the Múcsarnok Kunsthalle, Budapest, in 1988, because people identified with my pieces.

Two Figures on a Beam. 1992. Burlap, resin, and wood, 7' 1/2" x 8' 8 3/4" x 22 1/2"

Then I began dealing with the same problem in bronze. In 1992 I showed a crowd of thirty-six figures at the Walker Art Center, Minneapolis. I had been asked to inaugurate the Walker's new sculpture garden with an outdoor exhibition. Children treated the figures like trees; they'd just go up and sit on them. It was very nice, full of joy and pleasure—a great contrast to what the figures express.

Another series I worked on for many years was the seated torsos called "Backs." Each was made from a cast of a living person, then set in a group in which every example was different but all were similar in general shape and form. These groups resembled those made by nature, which manifests its creativity in its numberless masses—of leaves, mosquitoes, blades of grass—groups in which every member is individual, as if nature wouldn't or couldn't repeat an existing pattern.

The inside of the group is completely different from the outside. It is a space for contemplation, a space for meditation, a space that creates a view into reality. I would work at the foundry to create each group, outside and in. It was always a beautiful surprise for me when I put the pieces up. In autumn, insects accepted them the way they accept the bark of trees: they would settle on them and lay their eggs. There'd be little nests in summer. These pieces would become unique parts of the landscape.

My other sculptures I build by myself, in one-to-one scale. I attach enormous importance to the object's skin; I build the surface out of plaster, using my fingers— you can see their marks. There may also be Styrofoam, pieces of fabric, and other materials that let me get at the object's skin, its personality, its power of expression.

In 1987 I was invited to make a sculpture for the Art Garden of the Israeli Museum in Jerusalem. Seeing that the vocabulary of art in Israel lies in stone, I went to quarries looking for the right material. Finally I found it in the Negev Desert, near Micperamon, on the way to the Red Sea. I asked the family that owned the quarry whether they could give me this stone; they said, "Yes, of course, it's very easy, we can just take it out." The stone was really the surface of the desert. I worked there with them, drilling and forming the very basic shape of a wheel—an ancient component of human civilization, and a means of making wine and oil as well as of transportation. I made seven of these wheels. Walking through the work, you get something inexplicable from the stone, because of its reaction to light and because its surface is completely covered with fossils. This creates an atmosphere at the same time natural and unexpected.

None of these works is site-specific; I don't like that expression, because an artwork is limited by being fastened to one place. I believe that the work of art creates the space and the space creates the work of art.

Around 1990 I was invited to participate in a competition to extend the great Paris axis that runs from the Louvre to the Arc de Triomphe and then finishes at the Grande Arche de La Défense. The project was to continue this axis from the arch at La Défense to the River Seine through the town of Nanterre. Working there, talking

with the architects, and learning about the problems, I felt I had to find a vocabulary that would engage in a strong dialogue with the architecture of La Défense, which has a very strict, very dry geometry. So I proposed buildings like trees. They were to be about twenty-five floors high and completely covered with vegetation, growing not only from the base upward but from each floor. Every resident could plant vines and ivy, making the buildings completely green. Together these structures would create a microclimate oxygenated by the vegetation. Each building would be enveloped by a trellis system to support and irrigate the plants. At its top would be a swimming pool and recreation areas, and also devices to collect the energy of sun and wind, making the buildings self-sufficient in power.

The interiors of the buildings are not geometric. We live in geometric drawers without really wanting to; we feel much better in a space created more in relation to our bodies and movements.

My project was selected for further development, so one day it will happen. [The project was supported by President François Mitterand but abandoned after his death, in 1996.] This vertical garden can be seen as a solution for the crowding in modern cities, where there's rarely space for gardens. It is also a source of oxygen. And it lets everyone dream, and put a little plant on even the smallest balcony. This architecture creates the possibility of letting city-dwellers live among trees.

The most important quality of art is its metaphoric vocabulary, a language inexpressible in words. It means something different for everyone—this is its richness. When I exhibited at the Venice Biennale in 1980, the public asked me, "Is this Auschwitz? Or a Peruvian religious ceremony." And I could answer yes to both questions, because the work was about the human condition in general.

Creation is such a mystery. We are sometimes influenced by something we see on television—we can be influenced by anything around us—but only up to a certain point; every artist represents such a complicated inside world, and all this information is formed into a language specific to that person. Art comes from having not enough of one thing and too much of something else. This is why we have to express things in this irrational language.

Born 1933 in Dnjepropetrowsk, Ukraine, U.S.S.R.
Lives in Mattituck, New York

ILYA KABAKOV

Selected Solo Exhibitions
"Where Is Our Place?" With Emilia Kabakov. Russian Pavilion,
 Venice Biennale, 2003
"The Life and Creativity of Charles Rosenthal." Mito Museum,
 Mito, Japan, 2000 (traveling)
"The Palace of Projects." With Emilia Kabakov. The Roundhouse,
 London, 1998 (organized by Artangel, London, and traveling)

Selected Group Exhibitions
"Visions du futur: Une Histoire des peurs et des espoirs
 de l'humanité." Grand Palais, Paris, 2000
Documenta IX. Kassel, 1992
"Dislocations." The Museum of Modern Art, New York, 1991

In *School #6* [1993], at the request of Donald Judd, I transformed one of the barracks at the Chinati Foundation in Marfa, Texas, into a forgotten Russian school. That went very well with the idea of Marfa, which used to be a city of miners but when the mining ended the people moved out, so that now it is practically a forgotten city. The same thing goes on in Russia, where a lot of people leave country villages to go to live in cities. The villages have no more children and their schools are in the same abandoned condition that you see in Marfa.

So there is a schoolyard, which once had a lot of children running around and is now in complete disarray. There's no one there, everything is broken. There are some signs and posters left over, but no one looks at them anymore. Even the gates are broken. A strange thing happens there: everyone who enters the space somehow remembers his own childhood, his own school memories.

In the Russian Pavilion at the Venice Biennale in 1993 I made a total installation [*The Red Pavilion*] that was a complete reconstruction of the space, including floor, ceiling, walls, and everything inside: a creation of atmosphere. It was the kind of installation in which it is very difficult to say where the piece starts. In the beginning the public didn't understand that the entrance to the pavilion was itself an installation already. There was a fence that was part of the installation, and a lot of people just passed it by, saying "The Russians didn't finish," or "Construction hasn't started," because it had a lot of garbage next to it. We had an interesting problem with the garbage, because the president of Italy was supposed to visit the Biennale the night before the opening, so guards came and tried to clean up. We had to fight for this garbage, we had to stand guard on it.

Biennale visitors entered that dark space, with scaffolding all around and a lot of garbage, and they thought, "The Russians don't have any money and the pavilion is under construction." But all of a sudden they glimpsed a light from somewhere and heard music. And because everyone is curious, they would go toward the sound, toward the light, to see what was there. They would come to a terrace facing the Venice lagoon, and from that terrace they could see a little pavilion. Behind the pavilion was a fence, and coming from behind the fence was the sound of a parade in Red Square, in Moscow. Those tapes of music and sound were hard to find, because after *perestroika* the Russians destroyed all the original tapes of the Red Square parades. It was very patriotic music, nostalgic in some ways, but very happy, and altogether it created the atmosphere of a beautiful space. The lagoon was beautiful, and you knew you were in Venice, and there was a strange happiness coming from the pavilion, and from the sound. Understand that Russia today is under construction. Everything is either being destroyed or being built. Also understand that this little pavilion—which is so beautiful, like a piece of cake—stands there somewhere in the back of the big pavilion, but it's an era gone forever. Or else maybe it's just expecting its own time to come back—to return to the big pavilion and take over.

School #6. 1993. Permanent installation at the Chinati Foundation, Marfa, Texas

The installation *Ten Characters* [1984] is a kind of reconstruction of the communal apartments of Soviet Moscow. The communal apartment was where all problems came together, and were either solved or not—it was a concentration of Soviet reality. The installation has two kitchens and ten rooms. Each room is the home of a character. Next to the entrance of each room is a little explanation telling the story of the character who lived there—why he was there and what had happened to him. Each character had a certain fantasy, or maybe we can call it a dream. He didn't want to live under the present reality, he wanted to disappear, to escape from it. He was dreaming about doing something that would free him from reality. Each character represented one idea, as was often done in the novels of Dostoyevsky and other Russian writers. The hero of one apartment, for example, decided to disappear, and invented a device to take him out through the roof. He calculated that at a height of about forty meters above the city there was a certain force, and if he managed to go above forty meters he would leave forever. So in his room he built a catapult that would throw him into space. It was supposed to propel him through the ceiling and out through the roof of his building. We see [in this piece] that this has happened—he has disappeared from his apartment. He has managed to escape.

Another character was a collector: he would number pieces of garbage and write explanations of where he had found them, under what conditions, and why he had kept them. For him it was the memories connected with these things that were the collectibles, not the things themselves. The best "memories" he would put on the wall, with an explanation of why they were there, why they were important.

An installation of 1992, at the Documenta exhibition in Kassel, was called *The Toilet*. In the backyard of the museum we built an authentic Russian toilet, the kind usually found in train stations in small villages. Outside there were two entrances, with letters that in Russian stand for "women" and "men." So when people went in they expected to find a toilet, but instead they found an apartment, with all the signs of a regular everyday life. That was an unexpected surprise, to find a private life in a public space. The impression was that the people had gone for a walk, or to the store. Maybe it was uncomfortable, but it was personal and normal and actually very livable. A lot of people would think, "This is a very nice, comfortable apartment," despite its location in a public toilet. And the metaphorical idea, of course, was that the toilet could be in any place, any country, and it would be impossible to live there, but given no choice, we would. And we would be happy there and would have a "normal" life. Normality depends on your point of view.

In *Incident at the Museum or Water Music*, done in New York in 1992, everything was painted to look like an old-style museum, and we mounted an exhibition of a "very famous classic Russian artist." It was meant to be this artist's first exhibition in the United States. Everybody took it very seriously, and all of a sudden, maybe an hour before the opening, there was supposedly a catastrophe in the space—something

happened. You could see that the museum had tried to protect the paintings; they'd put plastic down, a chair. The sound of water was all around. Not only regular people but art critics were asking what had happened: "Please tell us the truth," they said— "it's such beautiful painting and such a catastrophe. Is it an installation or an accident?" The exhibition was built on a combination of sight and sound. Practically everything was a falsification: false museum, false walls, false paintings. The sounds were created by pipes set around the ceiling and dripping water, in sequences specially arranged by the composer Vladimir Tarasov.

Of course Soviet life had its own complicated context, and to understand it all is very difficult. Probably a lot of these installations were never completely understood. But the problems that happen to regular people all around the world are the same. Outside we're considered Soviet or American or German or European, but inside we're all the same, we have the same souls and the same problems. We are very human, and when you talk about personal problems, or everyday-life problems, it is everywhere understood the same way.

Most of these installations are total installations: the space is constructed in its entirety. The goal of the total installation is to create an atmosphere completely different from the usual atmosphere of the museum. The museum is a nice, brightly lit space. You walk around; you see different objects. When you enter these installations, though, it is not so much the objects that matter as the atmosphere, and you become not only the viewer but in a way a participant as well. You enter a different world, and all of a sudden your own memories, your own ideas, come forth. I guess we can say that the goal of the installation is a direct relationship between the artist and the viewer. If an installation is properly made, you can't leave without going through a whole cycle of emotions. You lose your sense of time.

This talk was spoken by Emilia Kabakov, Ilya Kabakov's wife, either translating what the artist was saying or speaking on his behalf.

Kabakov in his studio, 1996

Born 1949 in Far Rockaway, New York. Lives in New York

LAURIE SIMMONS

Selected Solo Exhibitions
"Laurie Simmons: The Music of Regret." The Baltimore Museum of Art, 1997
"Laurie Simmons." San Jose Museum of Art, California, 1990
"Laurie Simmons." Artists Space, New York, 1979

Selected Group Exhibitions
"Open Ends." The Museum of Modern Art, New York, 2000
"The American Century: Art & Culture 1900–2000. Part II: 1950–2000."
 Whitney Museum of American Art, New York, 1999–2000
"Louise Lawler, Cindy Sherman, Laurie Simmons." Kunsternes Hus, Oslo,
 1993 (traveling)

I started working in black and white in 1976. Around that time I started to under-
stand that I was beginning a larger project that, in hindsight, I can only call my work.
In 1977 I shot a figure in an interior that was actually a doll standing in a room in a
dollhouse. It's a replica of the dollhouse I had as a child; not the exact one, but some-
thing I rediscovered when I was older and started to use in my work. Then I set up
a number of images that moved through the rooms of the dollhouse. For the series
that followed, "The Big Figures" [1979], I used toy cowboys from the 1950s or late '40s
that belonged to my husband, they were his toys when he was a child—and instead
of working in an interior space I took the figures outside. I was trying to work with
issues of scale and ambiguity in photography. And just as the dolls and dollhouses
evoked the 1950s idealization of the perfect housewife that you'd find in magazines
or on television, the cowboys were the kinds of male characters, the heroes, who
were populating the TV screens of the time.

After the cowboy series I wanted to work again with an enclosed space where
things felt claustrophobic and would appear unreal. I was given an underwater camera
as a present and I started to photograph little doll figures inside fish tanks. Then I
took the dolls and toys and a bunch of friends and shot underwater in a swimming
pool. Once I saw how real people looked underwater through the viewfinder, it became
clear to me that this might be a way for me to work with the human figure. The water
would distort and compress the figures and turn them into something unreal and
in some sense reminiscent of the doll figures. So, in pictures from 1980, 1981, I pho-
tographed the actual human figure. My works with human figures are always the
most difficult and confusing for me; I'm always anxious and relieved to get back to
the dolls or mannequins or dummies. Over the last fifteen years it's been a challenge
to me to go back to the figure and see if this time I can finally get it right and make
it feel as unreal or artificial as the doll.

After working for a couple of years underwater, and thinking about water ballet
and underwater movement, I decided the next series I wanted to tackle would have to
do with ballet, in all its aspects, positive and negative: For me it symbolizes perfection
and also constraint, an almost unnatural activity and brutal training. When I was
growing up, it was very important for a little girl to go through a phase of identifying
herself as a ballet dancer and believing that she'd grow up to be that most perfect
female creation. The figures in the ballet photos are cake decorations, ceramic ballet
"sculptures," and toys that are toy-makers' ideas of what the stereotyped poses of a
ballet dancer might be.

I made the first of the ventriloquism pictures in 1986. I reached a point where
I decided that perhaps the use of the doll, the female figure, while it did depict the
situation of a woman in our society, might also be excluding the male viewer. I still
wanted to use dolls, but I wanted to feel like I had more of a hook for the male viewer,
I wanted to deal with the image of a man. The figure that seemed most obvious to me

Cafe of the Inner Mind/Chicken Dinner. 1994. From the series "Cafe of the Inner Mind." Cibachrome, 35 x 53" 139

was the ventriloquist's dummy. Ventriloquism is a very marginal kind of entertainment now; in the eight years that I've been working with ventriloquist's dummies, I've met a number of ventriloquists, and they tend to perform most at church functions, conventions, and on cruise ships. Yet ventriloquist acts are a very strong image for me from my childhood. I don't think they necessarily frightened me, but they were everywhere, and before the age of Spielberg-type special effects this was a form of entertainment that really could dazzle a child. To children, the idea that this inanimate object could be speaking to them, and that it's ultimately unclear who's really speaking, is very powerful. Is what the dummy thinks actually what the ventriloquist thinks? Or does this character have a mind of his own? So I felt, when I started working with the dummies, that I was mining a fairly rich psychological territory, at least for myself.

After I started working with the dummies, I found out about a place in Kentucky called Vent Haven, where a businessman named William Shakespeare Berger, a self-styled ventriloquist, had decided to start a museum of ventriloquism. It's the only one in the United States. He died many years ago but at this point they have over 1,000 figures, and lots of press shots and tapes and movies. It's a fascinating place for me, a disturbing and depressing place. When I got there I knew I wanted to shoot the dummies. There was the flavor of going to summer camp and making new friends, or going to a party and meeting new people, because in a room with 600 dummies, I had to decide which ones I wanted to photograph. I'd brought a rear-screen projection system with me, so that I could project these backgrounds behind them. I ended up making three or four trips to the museum, so overall I probably photographed about thirty of the figures, which is a pretty small percentage of what's there.

The series that followed "The Dummy Series" was called "Walking Objects." At the time, I'd become tired of the idea of the voice and mind of the dummy. It seemed like I'd been working with the idea of the brain; now I wanted to move to the area of brawn. I wanted objects to comport themselves in a certain way, with more physicality. If the ventriloquist's dummies could speak, then I was interested in inanimate objects that could walk. So I had to figure out which objects in my life I could see coming alive and walking around. The camera in *Jimmy the Camera* [1987] has human legs, because it's very large; it was a prop in the movie *The Wiz*. But the legs in *Walking Toilet* [1989] are about an inch and a half high. The works themselves, meanwhile, are about seven feet tall; I wanted them to have the same sense of scale, of presence, as a full-sized human.

The series I'm working on now is called "Cafe of the Inner Mind." After years of dealing with cultural images, and speaking about women's and men's place in society, I wanted to start to examine the inner voices and minds of some of the characters I'd been photographing. So I've gone back to using dummies, but I've been placing thought bubbles—a sort of cloud, the kind you'd see in a comic book—holding not text but an image of what I imagine the dummies are thinking about, their inner lives.

Of course I have no idea what they're thinking about, nor do I really have any idea what men think about, but the projection and depiction of these fantasies are very important to me. And men have been projecting their beliefs of what women's fantasies are forever, so I feel like rocking the boat a little and taking a turn myself.

All the dummies were set up in the studio, in front of either rear-screen projected backgrounds or constructed sets. I've collected hundreds of images of potential backgrounds. So what I've been doing while I've been shooting is collecting as many images of backgrounds and fantasies as I can, whether it's a slab of roast beef or a cabaret or something from a porn magazine. I'm amassing portfolios of images, some of which I'll use, some of which I won't, but that's been the really spirited part for me—collecting these fantasies and fantasy places, and also talking to people about what their fantasies are.

What I generally do is make a setup and maybe try ten to twenty backgrounds. It's in the editing process that I can actually see whether the dummies are integrated into the room. I can't always see that when I'm shooting the pictures, but I can see it on the light table. It's still a mystery to me why certain backgrounds end up feeling like real places and others don't work at all.

I worked with a ventriloquist and figure maker named Alan Semok. We spent a long time designing a dummy face that I was happy with—his own dummies are much more contemporary. My dummy is really a compilation of images from my memory. The boys have an incredible wardrobe, suits and jackets and ties. I've actually exhibited these as sculpture several times. I felt compelled to show them as they were in real life, not as photographs. In my starkest exhibition I had six dummies sitting in chairs mounted on the wall—completely identical except for six different suits.

What I'm trying to do now is break a lot of rules. I've always tended to work in a rigid, somewhat conceptual manner, in that I make a decision about how the work will be and I will not deviate from the plan. But with this series I've been trying to make rules and break them, to be a little more flexible and a bit more playful.

Born 1953 in Oklahoma City, Oklahoma. Lives in New York **PETAH COYNE**

Selected Solo Exhibitions
"Petah Coyne." Cincinnati Art Museum, 2004
"Fairy Tales." Butler Gallery, Kilkenny Castle, Kilkenny, Ireland, 1999
"Black/White/Black." Corcoran Gallery of Art, Washington, D.C., 1997 (traveling)

Selected Group Exhibitions
"Artists Take on Detroit: Projects for the Tricentennial." Detroit, 2001
Whitney Biennial. Whitney Museum of American Art, New York, 2000
"Selections from the Collections." The Museum of Modern Art, New York, 1997

Instead of talking formally about the work, I thought I'd speak personally about my life, so that you can see the correlation between my life and my work. When I was thinking about this, I was trying to figure out where my vision had come from, and I think one of the things that was the most important to me was that my mother was a great teacher. We were an army family, so we traveled all over the world—we moved fifteen times in my first twelve years—and during that time my mother would pull me and my brothers and sisters out of school for any reason. If a whale got beached, we'd all get pulled out of school to go see the whale. If a volcano was erupting, we'd get in a helicopter and fly over the volcano, and then we'd go onto the earth nearby and feel the volcano's heat and violence. And then five years later we'd go back to the volcano and walk across the crater—I remember how it would still burn the soles of your tennis shoes five years after it had erupted.

Even when my father started private practice in Ohio, after he retired from the army, we would still go to a new place every summer. My mother always wanted us to see different life-styles, different ways of thinking; she thought people were all the same but they had different ideas about what life was. And I still do this: every year I travel somewhere for a couple of months. I don't go to work, I go to read and think and observe. It's very important for me.

My mom was also convinced that you could do absolutely anything you wanted to do, that nothing could stop you. And I really believed this.

Thinking back on it, probably the strongest memory I have is of living in Hawaii for four years, which was a very long time for us. We lived in a Japanese neighborhood. It was in the decade after World War II, and a lot of soldiers were coming in who had been in Germany, and others had been on the Bataan Death March, and things like that. And they would all come to our house. My mom really loved these people, they were very special to her, and when they came we children had to be very quiet. They were probably just thinking, but I thought they were on another plane, which they probably were—but there was one man in particular whom I truly loved. I remember him so clearly. He was very tall and thin, and he was very closed off from the world, except that occasionally he would look at me and focus. You could see he had a soul that was just unending. I really cared about him, but I was so afraid he would leave, so every time he came to our house, I would move very little because I was afraid I would upset him. I would usually sit under his chair, and I would hold his pant leg because I thought if I held his pant leg I would tether him to this earth.

I was only four years old, so I have very vague memories of this. But I remember his presence so strongly. Then one time he came, and I knew he wouldn't come again. I knew he'd decided not to stay on this earth any longer. And I remember telling my father, who was just appalled—but in fact he had killed himself. And I think, for me, being so young, it wasn't a tragedy, it was just a decision he'd made. I guess I thought that everybody made these choices—when they would stay, when they would leave.

Untitled #752. 1992–93. Mixed media, 56 x 51 x 37"

I think that was further emphasized for me later, in my high school years, when I was very ill. I was sent to a special clinic, where—this was the '60s—they weren't going to give me medicines, it was all biofeedback. At the time it was considered kind of outrageous to be able to hypnotize yourself or move your blood into different parts of your body or make your heart go faster or slower. They also made you sit with maybe two or three people, and then go into a room, wearing a blindfold, and feel the presence of whichever person was there with you. I think that made me realize, or at least made me think, that you could control everything if you wanted to.

When I arrived in New York, in 1978, I began to work with people who were terminally ill. I was curious to know why some people survived and others didn't—I wanted to know if it was will, or luck, or both. Those experiences were what made my early work, which was dark and black. I was moved by these people. We would talk; they might not be able to talk to their families, but they could talk to a stranger, and it would be a release for them to speak about the things that had been important in their life and the things that hadn't and what they would have changed and what they would have kept. It affected me greatly, and I would memorize the emotions I had when I was with these people. But at a certain point, about three years ago, I had to decide whether I was going to go with them or stay on this earth. And I decided that instead of leaving with them I would try to keep my memories of them, of being with these people.

So that's what I'm trying to do with the white wax pieces I'm doing now—they're about those times that are almost perfect but not quite. You go searching to meet them again, and you're all excited, and it's never quite the same—but you always have the memory. So it's not just about people passing, it's more about friendships that have gone awry or people who have strayed. Just basically, humanity. That's what all these pieces are about.

I wanted to shift away from black, and I didn't know what I wanted to do, so I began to work with Irene Hultman. We did this whole installation, half black, half white, and there was also a performance in which she wore the pieces, or her dancers did. A lot of them come out of hat shapes or chandeliers. The wax is not a normal wax, it's made by a chemist so that it won't melt except at very high temperatures. It can get up to 180 degrees before it melts. In the summer my studio can get up to 120, 125, and in the winter I don't have heat so it's very cold. So these pieces have to be able to freeze.

I was raised religious, strict Catholic. We went to church every day and we prayed every day—that was the one thing that remained constant through all our moving. Catholicism is hard for me today, because we were raised so strictly that way, and I don't believe in Catholicism anymore. I have one Catholic grandmother and the other was Jewish, so I got both sides a little, but Catholicism was predominant. It is beautiful in its rituals but I have problems with women's position in it, they're so subservient.

But I think what Catholicism teaches, what all religion teaches, is so beautiful—it's basic humanity. So I kind of take what I want from Catholicism, or from any of the religions, and use it. It's more about spirituality than religion I think.

The form of this work is liquid because you have to make the wax liquid. It's pouring and throwing, an aggressive kind of thing. I usually begin with forms, but I work from an emotional sense—I don't do drawings, I don't do maquettes. (I wish I did because then I could do the understructure and so on.) Instead I just make the form and try to concentrate on the emotion I'm trying to get across. I never look at the thing, I just work on it, and then about halfway through I step back and look and think, Is this the best I can think of? Is this what I really wanted? And it never is. So when I say to myself, Is this the best?, I always think, Oh, that's not quite the feeling, and then I get kind of wild. I work with emotion and the shape comes. I can't have anybody help me because I don't know what I'm doing. I don't preconceive it.

Working from feeling is the way I was trained in the clinics. You work from feeling as opposed to seeing, and, then when you step back to look it's like, Oh. . . . And then you go back in.

Coyne's studio, 1996. Works pictured: early 1990s–1996

Born 1943 in Lafayette, Indiana. Lives in New York

JOHN DUFF

Selected Solo Exhibitions

"John Duff." Johnson County Community College, Overland Park,
Kansas, 1995

"John Duff." San Jose Museum of Art, California, 1991

"John Duff." The Clocktower, Institute for Art and Urban Resources,
New York, 1985

Selected Group Exhibitions

"Celebrating Modern Art: The Anderson Collection." San Francisco Museum
of Modern Art, 2000

"Innovations in Sculpture 1985–1988." Aldrich Museum of Contemporary Art,
Ridgefield, Connecticut, 1988

"Individuals: A Selected History of Contemporary Art 1945–1986."
Museum of Contemporary Art, Los Angeles, 1988

There are always reasons you're doing things. I'm messing around with wet sand; it's probably some kind of weird reflection of the beach, and of kids playing in the sand— I may not have gotten enough of that, or doing that may soothe something for me, or make me feel a certain way. That's why I'm doing this, to feel a certain way.

My method of making sculpture is a complicated thing that I've evolved over a long period of time. Your technique, like anybody's, just grows. You're drawn forward into your activity—you start to see facets of it, to see possibilities, to fantasize about it and think about it. You expand. It just grows on itself, until somebody seeing it from the outside thinks, How the hell did he get to that point?

I don't show my drawings that much, they're not that public. Drawing for me falls halfway between sitting in my chair trying to think about a piece and actually doing it. It's an intermediate state: it lets me think about something a little more concretely, a little more literally, I can work permutations, I can see more. Drawing's an aid to my imagination: I work up an energy and start doing the piece. Every morning I get up early, have coffee, sit down, and look at a page of drawings with half a dozen things on it, just scoping out the possibilities. Some days I don't even make a mark on it, or just one little mark—but all of these things are possible states of pieces, possible ideas. I'm just looking to grab onto something, looking for some energy somewhere, some connection. And when I see it, I'll try to make a more worked-out drawing to see what I've got. I keep doing that until I sort of hit critical mass. I've imagined enough about it that I can go in and start doing it.

A lot of the "imagining enough about it" consists of literally imagining how I might do it—how to proceed with the materials. I'm visualizing what I'll have to do to make the work. A lot of the interest lies in evolving things that will require me to go farther than I've gone: in order to make something, I'll have to invent procedures or stretch or extend my activity. That's interesting to me. I need to do a lot of different things to feel satisfied about something; I try to do what I feel activates the piece the most.

I do not polish or refine a work; I like to leave the birthing marks on it, the schmutz, the drag marks. Because the technique is kind of elaborate, it's hard to get a sense of where it came from—but I like giving you the feeling that the piece was really wrought, really handmade, really had another life, that this is the end product of another activity. The object has been somewhere; it's got a history. I like that about these pieces.

I have a quotation from Theodor Adorno: "A successful work is not one which resolves objective contradictions in a spurious harmony, but one which expresses the idea of harmony negatively by embodying the contradictions, pure and uncompromised, in its innermost structure." What that means to me is, the artwork's not trying to achieve harmony but is in a way saying harmony's impossible—it's not a state that can exist in the world. We've got disharmony in a very messy world, or we've got

harmony but in the messy, ugly, ambiguous, unresolved form that we're all dealing with all the time. For Adorno the work of art doesn't try to resolve those contradictions—that, he thinks, would be spurious—but it expresses them. It makes them and their relationship, the relationship of disharmony, absolutely clear.

The way I apply this is that I'll have a logic at work, a system, a structure I've evolved to do something—but if you put enough focus on any one thing, it's going to slip away. That contradiction is inherent in matter, inherent in the world: a pure state is not something we can comprehend or know. According to the Heisenberg uncertainty principle, on a microscopic level you can know the location of a particle, or its rate of speed, but not both, because the act of measurement itself introduces a distortion. There's always an irresolution. So what I try to do is take a system and make it turn in on itself in some way. You see a logic, you comprehend it, you're going along with it, you think you know where it's going—but then something happens that breaks or distorts the logic.

The things you notice—there's a reason you notice them instead of the other things around them. It's like the reason I use wet sand, why out of all the things I *could* be doing I'm doing that: it rings a bell for me. There's infinite variety out there for you to notice, so the things you *do* notice ring a bell for you, do something for you. Here's a motorcycle lock I found; one of the bells that rang for me about it was this little curve. There's a logic in this lock, a system—but then this curve is an eccentric element that's necessary to make it work as intended. A saying I have is, Work on the level of necessity. That's the critical point: you've got a logic, but in order to accommodate it, a little warp, a little distortion, a little discrepancy has to enter in. And I try to find that discrepancy, try to create a situation in which it appears. Maybe I even make the work itself that discrepancy. This is why I picked out the Adorno quote about pure and uncompromised contradiction.

I like found color, color with a past, a history, that you may recognize from somewhere before. A color like mailbox green, which is identified with a workaday object, an object that functions in a certain way—you've got the color's existence in that context in your mind, and you don't really see it as color because you're used to it in that context. I like to remove it from there and use it somewhere else, but my feeling or hope is that bits of its previous life will cling to it. There'll be a pull between your recognition of what it was and the fact that you're no longer seeing it there. In *Roberta's Tray* [1994] there's a well-known color combination from early-'60s interior decoration, and it transforms the piece into a funny, pillowlike thing. That recognition from a previous context modifies your experience, sets up a little vibration, a little discrepancy, which I like. I've made plenty of pieces that are just orange: you used to see fire escapes painted orange (with red-lead primer), and I thought it was great to be walking down the street and see an incredible orange fire escape. But you weren't supposed to see it as color, and people actually didn't see it for what it was: this

incredible great orange metallic structure clinging to the building. Because they knew it was prosaic, they didn't appreciate it as color. So I used that orange a lot. I've also used mailbox green, which is olive drab, and a blue—Florida Aqua—that's used to paint the bottoms of swimming pools.

So color in my work is a cultural reference. I think all art is cultural anyway; when we look at Greek art we don't experience what the Greeks did. That's why I think the idea of sending work even to Europe is difficult, not to mention Japan. I'm very much from California, with the surfing, the fiberglass, the beach, the whole schmear. If you share all that with me, you're going to get a lot more from my work. There's a Chinese proverb: Tell me, I forget. Show me, I remember. Involve me and I understand.

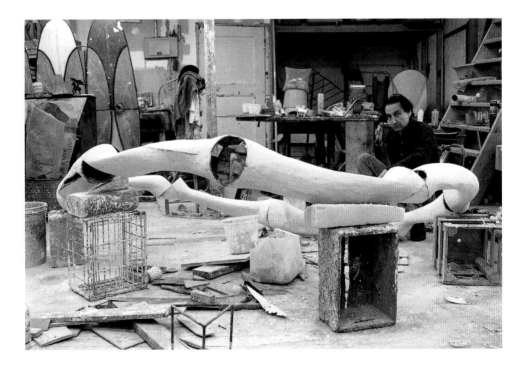

Duff in his studio, early 1990s

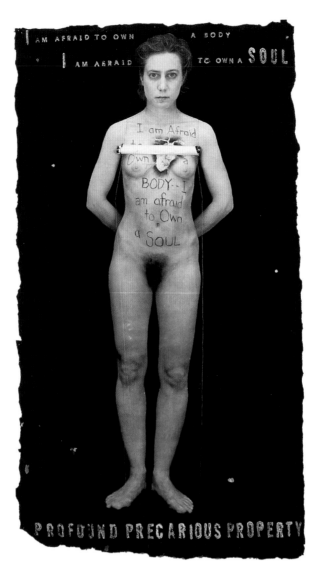

Born 1950 in Bronxville, New York. Lives in Brooklyn, New York

LESLEY DILL

Selected Solo Exhibitions

"Lesley Dill: A Ten Year Survey." Samuel Dorsky Museum of Art, SUNY New Paltz,
New York, 2002–2003 (traveling)

"Tongues on Fire: Visions and Ecstasy." Southeastern Center for Contemporary Art,
Winston-Salem, North Carolina, 2001

"Lesley Dill: The Poetics of Form." Wiedner Gallery, Trinity College, Hartford,
Connecticut, 1998–99 (traveling)

Selected Group Exhibitions

"Materials, Metaphors, Narratives: Work by Six Contemporary Artists." Albright-
Knox Art Gallery, Buffalo, New York, 2003

"Through the Looking Glass: Women and Self-Representation in Contemporary Art."
Palmer Museum of Art, Pennsylvania State University, University Park, 2003

"Triennial of Form and Contents: Corporal Indentity—Body Language." Coorganized
by the Museum of Arts and Design, New York, the Museum für Angewandte
Kunst, Frankfurt, and the Klingspor Museum, Offenbach, 2003–2004

Sometimes I feel skinless. I feel that my nerves and circulating blood stand before you without their normal masking protection of skin. So I go looking for a covering in my work. For me, words are a kind of protection, a mediating skin between myself and the world. So these dresses with words that I make are dresses of armor.

In *White Hinged Poem Dress* [1992], the words are backward so that the dress is unreadable. You can only read the poem—the poems I use are by Emily Dickinson—when the dress is open. This one says, "I heard, as if I had no Ear / Until a Vital Word / Came all the way from Life to me / and then I knew I heard." I was interested by medieval altarpieces, things that close up and then open wide. In another variation on that kind of dress, the poem is, "This World is not Conclusion. / A Sequel stands beyond— / Invisible, as Music— / But positive, as sound—." I thought that was applicable to a dress that was so much made of holes, as if the air going through the holes would make a kind of music to create the persona of the piece. But there's a potential danger there, as if the rest of her had snapped shut on you like a bug. It could be a sort of Venus's-flytrap of the soul.

When I lived in India, I couldn't understand the Hindi that was spoken all around me every day in the temples, the streets, and the homes. And a funny thing happened: when the surface sense of the language was removed, the words became like a kind of incantation. The signs could have been saying "Eat at Joe's," and they probably were, but since I didn't know what they meant, it all became magical to me.

I had a studio there, I was working, and I wanted to try to make a visual equivalent of the melodic unintelligibility that I was hearing every day. I wanted to make a portrait of what "talk" sounded like. I made *White Wall of Words* [1993] with seven Indian women I hired. Whenever I look at it, I remember when we made it, which was in the 120-degree heat of a New Delhi summer. The heat there was white; all day seemed like a wide high noon. And the air was filled with that hot, secret sound that you get in those kinds of days. The poem is, "Dare you see a Soul at the White Heat? / Then crouch within the door—." It's repeated over and over again, like a hypnotic mantra that you feel like when you see the shimmering layers of heat.

I've always been interested in the Middle Ages, and there's something about New York, I think, that's very much like a medieval city—those tall narrow buildings, very dark. I think our era too is akin to medieval times. We're in an age of an explosion of information, an age where science knows a lot but not enough, so we're extremely vulnerable. And we're also in a stage of a sort of spiritual flux, where people don't know exactly what to believe or how to believe or how intensely to believe. *Paper Poem Hands* [1992] is a pair of rice paper hands that are emitting language like blood. I am obsessed by touch. I think our society has built up a kind of craving for touch. Our entertainment, which is mostly movies, happens behind a screen. Our work also happens behind a screen, on the computers. And at night we go home and we watch TV, where all these narrations and stories happen behind a screen. So I feel that there

is just this craving to make a mark, sew a stitch, knot a thread. Obsessively marking the work gives the viewer an immediate sense not only of touch but of a scale relationship to your body. You know what it feels like to make a knot, to touch wire, to touch wood, to touch copper. I emphasize hand-stitching and -sewing as a way of marking time, a way of kneading life into my work. I think we've lost touch with our hands, because there are so many mechanical devices we can use now. So I like to give people that sense of something that takes time and has taken time to make, hours and hours and hours.

Copper Poem Circulatory System [1991–92] gets back to the idea of armor. It is a copper sculpture of the circulatory system, about six feet high. I thought, "Maybe you only really need to make armor for the most essential parts of your body," which I think of as the heart and the circulatory system. So, if you strapped this on, you would protect those aspects of yourself. And then I thought, "Well, actually, probably the truest kind of armor is if you have poetry in your heart." And the words circulate out to your various veins and limbs.

Now all of this armor is on top of the skin. And I thought, Actually, we sometimes need an armor that's *inside* the skin, that mediates between the epidermis and the universe within, not just the universe without. So I started making paper pieces that would be more like the tissue substance inside the body. *Poem Dress of Circulation* [1992] is a heart and veins, in charcoal on rice paper. I've done a number of these pieces. I feel that if you were to cut each one of us in half we would pour out words. I think our intestines and livers and hearts hold so many words in our bodies that are unsaid and unspoken throughout our lifetimes; the words that meet air are very few compared to the unlipped and untongued words that we have inside ourselves.

Those of us who get such pleasure from our eyes out of looking at art—I think sometimes at the end of a day you go home and it's almost like you can stack up the images behind your eyes. You close your eyes at night, you close your ears at night, and what comes forth unbidden from this blackness are the images and sounds that you hear. I think we go to bed at night singing, with our heads singing and our heads seeing.

I don't feel that I use text in my work, I feel that I use words. Words to me are heated, intimate things. When you're in the process of making words, you take a breath. You have a thought, you take a breath—you wrap that thought with your breath. Then you bring it up, past your throat, your teeth, your tongue, your lips, out into the world, onto your face, your skin, your arms, and into your ears. So the imprint of the person speaking is actually in the air that's going onto your body. The act of speaking is a very personal, intimate thing.

I started off as a sculptor, using wood, and I find I always come back to it. There's something about the fleshiness of it, the feeling that you want to touch it and that it's warm, that I think is particularly wonderful for making stories about human beings.

My challenge in woodworking is to make something that has weight but that still has some humanity and vulnerability. Traditional sculpture of years ago, big bronze sculpture, was dense, weighty, and big. When you looked at it, you were impressed, you felt frail. I want you to look at my work and to feel intimate, direct, and strong.

As you can tell, there are poems I become particularly attached to. I like this one for its vulnerability. In *Profound Precarious Property* [1995] the figure has painted on her, "I am afraid to own a Body— / I am afraid to own a Soul—." But her gaze is strong and direct. I feel that my work is very much about the soul. And I feel that the soul lives in the heart.

When you make work and you use words, you make metaphors for certain things. I come from an academic family, everybody teaches, so it's been a gradual process for me to let go, bit by bit, of defining why I make work. The reason I can make this work is that the ideas come up unbidden, like a dress of nerves. They come up fully formed.

The armor obviously relates to a belief that vulnerability and poignancy are important emotions, not only for me but I think for everyone. I don't necessarily *want* to make work that's savage, angry, or poisonous. I don't mind if there are drops of all of those elements in the work, but I want to make work about the emotional bath that we all live in most of the time, which I think is poignancy, vulnerability, hope, expectation, disappointment, fear, ecstasy.

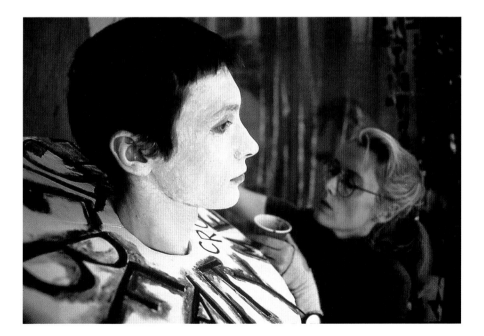

Dill in her SoHo studio, mid-1990s

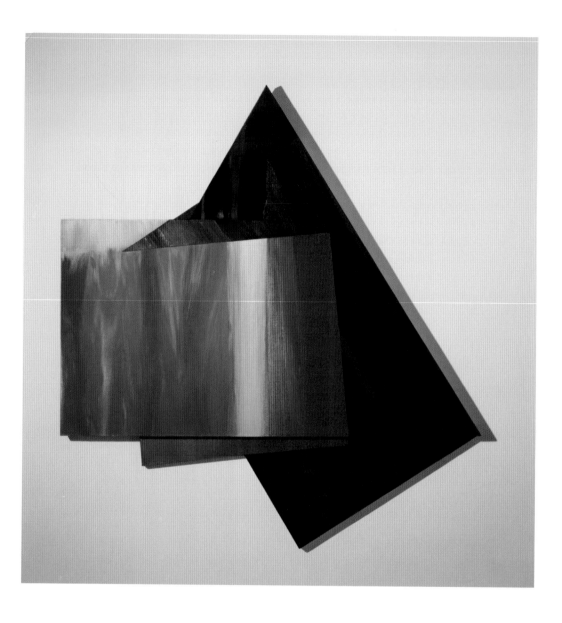

Born 1932 in Montreal. Lives in New York **DOROTHEA ROCKBURNE**

Selected Solo Exhibitions
"Dorothea Rockburne: Visible Structure." Portland Museum of Art, Maine, 1996
"Dorothea Rockburne: Ten Year Painting Retrospective." Rose Art Museum,
 Brandeis University, Waltham, Massachussets, 1989
"Dorothea Rockburne: Locus." The Museum of Modern Art, New York, 1972

Selected Group Exhibitions
"A Minimal Future? Art as Object 1958–1968." Museum of Contemporary Art,
 Los Angeles, 2004
" The Spiritual in Art: Abstract Painting 1980–1985." Los Angeles County
 Museum of Art, 1985 (traveling)

"Eight Contemporary Artists." The Museum of Modern Art, New York, 1974–75

I was born in Montreal, and as a child attended Ecole des Beaux-Arts on Saturdays. So early on I had a formal, old-fashioned art education from an art school 300 years behind the times. Next, in my teens, I studied at the Montreal Museum School, which mostly taught conservative French painting. After that I gravitated to Black Mountain College in North Carolina, a milieu of all things radical. I thrived. Around 1955 I came to New York and concentrated on staying in one place, letting New York rub off on me, working to support my child and myself, and spending as many hours as possible in the studio. I do the same thing to this day.

To give you some sense of part of my visual roots, I think it was in 1972 that I first saw Masaccio's frescoes in the church of Santa Maria del Carmine in Florence. I'd seen reproductions, but the frescoes themselves so stunned me that on returning to my hotel I just lay on the bed for three days feeling and thinking about them. These paintings pronounced a path, and in so doing changed my life. I could not get over their beauty. Masaccio invented the device of making a figure's eyes follow you around the room. Everybody studied in the church of the Carmine. Da Vinci studied in there. I'm sure he adopted Masaccio's invention of the eyes that follow you in the Mona Lisa. Everybody went there, from Van Gogh to the Russian Constructivists; they did drawings there and so did I. In one panel Saint Peter is reaching into the fish's mouth. Jesus is saying, "Give unto Caesar that which is Caesar's." He has told Peter he'll find coins there. The place is the Capernaum Gate. So, I did a two-layered panel painting in oil on linen called *The Capernaum Gate* (1984), 7' 8" x 7' 1" x 4". I used Masaccio's diagonal device of Saint Peter reaching into the fish. This was the first painting I'd done on stretched linen since my student years. In early exhibitions, I used paper and chipboard to visualize concepts of set theory. That early work encompassed walls and whole rooms. It was quite a break from my recent past to go back to my roots in Montreal, to rediscover linen canvas, the moveable wall, as well as ancient pigments and their binders.

When I attended Black Mountain, most of the art teaching was left over from Josef Albers. It was, therefore, all about making dark colors come forward and light colors recede. I never liked that kind of color. It's as though color were unemployed and needed to be given a job: I think color has such great resonance and personality. It's an amazing thing to use. The way I work, I never mix colors: I keep the pigments pure. If I want to paint purple, I'll put a red glaze over blue.

In 1981 I did a group of works called "The White Angels." I was intrigued by a statement from Courbet, who, in reaction against the ecclesiastical work around him in nineteenth-century France, said "Show me an angel and I'll paint it." I thought it would be marvelous to do an abstract angel: since there were no people with big wings sitting around posing, angels were probably the first non-geometric abstraction in painting. *Dark Angel Aura* (1982), 41 x 33", is painted in watercolor on vellum that's been soaked, stretched, and painted on both sides, one side in black, the other in

silver, then folded and glued. None of the folding is arbitrary, it's based on topology—I study math, applying it to art. *Dark Angel Aura* was influenced by the gray work of Giotto in the Scrovegni Chapel.

Guardian Angel II (1982), also painted in watercolor on vellum, is 6' 5 ¹/₂" x 4' 5". Again, decisions, while intuitive, are never arbitrary; shapes are not attached for design purposes, I never work that way—it's all one sheet, which when unfolded is very long. It's folded and glued according to topological principles. When you see bits of silver shining through, you're seeing what's painted on the reverse. I used watercolor in these works because, back then, watercolor was thought to be something used by women flower painters. I wanted to reinvent watercolor as a major painting medium. *Dark Angel Elephant* (1982), 32 ³/₄ x 31", was the first of this group. It's always hard to get the first work of a group. This work took so long to make I felt as if I were making an elephant; that's how it got that title.

Extasie (1984) is a painting in oil on gessoed linen that I did three times. It measures 6' 9 ¹/₄" x 6' 4" x 4". I was constantly listening to the pianist Glenn Gould, a fellow Canadian. He said the joy of recording in the studio rather than the concert hall was that he could play something over and over; the more he played it, the more something in the work took over. Once he knew the structure he could deal instead with the music's pure spirit. I thought about that, and purposely painted *Extasie* three times. I have little concept of time, as you can tell; this painting took about three years. I found out that Gould was right.

I Am Pascal (1986–87) begins the "Pascal Paintings." It's in oil and charcoal on gessoed linen, has two layers, and is 7' 11 ³/₄" x 7' 2 ³/₄" x 5". Because I grew up in a French province, I was handed Pascal's *Pensées* in the fourth grade. At first I wasn't too interested, but with time I began to understand what a rebel he had been, as well as a great philosopher; and then, later, what an inspiring, inventive mathematician. I decided to do work motivated by things he had said. *Les Pensées de Pascal*, (1987–88) 8' 7/8" x 5' 3 ¹/₂" x 4", is also based on certain color aspects of Mannerist painting, but my painting method is classic Renaissance. The bottom part of the canvas, which is red, is painted over gold leaf, and the section that is blue in the upper right is painted over silver leaf. When painting in oil on gold or silver leaf, there is only one shot at the brushstroke: going over it again will dissolve the gold or silver leaf.

I began to use gold leaf around the time of *The Capernaum Gate*, but never as a decorative element: I use it in the same way the Renaissance artists did, which was to illuminate a dark area. One reason they put gold halos around the saints' faces was to illuminate their faces. The work hung in a dark churches.

Artists have always used mathematics. Giotto's and Michelangelo's studies show that they employed geometry and math all the way along. I like to think I'm entering that grand tradition on some level. At a certain point, around 1960, I didn't like what I was doing in the studio, so I stopped. Although I had several jobs at once, and a

child, I had energy left over, so I began to take ballet classes at American Ballet Theater. That wasn't so difficult to do back then—in fact they advertised in the newspaper for people to take classes. From there I drifted down to the Judson Church, where I worked with Robert Rauschenberg, Robert Whitman, and other artist/chore-ographers. Although trained, I had never thought of myself as a dancer, but I did real-ize that we were dividing the floor and counting. Whenever I was in a performance, I always lost count: I was subtracting and dividing and trying to do the motions at the same time. Somehow or other this began to feed into my experience of math and painting, of visual, kinetic, and spatial divisions.

When my daughter could not understand new math, I said, "Oh, no problem," and I started to teach her. As I did, I began for the first time to visualize mathematics. That produced my work based on set theory. I never thought any of my work would be shown, women simply were not shown back then, but I continued doing equations visually, and people began to hear about this and began to ask to see work. Then I was asked to exhibit, because Eva Hesse, Jo Baer, and people like that were now exhibiting. I naturally began to work topologically. Math is some kind of odd ability I have that I've learned to incorporate into my work: I'm not a mathematician, yet math is so beautifully abstract and creative, it feeds my painting and my being.

Tearful Sisters (1993–94), 35 1/$_4$ x 42 3/$_4$", is done in Lascaux Aquacryl and Caran d'Ache on papyrus. Here I was working with the idea of the loneliness I think we all have now that we've seen people walk on the moon, we know that we are in fact very small. The grandness of it all—I think in our inner psyche, not in our surface everyday life but in the inner part of it, the effect is more profound than Galileo say-ing the earth wasn't the center of the universe. Andromeda, for example, is a whole constellation, like the Milky Way but more vast. Every time I hear this kind of infor-mation, I have a funny feeling: what is this flat surface that I'm standing on? How does it exist? When will it all disappear? I look at stars differently now, don't you? The core of the earth is so shallow, and molten inside. The nature of nature is threat-ening. This increasing knowledge produces an idea of our loneliness in the vastness of it all. I feel that strongly, and it's here in this work.

Born 1947 in East Orange, New Jersey.
Lives in New York

SARAH CHARLESWORTH

Selected Solo Exhibitions
"Sarah Charlesworth." Gorney Bravin Lee, New York, 2003
"Sarah Charlesworth." Margo Leavin Gallery, Los Angeles, 2000
"Sarah Charlesworth, a Retrospective." SITE Santa Fe, New Mexico, 1997
 (coorganized with the National Museum of Women in the Arts,
 Washington, D.C.; traveling)

Selected Group Exhibitions
"The Last Picture Show." Walker Art Center, Minneapolis, 2003
"The American Century: Art & Culture 1900–2000. Part II: 1950–2000."
 Whitney Museum of American Art, New York, 1999–2000
"A Forest of Signs: Art in the Crisis of Representation." Museum of
 Contemporary Art, Los Angeles, 1989

I first learned photography at college, while I was doing my senior thesis in art history. I began learning it in order to do a photo essay and from there went on to support myself for several years doing freelance work. I wasn't interested in photography as an art form, though; as an artist I was influenced by Conceptual art, and I was more interested in photography as a kind of language, a terrain that shapes the way we see and experience the world, than I was in just making pictures. I was interested in photography less as a medium than as a subject. For me, to confront the representation of our world is to confront the terms by which we think and act.

I believed that each generation of artists confronts problems that are unique to it. Pop art, for example, pointed to the world of commerce and popular culture—though it didn't really explore that world; it just said, Bam, wow, we're here. And Conceptual art similarly pointed to the linguistic and conceptual bases of artmaking in our culture, but didn't provide the conditions to explore them in depth. I felt it was incumbent on the artists of my generation to go one step further and explore the culture itself and its languages. I was reading structuralism, anthropology, economics, linguistics, and semiotics, and I was fascinated by the way writing on visual culture always translated it into literary terms. Roland Barthes, for instance, would say, "Ivan the Terrible raised his hand over the crown, and this symbolized . . . "—and so on. I wondered why we couldn't use visual culture itself to analyze visual culture. In retrospect a lot of my peers, whether Cindy Sherman or Richard Prince or Laurie Simmons, were engaged in a parallel process.

I started tearing images out of magazines and books and setting them out around my studio floor. I began to notice patterns. I remember, as a young woman, saying "Wait a minute, why is the man always standing out in front in the cocktail ads? And why is the woman always hovering behind him?" Following these patterns, I became interested in the perception that values were being constructed in mass culture that informed the way we think about the world, our possibilities as human beings, how it is to be a woman, how it is to be a man, how it is to be an American or a white person or whatever. My work took off from that point.

I began to explore visual culture as a landscape. I consider that landscape of the imagination, whether it's magazines or television or movies, to be as real and pertinent to my life as any other form of landscape—trees or ocean or countryside—because it's something that we absorb and is part of our life. My work explores that landscape. Initially I dealt with what we call news, a few years ago I was working on the Renaissance, and right now I'm involved in nineteenth-century photography and painting. I throw myself into some period or issue that concerns me, take it apart, and put it back together again.

In 1977 and '78 I made a series, "Modern History," that used newspapers to explore the visual representation of world events. A few of the pieces were based on the kidnapping of the Italian Prime Minister Aldo Moro by the Red Brigades. This

event appeared to me like a kidnapping of the front page of the public imagination: its circumstances were debated everywhere, and one particular photograph was seen all over the world. The Red Brigades were kidnapping a symbolic public space. I took no perspective on the kidnapping but explored the way news organizes a point of view. One piece used every newspaper in the world that reproduced that famous photograph on its front page. Because my interest was the treatment of the photograph, I deleted all the text. Then I organized the sequence geographically to show how the import of the event spread. None of the Italian newspapers cropped the photograph, for example, but in France the integrity of the image was disrupted right off the bat. This image appeared in newspapers all over the world, continually contextualized by local cultures. I produced about twelve of these newspaper pieces over a two-year period. Each is different.

My next body of work, "Stills" [1979–80], was a series of images of people in midair. We confront news photographs of horrific events all the time; I was curious about their ever-presence in our visual environment. I was also exploring the narrative nature of photography. Some of these people were jumping to commit suicide, some were jumping out of burning buildings to live; but for this one split second they were all in midair. Some of them lived, some of them died, some of them intended to live and died, some of them intended to die and lived—but all that takes place outside the photograph, which suspends that narrative relationship.

The next series, "Objects of Desire," began in 1983. I was aware that magazines created an image of model women, a standard of beauty that was not necessarily my own. So I started tearing these magazines apart, looking for patterns. One of my categories was color: I'd put all the red things over there, all the blue things over there, and see what each pile said. "Objects of Desire" wound up organized thematically by color—it was my first color work. The first group, "Objects of Desire 1," from 1983, dealt with gender issues; it's all in red and black, red being the color of seduction, and of anger. The second series, done the following year, dealt with culture's image of nature and was green to black. Then I was going to do a series in yellow dealing with material desire, and in blue approaching representations of metaphysical and spiritual desire.

Taking apart fashion photos, cutting the clothing off the models, I began to see a language articulated in the clothes themselves, preceding any individual wearer. Regardless of whether you were or were not the bride wearing white, the model of the bride wearing white preceded you. The same with the guy in the black leather jacket— why is it that masculinity always stands like that? The farther I got in the series, the more I became aware of my own ambivalence toward and entrenchment in the values I was supposedly critiquing. I'd say, "I won't be the fashion victim anymore; the girl wearing the red scarf will symbolize the vacancy of this idea of femininity." And then I'd go, "I kind of like that scarf. . . . " And there was the macho guy posing, but

I wouldn't have minded if my boyfriend had looked like that. So by using that process I was trying to seduce viewers into examining the conditions of their own desire.

In the "Renaissance Drawings and Paintings" series of 1991 I took apart paintings and tried to figure out how they were constructed. Then I reassembled them in keeping with psychological models—Freudian and Jungian and so on. Each speaks of the psychological ordering of the world. *Vision of a Young Man* is a slightly mocking piece about what I think young men are concerned with. It's taken from a horizontal painting by Raphael, of a knight lying down; I turned it into a vertical, let the tree next to the knight's groin grow very tall as he dreams, and sort of levitated the figures of the saints to suggest a spoof on sexuality. But this elongated tree also represents the flowering of the imagination and the unconscious.

The "Natural Magic" series of 1993 is concerned with the veracity of photography, which may or may not represent the truth. I play the role of magician. These were the first works I did using cameras and studio setups rather than found images. I had begun to feel I had moved away from the deconstructive process—that I was beginning to want to just say things. In *Trial by Fire* those are my actual hands, actually on fire, stuck through black velvet. In *Proof of Telekinesis* I offer an image of bent silverware as evidence of my telepathic powers. *Control and Abandon* is like a card trick: the cards are frozen flying through the air. All the blue playing cards are engraved with the word "abandon" and the red ones with the word "control," reflecting a constant battle that I think all artists fight with themselves. I got to express my sense of abandon by throwing up 104 cards in the air all day long one day, and just getting whatever chance shots of them I happened to get.

There are things I want to say with original photography that the medium will not say. I want to explore time, I want to go back to the mid-nineteenth century; that's something I could do in the old photographs but not in the new ones. What I can do in the new photographs is talk about a relationship with time in the present. So even though I've gotten interested in making original photographs, I'm not by any means wed to them as the thing I'll do from now on.

A lot of my work right now is about subject and object, seeing and being seen, and the rapport between them, which photography supports. I have piles of books on nineteenth-century photography and painting. Out of this dialogue with the past I'll create my next group of images.

Born 1952 in Brooklyn, New York. Lives in New York

RONA PONDICK

Selected Solo Exhibitions
"Rona Pondick: Current Work." Museum of Contemporary Art Cleveland, 2004
"Rona Pondick." Groninger Museum, Groningen, 2002–2003
"Rona Pondick." Galleria d'Arte Moderna di Bologna, 2002

Selected Group Exhibitions
"Sharing Exoticism." Biennale d'art contemporain de Lyon, 2000
"Alternating Currents." Johannesburg Biennale, 1997
Whitney Biennial. Whitney Museum of American Art, New York, 1991

When I was a graduate student in '77, an art history teacher was talking to me about the scatological references in my work. At the time I had no idea what he meant by this. I went home, looked up scatology in the dictionary, and was horrified. If I could have turned on a dime, I would have. I wanted to make classical work and there I was making scatological work instead.

In '84 I worked on a piece called *Dog* for a year. I wanted my work to have a visceral presence but I didn't know what form it would take. Frustrated, at my wits' end, I picked up *Dog* and threw it across the room. I don't know how I picked this thing up, it weighed 200 pounds. I stomped out of my studio, made myself a cup of coffee, went back to my studio, looked at this thing on the floor, and thought "There's something here."

From '86 until '88 I was working with a brown microcrystalline wax. I had a whole studio full of it. I invited a friend over. His reaction was not what I wanted or expected. His back was riveted against my studio wall, and he said, "This is really strong, but Rona, it looks like there's shit in your studio." I thought, "What's going on here? I've heard this before," and at the same time I thought, "Maybe there's something here I should pursue."

When I could accept the content in my work, I looked to Franz Kafka, one of my biggest heroes. I wanted to embody the contradictions and absurdity hidden in the darkness in his writing. I asked myself what was the most absurd thing I could do with one of these turdlike forms: stick it on a satin pillow. I took a wood beam, stacked the handsewn pillows on top of each other, then placed the bronze turd on top. When I piled these pillows on top of one another it was with the longest pillow on top and the shortest one on the bottom, with one side wider than the other. When I finished the first sculpture I thought it looked like a body sack, sarcophagus, or bed.

It's going to sound bizarre, but the idea of working with a recognizable object like a bed was more upsetting to me than making a scatological sculpture. I was trained by Minimalists who believed image and metaphor were taboo, so I saw what I was doing as a transgression. At the same time that I was afraid of imagery, though, I was excited and turned on by the possibilities, and I asked myself, "What other objects have the kind of metaphoric reading the bed has?" I started collecting objects and turned into a packrat. When I placed a pair of shoes in the middle of my studio I was surprised; here was a stand-in for a person, it implied so much. I felt like I knew the gender, age, and profession of the person who wore the shoes. I was attracted to and wanted to use this symbolic fragment in my work. From shoes and beds I moved to chairs, baby bottles, teeth, and ears. I looked closely at the forms and shapes of these objects. I was interested in what made something feel male or female. I walked around identifying everything obsessively: male, female, male, female. . . .

I knew Freud said that the chair is the holder for the body and therefore is female, but when I looked at a chair I didn't see it as either male or female. Since I didn't see

Pink Treats. 1995. Plastic, 1,500 parts, dimensions variable: each head 1 ¹/₂" diam.

it as either male or female, I wanted to see if I could inject sex into it. I tried making chair sculptures but they just didn't work, and I wound up throwing many of them out until I discovered that I needed to dwarf the chair so it felt removed from ordinary scale. I then turned the seat of the chair into a buttock and treated the surfaces like a skin. In *Seat*, 1990, I used lace to imply a female skin and in *Chairman*, 1990, I used Spiderman comics to mimic tattooing.

In '90 I started using teeth in my work. I began by using yellow Halloween teeth that the manufacturer soon after discontinued. I called asking if he would consider making them for me and he laughed, saying I was their only admirer and the minimum order was 50,000. I liked these teeth but not enough to order that many. I had to figure out something else. I decided I might as well start casting my own teeth. I'm interested in how the body fragment engages the viewer differently from the whole. When you see part of something you want to figure out immediately what the rest of it is and you assume there is something left out. It is natural to fill in or complete what's missing. I'm interested in the symbolic and metaphoric reading of teeth. We eat with them and they can have a sexual reading. Teeth are a part of us, and we leave them behind when we die.

I once found myself in a very funny position: I was sitting on a panel at the Whitney Museum and someone asked, "So why are you using teeth?" I panicked, asking myself, "Oh damn, I didn't think of this. What do I say?" And before I knew it I'd told 200 people that I had an obsession: every time I was angry with someone I wanted to bite, and I wanted to see what would happen if I channeled that urge into my work. Afterwards a blue-haired woman in a prim suit came up to me and said, "I know exactly what you're talking about: when I gave birth to my baby I wanted to eat it. So I went out and bought a suckling pig the size of my child and ate the whole thing." I thought "They say that artists are weird."

I'm now working on a performance and installation for the Brooklyn Academy of Music and the Brooklyn Museum. The performance is called *Mine*. The costumes for the dancers and a bed that will be used as a stage have the words "I want" written maniacally over the surfaces. We all want; I think wanting is the driving force in life. It is what propels us. We think we want specific things and when we get them we ask ourselves why we wanted them in the first place. We want what we can't have and when we get what we want we want more.

I'm very interested in my artistic roots. I feel close to Egyptian and African art, Brancusi, Giacometti, Bruce Nauman, and Philip Guston. When I finished graduate school I was obsessed with Egyptian and African art. I was trying to understand my likes and dislikes and building my ancestral tree. After looking closely at Egyptian art I started looking at Giacometti. I had a book of his work sitting on my table all the time. I remember the moment when I found a small Egyptian piece that looked like Giacometti's chariot. I realized that Giacometti was looking at Egyptian art and it

made sense that I'd love both. I started to see and understand the connections between things that I loved.

For many years I felt like a Martian, I had no sense of community and didn't feel that I was a part of anything. I was shocked when I found out that there were other artists dealing with the body. We don't create in a vacuum. We all have historical ancestors and teachers. When I went to school, I was trained by Minimalists. I wanted to move away from their ideas but I knew at the same time I had a direct relationship to them. Someone once said to me, "You couldn't do a vertical piece if your life depended on it." I thought, "Wow, that's true." My work is always on the floor, I work with the horizontal, and I use repetition. It was one of those moments when you think, "Oh my God, I am trying so hard not to be anything like my parents, and I am them."

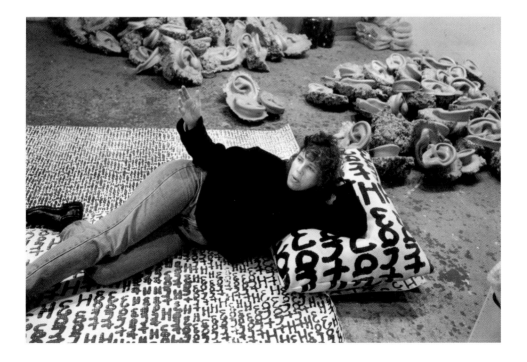

Pondick in her studio, 1997

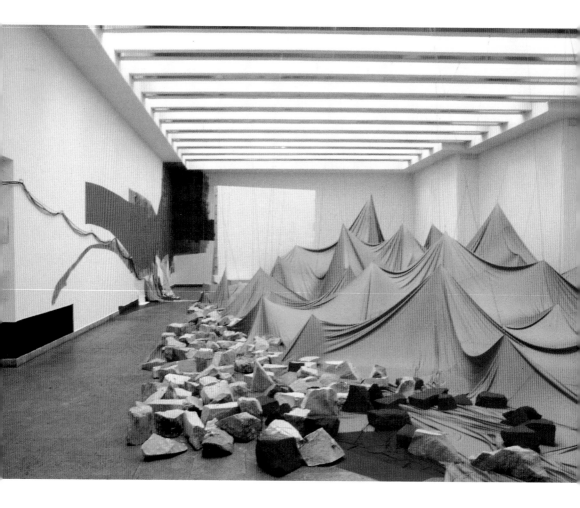

Born 1959 in Seattle. Lives in New Haven

JESSICA STOCKHOLDER

Selected Solo Exhibitions

"Jessica Stockholder." Blaffer Art Gallery, University of Houston,
 Texas, 2004 (traveling)
"Jessica Stockholder, TV Tipped Toe Nail & the Green Salami."
 CAPC Musée d'art contemporain de Bordeaux, 2003
"Vortex in the Play of Theatre with the Real Passion (for Kay Stockholder)"
 and installation "Pictures at an Exhibition." Kunstmuseum Sankt Gallen,
 Saint Gall, 2000

Selected Group Exhibitions

"Dijon/Le Consortium Collection." Centre Georges Pompidou, Paris, 1998
"Unbound: Possibilities in Painting." Hayward Gallery, London, 1994
Whitney Biennial. Whitney Museum of American Art, New York, 1991

I started out as a painter, but I was very interested in the material of the canvas itself, and I liked to place pieces in relationship to each other on the wall, so that the wall became part of the work. When I was in graduate school, at Yale, I got interested in trying to think about the space in *front* of the wall, that volume of air, and the way the space between the various panels of color on the wall became charged as you read from one to another. It was a very pictorial way of going about things. The pictorial as I understand it implies a certain passivity in the viewer, as well as something time-less and removed. Moving through space, on the other hand, and being aware of mate-rial, involves a time-based experience and the memory and accumulation of different views. The way this pictorial thing I do meets that more time-based experience is what I find exciting. My work isn't rectangular and it isn't framed, but it does rely on the rectangle and on framing—on people having some sense of framing in their minds, and some sense of what the pictorial is. The thing that I find most exciting, though, and that first brought me to artmaking, was color. My works are often concerned in some way with how to present color and make it physically and spatially significant.

The Lion, the Witch and the Wardrobe, from 1985, takes its title from one of C. S. Lewis's Narnia books, a children's story in which a bunch of kids disappear through the back of a closet into a fantasy world. So for this piece, at Artists Space in New York, I made a cut in the wall to reveal the tool room, where the floor isn't painted gray the way it is in the gallery, and there's no Sheetrock on the walls. Instead I painted the gray of the gallery floor up the tool-room wall. To me that implied that the floor was to be considered as a whole object in the gallery, like a lump of concrete. In cutting that hole I felt like I was cutting a hole in my work's foundation: the space was pretty funky, it was down in the basement, but it still depended on the gallery veneer. We assume white walls mean neutrality; my work depends on that convention, and on its own status as art. But at the same time I'm angry at the remove imposed on the art object by virtue of its art status.

So I developed installation as a way of working. I had no desire to keep objects, and I had no place to store them—I had a small apartment, I couldn't afford a studio, and I didn't want to be in a position of having to find a gallery space in order to work. So I had to figure out what to do in my studio, which was in my apartment. I began by making some small pieces in papier-mâché. All of the works from that time, around 1987, use some combination of sounds, materials, paints, and papier-mâché. It took me a year and a half to be happy with anything I was making. I made a studio-full of smaller pieces, and then I made a group of pieces in what I call furniture scale. *Kissing the Wall #1* [1988] has a light on it that makes a green circle on the wall. The space between it and the wall is charged and active. For me this was an exciting thing to discover: although this work isn't site-specific in the way *The Lion, the Witch and the*

Growing Rock Candy Mountain Grasses in Canned Sand. 1992. Installation at Westfälischer Kunstverein, Münster. Synthetic polymer paint, Spandex, sandstone native to Münster, gaseous concrete building blocks, plaster, basket material, electrical wiring, three very small lights, newspaper glued to the wall, metal cables, and Styrofoam, overall: c. 95' x 29' 6"

Wardrobe was, it's specific in its relationship to a wall, it calls attention to the space between itself and the wall, and as a result it becomes less a precious object, more an event. Also this furniture scale addresses the body in some way.

When you use gooey paint, where the colors get mixed up, it's hard to maintain a sense of the color as an object. I tend to use hard-edged pieces of color because I like the color to feel objectlike. So, in this piece I made in 1993, there's a yellow piece of stuff next to an orange garbage-can piece of stuff. In *Making a Clean Edge*, at P.S.1 in 1989, there was a turquoise shelf made out of Styrofoam, and on it were a lot of oranges and fluorescent lights. I thought of it as a still life. Because of the space, you couldn't get far from the work, so in some sense it was unavailable to see fully. *Making a Clean Edge* was in some ways about the difficulty of full understanding, about exploring thought processes, where ideas come from, and how complicated the mind is. When you feel you understand something and have it thoroughly explained, in some sense you've limited it; the explanation defeats the fullness of the experience.

Certain kinds of ideas, and ways of thinking developed over time, carry me from one work to the next, but my work is most valuable when I continue to put myself on unknown ground. In some large way, I don't know what I'm doing. That's what's exciting. My work is about creating a place for experience rather than illustrating an idea, and the things I have to say about it come after the process of making it. Some elements are wonderful for me and some aren't, but I don't know why. And whether I'm making a work in the studio or an installation piece, I don't know what it will be like. It isn't made until it's made, you know? For the installations I have to have some plan, to order materials and to make use of others' help, but the plan is really a recipe for activity rather than a way of telling what the piece will be. I feel some affinity to Allan Kaprow in that sense; he made recipes for Happenings. The recipe might have been interesting to read, but it didn't tell you what would happen.

Growing Rock Candy Mountain Grasses in Canned Sand, done in Münster, Germany, in 1992, presented no reason to move through it—it was like coming into a fishbowl. There were skylights above. There was no other room to move into, which was a little difficult for me; I tend to take advantage of traffic patterns. But I just went with that and put a huge volume of violet Spandex in the middle of the room. This shape addressed the objectlike quality of the ceiling. There was great pleasure in that amount of violet in the room, reflecting everywhere; the piece was beautiful, I think, in a way that most of my work isn't—not that my work isn't beautiful, but usually in a different sense. For me beauty generally involves a struggle, a stretching of what is comfortable aesthetically.

In most of my work, such as *Flower Dusted Prosies* at American Fine Arts [New York, 1992], you come in, walk through, and feel as if you're seeing the whole work. Well, you're not. The work involves the process of moving through it. You get that feeling from many different places, but it's a feeling of things cohering

compositionally and pictorially; in *Flower Dusted Prosies* that never happened, you always felt like you had to keep moving to make sense of what you were looking at. I felt that was an achievement, it was something I really appreciated, though I'm also quite wedded to the feeling of distance that's involved in not feeling you know what you're looking at.

I don't want my work to be atmospheric. I don't think of myself as making environments; although the work is often inseparable from the space it's in, it is a work in that space. I'm interested in maintaining some sense of the difference between what I do and the space. I like my work to be seen fluidly with what's outside the gallery; I always like to bring in as much of the rest of the world as I can, which is why I use all the objects I use. But the work is art, and needs to be defined as art to be understood.

I like to make use of what's available. I don't spend my time looking for exactly the right piece of furniture or exactly the right bucket. In some sense what material I use doesn't matter. I could make work out of any material. I don't spend my time judging it very much. On the other hand, certain themes, and kinds of narrative (for lack of a better word), clearly appear through the history of my work. That's much more difficult for me to talk about, not because I'm keeping a secret but because I know less about it. I think of the meanings that arise among the objects I use as similar to the

meanings of images in dreams. There are many interpretations and stories about a dream; there is no one true interpretation. And any single image or object in a dream means something different depending on what part of the dream you're looking at. My work is an exploration of what meaning is in that sense, and what the possibilities are.

Stockholder in her studio, 2003

169

Born 1946 in San Diego, California. Lives in New York

DAVID REED

Selected Solo Exhibitions
"David Reed: You Look Good in Blue." Kunstmuseum Sankt Gallen,
 Saint Gall, 2001 (traveling)
"David Reed Paintings: Motion Pictures." Museum of Contemporary Art,
 San Diego, 1998 (traveling)
"David Reed." Kölnischer Kunstverein, Cologne, 1995 (traveling)

Selected Group Exhibitions
"Painting Pictures: Malerei und Medien im digitalen Zeitalter." Kunstmuseum
 Wolfsburg, 2003
"Pittura/Immedia: Malerei in der 90er Jahren." Neue Galerie am Landesmuseum
 Joanneum, Graz, Austria, 1995
"Going for Baroque: Eighteen Contemporary Artists Fascinated with the Baroque
 and Rococo." The Contemporary and the Walters Art Gallery, Baltimore, 1995

DAVID REED April 2, 1996. Studio, TriBeCa

The way I construct a painting doesn't have to do with composition. If a painting is composed it is treated as a whole, with borders that separate it from the world and parts that relate to each other internally. Instead, I want the borders of my paintings to imply extension. I paint thinking of film—camera movements, pans and zooms, cuts between camera angles, a changing focus, fades and flashbacks.

My paintings are becoming a bit more rectangular now, but generally I have worked in long, extreme formats, whether horizontal or vertical. This was one way to avoid traditional composition; I wanted viewers to feel that they were putting the paintings together themselves. I love it when people see my paintings and they're off-balance. I like it when a painting doesn't balance, doesn't make sense. The long format breaks the composition apart. Critics have written that the format of my paintings refers to CinemaScope, the film format, and I agree that there's a connection, though I wasn't consciously thinking about it. To me, the best part of CinemaScope is the edge of the frame. Motion either from the camera or within the scene is what is important, not composition. In Budd Boetticher's great CinemaScope B-western *Ride Lonesome*, the camera follows Randolph Scott and Pernell Roberts, the bad guy, as they slowly ride across the desert. While they talk, *mescaleros* appear over the top of a hill, in the distance, far to the left of the screen. We are aware of them long before Scott and Roberts and I love the anxiety of this moment—the pause, which then leads to more movement and emotion. I try to involve a viewer by breaking out of the boundaries of the painting, out of the frame, invading the room, going sideways, being active. I want these effects to work psychologically as well as spatially, so that emotions are activated.

I've always admired the way some painters physically break the framing border. I've discovered that another kind of breakout can occur *inside* the frame: a mental breakout. The painting can seem to crack open, creating leaks out into the room. References to video, film, or photography further help this breakout by invoking various types of movement, physical and virtual. These connections to newer media offer alternatives to traditional painting language. Since these media move or imply movement, they represent continuity in a different way—continuities of both time and space. Events, even objects, are cut together or apart in time. The edge loses its physicality. Instead of a boundary, an end, it implies extension. The surface is not bound. It is a screen that can open in any direction.

I like it when people think my paintings are made by a photographic process. "What is that weird thing?" You know, they don't know what it is. Then the paintings have lost their traditional context and are available to be seen freshly, in ways that are more emotionally present.

I had a show at the San Francisco Art Institute in 1992 and didn't want to just send New York paintings. Originally from California, I wanted to make a connection to the place. We uncovered the skylights in the exhibition space and I thought about

Two Bedrooms in San Francisco (Scottie's Bedroom). 1992. Frame still showing #297, 1989–91.
Oil and alkyd on linen, 26" x 9'

California light—the harsh contrasts of light and shadow. John McLaughlin is my favorite California painter and the value contrasts in his work, often between black and white, relate to this California light. I talked about this with a friend, Nicholas Wilder, who had a wonderful comment: he said that McLaughlin was a bedroom painter. I loved that idea, and it was then that I realized that my ambition in life was to be a bedroom painter.

The show's curator, Jeanie Weiffenbach, told me that Scottie's house in Alfred Hitchcock's *Vertigo* was a couple of blocks from the Institute. So when someone asked the obvious question, "What bedroom do you want your paintings to go in?," what came to mind were the bedrooms in *Vertigo*. One of them, in Scottie's house, is dark with modernist furniture. It's where he takes Madeleine/Judy after she tries to drown herself in the Bay. Scottie undresses her in his bed. The other bedroom is where Judy lives in the Hotel Empire—a room often filled with turquoise light from the hotel's neon sign outside her window. It's where they make love. So I digitally inserted one of my paintings into a frame still from the movie—you know, fulfilling my fantasy. Then, in San Francisco, I put that same painting in the show over a replica of Judy's bed. Later, for a show in New York, I inserted a painting into a video loop of the scene in Scottie's bedroom, again hanging the same painting over a replica of the bed. One could see the painting in the gallery over the bed and also in the video loop. I had started by thinking of the bedroom as a physical and intimate, private space, then my thinking jumped to these strange nonphysical memory spaces. In some way we all share these bedrooms from Hitchcock's *Vertigo*. We can live in them together. Paintings are finding a new home in such in-between places.

I'm fascinated by lurid, artificial color. We all spend quite a bit of time looking at this kind of color, on our computers and TV sets and at the movies. Something in it appeals to us—means something to us psychologically. These are new colors that don't yet have clear meanings. It's so amazing that there are new colors in the world and artists can be the ones to define them. Painting has a great tradition of using color and giving it meaning. These old meanings and techniques can be combined with this new artificial color. Caravaggio would have happily given the arm he didn't paint with for a tube of Phthalo Green. And I can barely imagine what Andrea del Sarto would have done with permanent rose and his cobalt blue as changeant colors. I love it that we get to be the ones to exercise the new connotations of color.

In 1995 I worked on a project organized by Lisa Corrin of the Contemporary in Baltimore at the Walters Gallery, the old master museum. I chose to work with two Baroque paintings in the collection, excited to analyze the color. I love the color in Baroque painting because the painters try so hard to have a wide range of light to dark, warm to cool, and also of hues. This extreme color can show dramatic, even otherworldly effects of light. The paintings I picked have that kind of light. Dominico Fetti's painting has two angels looking up at a vision in the sky that radiates golden

light. The colors of their robes are reflected on their skin, but the emphasis is on the mystical light. The other painting I chose, by an anonymous artist, is similar: the body of a dead saint glows with a muted light as it lies out in a landscape. In both paintings the internally generated, mystical light coexists with naturalistic directional light that then seems to also have religious significance. God's mercy can reach us all. Our technological light, projected and emanating from behind screens, glowing from many artificial sources, and reflecting off of many surfaces, also seems to reach everywhere. We live now and move through spaces that are filled with this light, and that have the same sense of multiple light sources as do those Baroque paintings. This technological light is our equivalent. In Baroque paintings of, say, the conversion of Saint Paul, the light, like a spotlight, comes from God. Figures move in this light, fight against it or go along. The light seems beyond the human, as does technological light today. We have no choice but to move through this light trying to keep our humanity. We have to deal with it.

I saved one of those paintings from the basement of the museum. It had never been shown or cleaned. To my surprise, a lot of visitors told me they preferred the dirty painting, because it looked like an old painting should look. The other painting, which had what I thought of as real Baroque color, was too bright for them. One guy even said that the painting looked like a depiction of a nuclear explosion. But that's just the kind of color effect I want.

My paintings are about movement, certainly—movement made still. They're getting closer to being human, almost embodied—it's as if light were becoming a body. I think they have a lot to do with a kind of changing being, a coming into consciousness, coming into form. That's one of my advantages as an abstract painter: the Baroque painters depicted objects by having the light falling on them, they had to use their range of value to model forms, they couldn't have light turning into an object in the way that I can. Since my paintings are abstract, I can have light, I can have form, and I can make them, in various degrees, turn into each other. It seems to me that this is the way our lives are now: the boundaries of our bodies aren't really there anymore. Sometimes I wear a hearing aid, so I feel like I'm part machine. Certainly when we're watching a movie, empathizing, when we're using a camera or a computer, we become part machine. So we have a strange relation to our bodies now, and to our consciousness. Where do we begin? Where do we end? What are we becoming?

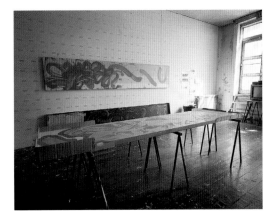

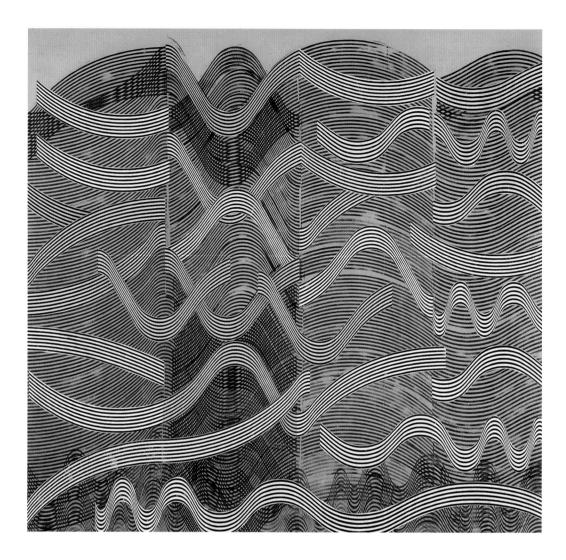

Born 1950 in Elizabeth, New Jersey. Lives in New York

PHILIP TAAFFE

Selected Solo Exhibitions
"Philip Taaffe." Galleria Civica di Arte Contemporanea Trento, 2001
"Philip Taaffe." IVAM, Centre del Carme, Valencia, 2000
"Philip Taaffe." Wiener Sezession, Vienna, 1997

Selected Group Exhibitions
"The Mountains between Art and Science: From Leonardo to Beuys."
 Museo d'Arte Moderna e Contemporanea di Trento e Rovereto, 2003
"Ornament and Abstraction." Fondation Beyeler, Basel, 2001
"The Birth of the Cool." Kunsthaus Zürich, 1997

My first real body of work, which I started in 1980, was done in bookbinding tape on single sheets of paper. The idea was to make an architectural fantasy using only straight lines. I worked on the series for a couple of years, putting on tape, removing it, and changing it so that every point in the work moved toward an expression of infinitude. For me these were enormous spaces—I was thinking of walled medieval cities, and of certain Constructivist works of self-contained abstract composition.

These early works were labor-intensive and rigorously composed. They developed over a period of weeks and months. After I'd made maybe twenty of them I moved into the idea of large-scale collages. I was collecting paper from various sources—touring wastepaper-disposal plants, taking printer's end runs, and studying all this material to figure out some way of building imagery out of it. I wanted to work on a larger scale and to expand the possibilities of collage. *Martyr Group* [1983] is the first of the big collages, and it was a radical break from previous concerns with straight lines and imaginary architectures. I wanted to get outside that self-referential field of inquiry. *Martyr Group* was inspired by thirteenth-century outdoor frescoes from the Moldavian Valley in Romania, paintings of saints in rows. It's quite large, almost nine feet square.

Around this same period I also began to make optical works, collages with an unwieldy, distended surface that had an almost sculptural quality. They were done after Bridget Riley, and I decided that I would also try to examine, or make homage to, or somehow recapitulate, certain works of Barnett Newman. I needed to see what I could do with this idea, because I was always very focused on New York School painting—Mark Rothko, Clyfford Still, Newman, and to a lesser degree Jackson Pollock. *We Are Not Afraid* [1985] is after Newman's painting *Who's Afraid of Red, Yellow and Blue II* (1967). It's the same scale, but the vertical lines are printed from linoleum carvings—the same method I'd used to make the optical collages. To take the Newman zip and handle it almost physically, yet illusionistically too, was something I needed to see at that time.

I made *Written on the Bay* [1988] after an Ellsworth Kelly painting called *Bay*. I was living in Naples, where there are old Roman anchorages, and I made my version of Roman anchors out of cut pieces of cardboard, creating a relief surface; then I used an encaustic material (similar to large round crayons) that I made myself to transfer their impression onto paper. I wanted to make a connection between Douglas Sirk, the Bay of Naples and the anchorages there, and Ellsworth Kelly. *Cappella* [1991] was inspired by the decorations in the Cappella Palatina in Palermo, Sicily. Again, I made cardboard plates to print from, collecting images to make a composition related to a historical place or cultural location that I wanted to reenter in my own way. I tried to draw out a narrative from these possibilities. *Cappella* was also related to some of the earlier optical works I'd made.

North African Strip [1993] is taken from templates I found in Morocco that are used by furniture makers to draw designs onto tables, shelving, and doorways.

I collected these templates, turned them into relief plates, and made prints from them to create this woven space. One part of the work is left open, to give a sense of a window to move through. I used these impressions in a structured way, to push the capabilities of the arabesque idea.

I based *Tsuba Colony* [1995] on a form of samurai ornament—the tsuba is the Japanese sword-guard. I've had an interest in this form for quite some time, and I made relief plates that I used in a very scattered way. *Tsuba Colony* is a work that I'm completing right now, using Razor Ribbon that I silkscreened onto very thin paper. It's carefully composed, but it has this overall feeling of moving off the edges. When I first arrived at this idea, I immediately went out and acquired some of this Razor Ribbon material—I took many photographs of the coils, then made quite large silkscreens from these photographs. The two layers of the painting together are a kind of historical comparison: I wanted to propose a meditation on Japanese swordmaking (which was very advanced as long ago as the twelfth century), and equate or oppose that with Razor Ribbon, which we all know as an insidious new way of keeping humans at bay. I set up what I would describe as some sort of metallurgical narrative in this way.

I suppose I have a natural inclination to do things in a deliberately Zen-like way. I like to define the parameters of a work indirectly, by gradually eliminating considerations that are not essential to what needs to be stated. Also, a lot of my work is ritualistic, and is developed in clearly distinct stages. Perhaps for some of these reasons that I myself don't completely understand, I feel comfortable involving myself with certain forms and images from Asian cultures.

The snake motif of *Spiraloom* [1996] is very recent. I think it involves my identifying with something that has had the capacity for being culturally defined as divine and evil at the same time, and with how the snake impresses me as an evocative calligraphic line. I'm trying to see how this straightforward symbolism can be activated in the kind of work I do, which is usually more architectonic.

I'm a great admirer of Jean Arp. The American artist Charles Shaw had a relationship with Arp's work in the 1930s, and I was curious to have it again. It has to do with Dada, obviously, and with an American bringing about a synthesis of abstract and Constructivist attitudes toward Dadaist thought. I think there is a consciousness here of being once removed or displaced from the central phrasings of twentieth-century art.

Someone told me recently that they thought my work was related to the composer Scriabin. I love music, and I'm interested in many different kinds of music, but I've never been able to find a parallel. I tried to study Kandinsky and Klee, to see what they had to say about this, but I never could get it: I always feel that no matter what I do, painting for me is about silence. Music is tangential, peripheral to the visual experience, and I cannot make that equation: I've never been able to say that there's a parallel in sound. Painting is rhythmic, yes. *Inner City* [1993], for example, has what

I would call riffs—these energy points that come out of certain parts of the painting, and coalesce and collide and make an aggregate experience in time as we move from one part of the picture to the next. There are these interrelationships and connections and rhythmic bounces to the painting. The rhythm is very important; the painting has to move. It has to have a kinesthetic reason to exist. That's how I compose the paintings: every part has to be activated, has to have energy. If a composition is flat, or if it's boring in certain parts, the whole thing falls apart. Every part of the painting has to be alive. I try to work on every part of it and turn it into a unified whole. I'm very traditional in that sense—it's a desire I can't get around.

I think a painting has to be exemplary. By this I mean that a work of art has to demonstrate certain findings that can lead to the opening up of further possibilities or outcomes. Doing this requires taking a great many things into consideration. A painting should come out of a grand synthesis of visual forces and ideas. Twentieth-century modernism has been a series of ruptures: it was about abrogating belief, about consuming and moving on to the next thing and dismantling what went before it. My attitude at the end of the twentieth century has more to do with healing, storytelling, and craft. I think there is far more potential in this, more along the lines of what we need to look at. Artists can help us come to terms with an understanding of how we're supposed to live and build a future and behave and look after ourselves in the world. I think art can be exemplary in that sense.

Taaffe in his studio, 2000

Born 1949 in Bangor, Wales. Lives in London

RICHARD DEACON

Selected Solo Exhibitions
"New World Order." Tate Gallery, Liverpool, 1999
"Richard Deacon Esculturas 1984–1994." MACCSI, Caracas, 1996 (traveling)
"Richard Deacon." Bonnefanten Museum, Maastricht, 1987 (traveling)

Selected Group Exhibitions
"A Quiet Revolution: British Sculpture 1965–85." Museum of Contemporary
 Art, Chicago, 1987 (traveling)
"Correspondentie Europa." Stedelijk Museum, Amsterdam, 1986
"An International Survey of Recent Painting & Sculpture." The Museum
 of Modern Art, New York, 1984

I attach importance to the idea that I'm a sculptor. I'm not particularly dogmatic about it in relationship to other people, but for me, the activity of making sculpture has to do with making objects—with being able to make objects that have meaning. Certain consequences arise from that task or preoccupation. It seems to me that what I have tried to do is put meaning into objects rather than use meanings that are already inherent. Materials are a component of what I do; they're not the end product. They contribute significantly to the work, but they're not the work itself. The notion of an object has interest for me—the way in which an object is an object, and what makes an object different from not-objects.

In the '80s I wanted to make objects that weren't defined by their own making. I wanted the object to have the capacity to have a meaning. And it seemed to me that one way you could do that was by trying to make the object empty, and allowing the center of the object to be the container for meaning and the outside of the object to be where its objecthood, its physical reality, was placed. If you take a sheet of paper and roll it up, the rolling up, which is a sort of work, creates a structure in the paper, which previously had a fluidity of form. The relationship between the volume enclosed, the active work, and the paper—that combination of three things is interesting to me. And the fact that the rolling up encloses a particular volume that isn't defined by the material but is related to the material in a particular way—that too is something of interest to me.

There is a neutral position where the object is not in balance or out of balance but is in-between. A curving relationship to the ground is characteristic of this sort of neutral balance, and somehow there's a sense in which that curving relationship to the ground, and the neutrality of the equilibrium, emphasizes the object's autonomy. Perhaps you'll have noticed that a lot of the work I've made tends to have that kind of curved relationship to the ground.

I'm interested not in all materials but in certain kinds of materials. And the materials I'm interested in are capable of deformation, of being bent or twisted or built up or added to. They have the capacity to be manipulated or transformed. I'm not interested in materials that are solid, lumpy. I'm also not interested in materials that are fluid, like water. What interests me is a material that has some flexibility but is dimensionally stable and therefore seems open to being manipulated, nudged, played with. It has some structure, but my engagement, or the activity of working, plays with that structure.

A lot of my early works in the '80s were based on a notion of trying to make a volume that had "resonance" (this was the word I used). I talked a lot about speaking and listening as metaphors that I found worked in the sculpture I wanted to make; meaning was generated by a sense of resonance, so that the enclosure was akin to the sounding box in a musical instrument. Toward the end of the '80s the things I was making began to move slightly away from that: I became interested in making work

that was solid, that had a complete form, that was less skeletal than the things that went before, and I began making work in clear plastic. It also began to be necessary for me to make molds or patterns for the works that I was making, and then at some point I became interested in what the patterns were; it became intriguing to me that you'd make something and then throw it away. The status of the thing that you made became of interest to me. So in the last show I had in New York, in 1992, two of the works were fairly solid wooden forms, and the genesis for those was this pattern-making.

The way I've tried to both make and select the work in this exhibition five years later has been to try to make a group of objects that are one-of-a-kind, or represent a type of landscape, or a particular type of thing. Each of them is made using one material and one procedure. They're all at a scale that allows you as viewers to imagine yourself above the imaginative landscape that the work creates. The sense I wanted to get was that from this kind of overview of a landscape, you have works that put you in a different position, change your size. Your sense of being above the work is then reduced; now you're below or smaller than the work. So your physical sensations, your sense of your body size, your sense of your position, are in flux. The objects, then, are as much about interpreting you as you are about interpreting the objects.

The forms I've been interested in have a certain fluidity to them, a certain unformed-ness. They reflect the classic artist story about reading the shapes in the fire as a source of imagination, or the way Rorschach blots are used as a way of looking into the imagination, a kind of testing device. #8 and #9 [both 1997] are made of steamed beech, it's a fairly laborious process. I was thinking about Swiss cheese, and intrigued by what might happen if the holes in Swiss cheese became so big that there was very little cheese and a lot of hole. I began to try to make work like that, and these are versions of that idea. What's interesting is that as you look at them, your eye moves from seeing the inside to seeing the outside. You're imagining what it would be like to be inside the thing. You have this quite dynamic relationship to the object.

What was interesting to me about the materials was a sense of their being able to be manipulated. There was also a sense in which they were between solidity and fluidity; the forms I'm interested in are equally between one thing and another, the kind of object I'm interested in making is between me and the world, and the kind of balance I'm interested in is between stable and unstable. It's that sense of the in-between, and the possibilities that the in-between raises, that I think drive the work I do.

I think these objects act as triggers for a capacity to engage with the object, and to find reference within the object, but also, in their very specific physicality, they inhibit pure associative free-wheeling. There are points to which you come back. These are substantial physical objects. Also, on another day, I find them quite medieval in their construction.

I began the "Art for Other People" series in 1982. The objects were intended to be small in scale and independent of special conditions—they could go anywhere, in

other words. I thought of them like letters. Larger objects often play off the relationship between the space outside and the space inside, which doesn't happen with the smaller works. And a part of the way you look at the larger objects is conditioned by your awareness of the walls of the room, and the sense of the relationship between the interior-exterior of the object and the interior-exterior of the room.

To make the bentwood pieces I steam and bend the wood in a jig. It's quite a magical process, because it's a solid piece of wood that you're bending, and there's about thirty seconds when it's flexible. It has a kind of fluidity to it, and it doesn't break—it's really quite extraordinary to watch. A lot of the work that I do enjoys the moment when solid becomes flexible and then goes solid again. It's as if the world momentarily becomes less determined than otherwise, and then becomes re-formed again.

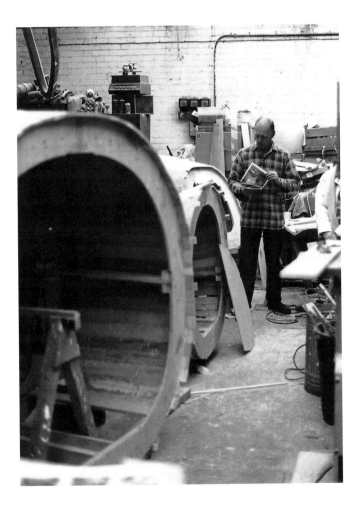

Deacon in his studio, c. 1990

Born 1949 in San Francisco. Lives in New York

DAVID LEVINTHAL

Selected Solo Exhibitions
"David Levinthal: 1975–2001." Asheville Art Museum, North Carolina, 2002
"Small Wonders: World in a Box." Detroit Institute of Arts, 2001 (traveling)
"Girlfriend! The Barbie Sessions." San Jose Museum of Art, California,
 1999 (traveling)

Selected Group Exhibitions
"Pictures from Within: American Photographs, 1958–2002." Whitney Museum
 of American Art, New York, 2003
"MoMA 2000: Open Ends." The Museum of Modern Art, New York, 2000–2001
"Made in California, 1900–2000." Los Angeles County Museum of Art, 2000

I've been photographing toys since about 1972. I got started when I was in graduate
school at Yale, where one of my classmates was Garry Trudeau, who's much better
known for his comic strip than for his graphic design. In 1977, though, Garry and
I did a book together, *Hitler Moves East*, which unbeknownst to us made us the pre-
cursors of what is now a movement among postmodern photographers to construct
their own imagery. At the time, we were just two twenty-four-year-old kids who were
very excited about an idea: we were attempting to create pseudo-realistic imagery
of the Eastern Front during World War II. We tried to make images that when you
looked at them closely were clearly toylike, and to have the viewer of the book try
to distinguish between reality and fantasy.

A series called "The Wild West" [1986–89] marked my first use of the twenty-by-
twenty-four-inch Polaroid camera. Here I was attempting to deal with the mythology
of the West; I'm a child of the '50s, when just about everything on TV was a western.
The twenty-by-twenty-four camera is a perfect medium for working with toy figures,
because just the slightest movement of one of them can completely change the image.
The camera also lets me see and respond to the image instantly. *Untitled, cowboy
hanged from tree* [1988] is a photograph from this series that has always intrigued
me. I used a cowboy from an Italian box of toys; somebody must have said, "Let's
mass-produce a man hanged from a tree as a toy for children to play with." In toys,
I've found, there's no end to the amazing things that are already made for you.

In these photographs from 1988, '89, I used a background that I could shine
light through, which gave me a sense of depth that I liked very much. Although the
photographs have very few elements, we tend to fill in a lot of information because
the imagery is so iconic: it's really just a cowboy on a horse, but there's this whole
sense of the southwestern desert or somewhere like that, simply I think because we're
accustomed to associating these images with that kind of background. For the western
series I watched John Ford's film *The Searchers* a lot, because it has this wonderful
sense of the color you get in Utah and the Southwest.

The "Modern Romance" series has always been a favorite of mine. It was actually
done before the cowboy series, using SX-70 Polaroids initially and then later incorpo-
rating a video camera to help frame the photographs. I took the figures from model-
railroad sets—I was never quite able to explain to people why model-railroad companies
made little figures of naked women, that's one of the great mysteries of contemporary
art, but I'm grateful that they did. When I first got to New York, in 1983, I would sit
home at night and build little HO-scale buildings, very quickly filling an area almost
as large as a tabletop. The series was extremely influenced by Edward Hopper's work,
which I love, and also by film noir. Later, in an effort to make the images larger, I
put them on canvas, using a scanning process, so that they became very much like
photorealist paintings. Again, as in the "Wild West" series, there are surprisingly few
elements in each photograph, but the imagery is so evocative that I think we tend

Untitled, from "Blackface" series. 1995–98. Polaroid Polacolor ER Land film, 24 x 20"

to fill in the blanks. The little figures are about a half-inch tall. I used to move them around with tweezers. A college friend who's a psychiatrist used to tell me, "Life must be so satisfying when you can move everyone around with tweezers."

The "American Beauties" series [1989–90] is back on the twenty-by-twenty-four camera. It's based on a series of eight or nine figures that the Marks toy company made in the late '40s or early '50s. They weren't made for sale—they *couldn't* very well be sold: Louis Marks, who owned the company, had lunch every day at 21 in the days when it was an all-male club, and he had these semiclothed plastic female figures made to give to his friends. They were collected over the years and given the name "American Beauties." I found some at a flea market, and then a toy dealer said, "Oh yeah, these are the 'American Beauties,' you can now get them as a whole set from various and sundry dealers." They're about 3 1/2, 4 inches tall. They very much fall into the Marilyn Monroe, postwar aesthetic of beauty.

The series called "Desire" [1990–91] came about when I ran into a dealer at a toy show who said, "Well, if you think those 'American Beauties' are sexy, you ought to see the stuff you can get in Japan." It took me about nine months to get hold of this catalogue, from a very small company whose stationery was a white sheet of paper with no return address, and every once in a while I get these little brown packages in the mail containing plastic dolls of Caucasian women in bondage. They're made in Japan and called "adult sexy fantasy figures," so already you have a lot of sociological issues going on. The dolls are six inches tall, and if you'll pardon the pun, they're very crudely made—badly manufactured: they're polyurethane and you had to glue them together. But their poses were so strange—I found them incredibly intriguing. In fact I was very intrigued by the whole idea of the iconography of sexuality as one was exposed to it in New York in the '80s and '90s.

By using a dark background, I felt I could get these figures to seem to emanate from the blackness, making them even more mysterious and sensuous. When I showed this work here in 1991, somebody came up and asked me which ones of these were real and which were toys. I said, "Well, I really don't know anyone well enough to ask them to pose in this way—so they're all toys."

The "*Mein Kampf*" series [1994–95] is about Nazi pageantry during the Holocaust. It came about, in large part, because when I was spending a lot of time in Austria I came across a small toy figure of Adolf Hitler, and it wasn't from the '30s or '40s—it was a contemporary figure. So I was able to find this man in Germany who had the molds of these toys and was remaking them and painting them by hand.

At first I was interested in creating what I call a Leni Riefenstahl type of feeling about Nazi pageantry. As I kept working on the series, and doing, as I always do, a lot of visual research, I became intrigued about the idea of incorporating some of the imagery that I'd seen of the Holocaust. When that happened the series really took a dramatic turn. I would say 60 percent of it is Holocaust-related imagery, and the

combination of the two under the title *"Mein Kampf"* seemed to me to create a very interesting dynamic between the two sorts of imageries.

The first shot that I did of the Holocaust part of the series was one of those, I hate to say, epiphanies: when the print came out of the camera and we tacked it up on the wall, it was just so powerful that I realized I really wanted to devote a lot of time to this area. Many of these images are based on historical photographs, or are an attempt to reinterpret them. In one of my favorite photographs in the series, off to the right there's a trench filled with bodies that become somewhat abstracted but more and more readable as one looks at them. I did this as a way of synthesizing the many photographs I'd looked at of men being taken into the woods and shot on the Eastern Front. This particular image I feel captures much of the feeling of the whole series, it has power and presence and at the same time a certain abstraction as well.

With my most recent series, "Blackface" [1995–98], for the first time in my career I find myself surrounded with controversy. This work, which to me is extremely powerful, takes what is now often called "black memorabilia" and treats it almost as iconic sculpture. There's such an incredible field of objects to choose from: some of these images show objects dating from the 1800s, while a cookie jar in a photograph from the beginning of the series was produced in 1992. So this is an ongoing phenomenon in our culture.

I tend to be very object-driven, but the "Blackface" series came about because I had the idea of basing a series on the D. W. Griffith film *Birth of a Nation* [1915].

The one thing I didn't have was black figures, so I went to a big toy show and bought a lot of those—and came away feeling that these were fascinating objects in and of themselves. I began researching them, finding more objects, and honing my direction. All of these things are lumped together under the title "black memorabilia," which I think is a misnomer: one could just as easily call them "white memorabilia," because the objects were made by whites, for white society, to perpetuate the stereotypes. I felt that this series would provide the springboard for discussing issues that unfortunately have as much need to be talked about today as they did many years ago.

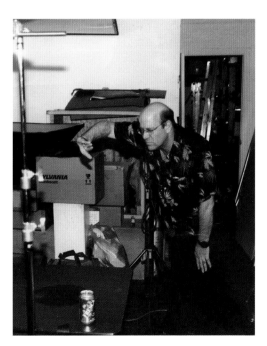

SHE HATH GOOD SKILL AT HER NEEDLE...

This rag of scarlet cloth assumed the shape of a letter. It was the capital letter A... Each limb proved to be precisely three inches and a quarter in length.

A

The SCARLET LETTER, *so fantastically embroidered and illuminated upon her bosom, had the effect of a spell, taking her out of the ordinary relations with humanity and enclosing her in a sphere by herself.*
— NATHANIEL HAWTHORNE

Born New York. Lives in New York

ELAINE REICHEK

Selected Solo Exhibitions
"At Home & in the World." Palais des Beaux-Arts, Brussels, 2000 (traveling)
"Projects 67: Elaine Reichek." The Museum of Modern Art, New York, 1999
"Home Rule." Irish Museum of Modern Art, Dublin, 1993 (traveling)

Selected Group Exhibitions
"House Guests: Contemporary Artists in The Grange." Art Gallery
 of Ontario, Toronto, 2001
"Referencing the Past: Six Contemporary Artists." Addison Gallery
 of American Art, Phillips Academy, Andover, Massachusetts, 2000
"Labor of Love." The New Museum, New York, 1996

My work takes several different forms: photocollages, installations, hand-painted photographs set beside knitted copies of their subjects, and embroideries. The photographs I use come from a lot of different places, including Hollywood movies, documentary photography, and family snapshots, but the most important single source is ethnography. The thing that attracts me to ethnographic images is largely the fact that I'm suspicious of them: I'm troubled by their pretense to be objective records of different cultures when in fact they're deeply invested in the code of Western science and the code of photographic representation. Both of these codes imagine themselves as conveying matter-of-fact truths about the world. Actually, though, both are only one way of seeing among many possible ones.

Some viewers of my work may think the imagery I use is somehow quaint or charming. They don't see photographs of body-painted Tierra del Fuegians every day. Other viewers may be angered by my work because they think it just repeats the unpalatable ethnographic assumption that non-Western cultures are somehow present in the world only as fodder for Westerners to study. Both of these responses miss the point: I'm not really dealing with other cultures in my work, or at least I'm dealing with them in only a qualified way. To an ethnographer, a photograph of a Native American may simply be a record of that person. To me, it is also a record of an attitude implicit in ethnography. All the images I use were produced within Western culture, and they document Western beliefs, morals, and fantasies. What I'm trying to explore and unravel in these works is my own culture's history.

This is probably clearest in an installation I did at the Jewish Museum here in New York in 1994, in which I used embroideries, photographs, and a reconstruction of my childhood bedroom to investigate my own Jewish family's attempt to assimilate itself into American society. Another body of work, based on a group of architectural photographs taken mostly by Walker Evans in the American South, is also close to home. In both, I'm still dealing with the way one culture approaches another, and with the tools used in the encounter, particularly the camera. Evans, for example, was working for the federal government, and his photographs reflected the motives and desires of his bureaucratic employers—but they also put his own subjectivity in play. As he fetishized certain aspects of poor, rural, Southern culture, he was inescapably a visitor, a Yankee, steeped in Baudelaire and Flaubert and determined to make his way as an artist. His pure record was actually his own poetic endeavor, and a fictional construct.

I feel a central issue in American life is how we deal with people not ourselves, or, more particularly, how we deal with people outside the white male mainstream. Since I'm white but not male, I'm both of and not of the dominant culture, and I inherit a vast body of fantasies, prejudices, and bogus notions about what everybody else outside it is like. These ideas are passed on in countless ways, from the family conversations that children overhear, to movies and entertainment, to the values my culture expects me to share about what is worthwhile and what is fundamentally

Sampler (The Scarlet Letter). 1996. Embroidery on linen, 26 ¹/₂ x 12 ¹/₈" 187

unserious—like knitting and embroidery. For me there are parallels between these suppressed media and the subjects of the photographs I use—photos of people in their homes, or of vanished architectures that have been emptied out and extinguished by a culture alien to them. In combining these images in pointed ways in photocollages and installations, or reworking them in hand-painting and knitting, I'm trying to bring out the values encoded in them, instead of letting them lie as unexamined assumptions. I'm also trying to give their subjects some other sense of presence—necessarily artificial but I hope suggestive. My work is not an attempt to prettify an exploitative body of photographs; instead, I deprive the photograph of the illusion of being an objective document. Knitting isn't the most everyday way to create an image, but when you see this knitted shape on the wall, you know that it's an image, if only because it duplicates the photograph next to it. At the same time, its texture and volume make it completely unphotographic. These paired images are the most shadowy record possible of their subjects.

The work I'm making right now is a group of embroideries, part of an installation I'm planning called "When This You See. . . ." That's a quotation from a phrase often used in eighteenth- and nineteenth-century embroidered samplers: "When this you see, remember me." I've been working on this body of work for 2 1/2 years, and I probably have another year to go, so I'll end up with maybe thirty pieces. They don't construct a linear narrative, but there's a consistent theme: they're about the way in which ideas about sewing, knitting, and weaving appear in both literature and the history of art. It's like the return of the repressed: they're not taken seriously as art media, but they're interwoven historically in the culture. I think they carry a great deal of weight.

I studied with Ad Reinhardt, and I sewed up these little Reinhardts, copies of his grid paintings. You think he was making big black crosses? I think he was making plaids—grid equals plaid. My Reinhardts get an embroidered quotation from him: "Starting over at the beginning, always the same. Perfection of beginnings, eternal return. Creation, destruction, creation, eternal repetition. Made—unmade—being made." Who does that sound like to me but Homer's Penelope: "I wound my skeins on my distaff. I would weave that mighty web by day. But then by night, by torchlight, I undid what I had done."

Depending on who's translating Penelope, she's a different person. In the nineteenth century she's waiting. In the twentieth century, in the new translation, she is a match for the wily Odysseus—she's a very strong woman, who makes this work every day and undoes it at night, to keep those suitors at bay. And here's an image from an ancient Greek pot, showing a loom—the kind of loom Penelope might have used. There are different stories about what she was weaving: some say a shroud for her father-in-law, Laertes, some say a story cloth. So she could have been telling her own tale. For the border of the embroidery I made a little Greek frieze, the Greek key pattern. Sometimes I make up my own patterns, sometimes I copy them.

Now, if you weren't reading Ovid last night, *Sampler (Ovid's Weavers)* [1996] treats one of his poems from *The Metamorphoses*. The story of Arachne for me is a story of class. "Arachne was renowned," Ovid writes, "but certainly not for her birthplace or her family." She's got nothing but her work—"Yet consummate work had won the girl much fame. She weaves her pliant golden threads into her web—and traces some old tale." Arachne challenged Athena to a weaving contest. Athena wove the stories of all the good things about the gods; Arachne wove the alternate story—rape, pillage, mayhem. When Athena saw Arachne's weaving, she was infuriated, both by its content and by the fact that it was as good as her own. So she picked up her shuttle and beat the poor girl. Then, just as Arachne was dying, Athena took pity on her and turned her into the spider, weaving and weaving forever.

The first quotation in *Sampler (The Little Work-Tables)* [1996] is from an article by a woman called Jenny June. She was one of those ladies who wrote knitting columns in late-nineteenth-century women's magazines. The sampler pattern is kind of a homey one; there are little secrets in samplers, and this one has my signature—my knitting needles, the initials "E R," and a crown over them. The quote goes, "The little work-tables of women's fingers, are the playground of women's fancies, and their knitting-needles are the fairy-wands by which they transform a whole room into a spirit isle of dreams." But then what are those women really thinking? For that we go to the second quotation, from Ogden Nash: "Knit 2. Purl 1. Hubby 0."

Nathaniel Hawthorne's *Scarlet Letter* is a favorite book of mine. Rereading it as an adult, it seemed to me that the embroidered A that Hester Prynne has to wear, which is meant to stand for "adulterer," could also stand for "author" or for that matter "artist." That's what *Sampler (The Scarlet Letter)* [1996] is about. Hester sews for a living. She is condemned for adultery, and forced to make a kind of badge to wear: "This rag of scarlet cloth assumed the shape of a letter," a capital A. Each limb is 3 $\frac{1}{4}$ inches long, as you can see by the little rulers I've included in the image; in part those are a little joke about Jasper Johns's paintings with rulers in them. Hawthorne's narrator is interesting: he says his ancestors would see him as only a scribbler because he writes novels. Hawthorne's own ancestors attended the Salem witch trials—they were stern stuff. Novels, they would have thought, are books for women. The second quotation reads, "The SCARLET LETTER, so fantastically embroidered and illuminated upon her bosom, had the effect of a spell, taking her out of the ordinary relations with humanity and enclosing her in a sphere by herself." So Hester is outside society—like an artist, she's beyond the pale.

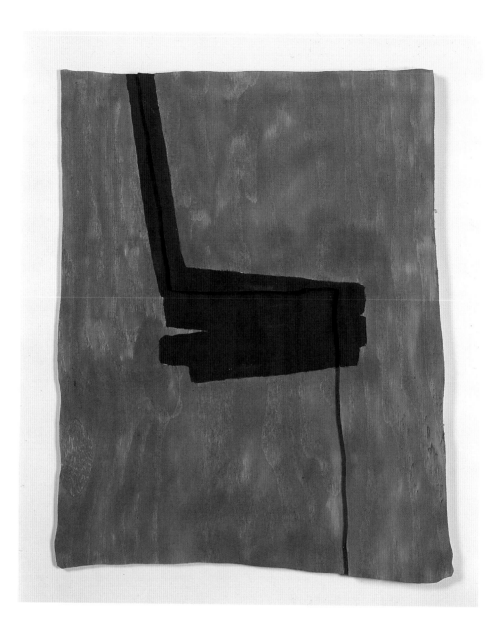

Born 1941 in Rahway, New Jersey. Lives in New York
and Abiquiu, New Mexico

RICHARD TUTTLE

Selected Solo Exhibitions
"Richard Tuttle: cENTER," Centro Galego de Arte Contemporánea,
 Santiago de Compostela, and "Richard Tuttle: Memento," Museu
 Serralves, Porto, 2002 (two-part exhibition)
"Richard Tuttle, Selected Works: 1964–1994." Sezon Museum of Art, Tokyo, 1995
"Richard Tuttle." Whitney Museum of American Art, New York, 1975

Selected Group Exhibitions
Venice Biennale, 1997
Carnegie International. Carnegie Museum of Art, Pittsburgh, 1995–96

Documenta VI. Kassel, 1977

This "New York/New Mexico" show is a predicament. It declares itself in a very rapid way. The rapidness makes mistakes, one of which is I didn't title the show "Conjunction of Color." Each piece is a conjunction of color. I must say I don't know what a conjunction of color means. In grammar we all know a conjunction is an "and," "or," or "but." I think each piece looks like an "and," "or," or "but." Each connects to the verbal world, is offering a transparency to the verbal world.

Since the big revolution after the Second World War, American art has exploited the ambiguity between near and far ground. If you look at Pollock, you don't know whether you're looking at the thing closest to you or farthest from you. The wall surface is half the ambiguity and the painting surface is the other. What's happened in recent years is the wall has died. This didn't matter much because the middle ground was rediscovered. But now the middle ground has died, too—a crisis parallel to a crisis in the whole culture.

So that became something to wrestle with. In my work another plane emerged. As you see, what's going on in these pieces is that you still have this ambiguity of near and far, but now it's between the frontal plane, or overstrate, and the rear plane, or understrate. What's exciting to me is this also gives us a chance to investigate exactly what those planes were originally. In Pollock, where you have the surface of the painting and the surface of the wall, we never really got to know very much about those two planes in the art experience, which destroyed this distinction. But in this show the pictures are always hovering between painting and sculpture, allowing time to distinguish.

Each picture is held up by two nails nailed directly through the bottom plane. Theoretically you can use as many nails as you like, and even slip off their heads while hammering, denting the surface, because it's the nature of the lower plane to have more to do with sculpture. The top plane is more inviolate. Paradoxically, twice as thick, it is twice as transparent. They all share a height of fifty-four inches off the floor. That relates to a group of works I made in 1978, the "Collage Pieces," where I cut out pieces of paper painted in watercolor, pasted them on the wall at fifty-four inches, then finished them by painting on the wall, so that the works, which I thought of as combining two diametrically opposed forms of memory, became a unity.

In one new work you have the orange and the red, which function in the same way as the gray and the orange in another work. A curious thing happens where the two colors start to split and where the colors have indeed split. This conjunction-of-color idea is as much about how things come together as about how they are separated. If you have an "and," "but," or "or"—black and white, black but white, black or white—they have this funny way of joining as well as separating. My love of art lies in my finding that polarities that cannot be conjoined in any other way, in life, in nature, or in the world, can be conjoined in art.

The colors of these works aren't colors one ordinarily would think of. It interests me I find the works very meditative or contemplative. Years ago I meditated a lot, but

the ability left me. I've been searching for where it left. With the two blues in *NY/NM A26*, for example, even though there's a distinction between the light blue and the dark blue, a total luminosity comes off them as if they were one blue. If we could carry that sort of luminosity around, we'd be in a state of meditation all the time.

I've involved myself specifically in color that has structure. Western art makes structure with black and white, and color is then painted onto the structure. So the art experience essentially comes from the structure, the black and white. There are outstanding examples in world art where color, on the contrary, is allowed to have structure, and the art experience comes from the color. I feel our society is growing toward that direction, and that's thrilling to me. I try the best I can to open my mind to that kind of color.

Making this work was like wading through my own history. This fall I made works that looked like my works from the '80s, with all their complexity and kinds of materials. My very earliest works, on the other hand, were simple hollow boxes; it was as if I had to get into the space of the interior box and explore. The 80s works were not about shape, they were about being inside the box. It seems I had to repeat that kind of work in order to do these present works. Then finally that top surface joined to the lower surface, a reduction to only two elements, and they became simple again.

The work isn't about representing phenomenon, it's about making phenomenon. Pollock may have started his paintings representing phenomenon but they wound up being phenomenon. That's a huge difference. To me this show is a phenomenon. We're in the zone of the abstract world. We have very good artists who are not within the abstract world. Susan Rothenberg's paintings, though representations, are phenomena. One of her first horses was drawn on a plane divided in four colors and four triangles. I decided to get on that line that made the horse, my eye traveled all around the painting's four parts. At the end I felt I had been through the whole universe! That was her enormous breakthrough—that she found a way to add representation to the palette without giving up the tremendous achievement of painting as phenomenon.

My work is not about size, it's about scale. The smallest works from the mid-'70s are not small at all. I thought, "You know, you're alive. What's the most fantastic thing you can relate to in the contemporary moment that your life, your being alive, can conjoin?" I felt a point in space was changing into a point in time. And the question was, How can we see that? A lot of my work is about seeing, the chance to see what we don't ordinarily see. So the work got involved in these small, small pieces. They stimulated a lot of controversy. Now we understand: if you're trying to see what a point in space looks like as it changes to a point in time (if seeing that is possible), the size fits the scale.

When art was just this plane and that wall, the viewer was in another space from the work. The work was over there; you were distant. But in this situation, a collapse

of subject/object relations, you're in the same space as the work. Or else your distance from it is now a known thing, just as it was an unknown thing before.

We all know that civilizations get more and more complicated. As they do, we are inundated with I-it relations, and finally the civilization topples because there's a total loss of the opposite: the I–not-it relations. I find each of these works is sort of laughing at me, saying, Relate to me as not-it if you can.

The job of the artist is to find reality. There are millions of routes to reality, and they're changing all the time. The type of person I may represent to my society is someone who, in following a particular creative direction over the years, can consistently find a new route to reality through the ever changing pathways. What art is in America is the sense of energy emitted by finding a new route to reality, something exciting and important to all.

Tuttle installing works at Sperone Westwater, Chelsea, 2004

Born 1955 in Abington, Pennsylvania. Lives in New York

POLLY APFELBAUM

Selected Solo Exhibitions
"Polly Apfelbaum." Institute of Contemporary Art, University of
 Pennsylvania, Philadelphia, 2003 (traveling)
"Polly Apfelbaum." Bowdoin College Museum of Art, Brunswick, Maine, 2000
"Polly Apfelbaum." Kiasma Museum of Contemporary Art, Helsinki, 1998

Selected Group Exhibitions
"Solares (or on optimism.)" Valencia Biennale, 2003
"Everyday." Sydney Biennale, 1998
"Painting the Extended Field." Magasin 3, Stockholm, 1995

Level World, Hilly Sea [1989] has a sense of lightness, a spontaneous quality. It looks like pompoms but it's not: it's made out of shredded paper, the kind Hallmark sold you to pack your gifts in. I was putting something ethereal up on a pedestal and making a structure out of the everyday. I was interested in the familiar, in the rituals, habit, order, and arrangement of the everyday, in taking what you'd find at the five-and-dime and elevating it onto a pedestal. It's a table of color, all found, but each has a particular meaning.

A Pocket Full of Posies [1990] was in a sculpture show at the Snug Harbor Cultural Center. In this early work I was interested in sculpture that could be informal, you could rearrange the parts; it would not be hierarchical, that is, it wouldn't be on a pedestal; and it would deal with cultural stereotypes and signs. Some people saw a reference to Carl Andre, but the forms are dingbats, like Andy Warhol had used. In the early work I also wanted to see if I could make a memorial with a very simple gesture—like laying flowers on a grave. For me it put a little poesy, a pocket, in the architecture: it stayed outside and changed with the weather and the elements.

In *Wallflowers (Mixed Emotions)* [1990] there are 650 crepe-paper flowers pinned to the wall. Again there's an optical, changeable quality, and the works aren't on any kind of pedestal—or the wall becomes the pedestal. There's also a critique of the stereotypical: the woman who's not asked to dance, the wallflower, becomes very beautiful—a role reversal. I wanted to bring color into my work, I saw painters using color and I wondered why there was no color in sculpture. In trying to figure out what color was, I started out with found color—it was already in the paper flowers I used. They're very beautiful and also very ethereal.

In *The Dwarves without Snow White* [1992] I was beginning to equate color with emotion. I wanted this kind of emotion back in sculpture, this kind of familiarity; the work was about possibility and potential. The earlier work had had a lot of narrative, the titles were filled with it; here I was getting more interested in abstraction. I was also rationalizing my use of color. The piece has a Minimalist kind of structure; I was looking at Minimalist precedents (Donald Judd, for example) and at a certain formal structure, the box as pedestal. But even for Judd, these simple forms can be useful objects: furniture, for example. I'd grown up with the box as a kind of hope chest; the decoration on top was an added bonus, but what mattered was what was inside. So here I wanted to play with inside/outside, and to soften up order with the fabric, the decoration, on top.

Peggy Lee and the Dalmatians, from 1990, was the first velvet piece. It was an important work for me because it has all the narrative I was interested in but was also moving even further toward abstraction. I was interested in a formal arrangement but also in collapsing form, taking the work directly to the floor, getting rid of the pedestal (the box), going casual—folding, dropping, spilling. I think most artists are rebellious in nature, and I really love the fact that the material is on the floor, where it's not supposed to be, like one's dirty laundry.

Compulsory Figures. 1996. Synthetic velvet, dimensions variable (c. 26 x 36').
Installation view, Institute of Contemporary Art, Philadelphia, 2003

L'Avventura [1994] I also call my "Woodstock 94." People think it's tie-dye but it's not; I don't know how to tie-dye, but it still has a '70s, improvisational feel. Part of the thinking in my work involves ideas of craft, high/low, the sense of making something accessible and very simply. I made *L'Avventura* out of everything that was in the studio. I think it looks like a specific pictorial space—you're looking at the floor but it feels like the wall. In a sense it's a conventional painting space.

In *The Dwarves without Snow White* I started adding color to fabric by staining it. I use liquid fabric dyes and I like the looseness and directness of the process. So the stain had been part of my work for a while, and one day a light bulb went off: I saw these quirky forms, thought "Wow, those are really interesting," and started taking my scissors and cutting up the form and seeing what it would do. This first piece, *Eclipse*, from 1996, is dyed in dark colors, because I wanted a specific sense of the weight of the material. The fabric is synthetic crushed velvet, which responds to the light in a specific way. I work with the flows and patterns of the dyes as they move through the fabric, making unpredictable forms. Then I start combining large numbers of the cutouts to make a shape on the floor. In that way it also responds to the architecture. It's like painting on the floor; the gallery becomes my studio. I'm really creating a new space. In *Eclipse* there are four parts to that piece: a red part, a yellow part, a blue/green part, and a brown/black part. The only other colors are opposite hues, to give the work a glow. The color provides a physicality, a different kind of weight. The floor becomes incorporated into the work.

A work like *Eclipse* is made up of more than a thousand individual parts. It changes every time I do it. I've installed it three times now and certain shapes have stayed the same, but basically I'm not interested in re-creating it; I'm interested in the experiential and the potential, in change and chance. That's the control that I have, the pleasure that I have, the unknown that I have, the thing that so interests me in my own work: it's different each time. It makes a space that you don't know exists. Artists are often a lot about control, so this is a change for me, and it's exciting—so exciting that I'm a little uncomfortable with it. It's integral to my way of working.

A further and somewhat more systematic development of this idea is *Ice* [1998]. In this piece I'm going through every color available in the series of fabric dyes I use; so ultimately there'll be 104 sections, each color combined with all of the primaries, and black. There's a blue section, a red section, a yellow section, and a black section. There are fifty or sixty individual pieces in each of the 104 sections, so there must be over five thousand loose pieces in the work. I was interested in the attempt to control something that seemed so out of control, and in seeing if that brought a different kind of physicality.

There's always a real sense of physicality in my work, both in the doing of it and in how people look at it. Looking at something on the floor involves a different way of looking from looking at something on the wall. It's funny, I look at this piece, *E* [1996],

which is on the wall, and it seems to me to be about the floor, so this issue is innate to my sensibility. I want to work back and forth between the wall and the floor. The pieces on the wall usually relate to something on the floor.

For me, *Compulsory Figures* [1996] relates formally to painters I love, like Imi Knoebel and Blinky Palermo, or Ellsworth Kelly. In the back of my mind I think a lot about abstract painting. I like the sense of color fields—the way, when you look at a painting, you see big parts and the small parts that make them up. The piece is a field of about twenty squares. It looks like there's an order, so you're trying to figure one out, but it's actually very intuitive. This is one of my favorite pieces. It's very simple, all bought fabric from the same dye line. In general I think there's a real simplicity to the gesture in my work—how I make things is not a big mystery. I also want the sense of visual pleasure, of sensuality.

Sometimes I think, Do I have any experience? Do I know anything? I feel like I'm starting from scratch every time. That's a wonderful place to be, but it's hard, too, and scary. I can prepare myself only so much by my little sketches. Can I control this? Will it realize its visual potential?

A lot of my work has to do with the feeling of a visual puzzle. I'm very interested in each piece being particular to the space and site, and in seeing what it can do there. The fact that I don't know what it will be in advance is the interesting thing. The meaning of the work should be open-ended. But that's what I love about my work: the personal experience of learning about space, and the range of ideas that the viewer can bring to the work. When I talk about the color, the atmosphere, the texture of the material, that's something I can control and know. But what kind of shape the piece will have in space—I'm curious about that. I'm very conscious of the physicality, and the optical experience, that I want the work to give to the viewer. I spend a lot of time in the studio, dyeing, cutting, and so on; the work is very labor-intensive, but finally it's what happens when I'm in the space. The process of installation has a performative, improvisational character to it. I try to describe that to people, but in the end it's the unspoken part of the work. Optical intensity, theatricality, visual intelligence— the dialogue, that's what keeps me going.

Born 1954 in the Bronx, New York. Lives in New York

FRED WILSON

Selected Solo Exhibitions

"Fred Wilson: Objects and Installations, 1979–2000." Center for Art and
 Visual Culture, University of Maryland, Baltimore County, Baltimore,
 2003–2004 (traveling)

"Speak of Me as I Am." American representative, U.S. Pavilion,
 Venice Biennale, 2003

"Mining the Museum." The Contemporary and the Maryland Historical
 Society, Baltimore, 1992

Selected Group Exhibitions

"The Museum as Muse." The Museum of Modern Art, New York, 1999 (traveling)

"Cocido y Crudo." Museo Nacional Centro de Arte Reina Sofia, Madrid, 1994

Whitney Biennial. Whitney Museum of American Art, New York, 1993

The museum is part of my life in many ways. I've worked in many different muse-
ums; the turkey and other stuffed birds here in my loft come from a museum that
was getting rid of things to redo part of its space. I've worked at both the Metropolitan
Museum and the Museum of Natural History, and I became aware of their differences
and similarities—Beaux Arts structures built at around the same time, both housing
cultural artifacts but in very different ways.

I used to run my own gallery in the South Bronx, in a space in a former public
school. One of my first projects there, in 1987, was "Rooms with a View: The Struggle
between Culture, Content and the Context of Art," a look at what these museum
spaces were saying about culture. I invited thirty artists to contribute two works each.
I put one work in a white-cube gallery space, the other in one of two rooms: one that
I designed to look like an ethnographic natural-history-museum space, the other to
look like a turn-of-the-century salon. In the ethnographic-museum space a particular
artist spread out her sculptures on a bed of sand. When she left, I came in and put
a museum barrier around them. She wouldn't have liked it had it been in my gallery
space, but this was my ethnographic museum. Things are done differently in ethno-
graphic museums, and no one asks the artists how they want their things displayed,
so I didn't either. The label said "Pile of heads, ceramic, found Williamsburg, Brooklyn,
late twentieth century." Everything was true except I'd left out the artist's name. In fact
everything in this space had all the correct information except for the artist's names,
which is of course how it is in natural history museums. So the space really changed
how people thought about the works. Everyone had a second work in the white-cube
gallery space for comparison.

This event was quite important for me. If the spaces were manipulating the
works to that degree, I felt, I wanted to work with that manipulation. So I started
using the museum environment as my work—the wall labels and text, the lighting,
and the objects themselves. I got intrigued by these things.

After I'd done several museumlike installations in galleries and nonprofit spaces,
the Contemporary, an institution in Baltimore, invited me to do a project there, to open
in 1992. I could work anywhere in Baltimore and I chose the Maryland Historical Society,
because it felt like raw material: the environment, the display, hadn't been thought
about forever. The Society was founded in 1840, and has a quite impressive collection
of paintings, sculpture, and decorative arts. But I felt very uncomfortable there, and
wondered why, and decided that since I was so uncomfortable, this was the place I would
work. I titled this exhibition "Mining the Museum," because I wanted to foreground
the fact that I was looking at the museum itself, through the theme of the exhibition.
To this end I used things that were on view and things that were in storage. Things
on view in a museum tell you a lot about it, but things in storage tell you even more.

I found busts of great men in the museum. Unfortunately none of them were
from Maryland, which is kind of strange in the Maryland Historical Society, but I put

them in the exhibition anyway. There was Henry Clay, Napoleon (*he* certainly wasn't from Maryland), and Andrew Jackson. Then I found three empty pedestals and I included them as well, without busts but with labels, which said "Harriet Tubman," "Frederick Douglass," and "Benjamin Banneker"—three important African-Americans, all from Maryland, but nowhere in the Maryland Historical Society was there anything about them.

This probably could have been a Black History Month show if I'd worked in that direction, but that wasn't what I wanted. I'm not interested in making exhibitions per se, but in making art about museums and museum practice. I really was trying to understand how the Maryland Historical Society people thought about their collection, so I mimicked how they might display their things and tweaked that a little. I used several paintings that I found really unusual. In one there are seven children, including two black children. You almost didn't see those children, because in the context of this museum you're not supposed to see them; you focus on the five white children, because the whole display is about Maryland's nineteenth-century elite. A lot of other stories are told silently, though, so I made those other stories visible. In this case, as you stepped up to the painting, the two black children were lit up, and voices seemed to emanate from the painting, saying things like, "Where's my mother?" "Who calms me when I'm afraid?" "Who washes my back?"

The history of slavery is so horrible that none of us really want to focus on it, but this project turned out to be a real catharsis—for me, for the Historical Society, and for the local communities. It aired issues that were certainly still there. I was very pleased that the museum let me do this. People really enjoyed the exhibition, and word of it went around the country and changed my career, and changed the Historical Society too, in many ways.

Old Salem, in Winston-Salem, North Carolina, is like a smaller version of Colonial Williamsburg—a collection of period houses where people dress up in costume and interpret everything for you. I found it fascinating, and in 1994 they let me do a project there. This little community was founded by the Moravians, a German-speaking Czech group that came to the United States for religious freedom in the 1600s. They still control it. But it turns out there were African-Americans in this little enclave, though they didn't talk about them much. Of course that always intrigues me, so I did a display in a couple of the buildings there: I organized several objects from their various museums, then had interpreters talk about the things you saw. I also had people read the memorials of various African-Americans who had lived and worked there. This was a religious community, and according to their belief individuals couldn't own property; that's why they didn't have that many slaves.

The one building that wasn't renovated in this whole property was a church, and it turned out to be the black church. So I decided to do a project there. Originally, apparently, the Moravians worshiped with their slaves, and were buried in the same

graveyard. But little by little the outside world encroached, and eventually they stopped living with their slaves, stopped worshiping with them, and were not buried together. So there was a plot of land that had been a graveyard for African-Americans, but it had no gravestones. We wondered what had happened to them. Apparently an old woman had said a long time ago, "Look under the church." We searched around the property but had no other leads, so we looked under the church—and there were the stones. Nobody had seen them for over 100 years. They were just thrown under there. Some of them were holding up the church's joists. They said things like "Timothy, a native of Africa, 1706."

So I took up the floor of the church entrance and put in a new one—you walked into the church across a Plexiglas floor through which you could see these stones under your feet. I left the stones themselves as I found them because the local archaeologist wanted to study them in situ. I also made audiotapes from the Moravian church in Old Salem, so that as you were coming into the space you heard people rustling in their pews, a choir singing, but when you got inside, all you found were ghost images of different architectural structures that had been important to the African-American community in Old Salem but had been taken down to develop the town.

After I did this project, I started collecting objects bearing stereotypical images of African-Americans—cookie jars, salt shakers—because I didn't like them and I wondered why. I also wondered why they were collected, so I started to collect them to understand that. Then I started having them photographed to understand my relationship with them, and I began organizing them in various ways and making videos of them. One showed a woman's arm smashing the "Mammy" dolls; one showed me mimicking the objects, contorting myself to make unnatural positions and grimacing faces. One object is a penny bank, so in the video I take money in my mouth the way the bank does. In trying to mimic these things, I was trying to draw out how I felt about them by personifying them.

I found a cast-iron "Mammy" that seemed to have power. I don't know if I was giving her that power or if she just had it, but she reminded me of Tituba in Arthur Miller's play *The Crucible*, which I'd read in junior high school. I remembered thinking of Tituba, a slave, as a strong character, but when I reread the text, she wasn't particularly strong—she was as scared for her life as anyone else in *The Crucible*. But in junior high school I had given her power for some reason. I needed her to have power. So in the artwork I did with this Mammy I juxtaposed a photograph of the cast-iron Mammy with Miller's text but reedited it to give her the power that I remembered her having.

Born Heidelberg, Germany. Lives in Brooklyn, New York **OLIVER HERRING**

Selected Solo Exhibitions
"Oliver Herring." ArtPace, San Antonio, Texas, 2004
"Sleepless Nights: Video, Sculpture & Photography." Cleveland Center
 for Contemporary Art, 2001
"Oliver Herring: Sculpture." Camden Art Center, London, 1997

Selected Group Exhibitions
"Seriously Animated." Philadelphia Museum of Art, 2003
"Regarding Beauty: A View of the Late 20th Century." Hirshhorn Museum
 and Sculpture Garden, Washington, D.C., 1999 (traveling)
"Art/Fashion." Solomon R. Guggenheim Museum, New York, 1997

I went to art school at Hunter College, New York, and studied painting. I also went to a lot of theater, a feature of New York life that I really enjoyed. (I am originally from Germany.) The performance artist Ethyl Eichelberger inspired me enormously, and I saw him work as often as I could. Then suddenly, in my second year at Hunter, in 1991, I heard that he had committed suicide due to AIDS-related symptoms. I took the tragedy of his death very personally, perhaps because he was a creative model for me and because I myself felt vulnerable in relation to AIDS.

I decided to make a tribute to Ethyl Eichelberger. I didn't want his life and its effect on me to disappear with his death. I also needed to process some of the issues his death stirred up in me. My immediate idea was to make a flower, which seemed appropriately beautiful, but I also had to express Eichelberger's flamboyance, so I made a larger-than-life transparent flower out of packing tape and suspended it in the air. Once completed, the piece did something my paintings hadn't done: it moved me profoundly. That level of emotional engagement with an object I had made was new to me, and I wanted to pursue it. So I decided to put painting on hold.

I had tape around the studio, so I played with it. Eventually I made it into a kind of yarn and decided to knit with it. I didn't know how to knit, but knitting seemed a hands-on, humble way to tackle these difficult issues. Since knitting is made of individual moments, one stitch at a time, a time component is inherent in it. When I knit I spend many hours just moving through time, not thinking. This frees up the mind to experience time, and it had a healing effect on me. Through knitting, also, my hands kept building something, which counterbalanced some of the feeling of destruction that had led me to knit in the first place. This seemed to me very poetic.

My first knit pieces were a pair of trousers, then a sweater, and finally a coat. They were items of clothing, but I wasn't making work *about* clothing; I wanted to suggest the remnants of a person. Of the three pieces the coat was the only one I felt comfortable with, because it wasn't gender specific. I made more coats, and to dilute the clothing reference I embedded them into larger structures. The effect was a sense that the coats simultaneously disintegrated into and grew out of the shapes surrounding them. I tried to keep the work somewhat abstract, since the objects themselves meant less to me than the process of making them. Sitting alone in my studio, I felt I was engaging in a form of private activism that lent the work a performative quality and connected me to Ethyl Eichelberger. In the end I wanted most to get over his death, and to find out why it affected me as it did.

I placed most of these pieces on the ground, which I felt was an appropriate plane for dealing with mortality. I know this sounds simplistic but things come from the ground and resolve back into it. My silver Mylar work is a variation on that theme. Knit silver Mylar suggests more weight than it has. The pieces seem not just to stand on the ground but to be pressed into the ground. I was also attracted to their resem-

blance to armor, a protective garment. The Mylar's light-reflective metallic coating seems extroverted and aggressive.

During my first show, at the New Museum [New York] in 1993, I performed among my works, interacting with visitors. A year later I performed again, in a space that had a coffee shop as well as a gallery, so catered to a larger variety of people. I filled the gallery space with knit pieces while I sat on a platform in the coffee shop. The performance had two parts: for the first two weeks I knit a transparent Mylar coat, then for the next two weeks I cut it into tiny bits with scissors. Once again I was interested not in the object, which I literally destroyed, but in the act, and in how it catalyzed dialogue between myself and a variety of people.

In 1995 I was in a group of 100 artists invited to work for three weeks in a remote desert town in Israel. I found an abandoned quarry and dug a hole six feet deep into solid rock. (I had help.) I painted the hole's walls with a local reddish mineral pigment. For so long my works had had a relationship to the ground; going below ground was a logical next step. It was also a way to experience the place physically. Inside that hole all I could see was the sky above me, and the changing light throughout the day. Being below ground can be frightening, given its metaphoric implications, and I wanted to distance myself from that by demystifying the location. My plan was to spend one day, sunrise to sunset, inside the hole, knitting and writing down whatever came to mind. I also hoped to engage whoever made it out to my site. From the beginning, though, things went wrong. First, the hour-long walk to the site through the desert, in almost pitch darkness, was cold and scary, as was the site itself. The quarry walls amplified and distorted the desert's sounds; inside the hole I couldn't see out, so these sounds took on significance, fueling my fear that I'd be found by some animal, like a snake. Then the organizers forgot to distribute maps to my site, and my assistant overslept so I had no water or breakfast. I ended up sitting imagining in that hole, first freezing, then baking hot, until two P.M., when I finally gave up. I repeated the performance the next day. Ultimately I think the project's failure really sparked my imagination.

For me one of the most interesting aspects of that performance was how I located myself in relation to my environment and activated otherwise inactive space. In 1996, in a Project show at The Museum of Modern Art, I used this strategy of claiming inactive space again: two of the four works in the show were set into the wall. I replaced my physical presence with a seated knit figure. It had childlike proportions but was knit from silver Mylar to give it an aura of strength and invincibility. There was a hole in one of its knees, and it was trying to fix itself back together with two knitting needles. I called the piece *Wounded Knee*.

I did another performance last year at the Guggenheim Museum and in London. The premise was again very simple: four people sat on a stage, each in one corner. To each performer I gave a different-colored knit sheet of fabric. The bottom and top of

each sheet were finished with a piece of loose yarn, each of which was connected to the sheet of an adjacent performer to the left or right. The performers had to knit new stitches, which they could only do by pulling on the yarn, unraveling a neighbor's garment. The neighbor would do the same thing, so each performer was simultaneously pulling yarn from someone and losing yarn to someone else. This flow of gains and losses was graphically explicit through the yarn's different colors.

Trying to cast as diverse a group of people as possible, I ended up with two women and two men of different ages and different knitting abilities. The idea was to create advantages and disadvantages within the group from the outset, making it a microcosm of the world at large. The performance was to unfold over at least eight hours, with two half-hour breaks. I had no idea what to expect: for instance, it turned out the person I thought would lose almost eliminated two other people. The performance was intense—the performers were oblivious to everything offstage. The piece became a symbol of trying to survive within a structure of limited resources.

My paintings had always been colorful, and to give up color was an amazing discipline for me. Now I've taken the risk of plunging back into color, using glass paint on Mylar. When you look at, say, *Silver Surfer* [1997] from a distance, you see color. The color is up front, it *is* the surface. Then when you come closer you become aware of the hollowness inside. There's a juxtaposition between an empty interior and an aggressive surface. My earlier work was more reflective and retrospective; I want this work to project outward.

I'm not interested in knitting as such, it's simply a means to an end. I know one stitch, how to finish and how to start, and I know how to add and subtract. That's it. Originally knitting was a way for me to mark my way through time; now it's become a way of claiming something, of making sculpture that moves me. Most of the time it's that simple. *Red Cloud* [1997] moves me, small though it is. There was enough in that piece to suggest that if I pushed it farther I could achieve more from it, so I've been making a larger version of *Red Cloud* [1998], and I'm just fascinated by it. It's my favorite piece. But of course my latest piece is *always* my favorite piece. I can't really talk about it yet.

Herring in his studio, 1998

Born 1949 in Liverpool, England. Lives in Wuppertal, Germany

TONY CRAGG

Selected Solo Exhibitions
"Tony Cragg." Museum of Modern Art, Malaga, 2003
"Tony Cragg." Malmö Konsthall, 2001
"Tony Cragg." Whitechapel Art Gallery, London, 1997

Selected Group Exhibitions
"Mood River." Wexner Center for the Arts, Columbus, Ohio, 2002
"At Home with Art." The Tate Gallery, London, 1999–2000 (traveling)
"Future Past Present." Venice Biennale, 1997

The first art school I went to was in the West of England, in 1969. It was very exciting for me, a new adventure: I hadn't studied art before, and I was quite surprised to end up in art school. Toward the end of the first year I had the opportunity to make something out of materials. I felt incredibly excited having that power over a little bit of material, and at the same time feeling that the material in turn had a little bit too much power over me—it was always trying to do something I didn't want it to do. Which continues to be the problem today.

I next went to an art school in South London, actually a painting school, where I spent my time standing behind an easel doing little drawings and paintings. I had the wrong energy, and the wrong kinds of ideas, to be standing behind an easel; and it was too quiet, and too warm. But I thought, "I have to do something; I can't just do nothing." So I started tying up pieces of string, just cutting them into lengths and tying them up and making lots of knots in them. The teachers were tolerant, polite—they didn't ask me what I was doing for a very long time, not until there was a very big pile of string. Then they did say, "What are you doing?" And I said, "I don't know. I'm just trying to figure out what I'm doing here." But I did enjoy sitting tying knots. It gave me time to think. Also, I'm a nervous, active person, and this gave me something to do with my hands.

Eventually I started to move the string around, and to take it where I lived. I put it over the furniture, and in the bathroom, and just generally played with it. I think that was really the first sculpture I made. I remember having a lot of ideas about what I could do with this string; without truly understanding what these ideas were for, I thought, "This is fantastic, because if I hadn't gone through this silly, rather boring process, I wouldn't have any of these ideas." And that in fact was my first realization about what making sculpture could mean to me.

I then proceeded to work with a lot of different materials. One could say they were found materials, but mainly they were any material available. In 1971 the school I was in staged an exhibition, and somebody said of my work, "It's very *arte povera.*" I ran off to the library to find out what the hell *arte povera* was. And shortly after finding out about *arte povera*, I also found about Conceptual art, Minimal art, and Land art, one after the other. These were really the things I was impressed and influenced by for the first two or three years of making work. So artists like Donald Judd, Dan Flavin, Richard Long, Gilbert & George, and Mario Merz were my examples.

Then, very slowly, I realized that these artists were years older than I was, and already exhibiting worldwide. And I thought, "What's going to happen to me in this situation?" Even if in the end I managed to make something interesting, I didn't want to be the last in this generation of people. And so, in 1972 and '73, I was starting to think of reasons why I didn't want to be a Minimal artist, why I didn't like *arte povera*, and why I didn't think Conceptual art was that interesting. This was a way of trying to find my own position. Generally I wanted to make something more complicated,

Envelope-Pod. 1998. Bronze, 44 $\frac{1}{2}$ x 56 x 43"

something that in a sense I could never understand. It's much easier to make things that you *can* understand; it's always a little harder to be always lurching forward, which is something that I tend to do.

Eventually, in 1973, I went to the Royal College of Art and studied in the sculpture department there. That was the first time I met serious sculptors, and they were *very* serious—people who had studied with Anthony Caro, so they came in every day in their boiler suits, with their goggles on, and they spent all their time welding. They had sort of bright red faces from their welding apparatus, and they'd stop at eleven o'clock, open up their tin cupboards, get their sandwiches out, and sit there for quarter of an hour and eat their sandwiches. Then they'd close their cupboards and go back to work. That was much too serious, I didn't want to do that. So I worked at finding different materials, inventing new ways of making sculpture for myself, and in a sense trying to formulate a new position for myself.

I made a lot of work using little things I found. I had a period of using plastic objects, and beginning in about 1983 I had three or four wonderful years of rushing around Europe and America, being able to make my work and find materials. This finding of materials was very important to me, because it was a way of giving them a kind of democracy. I felt that it would be possible to use every material, and that this in a sense would be a small image of what had happened in the twentieth century, when there was a process of what I call nomination: the predicate of twentieth-century art has been that artists have nominated possibilities of things to make art with. If this is an interesting object, they've said, it becomes art. That process continues through Dada, Fluxus, Pop art, and *arte povera* up to the present day. In the nineteenth century there were probably only twenty materials to make sculpture with; at the end of the twentieth century there is hardly any material you *can't* make sculpture with. And as with the material, so with the techniques: people can spit art, walk art, bang art, explode art. One slowly realizes that in a finite world one can name all the materials, and then that's it.

There are still new materials to be found, of course, but is that any longer the prime motivation for making art? I don't think it is, quite honestly. So my conversations now involve less of a search for the next new material and more of a deeper search for some poetic, metaphysical quality in the material, and how to use it, and what to express with this newfound vocabulary. Sculpture is at the beginning of a new era. It's a difficult thing to do; it's a rare human activity, and when you get to art school you find a lot of painters and very few sculptors. The reason for that is simple: you need a real existing space, you need the material, and you need the energy to change that material into the thing you want it to be. When people come a few meters into my studio and they're already grimy and dirty, I say, "It's not really dirt, it just *looks* like dirt. This is just what happens when sculptors collide with material: there are little bits of blood and dust everywhere." So it's a difficult activity with a simple existential framework, which is not easy to grasp.

The other reason that sculpture's a rare activity is that in this enormous flood of people making things, most objects are made for practical or functional reasons. I think that's one of the wonderful things about sculpture: it's eminently useless. It's very rare for human beings to take material, play with material, think with material, without an end product in sight. But if sculpture isn't really useful, on the other hand I see it as a catalyst, as a very small part of a reaction. And a catalyst radically changes the outcome of how things proceed.

I decided a long time ago that I'm not a conceptual artist. I have to experience materials, which I find is much more complicated than sitting in a chair and figuring out how to make another artwork. My attitude is, I actually get material, and I move and it moves, and I look at it and think about it, and I move and it moves, and very slowly it gains a degree of autonomy and starts to make suggestions. It says, This is a fantasy, or, This is an idea, or maybe, This is concrete knowledge. It's very surprising when that happens. It's something I could never possibly arrive at just by sitting down and thinking the work out.

Not many people make sculpture but many people write, and if you write, you know a similar kind of activity: you take a pen and a piece of paper and you write down what you want to say. Then you read it and say, "This isn't such a good word," so you find another word, and maybe you move a clause earlier in the sentence, you

mold the sentence, and in the end you say, "That's great—that's what I wanted to say." So it's a curious process, because what you've done is you've taken a piece of pulped-up tree, and some mineral mixed in water, and you've used these materials outside your body as a kind of reflector of your thoughts. And this is creation—extending yourself out of your body into the material, discovering forms. So that's really the basis of my sculptural activity. Saying it like that, it becomes a kind of proposal: I believe that making sculpture is a way of thinking.

Cragg in his Wuppertal studio, 1990

Born 1942 in Urbana, Illinois. Lives in New York

DAN GRAHAM

Selected Solo Exhibitions
"Dan Graham Works 1965–2000." Museu Serralves, Porto, 2001 (traveling)
"Dan Graham." Centro Galego de Arte Contemporánea, Santiago de
 Compostela, 1997
"Dan Graham." The Museum of Modern Art, New York, 1980

Selected Group Exhibitions
"Westkunst." Museen der Stadt Köln, Cologne, 1981
Documenta V. Kassel, 1972
"Information." The Museum of Modern Art, New York, 1969

I began doing art because I ran a gallery. Not knowing anything about art, my friends, who had a little bit of money, knew that you could have an art gallery and social-climb. They'd read about the art world in glossy magazines like *Esquire*. Since I was out of work, wanting to be a writer but really having nothing to do, they said I could do all the work. I knew a little bit about the art world because I had read all these articles. My parents and some relatives put in a little money, because I didn't want to go to college or art school and they could take a tax loss. So, knowing nothing about art, I had a gallery.

I grew up in the suburbs of New Jersey and the aesthetic a lot of us had was suburban do-it-yourself. People like me, Robert Smithson, and Dan Flavin, who had tried to drop out of high school but spent all of their time reading paperbacks, came together. We all wanted to be writers. I was interested in Roy Lichtenstein, as we all were, for his incredible sense of humor and his modesty. Lichtenstein had taken works out of magazines and put them into paintings, so that the paintings would have no value. It was a shocking way of devaluing painting, and also the Abstract Expressionist gesture, because there would *be* no gesture, there would just be schematic ideas. When I saw paintings devalued, I realized that art magazines were important. And I thought, why not put things directly into magazines, where they would be mass dispensed?

Then I had to go back to my parents' place to flee my creditors, and I found a way of doing art with a cheap Instamatic camera. Taking a suburban train, I noticed houses that looked a little like the early works of Donald Judd, Sol LeWitt, and other people, but that were contextually related to the suburban landscape. So I took photographs of suburbia [*Homes for America*, 1966–67] and showed them in a show called "Projected Art" [Finch College Museum of Art, New York] as enlarged slide projections. It was out of this show that I got the possibility of actually publishing in a magazine, when *Arts* magazine asked me to do something about my works there. I wrote an article ["Homes for America," January 1967] about the suburb as the new city. The article functioned like a think piece you'd see in the magazine, but rather it parodied a think piece, and also, with these do-it-yourself photographs, it parodied both Minimal art and the so-called good photography you were seeing then. So it was a parody of a parody of a parody, which is of course what Lichtenstein was doing.

After that, I designed a lot of magazine pieces that were disposable—the magazine was dated and the piece related only to that particular issue. A lot of them were humorous, like one for *Ladies' Home Journal* on the side-effects of drugs. It had to do with the Rolling Stones song "Mother's Little Helper": people were accusing rock musicians of using drugs but actually more drugs were being used by houseives. The piece was a vertical/horizontal chart that had an optical effect like Op art. For every drug you took, there was a side-effect, for which you had to take another drug, and get *another* side effect. Other pieces were philosophical, about information theory.

Two Different Anamorphic Surfaces. 1996–2000. Two-way mirror glass, and stainless steel, 6' 6 3/4" x 11' 5 3/4" x 20' 8 1/4". Installation at Wanås Foundation, Knislinge, Sweden.

Basically these pieces were the first Conceptual art. But when people began wanting to make a movement out of Conceptual art, it seemed to violate the original idea.

Since 1974 I've been doing installations using mirrors, windows, video with time delays, and broadcast TV. I did a book, *Video, Architecture, Television* [Nova Scotia College of Art and Design Press and New York University Press, 1979] about what the video system was doing to perspective: with time delays you didn't have the instantaneous fixed view of Renaissance perspective, instead you had a view of yourself eight seconds earlier. It was a kind of mental-feedback time, and it could be related to a consciousness-raising-drug time but also to architecture, spaces between places, and seeing oneself from different views. So I combined time delay, mirrors, and the Renaissance mirror, which gave fixed time a sense of floating, just-passed time. I was getting to be interested in the just-passed and the subjectivity of the spectator. Minimal art seemed to becoming more and more objectified; I was becoming more interested in the spectator's own subjectivity relative to a real environment. Where the Minimalists abstracted things from the environment of the city or even the suburbs, I was more interested in referring back to the city.

The roof piece [1989–91] at the Dia Center for the Arts, in Chelsea in New York, has to do with the grid of the city, and also alludes to Sol LeWitt's cubes. There's a curved two-way mirror, a cylinder, enclosing a 360-degree space. The surface of the visitor's body, the horizon, the sky, the landscape, and people inside and outside the cylinder are all superimposed, which is possible with a two-way mirror when it's lit on all sides. Both the transparency and the reflectiveness of the material are also superimposed, as a way to defeat the way the one-way mirror was being used in glass office buildings, which are always lit from the outside—so you see the corporation as ecologically nice because it reflects and identifies itself with the sky and the environment. You see it as God-like, and the glass sets up a surveillance system: people on the outside see it as a mirror, while people on the inside can be looking transparently out. I wanted to defeat that while using the same material.

You'll notice that there's a boardwalk: I wanted to refer to Battery Park City and Coney Island, an amusement park situation. To the side of the pavilion there's the soft, rubberized material you find in school playgrounds, friendly for kids to fall down on or for people to lie down on. So in a sense it's like a park. The cylinder on the roof looks like a water tower, which is a symbol of New York's roofs. I was referencing both the uptown penthouse and the way roofs in poorer neighborhoods were used for pleasure during the summer. The center of the cylinder is for performances. There was also an old tool shed on the roof that I turned into a coffee bar.

For a show called "*Chambre d'amis,*" in Gent, Belgium, in 1987, the organizers put an ad in the paper asking for people who would let artists make a work in their house or yard. The people who allowed this would in a way become temporary guards and curators. Gent is a city of art lovers, a new business class. There's an important

museum there, and the person who conceived "*Chambre d'amis*" was the museum's director, Jan Hoet. Interestingly enough, the show had an anthropological bent. Going around to look at houses, I noticed that the people who answered the advertisements were professional or upper middle class: doctors, not so many lawyers (thank God), architects, schoolteachers, social workers, some academics. Since I was interested in architecture, I chose an architect. This man had built a brand new studio/office. He was rebuilding the old house in front to be his home and he wanted to direct people to the studio through the driveway. The area between the house and the studio, a muddy playground area for kids, he wanted to turn into a garden. Together we thought I would do a kind of conservatory for plants, so people could go through if they wanted and see the studio.

I made a plan, but I realized it was so large it would dwarf his own architecture, which he had to show off to succeed. So instead I made a small, children's-scale version, a children's pavilion. It consists of two-way-mirror glass and transparent glass combined in the walls, and the ceiling is two-way-mirror glass. There's a pole that the kids can play with. If the glass is thick enough, it can't be destroyed, and it's graffiti-proof—you can wipe graffiti off glass.

At the Carnegie Art Institute in 1991 I used a large empty lobby. Pittsburgh is on the one hand a hard, can-do city, and on the other hand it reminds me of Hallmark: it's sentimental. So I designed a heart-shaped pavilion in two-way mirror as a kind of romantic meeting place. The doors were clear glass, and large, so the light from outside streamed in, along with the silver quality of the two-way mirror and the changing light from the skyscape outside. Those things were what made the piece work. I often use curved two-way-mirror glass, which relates to the body and becomes sort of baroque, making for a kind of funhouse look.

On the whole, only about 10 percent of my pieces ever get done. The money gets raised but then they fall through, because people want standard things, things that are simple, trademarked—things that they've seen somewhere else.

Graham at work, c. 1998

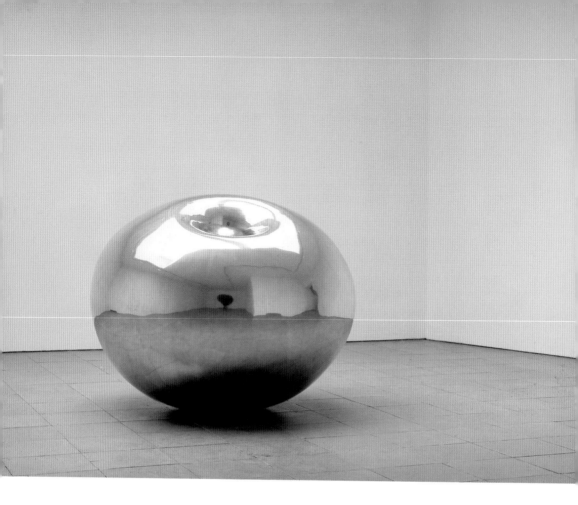

Born 1954 in Bombay. Lives in London

ANISH KAPOOR

Selected Solo Exhibitions
"My Red Homeland." Kunsthaus Bregenz, 2003
"Marsyas." 3rd Unilever Commission for the Turbine Hall, Tate Modern,
 London, 2002
"Anish Kapoor." CAPC Musee d'art contemporain de Bordeaux, 1999

Selected Group Exhibitions
"Blast to Freeze." Kunstmuseum Wolfsburg, 2002
"La Beauté." Papal Palace, Avignon, 2001
Documenta IX. Kassel, Germany, 1992

I'm going to start by talking about some things that are important to me. The first thing I want to say is that I have nothing to say as an artist. It is central to my concerns that expression isn't part of what I deal with. I might as well continue with some more denials.

I'm not interested in composition. I don't look to juxtapose within a work one element against another. What I'm looking for are conditions of being, conditions of matter, whereby things are in pure states. That is to say, if I'm making something red, I want redness to be the same as wetness or heaviness or dryness, a total condition.

What this leaves me with as an artist, apparently, is very little. Going into the studio with a determination not to express myself forces me into a process of emptying out, and it's that process that I'm interested in.

The work I was making fifteen years ago started perhaps in a different place. I was making groups of objects that worked together. They seemed to contain a space, an interior space. I'm talking here about the works I made from say about '78 or '79 through to the mid-'80s, mostly with pigment. Their kind of pregnancy is what I was concerned with. What slowly began to happen was that the space contained between the objects began to move inward and the objects came to be hollow.

Now hollowness is a notion, especially in the country where I work, that immediately connects to Henry Moore. I want to point out that Henry Moore made objects that had holes in them that seemed to be punched through to the other side, allowing a space through the object. That is not my concern. The thing that I'm dealing with is the negative, in a certain sense, without the positive. The nonobject. I'm looking for the skin, if you like, that somehow describes the space within, almost without des-cribing the space that's outside. This is questioning the notion of what an object is, pointing to something I call the uncertain object. If interiority is a condition that can't be described, the objects of interiority are these nonobjects. This is the opposite of Brancusi—not the making of form but the "making" of nonform.

I started with the pigment pieces and I began to talk about the idea of form, form moving toward the interior. Now I began to discover with this that the interiority that I was looking for was a condition of darkness. I began to make the first hollow forms. I needed the space inside the objects to play a particular "color" role. The dark blue I used did not describe the form, it seemed to deny the form. Form seemed to be swallowed in the darkness of the color, and, curiously, space seemed to be filled up. The hollow object seemed full. Emotionally, in some sense, emptying out had become filling up.

I began to see that my abiding concern with the sublime, with the idea of a poetic halt, a moment of stillness, a moment of silence, was there in this moment of darkness in *Void Number One*. It wasn't empty; it was somehow full and pregnant again, in a completely different way from the earlier pigment pieces. This led me to a new body of work, which is to do with looking for darkness. The work that most poignantly

encompasses this is *Descent into Limbo* [1992]. The title comes from Mantegna's *Christ's Descent into Limbo* [c. 1492]. Descent into limbo is a condition of the poetic sublime. It describes the moment of a kind of reverie that is a condition of a loss of self—self-absorbed in the gaze of darkness.

Physically, *Descent into Limbo* is a room, six meters by six meters, with a hole in the ground that is made in such a way that the hole is absolutely flat and flush with the floor surface, rather like the mirror piece here in the show. It is painted a very dark blue. There is a little story that I should tell you: when one makes a building and closes the door, there is always a queue. A man stood in the queue for forty-five minutes, and after his patient wait, he went into the room. He was absolutely furious that he had had to wait for forty-five minutes to look at a black carpet. He would not believe that it was a hole. To him it was a black carpet.

In my terms this is total success. It means that my project is not just to fool the eye, and I think that's another point I must return to, but it is to fill up emptiness, or to make another kind of emptiness, to propose that the empty isn't empty, that we, as psychological and poetic beings, carry notions of emptiness within ourselves, that the proximity of vast dark emptiness is something psychologically uncomfortable.

The sublime, while it is a notion about a moment of reverie, is also a notion about danger. It isn't all beautiful. When we look at a painting of Caspar David Friedrich's, we partake in somebody else's reverie. There's a little figure looking at the sunset; we poetically partake in their dreaming. It is my project to shorten that distance, to make it possible to feel the whole of the reverie, to make that reverie as palpable as possible.

I worked with darkness for a number of years, and I don't say blue, I say darkness, because I think that is what it is. It just so happens that blue makes a much denser darkness than black does, because we don't see color entirely with our eyes. The eyes are intellectual instruments, which cause us to perceive even color with our minds.

From the absorbed gaze to the idea of the loss of self, I then began to wonder if the opposite was possible. Was it possible to return the gaze and still deal with the sublime? Was it possible, in other words, to make mirrored objects that also have spatial ambiguity, that also, because of their reflectivity, are robbed of their physicalness? Is this then what we might call the modern sublime? The idea of the returned gaze, of the self reflected or included, is what this present show is engaged with. Hollow mirrored objects do something very similar to hollow dark objects. They both seem to disallow emptiness.

As you can see here, these hollow forms are not empty. If the traditional or dark sublime engages with deep space beyond the picture plane, this mirrored or modern sublime works with a different space, one that is in front of the picture plane. I work to see where this will lead me next.

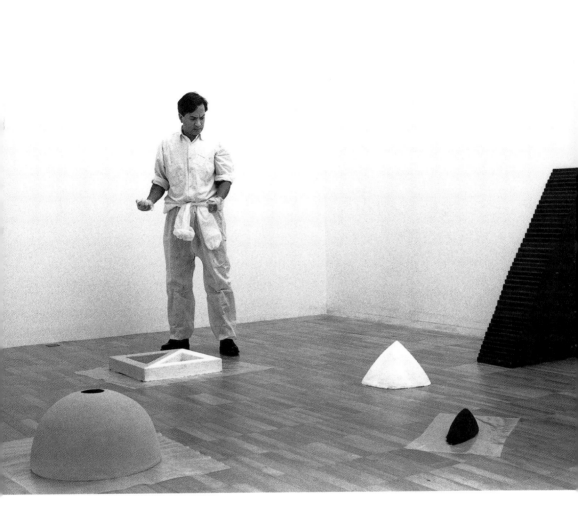

Kapoor working at Galerie Jeu de Paume, Paris, 1996

Born 1965 in Escondido, California. Lives in Brooklyn, New York,
and Joshua Tree, California

ANDREA ZITTEL

Selected Solo Exhibitions
"Andrea Zittel." Deichtorhallen, Hamburg, 1999–2000
"The A–Z Travel Trailer Units." Louisiana Museum of Modern Art, Humlebaek,
 Denmark, 1996
"New Work: Andrea Zittel." San Francisco Museum of Modern Art, 1995–96

Selected Group Exhibitions
"Skulptur Projekte in Münster 1997." Landesmuseum Münster, 1997
Documenta X, Kassel, Germany, 1997
Whitney Biennial. Whitney Museum of American Art, New York, 1995

When I moved to New York, in 1990, the first real studio I had was on the south side of Williamsburg, in a small storefront. I wasn't showing in commercial galleries yet, so this was a good solution for me, since the storefront meant I'd have access to the public who walked down my street every day. It also gave me the autonomy and the freedom to pursue my work without worrying if it fit into a commercial gallery context. This space was 200 square feet; two 100-square-foot rooms. The front was a ten-by-ten-foot room in which I kept all my birds in stacking cages, and it was where I met with people in a more official capacity. The back room was my "personal room," where I slept on a cot with all this stuff all around. At a minimum I would have twelve chickens, but sometimes I would have up to thirty-nine. I was also breeding quails and flies, and I have a huge dog. As you can see, my life was pretty chaotic back then.

I remember that at one point I looked at the structures I was making for the animals to live in, which were beautiful self-contained modular units, and I thought to myself that their lives seemed so much better than my own. So I started to make similar structures for my own life. I didn't originally intend these so much as art than as a form of personal exploration. I figured I needed sixty square feet to live in. There was a toilet, and a plastic slop sink that I used for bathing. The kitchen area had a table/desk and above that was a loft bed. I was starting to figure out how much space I really needed for each thing that I did. Then I had a friend who was a welder, and he welded up a steel grid for me, and I made wooden cabinet "inserts" to complete a unit containing all of these needed areas.

For seven years it seemed like I moved every six months—so I was feeling disoriented by how impermanent my life seemed. I craved some sort of stability. Living in this *Living Unit* was almost like buying a house—a way of making a structure that was permanent, and that I could have forever. Even if I had to move into some other environment, I could take my *Living Unit* with me.

Another thing that was special for me about the *Living Unit* was that I'd never really liked modern design. I've always been interested in furniture, but would spend my money on Mission style, or antiques. Then I read Ayn Rand's novel *The Fountainhead*, and started to think about how appreciating any style just involves configuring your brain to perceive things in different ways. I started thinking about how before the modern period, luxury had always been indicated by either rare materials or extensive handwork. At the turn of the twentieth century, if someone had a sparse interior, white walls, and functional furniture, it meant they were really poor. Then the modernists created an intellectual code that said these same things were all signs of good taste. I thought this inversion was beautiful. I was poor myself back then; I couldn't even afford a telephone. But if I could take the modernist code and translate my own limitations into a luxurious, glamorous life, it would seem so much more appealing. Reconfiguring the perception of my life was more important than what actually existed.

A-Z Escape Vehicle Owned and Customized by Dean Valentine. 1996. Exterior: steel, insulation, wood, glass. Interior: mixed media, 60" x 40" x 7'

When I first started I was convinced that as soon as the *Unit* was exactly right, my life would likewise be perfect. I believed this structure would solve all of my problems. Instead, though, I felt lost and directionless when all of the designing and building were complete. This led to an important realization that has underscored much of my work since: I now believe that nobody really wants perfection. We want the promise of perpetual improvement, but when we find a system that works we seem to lose enthusiasm for maintaining it, and we start to long instead for a new and even more improved scenario.

When I made the *Living Unit* for myself, it was very different from making a product to sell to people. When you make something for yourself, it's a form of empowerment, of liberation, but in making products for other people to use, I often wondered whether my role would become more that of an oppressor: instead of expanding their lives, and helping them to ask questions or feel empowered themselves, would I be imposing restrictions or creating limitations? I've struggled with that a lot, and I've tried a lot of experiments. At one point people could commission a piece from me and I would just make whatever they wanted. That didn't work out so well, because it's excruciating trying to make something for someone else that you think they'll actually like. I became so frozen that a collector commissioned a piece and I was immobilized, totally terrified to try to make something for her, because I was afraid she'd hate it. So next I ended up making pieces that people could customize. Eventually I decided to produce "Living Units" the way cars are produced, with a new model each year. At that point people started customizing them more heavily.

In 1995 I received a DAAD grant to live in Berlin for a year. This experience made me realize what a product of suburban California I really was. My work had often made references to European modernism, but this wasn't the culture that I came from and I realized more and more that things where I'd grown up—suburban neighborhoods, tract homes, Price Club—had been huge influences. I started to think there was an idealism out in the West, a utopianism of sorts that relates a lot to early European modernism. I started looking for the common vein of human desire that connected the two frontiers, but also for their differences. Our culture, for example, cares much more about the home craftsman, the enthusiast. Whereas the European modernists were intellectuals, or experts.

So I tried to make pieces that linked the European modernists to the ideal of the American home craftsman. I decided to make trailers, but they had to be better than ordinary trailers. Ordinary trailers are theoretically about freedom, and function as the ultimate "machine for living." But even though you can take them places, they have ugly interiors that there's no way to change. I thought that my skills would be perfect for making a beautiful, flexible interior with everything you need to live, like a shower, a stove, a sink.

For my show at SFMoMA I designed and fabricated three identical travel trailers and chose three teams to customize and test them out. The first team was my parents, Miriam and Gordon Zittel, who were the perfect candidates for compact living since they live full-time on a thirty-one-foot sailboat. The second team was Todd and Kristen Kimmel, who publish the classic trailer magazine *Lost Highways*, and the third team was myself and my boyfriend at the time, Charlie White. Each of us customized our trailers in totally different ways, and when they were finished we took them on the trips of our choice, ending up at the museum in San Francisco.

It was really a fantastic experience—I probably learned more practical lessons in that one trip than in the last five years combined—but the most interesting part was really just spending time in the trailer parks with other people who lived in RVs, not only comparing trailer designs and technical tips but also talking about life-styles and preferred ways of living. I really believe that a lot of the people who live this kind of pared-down life-style are today's true freedom-seekers. Sometimes the only way to avoid bureaucracies and the restrictions of larger systems is to shrink down and fit between the cracks.

The "Escape Vehicles" [1996] were the culmination of all of my thinking about recreational vehicles. These were ten "vehicles" that I designed and had built, all identical on the outside and all small enough to fit in a living room or backyard. You didn't have to hook it up to your car and go someplace to escape; when you bought one you could construct your ultimate escape fantasy inside, so all you'd have to do to escape was climb in and close the hatch. As our external worlds become more universalized and everything becomes more and more the same, we've become increasingly focused on our inner worlds. Today we look at the way people decorate their houses as something that reveals their soul. That was something I wanted to talk about with the "Escape Vehicles"—how we try more and more to create these unique environments on the inside instead of projecting ourselves externally. I don't know if that's a good thing, but I think it's a reality, and I'm interested in trying to examine it.

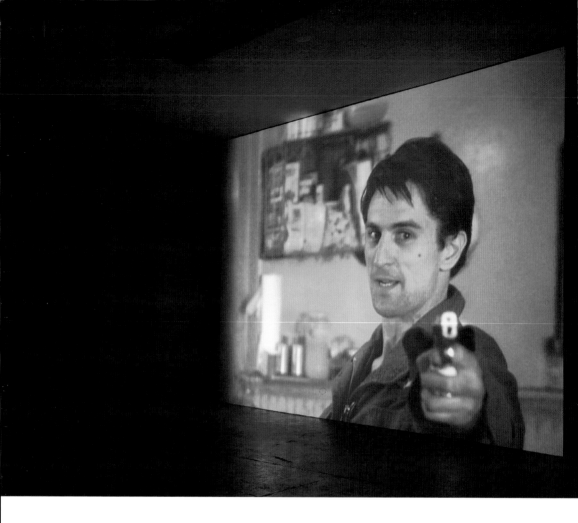

Born 1966 in Glasgow, Scotland. Lives in Glasgow
and New York

DOUGLAS GORDON

Selected Solo Exhibitions
"Douglas Gordon: Play Dead; Real Time." Gagosian Gallery, New York, 2003
"Douglas Gordon: What Have I Done?" Hayward Gallery, London, 2002–2003
"Douglas Gordon." Geffen Contemporary, Museum of Contemporary Art,
 Los Angeles, 2001

Selected Group Exhibitions
Hugo Boss Prize. Guggenheim Museum SoHo, New York, 1998
Venice Biennale, 1997
Turner Prize. London, 1996

I've always tried to deny the accusation of being a video artist, and just to be a regular artist who happens to use film, video, text, or whatever. You use the appropriate medium to get the idea across. When I was a student I was interested in making film and video, but I didn't do it because I didn't want to get involved in super-8 low-budget film culture. I already wanted to get into the heavy end of things, but I couldn't get a $25 million budget. So one way to circumvent that problem was to borrow someone else's epic and do something else with it. If you were being cruel about it you could say I'd abducted it, but maybe I just borrowed it for a little experiment.

I return to Hitchcock more than anyone else, probably because of the status his material already enjoys in the world. With *Psycho*, it doesn't matter if you've seen the film or not; you're probably three feet away from someone who did, and you know its position in the world. It's a common denominator, and I'm interested in establishing what the common denominator is and then starting to work with it. I try to take something familiar and look at it again, and again, and again, reexamining and re-presenting it. Most of the work is demanding in terms of the time I expect people to spend on it. But looking at something familiar can act as a metaphor for all sorts of other things in your life. One way to look at something over and over again is to take it apart. It can be taken apart in an analytical, structural, quite academic fashion, or we can simply put one thing beside itself and see how they compare. I suppose this is like those children's games of spotting the difference between two apparently identical pictures: it tricks you into looking harder at something that you may have taken for granted.

The title of my piece *through a looking glass* [1999] is a reference to Lewis Carroll, an author I've been interested in from childhood. Take the idea of tales for children, and how sweet they can be, and combine that with the Martin Scorsese movie *Taxi Driver*, and you might end up in quite an interesting place. The particular scene in *Taxi Driver* that I wanted to use was the point where Travis Bickle is looking in the mirror, which is exactly what Alice does as she's about to enter Wonderland. So you can look at Bickle's role as going into some other land—maybe not a Wonderland, but certainly another land. If you know the film (and a lot of what I do is based on the supposition that people will already know an element of the material I'm using) you know the character of Travis Bickle, and know he's a split personality. What would happen if a split personality actually began to split physically in an exhibition space? Technically, what happens in *through a looking glass* is that the image playing on one screen is the mirror of the image on the other. They run together at the beginning of the sequence, then one slips out of sync by one frame, and they pass right through the scene with this one-frame difference. It's almost not apparent; a one-frame difference is impossible to see, because one frame takes up just one twenty-fifth of a second. Then the next time they play, one of them flips out by two frames, and the next time by four frames, then eight frames, sixteen, thirty-two, and so on. The film

through a looking glass. 1999. Two video projections, dimensions variable. Installation view, Gagosian Gallery, SoHo

doubles away from itself. Bickle is a double of himself, and he's doubling himself away from himself.

The cleanest way to grasp this is through what's happening not visually but audibly. When the sequences slip out by one frame, it's almost like listening to a sound signal that's mono and then switches to stereo. There's a very, very slight difference. Then when it goes four frames out, it's almost as if the room has gotten physically bigger, because you get an echo. At eight frames out, the room increases in size again.

A while ago I saw the John Ford film *The Searchers* again, and that reminded me of seeing it when I was a child. I first saw it with my parents when I was maybe only three or four years old. I couldn't understand it then, because virtually nothing happens: basically Natalie Wood gets kidnapped and John Wayne looks for her for five years. I couldn't understand what all the fuss was about. But the film would be broadcast on TV at least once a year, so we saw it every year, and the older I got, the more I understood the emotional charge that Ford was trying to communicate. Looking for a member of your family for five years—how could you possibly condense that experience into a two-hour movie?

I thought, "Wouldn't it be interesting to take *The Searchers* back to its literal time frame." In other words, why not run the film for five years rather than two hours? We're still trying to work this one out, but basically you see one image every 15 $^1/_2$ minutes. One picture—one frame—isn't even one second of the movie, and you just see one every 15 $^1/_2$ minutes, which causes terrible problems when you're trying to install the piece because you can't tell if your player is working. It takes you hours to find out if the image is moving. And some people say, "Oh, this is ridiculous. There's nothing happening." But of course everything is happening.

Over the last six years or so I've made three tattoo pieces. The first I had put on my left arm, and it just says "Trust me." That's a very blunt statement. It has a lot to do with my family history, and the fact that, as a child, I was warned two things: never get piercing, and never, ever get a tattoo. Like most people of their generation, my parents were convinced that anyone who would get a tattoo was never to be trusted. Therefore, to have a tattoo asking for trust seemed like an interesting game. I didn't tell my mother about it for three years, and I kept the catalogues hidden—she had no idea. Then one summer's day in Scotland I was lying out in the garden. My brother and my father saw the tattoo, so I thought, "Okay, I'm going to have to tell Mum," and I went in and said, "Mum, I'm sorry, but I've got this thing." She just laughed, she thought it was a fake—"Trust you? Yeah, right." And that again was part of the whole idea of having it: she didn't believe it.

Tattoo for Reflection was made for a friend of mine who's from a Catholic background, and we sometimes have late-night discussions about guilt. Not that we do anything to be guilty about, but guilt is a nice idea. So I made a tattoo for him, the word "GUILTY" in mirror writing: it's on his left shoulder, so when he wants to read it he

has to look over his shoulder and into the mirror. So his mirror image is the one who carries the guilt, and he should feel free to live life as he wants.

The trust tattoo is hidden most of the time, and Oscar's tattoo is mostly for him or for his friend. I made a piece about two years ago that's a lot tougher, because it isn't hidden at all. The Yvon Lambert gallery in Paris invited me to do something at a time when I was very busy, and I thought, "Well, if I'm going to do this show, I have to do something that would be very difficult to do somewhere else." So I told Yvon, "I want to make another tattoo piece—I want you to find me someone who'll let me tattoo their index finger completely black." He was a little shocked. So I made my own finger black with ink, and I spent the day like that with them to see how disturbing it would be.

This piece relates to a story I'd been carrying around from my childhood. In the 1960s and '70s, Glasgow was incredibly violent. The police used to stop and search anyone in the street, and if you were carrying a sharp object that was three inches or longer, you could be arrested. This was based on the idea that by penetrating the body to a depth of three inches you could cause a fatal injury. Now the average man's index finger is about three inches long, literally the distance it would take to touch someone's heart. Yvon was interested in that story. and found a guy who said he'd have his finger tattooed black. We went to a tattoo parlor in the Bastille and he got it done. It was a shocking thing for everyone.

Part of the idea for that was that it came from a childhood story. Also, this guy with the black finger, every time he goes out for a drink, someone is going to say, "What the hell is going on with your finger?" Then he gets to tell them a story, or another story, or another one. And that, for me, is an important thing about all the work I do: my interest in art is not so much to create valuable or beautiful objects as to create situations that people can go home from and tell stories about. That pretty much sums up what I'm doing.

Born 1964 in Freeport, The Bahamas. Lives in New York

JANINE ANTONI

Selected Solo Exhibitions
"Taught Tether Teeter." SITE Santa Fe, 2002
"The Girl Made of Butter." Aldrich Museum of Contemporary Art,
 Ridgefield, Connecticut, 2001
"Swoon." Whitney Museum of American Art, New York, 1998

Selected Group Exhibitions
"Moving Pictures." Solomon R. Guggenheim Museum, New York, 2002
"Public Offerings." Museum of Contemporary Art, Los Angeles, 2001
"Open Ends: Minimalism and After." The Museum of Modern Art,
 New York, 2000

Wean was the first piece I did out of graduate school, in '89. It is made up of negative imprints in the wall. The first image you see is my breast; the second is my nipple; then there are three latex nipples; and the last form is the packaging that those three latex nipples fit into. This was an important piece for me, because it mapped out a certain territory that all my work would deal with from that point on. All my work deals with objects like the latex nipples—objects that mediate our intimate interaction with our bodies, objects that replace the body, and objects that somehow define the body within the culture. In *Wean* I was thinking about stages of separation from the mother, as well as the separation we experience from our own bodies, as we are weaned into the culture.

In *Lick and Lather* [1993–94] I cast a bust of myself seven times in chocolate and seven times in soap. By licking the chocolate and washing the soap, I reshaped my image. I can't tell you how charged it was to be in the studio alone licking a portrait of myself. When I started the piece, I had been asked to be in the Venice Biennale, and I wanted to create work related to the site. I knew there would be classical sculpture everywhere so I decided to do a classical bust. I've noticed a reoccurring desire in my work to get outside of myself in order to see myself, and I began by asking myself why artists have traditionally been motivated to make self-portraits. One answer I came up with was the desire to immortalize oneself, so I decided to use ephemeral materials. The other reason artists were motivated to make self-portraits was to produce a public image. But eating and bathing are relatively private acts, so I thought they would offer a more interesting way to describe the self. Are you more yourself when you're alone with yourself?

When I got to Venice, it was extraordinary—there were eroding stone sculptures everywhere, and in many of these sculptures the features were washed away, very much as in my soap heads. It was a revelation for me to think that even stone has a life span. It spoke about the inevitability of our mortality. It also made me think back on my process, and about aging as a creative process, in the sense that the way we choose to live our lives is the way we choose to age ourselves. For me both the licking and the washing were loving acts—but slowly, through these loving acts, I was defacing myself. *Lick and Lather* is really about this tension, and the love/hate relationship we have with our physical appearance.

The notion of body knowledge is important to me. I am aware of it when I make sculpture. That's one reason why I do these extreme tasks, because viewers understand the labor somewhere in their bodies: I know their relationship to those activities isn't neutral. I want to position the viewer in a particular relationship to the object, one of empathy toward my process. That's very different from the way we normally approach a conceptual work of art, where we remain very objective and go through a process of decoding information. I'm very interested in this subjective relationship to my process.

And. 1997–99. Two 600-lb. limestone boulders and 10' steel rod

I started *And* in 1996, during a residency at Sabbathday Lake, the last active Shaker Village in the world. While living with the Shakers I decided to make my first stone sculpture. After extensive research, I flew to a well-known limestone quarry in Indiana. I chose two six-hundred-pound boulders, loaded them in a Ryder truck, and returned to Maine. At the Shaker Village, one boulder was placed on top of the other, using a steel pole as their central axle. A second pole was then inserted into the top rock, parallel to the ground. Pushing the pole in a circle for five to six hours a day, I began grinding the stones into one another. I was interested in the place where the two forms met: I wanted to make a sculpture where the forms would give in to each other and resist each other at an equal rate. That seemed like an ideal relationship. So, with great effort and a few complications, these two forms slowly ground into one another.

The idea came to me when I was in Delphi, looking at the incredible stone walls there, constructed perfectly without the use of mortar. The stones fit together like a honeycomb. My friends explained that the stones had been rubbed together until they were airtight. When I conceived *And*, I thought it would turn out something like Brancusi's *Kiss*. The two forms would be completely flat and married to one another. It didn't work out that way, though: the stone had hard and soft areas, and the hard areas started to carve out an upside-down bowl in the top rock. Instead of getting closer, the grinding created this wonderful arch, which was getting bigger and bigger. On one side the stones carved a ball-and-socket joint and on the other they touched gently. At that point I decided the piece was finished. This relationship was much more complex than the flat surface I had anticipated; rather than thinking of an ideal relationship as a perfectly matched union, I was excited to think about the process of sculpting a space between us. That union does not always mean that the parts will completely conform to one another, but that they will respect the hard and soft areas. It is much more complicated and interesting.

I have never been happier in my life than when I was making *And*. At the end of every day I was completely satisfied. I realized that I have to be physically exhausted to be happy. I also identified the labor as a kind of meditation. A lot of critics have talked about my labor as obsessive-compulsive behavior, but I've never really seen it that way: I do feel that I push my body to a limit, but I know where that limit is, and I stop there. I believe in labor but my work isn't masochistic. I see it as a discipline.

It was incredible to be doing *And* while I was staying with the Shakers, because they too believe in labor. For them, labor is a kind of prayer. My relationship with them was funny, they started to understand by observing. And of course they teased me the whole time: what was I doing walking around this rock? There's a beautiful Shaker song, "Simple Gifts," that talks about turning, turning, till you turn around right. They kept telling me, "You're trying desperately to turn around right." I think they were right in a way. Something happens out there, alone in a field, walking around in a circle.

I've come to trust my process and the slow transformation of the object. Joseph Beuys called beds "energy catchers," because in your bed you have sex, you have dreams, you are sick, you have babies, and you die. He felt that beds collect all this energy. I'm interested in whether an object can really do that or not, and how it works. The relationship I have with the object is a real one. I'm interested in the point where I'm not sure whether I'm making the object or the object's making me. When I get to that point, I usually know I have something interesting.

Antoni in her TriBeCa studio working on *Moor*, 2001

Born 1961 in São Paulo. Lives in Brooklyn, New York

VIK MUNIZ

Selected Solo Exhibitions
"Vik Muniz." Indianapolis Museum of Art, 2003 (traveling)
"Vik Muniz." Museo d'Arte Contemporanea di Roma (MACRO), 2003
"The Things Themselves: Pictures of Dust by Vik Muniz." Whitney Museum
 of American Art, New York, 2001

Selected Group Exhibitions
"Moving Pictures." Solomon R. Guggenheim Museum, New York, 2002–2003
"La Mirada: Looking at Photographs in Latin America Today." Daros Latin
 America Collection, Zürich, 2002–2003
"Tempo." MoMA QNS, Long Island City, New York, 2002

I never intended to be an artist. I was born in Brazil, and had a humble upbringing; in the 1970s it was inconceivable for a person from where I'm from to become an artist. I'm an only child, and the normal thing would be to try to be a postal worker or something so you could bring some money home. I've worked in a gas station, I've been a house painter, and one of my first jobs was in advertising. I'm not proud of these things, but ultimately I think things like this contribute to what an artist is. I think every stupid job I took is part of what I do today.

My first interests were in perception, and they never left me. I wanted to do research and maybe turn out to be an eye doctor if I was lucky, but I couldn't get into medical school in São Paulo—it was very hard, and you needed a lot of influence. I could, however, get a job in advertising, and I thought that would be a great opportunity to use these ideas about psychology and perception that had been brewing in my head for so long. There was a famous book that showed how advertising could control the way people think, through hidden messages and things like that. I was all excited about that, so that's what I wanted to do. Little did I know that I didn't want to sell whiskey by putting pictures of frolicking people inside ice cubes; I just wanted to put pictures in ice cubes.

Walk toward anything and it transforms. Metamorphoses always happen with proximity and distance. We do this with paintings almost without knowing it: we go to the Frick, there's a Vermeer of a woman in a fur collar, we get very close and we see no fur, we get farther off and we see fur. How can that be? It's ingenious. I thought a lot about things that transform as you get close. I also thought of why things transform to begin with—why we can see something within something. I first tackled these issues as a curious person, not as an artist, but I was also always drawing, ever since I was a kid. And I was always copying paintings. In fact I loved paintings, especially from the sixteenth and seventeenth centuries, and I couldn't bear to call myself an artist because I had all these ideal models.

The most primitive cultures have shamans who try to call up spirits, let's say the spirit of some animal. To do that, the shaman will either do a dance to represent the animal or he'll draw it on the floor. These things are old, and I think they're still the basis of all kinds of artmaking today. Art is a type of magic, but we don't call it magic anymore, we've become too sophisticated. But that's the true meaning of magic: I can make a circle on the floor, with radiating lines, and everyone sees the sun. That's magic, and I always thought of it as such.

It took me a long time to realize that I could be a magician too. I had an epiphany: I was looking at Rubens at The Metropolitan Museum, and in these paintings you could see the entire spectrum of information at the time they were made: notions about sex, politics, aesthetics, beauty, heroism, royalty. People would stand before these big paintings and see a detail here, they'd move sideways, see something else. And I realized that was what I didn't like about art: everything means the same thing. It's like

Teacher, 1999. From the "Pictures of Chocolate" series. Dye destruction print, 60 x 48" 231

a crossword puzzle: people solve it differently, but in fact it's packaged for a large number of people to see the same thing. Then, when I turned a corner, I bumped into another kind of mechanics: people were making a line to walk toward a painting. They would stop at this invisible mark, all at the same place, and gaze at this little painting of a child, five years old, slightly cross-eyed. Her name was Clara Serena. She was Rubens's daughter. When you paint someone you know, you tend to make things very symmetrical, because you fool yourself into thinking you know that face. But Rubens was such a great artist he made every bit of symmetry present. This thing was just alive, bursting out of the canvas. But people walking toward it in a line—that, I thought, was something else, something I hadn't tried yet. And I thought maybe I could make art with that in mind.

I was making images before; this time I thought of making objects. Every sculpture has a good angle to view it from, the angle from which the artist meant the viewer to see it. So I made objects that had identity problems, and then I made photographs that had identity problems. When I photographed the objects I made, I was immediately taken by the photographs. I realized I wasn't such an iconoclast after all; I started liking the pictures more than the sculptures. Once the picture was taken, in fact, I could throw the sculpture away, set it on fire—I wouldn't care. Before I knew it I was changing the sculpture a little, thinking how it would look in the picture. Then I was making things just to be photographed. I'd been interested in theater; theater was there—I could make something represent something else, like in a little play. I could also work with drawing, and I could work as a copyist, which I always intended to do. I feel I'm becoming a very traditional artist in a strange way, because I'm a traditional draftsman. I make representations that try to be faithful, try to convey something's graphic meaning. I'm also a traditional photographer: I don't rely much on effects, or toning, or ways to make an image look interesting, I'm a very boring photographer. I just take pictures of things the way they are. But these two things together give a contemporary character to what I do.

Photography tends to be seen somehow outside the history of representation. We imagine, "Oh, this is transparent. I can see right through it." In fact it's not quite so. The difference between a photograph and a drawing is that a photograph is made of tiny little dots, so small that they fall beneath the threshold of perception. You do see the image right through them, but it's an illusion. I think I've been trying to make pictures that are not so transparent—to make *thick* pictures, pictures whose meaning you have to go through stages to get. And you're never satisfied, because you're always going back the way you came in the picture; you look at the picture and you go to different meanings. I started doing this with a series called "Equivalents" [1993], which were pictures of cotton clouds where you could see three things: you could see a cloud, a lump of cotton, or Dürer's praying hands, but you couldn't see all three at the same time, you had to see them one at a time. You had to shift the way you perceived them.

In 1993–97 I made pictures called "Pictures of Wire" that look like pencil drawings. When you get close, you realize that they're photographs of sculptures made out of wire, and you immediately assign to them a time, a place, a space—it changes your perception of them. After that I made drawings with thread. I was working with linearity, a very old art method. It's funny, the development of my work mimics the history of representation: I was working with line, but I shifted it into the tiny dots of photography.

These thread things drove me crazy, they took a long time—three weeks sometimes. I wanted to do fast drawings, and I wanted to do something dynamic and performancelike, so I started making pictures out of chocolate. I would look at a picture and I'd draw it in a chocolate syrup called Bosco on a piece of white Plexiglas, working fast enough so the chocolate wouldn't dry. It was like "beat the clock." The chocolate was reflective so you could add your own reflection into the piece. Also, color photography—I used Cibachrome—looks like it's on top of the surface; it's repellent, in a way, it doesn't let you in, it has an in-your-face kind of feel. I tried to work this concept in. You have a piece that has something to do with taste and also the same pleasure as painting, where there's this scatological thing that you move around the space.

Now that photography is a digital medium, the ghost of painting is coming to haunt it: photography no longer retains a sense of truth. I think that's great, because it frees photography from factuality, the same way photography freed painting from factuality in the mid-nineteenth century. The painters of the nineteenth century said "Okay. We can no longer paint objects because that doesn't mean anything anymore; there's this thing that does that much better. So what is painting?" I hate to say I'm a photographer, because I learned photography as I went along. But I also hate to say I'm a painter, a draftsman, even an artist. I think it's good when you're confused about what you are; it means you haven't defined yourself as an artist yet. I hope I don't get to that point anytime soon.

Muniz in his studio in Boerum Hill, Brooklyn, working on *Spiral Jetty*, 1997

KIKI SMITH

Born 1954 in Nuremberg, Germany. Lives in New York

Selected Solo Exhibitions
"Kiki Smith: Prints, Books, and Things." MoMA QNS, Long Island City,
 New York, 2003–2004
"Kiki Smith: Homework." The Fabric Workshop and Museum,
 Philadelphia, 2002–2003
"Kiki Smith: Telling Tales." International Center of Photography, New York, 2001

Selected Group Exhibitions
"Nancy Spero and Kiki Smith." Baltic, Gateshead, England, 2003
"Proof Positive: Forty Years of Contemporary American Printmaking at ULAE,
 1957–1997." Corcoran Gallery of Art, Washington, D.C., 1997–98 (traveling)
Whitney Biennial. Whitney Museum of American Art, New York, 1993

I've stayed home now since December—the longest period I've stayed home in practically ten years. I remember [the curator] Harald Szeemann talking in an article about all the young artists traveling all the time, and saying this sort of internationalism was really fresh and energetic and wonderful; and I thought it made me sick. I hate traveling; I want to stay home and work. That makes me the happiest.

On the other hand, it's always interesting to go someplace, visit museums, see things other people have made, and learn technically how they've made them. Or if you go to an art fair it's exciting to see what different artists and different generations know. I'm looking forward to the Asian art fairs coming up, because then I can learn a lot. That's one of my favorite events of the year in New York.

Once I read that in New Jersey a lot of crows had fallen from the sky and died. I had a vision that all the birds were going to die, so I started making prints of dead birds. I was trying to figure out how to make a sculpture that could have a lot of small elements. A lot of my work is small, individual things that add up and turn into multitudes. For me that comes from my father [the sculptor Tony Smith] making things out of tetrahedrons and octahedrons; when I was a kid he had us put tetrahedrons and octahedrons together after school every day. I sort of like that device. It's like the way movie images repeat to make an appearance of something happening. I used to make Super-8 films when I was younger.

My father was a big influence on me. His main preoccupation in life was his work, and if you're an artist that's a good way to be. So I saw a rigorous practice of this when I was young, and it's actually ended up suiting my own life too. In a certain sense I put artmaking before everything; sometimes that's not good. My mother too was an important model for me. She had a career as an opera singer and actress and at forty she chose to have children. Growing up with a woman who had the ambition to express her creativity was extremely influential. She has also been enormously supportive to myself and my sister Seton Smith, who also became an artist.

Besides creativity and reproduction, the other thing we create is technology—we're technological beings. We create technology and interface with it. All our technologies are vehicles. The computer, for example, is totally interesting, it must be changing the paradigms of how people are working and thinking, but on another level it's just a tool, like paint or paper. It's all just material, though maybe it takes a while to figure out its possibilities. I worked a lot with papier-mâché when I was starting out, and then I had the opportunity to work in metal; then I got sick of doing that and went back to papier-mâché, and in another two months, I know, I'll pray that I never papier-mâché anything again. Each medium affords you a different experience. The physical manifestation of it is how meaning is constructed. You have to choose the medium, to exploit its properties—the way wax or paper, for example, is luminescent and reflective, like skin. They have similar characteristics.

Daughter. 1999. Nepal paper, bubble wrap, methylcellulose, hair, fabric, and glass, 48 x 15 x 10"

To me that's always the pleasure of making art. The other side is a kind of necessity, a personal necessity. How you play that out is your personal, intellectual choice. You're manipulating the world.

Craft is certainly a deep space of information for many artists. My superfavorite artist is Richard Tuttle, who's one of the great connoisseurs of decorative art. I think Saint Francis or Saint Anthony made a distinction between art and craft by connecting art to the heart and mind and soul, or something like that; but I'm totally interested in craft, and in what's passed through craft or the decorative arts. That stuff is a kind of celebration of being physical, and an investigation of the different properties of materials. On the other hand, I'm a little lax in the patience department. So although I can do my own casting of glass, I'm perfectly happy for somebody else to do it. I like *painting* on glass very much, though, and I want it to be from my hand. I can't tell an assistant to help me with that; I have to really do it. Also I want to have the experience.

One of my main interests in life is to slowly learn about forms. Sometimes you see a form or technique used that you're attracted to and you know you don't have the content to fill it with. You say, "Oh, this is a great form, or a great way of making something," but you don't get an idea for how to utilize it. Even so, it's a great space of information. I'm an ambitious person; I want to have as many experiences manipulating forms as I can. Painting, I can't quite get there, except painting on glass or three-dimensional forms, but other forms I like. I love printmaking very much and I'm extremely interested in its history and in its technical aspects. I can also say, in my weeny little way, I have to compete with Richard Tuttle. He just blows other artists away. He keeps spinning and manipulating the possibilities. He always ups the ante. I try to run behind and go, "Okay, I can try to stick this out," because I think a lot of the time that's what artists are doing—raising the ante of what one has to push for. Formally, Richard always raises the stakes because he's so inventive.

A couple of years ago I was working and watching television, a minister was on, and he said that you had to think about what you wanted in life. I said to myself, "I want to make a chapel for the Virgin Mary. That's my job on earth." Then I felt, "Oh, maybe you can get over this." Then last year I was in Germany painting on glass, and I thought, "Now I want to make a cathedral." I'm upping the ante—I'd like to make big paintings on glass, or one big architectural work. My fantasy is that I can have one at an airport someplace, or maybe somebody will decide they need a chapel or a cathedral in their backyard. I like to collaborate with architects.

I don't know if I'm a particularly religious person, but I certainly was seduced by icons as a child. Catholicism is probably one of the most icon- and idol-worshipping religions, because it believes in the physical manifestation of the spiritual world. It certainly goes well with Western art history, because it believes in making things—it glorifies the physical. A lot of my work makes it seem like I'm obsessed with religious

things, which I am, but really just as an image to manipulate. Religion is like a fairy tale or something. For my last show here I made images of Little Red Riding Hood, who for me is a cultural icon that I can take out of context; the Virgin Mary is like that for me, she has attributes and physical qualities and a vague personality that one can move around in. I was very influenced by Jean Rhys's novel *Wide Sargasso Sea.*

I've never really wanted much. I mean, right now I want a stove, and I think, if I just get a stove, my whole life will be so much more organized; but all I really do is make coffee, so things like that are vague. I want to be good; that's my Catholic upbringing talking, and I pray every night so that I act better. I never had a vision of how my life should be, and I think, as an artist, that's sort of a good position. Sometimes you can control the subject matter of your work and sometimes you can't; I'm just seeing where it goes. Sometimes it would be nice to know where I was going, but in a way it's very nice just to say, "I put my total faith and trust in the deep part of my curiosity about things to take me where I'll go." My life is an expression of being here.

The big doubt always feels like, "It's going to be taken away—I'll never have another idea—my work will have no clarity—and I'll have to go bag groceries or something." A lot of artists have no economic certainty, and live in a precarious way. A lot have health problems from the poisons some of them work with in their materials. But maybe all life is like that anyway, though we like to pretend sometimes that it's more stable. Anyway, when I was maybe thirty or thirty-five, I learned to respect what it is to live with that level of creative and artistic uncertainty. It was great being around artists. I saw that for the most part they'd survived pretty well through that devotion to the unknown.

Smith working on *The Remains* at the Harlan & Weaver print workshop, Chinatown, New York, 2003

MATTHEW McCASLIN

Born in 1957 in Bayshore, New York.
Lives in Brooklyn, New York

Selected Solo Exhibitions
"Matthew McCaslin Survey." Kunstmuseum Sankt Gallen, Saint Gall, 1998
"Harnessing Nature." Whitney Museum of American Art, New York, 1996
"Projects 33: Matthew McCaslin." The Museum of Modern Art, New York, 1992

Selected Group Exhibitions
"Tempo." MoMA QNS, Long Island City, New York, 2002
"I Love New York." Museum Ludwig, Cologne, 1999
"Le Consortium Museum Collection." Centre Georges Pompidou, Paris, 1998

I've been working site-specifically for about ten years. Before that I'd basically been working on landscape, the overlapping relationship between technology and nature, and prior to that work I was making "non-site," [Robert] Smithson-esque pieces. I'd been showing, primarily in New York, and I had a couple of touring group shows in Europe, but I became disenchanted with the idea of making something and putting it in a crate and then it would be brought someplace and taken out and put on the wall. Something about that wasn't gelling for me—I wanted to have more of an interaction with the whole experience of what this journey was, what my *life* was. It's kind of like the presidency: there's no on-the-job training for artists, so it's your form. You can look at Jeff Koons as he emerged in the early '80s and say "I want to do *this*," but it's not until you find your journey, your way of making and seeing, that you start to get to something a little deeper that may possibly be yours. I quickly found that I was excited about being given another opportunity and another place. So I would just bring in materials and work directly in the gallery with very few preconceived ideas—I was kind of like a squirrel in a garage that couldn't get out. So that's really how I approached the early work, and what I continue to do on some level.

I was looking for a material that was inclusive and expansive. I was a student of Pop and Minimalism, like everybody my age, but I was also very drawn to Minimalism, its implicitness, its power, its finite quality—yet I realized that it was at an end; there was really no place for young artists to go with it. It had lived itself out so completely that there was a need to look for something that maybe had the formal qualities of Minimalism but also had metaphor and was more expansive. I'd been working in construction for seven or eight years. Although I hated my day job with a passion, as most artists do until they make it, I went through a realization where I shifted my feelings about it. This idea of inclusion was happening in my life: instead of hating my day job, maybe I should look at the materials I was working with there in a different way. In general, I started to get into the idea of asking, How can I work in a way that's inclusive and expansive? Can I find something that, instead of being reductive and finite, would do the opposite—would have the ability to constantly move outward? And I started working with electricity. I found it to be just the perfect material. It's a woven medium that connects us culturally, but most of the time we take it for granted: it's hidden behind the walls.

My first outing with electrical material as a means was a show in 1991, at Daniel Newburg Gallery in New York, that I did with a friend, Dan Walsh, a painter. We were both doing electrical work during the day anyway, and I had a couple of oddball drawings, so we went in and did these weird things on the walls, hung some things from floors, and left the gallery like we would a job site—you know, when the electrician goes to your house and leaves his stuff all over the place. We did that as the show. And everybody was very familiar with this. I thought it was funny: a lot of people

Installation view, Shoshana Wayne Gallery, Santa Monica, 1999

would come to the gallery and say, "Oh, they're working on it. We'll come back when it's finished." That was the overriding reaction.

One thing starting to take hold in "Indigenous Species" [1991] was this sense of an entropic electric jungle field taking over, the way a viney plant would—the way ivy takes over and you can't get rid of it. Then my first show in Paris, at Jennifer Flay Gallery in 1991, was a dropped-ceiling installation that basically split the gallery in half: half of the gallery had its regular ceiling, the other half had a lower one. These two dropped ceilings hung in the middle of the space, halfway down, so you could only go around the edge of the gallery. I was interested in the architectural idea of place, as opposed to the artwork as object, so the idea was to create something that was awkward in its location as a thing—not quite a thing, not quite a place. And it was always in the way. It's a dropped ceiling in two levels.

In a piece called *Happy Hour* [1991] you see very quickly that I'm basically a helpless romantic, no matter how much I try to deny it. There's a lot of romantic drawing going on. As a young student I was very influenced by David Smith, and I still feel an affinity with that work, and with the drawing in it.

A show in Geneva, Switzerland, in 1992 at Art in Public, was the first show where I started working with sound as well as with electrical material, but I was also expanding into video work. I was starting to find that I'd pushed the barrier of where I could go, emotionally and psychologically, with this abstract electrical equipment, and I started to bring more metaphor into the work. *Why Can't We Be Three* [1995] was an early flower piece where I set up a video garden with time-lapse at the Consortium in Dijon. It was just beautiful flowers in time-lapse. You're seeing something you wouldn't experience in nature, something only technology could give you: this beautiful electric garden. The flowers come to life in the dark, and all the TV's are bouncing off each other so you're constantly getting different flowers.

In 1996 I did an installation at the midtown Whitney in New York, the Whitney at Philip Morris as it was called then. The title of the installation was *Harnessing Nature*. The show was all black and white footage of the ocean out of control. As you looked in from outside through the glass, you saw these ominous seas all over the place but once you opened the door, the sound was so strong you were knocked over. It was the sound of oceans at mega-decibels. I wanted to play with the notion of containment, and with the notion that the Philip Morris company had created this container for culture and I was going to make a TV the container for something out of control. I was pushing at the idea of what that space was about.

I've always been a fan of low technology. I'm a very simple guy and I've never been good with high technology, it's not my thing—in terms of how things function, I'm really more interested in failure than in success. So often the narrative that runs through my work in terms of sound will indicate things not going well, even while you're looking at this formalist fluorescent bulb object on the floor.

About 2 ¹/₂ years ago I started shooting out at Coney Island. It was an extension of something I'd been doing earlier: going out at night looking at lights. I was interested in light at nighttime, and I started filming a lot at amusement parks. I became enthralled with amusement parks, not only because of the light but because amusement parks are places we go to let go. There's a weird mix in them between this frenzy of feeling free, of letting go of things, and an incredible fear at the same time. I like that tension between fear and joy, and I tried to evoke it in a show in 1999, at the Shoshana Wayne Gallery in Santa Monica, in the way the pieces were set up, what the images were, what the sound was. And it had that feeling, because of the color, the movement, the rides—it really had a funny way of extending the idea of the amusement park right into the gallery.

My way of working has been to get in the back seat and let the work be the driver. It's a different way of working; I think it's less one-dimensional. I'm not interested in trying to set up a narrative in which I'm telling you about your world, and why this sucks and this is good and why you should eat vegetables, not meat. I feel I know what I am enough that I can get in the back seat, let the car do the driving, and then let it take the viewer where it wants to go.

Born 1961 in New Bedford, Massachusetts.
Lives in Beach Lake, Pennsylvania

MARK DION

Selected Solo Exhibitions
"Full House." Ninth Annual Larry Aldrich Foundation Award, The Aldrich
 Museum of Contemporary Art, Ridgefield, Connecticut, 2003
"Mark Dion: Encyclomania." Villa Merkel, Esslingen, 2002
"Two Banks." (Tate Thames Dig.) Tate Gallery, London, 1999

Selected Group Exhibitions
"De l'homme et des insectes. Jean-Henri Fabre." Musée National
 d'Histoire Naturelle, Paris, 2002
"Museutopia." Karl Ernst Osthaus Museum, Hagen, Germany, 2002
"The Museum as Muse." The Museum of Modern Art, New York, 1999

I don't actually make things in the studio, I really make things on site, *for* site. I don't mean just that I make things in specific relationship to the architecture where they are going to exist; I also work in terms of the context, the social and political history and also the temporal context, by which I mean, What's going on? What's in the air? What considerations are current? I work with local materials, local technicians, and I rarely make things in one place and then move to another. That changes the nuances in the way the work comes together.

My work is largely about the history of natural history. I don't really think of it as being about nature, I think of it as being about *ideas* about nature. One thing I'm trying to do is chart the history of ideas, starting with Aristotle—a lot of my work exists as examinations of important figures who have changed our thinking about the natural world. Imagine a historical line from Aristotle to today: each of my pieces for me is like putting a little pin on that line. So one time I may be looking at Baron Georges Cuvier, or in the nineteenth century I might look at Alfred Russel Wallace, the cofounder of the theory of natural selection. All of the work has undercurrents of a passionate interest in biology and nature, and is motivated by witnessing diversity disappear.

All of my work is in the landscape tradition somehow, but in nature there is no landscape, there is only land. Landscape is when we make a frame. I'm interested in looking at that frame and trying to understand how it affects what happens to land. When you travel down the Amazon, you see a microcosm of the history of human interaction with nature. You start in a city and you go to a smaller town; then you come to the river settlements; finally you reach people who don't really make a division between culture and nature. It's almost like time travel. That experience informs my work. Also, when I began to work, I was deeply motivated by conservation. Probably my first piece was in 1988, a series of childlike silhouettes in different colors on the wall that told the story of something that happened to a remote village in Borneo in the 1960s. To eradicate mosquitoes, which were causing a malaria problem, they started an aerial spraying campaign. The mosquitoes seemed to disappear, but a couple of months later the villagers' huts started to collapse. The spraying had killed a parasitic wasp that ate the caterpillars that ate the thatch on the houses. That led to indoor spraying, and soon the caterpillars were dying. The sick caterpillars were eaten by geckos, which accumulated the poison in their fatty tissue. The poisoned geckos were eaten by the village cats and dogs, which then all died, causing an explosion in the rat population, which ate all the village's grain for the year. It ended with the World Health Organization—the same organization that had tried to eradicate the mosquitoes—parachuting in crates of cats.

That was the first time I worked on natural science narratives, but I've always been interested in this kind of storytelling and truth-telling. Some time around Pop art, I think the art world gave up asking the really difficult, complex, cosmological

The Museum of Poison (Biocide Hall). 2000. Wood and glass display cabinets, wooden pedestals, pesticide sprayer, pesticide containers, mounted photographs, plastic, dimensions variable

questions, and became self-reflective, interested in mirroring its own culture. To me that's not enough. I want to ask the big questions; I want to get back to a time when science and art were close together, and tackled some of the same things. I think you have to be suspicious of the way artists use science, with a kind of flippancy and mastery that sometimes need to be more careful; I try to make it clear that I'm really not an ornithologist, I'm not an archaeologist, I'm a passionate amateur. But even if I believe that art and science are profoundly different, I think they both have things to say about crucial issues, political, aesthetic, philosophical.

I'm inspired by the history of museums—the early cabinets of curiosity, pre-Enlightenment ways of putting things together. Museums are about gaining knowledge through objects, and for someone who is somewhat a sculptor, gaining knowledge through objects is what the game is about. For *Tate Thames Dig*, in 1999, we did two digs on the banks of the Thames, one in front of the old Tate Gallery [now Tate Britain] at Millbank, one in front of the new Tate Modern at Bankside. Of course the neighborhoods of these museums are different social scenes; they're different kinds of place. I worked with about sixteen volunteers, eight of them under seventeen and eight of them over sixty-five. That's a great combination, because some of the pensioners could actually identify objects we found—they'd say, "Oh, this can is such-and-such, we used to eat this during the war." They made history very real for the teens, who conceptualized the past as the "olden days," which covered everything from the Beatles to the Romans. By meeting with archaeologists and the pensioners, the young volunteers began to experience the past as an inclusive continuity.

The Thames is a tidal river, so areas of the bank are exposed at extreme low tide. Every day we'd meet and everyone would go out. They were instructed to collect anything and everything artificial. We worked for about two hours each day for a week on each side. We were allowed to dig only six inches down, because beneath that there's a very fragile ecology of invertebrates. However, since the river is turbid, fast moving, and strong, each change of tides brings new finds to the surface—there's little need for actual digging. That was stage one. Then, stage two, we had this enormous mountain of material, hundreds of objects in buckets and bags. We erected three Indiana Jones–like tents on the lawn of Millbank: an interpretation tent, a tent containing all the finds from Bankside, and a tent for all the finds from Millbank. Every day the volunteers would clean every artifact—every nail, every coin, every bit of porcelain. Then, somewhere about the third week, we went into organizing: white porcelain, blue porcelain, stoneware, et cetera, breaking it down continually. We found hundreds of thousands of bones, like animal teeth. Bankside was always the rough place with the real interesting stuff.

I think this entire show, "The Museum of Poison" [at the Bonakdar Jancou Gallery, New York], is in some way a portrait of Rachel Carson. I wanted it to seem at first to have an optimistic, better-living-through-chemicals idea, but then have it fall into

disrepair and disuse as ideas about these chemicals changed. It's a museum that isn't closed, or open, or about to open; it's closed for installation—will it reopen? That question is part of thinking about it. I wanted it to feel sinister, and I think it does, remarkably so.

Carson's *Silent Spring* was published first in *The New Yorker*, in 1962, and then became an enormously influential book. It came out of nowhere and brought people to a realization in a very shocking way. The misogyny, the anger, that was coded into the attacks on Carson was just amazing. Yet her science was accurate. An independent presidential panel looked at her report and said, "Well, if anything, she's understated the enormity of the problem," so she was vindicated. You don't often think about pesticides; I don't think about this stuff all the time. Every once in a while, something like the spraying of New York City for West Nile virus brings it to the foreground again. But pesticides are always with us, as an essential aspect of food production and consumption. Over 600 different active ingredients are licensed in the United States. Before the publication of *Silent Spring*, nearly 60,000 separate pesticide products were registered with the U.S. government. Today insecticides, fungicides, rodenticides, herbicides, and algicides come in liquid, oil, paste, powder, and granular formulations. Pesticides that are banned here are produced here for export to countries like Chile and Mexico, and then come back here sprayed on oranges. I wish this was part of our past, part of our history, but it's not. I wanted the museum to be historical—otherwise I could have done something very contemporary as well. I could have gotten this new Martha Stewart hornet spray, for example.

One thing I did want to do was bring in the domestic. These things are meant for the home. We think of them as industrial products, but they're around us all the time.

I want there to be ambiguity: is this to be stored, or is it about to be installed, or has it been in storage and is about to be revealed again? What is the future of this museum? Pieces like this one are a lot about a certain kind of faith. As someone concerned with our historical relationships to nature, I think religious relationships are interesting: our religion today is really science. We put an enormous amount of faith in what scientists say. In some way I want these pieces to undermine that. If I'm a scientist and I say this is safe, do you believe me? As an artist, on the other hand, I can pick up that glass and take a sip and show you it's not poison. Somehow I want that testing, that question. Are these what I say they are? Who am I that you should believe me?

Born in Detroit. Lives in New York City and Tivoli, New York

AMY SILLMAN

Selected Solo Exhibitions
"I am curious (yellow)." Brent Sikkema Gallery, New York, 2003
"Letters from Texas." Jaffe-Friede Strauss Galleries, Hopkins Center,
 Dartmouth College, Hanover, New Hampshire, 2002
"Amy Sillman." Galleria Marabini, Bologna, 2001

Selected Group Exhibitions
"Comic Release: Negotiating Identity for a New Generation."
 Carnegie Mellon University, Pittsburgh, 2003 (traveling)
Officina America Rete Emilia Romagna, Galleria d'Arte Moderna,
 Bologna, 2002 (traveling)
"Greater New York." P.S.1, New York, 2000

I'm interested in simultaneity—the copresence of abstraction and figuration, deep space and shallow space, high and low, recognizable, literate, narrative, mythic things and dumb, vernacular, kind-of-stupid, jokey things—all these dialectics. I think in that way. I'm a process painter, which is to say that I have no idea what I'm going to do when I start; I just start working, and then I'll add something and then something else. Those additions take the form of contradictions. Maybe something will start as a green field, then I'll add some figures, then I'll erase them, then I'll add some green, some yellow, then I'll turn it upside down. It's an accumulative process, mutating as it goes along.

I became interested in the idea of narrative sequence because when I'm working, I feel like I'm making a painting with 100 layers, but you never see them. If I took a snapshot every time the painting changed, it would be a movie: every painting would have 100 different mutations, with things coming and going, moving to the left, falling down, turning right, turning green, turning upside-down. But because I'm a painter, you only see the top layer, which is a combination of everything that's happened, all the logics that went into the work, all sort of crystallized into this top layer. I'm interested in exposing that layering process.

I'm connected to Abstract Expressionism in the sense that I go into my studio and just start painting. I'm connected to Surrealism in the sense that I'm interested in psychological content, culled from memory and the subconscious—I'm interested in automatic drawing and other processes that come from Surrealism, and that maintain a relationship to figure, image, icon, as Surrealism does. The fact that I'm from Chicago means that I grew up looking at cartoony work. I didn't grow up looking at heroic New York School painting, at Kline, Pollock, Rothko, although I love that painting; I grew up looking at imagistic work that was charged with a sense of humor and a knowledge of high and low—people like the Hairy Who, Jim Nutt and Barbara Rossi especially, and the modern paintings in the collection of the Art Institute of Chicago that were less strictly pruned into the shape of the New York School canon and were often funny or quirky, like works by Yves Tanguy, Florine Stettheimer, and that immense Georgia O'Keeffe painting of clouds from a plane. My work has a commitment to this vernacular form.

I've lived in India twice, each time for about six months. Once I toured, once I had a residency and stayed in one place. I'm very influenced by and in love with Indian art. I looked at the work and was moved and touched by art that was small and intimate and psychological and narrative and mythic and beautiful and colorful, all qualities that weren't valued when I studied in New York. I was trained by Abstract Expressionist mark-makers. They're great, I respect and love them, but in India I saw work that was like what I saw as a kid, but better. I was interested in the idea that there was a very high art form out there that didn't follow the model of the Western modernist canon. I was thrilled and touched and delighted by the Indian way of

Letter from Texas. 2002. Mixed media on paper, three parts, 15 x 40" each, 45 x 40" overall

dealing with landscape and nature, story and figure—and I was already doing the same stuff. I felt I'd found a spiritual buddy.

I went to Italy almost two years ago for a residency. I've always been interested in the painting of the early Renaissance, not Florentine High Renaissance but Sienese, early Renaissance work. I think there's an interesting analogy between early Renaissance painting, that flat space and naively drawn, not perfect kind of perspective, and Indian painting, with its flatness and pattern and surfaces. Early Renaissance painting, Indian painting, and then folk art (I love folk art)—those are strong alternative traditions to the art history I was taught.

Painting generally takes a long time to develop. It's a slow and private language. It's such a specific thing to do: you've only got a rectangle and some paint. There's nothing there except you and the paint. It's not so much that you're dealing with a big history; I try not to care too much about history when I'm painting, in some way you just ignore all that stuff. It's just that you are dealing with such limited means. A lot of painters don't really come into their own, I feel, until they've worked for ten years. But I love paint. I think painting is so fantastic. I want my work to be funny and beautiful and personal and complicated and psychological. I'm not an overly analytical person; I'll mix up colors, maybe a whole bunch of different greens, and I'll just start putting them down and then I'll look at it. That part is largely intuitive, and I don't always know where it comes from—maybe from looking at stuff around me, everything from the sky to photographs. Recently I went for a walk at 4:30 and saw homing pigeons going around and around, and I ended up resolving a painting based on the way the light hit their wings, which made them look pink against a kind of blue, and I thought, Bingo, that's how I'll finish that painting.

I often don't know when a painting is finished, but you get to the point where the surfaces aren't working anymore, they're not going to have any freshness. After a certain number of layers of paint, the thing will have a certain deadness, but you know it's not done. What are you going to do? You either have to blow it off or just go for it, which could wreck it. That's why I have to have other paintings to start, because when you're starting a work, you can do anything. I'll get to the point where I just don't know what to do, so I'll put it to one side and just look at it passing by it when I'm on the phone, or waking from a nap and just getting the feeling that I might want to change something. I have to let it season. Then sometimes when people come over they don't like the most recent things; they say, What about the old things? The ones we liked? But then a year later they'll say that one from last year was fantastic. So you've got to let it season. Something happens—it meets its audience or something.

For the series "30 Drawings" [2001–2002] I just went across with a decorative pattern first, without any imagery—just moving across from left to right, like you would write a letter. I kept it to pattern, shape, color. Then I went across again, thinking about some kind of image. Then I went back across a third time and erased.

Now I'm planning on going back through, so they aren't really done. You can see that there are mirrors, eating, sex, looking at a twin, a doubling, a tripling. Certain contents, very specific things, come back again and again. Somebody asked me what the content of the work was. To me the content is psychological and bodily experience, like being in your body and at the same time thinking about that.

Every artist swings back and forth between two poles—we all have our own. Mine are "excessively sloppy," "excessively neat." My work was much messier before, then it got really tight, then it got really ragged again. I don't know why that is, but I feel like every artist has one crucial thing to deal with. Maybe a genius has five; I only have a couple.

I made a hundred-foot drawing. I thought I'd make an installation of odd little images and collect them together. I liked the idea of a long line that would extend the gesture out, but I also liked the idea of clunkiness, of things not being the right size, not being neat, not all the same canvas. I love thrift-store things, and the aesthetic of being unpretentious, of things that seem very casual, almost an accident. So I took all the little canvases I had and put them next to each other. The top is a straight line but the bottom and the thickness are variable. I made the drawings go around the corner so they deal with the room—they take a little walk around the room, and you have to take a little walk to see them. I like the idea of fragmentary thinking. I don't feel like I have a monumental, predetermined message, so rather than thinking monumentally, I took all my cultivated little friends and put them together. I can work in a casual way; then, when I put these little things together, they make sense in the end.

ROBERT MANGOLD

Born 1937 in North Tonawanda, New York.
Lives in Washingtonville, New York

Selected Solo Exhibitions

"Between Image and Object: The Prints of Robert Mangold." Addison
 Gallery of American Art, Phillips Academy, Andover, Massachusetts,
 2000 (traveling)
"Robert Mangold: Painting as Wall. Werke von 1964 bis 1993." Hallen für
 Neue Kunst, Schaffhausen, Switzerland, 1993 (traveling)
"Robert Mangold: Paintings 1971–1984." Akron Art Museum, 1984 (traveling)

Selected Group Exhibitions

"The American Century: Art & Culture 1900–2000. Part II: 1950–2000."
 Whitney Museum of American Art, 1999–2000
"Test Site." Mass MoCA, North Adams, Massachusetts, 1999–2000
"American Art in the Twentieth Century: Painting and Sculpture 1913–1993."
 Martin-Gropius-Bau, Berlin, 1993 (traveling)

We live in such a different time in 2001 from what I recall in 1955, when I went away to art school. I'm not sure I knew that there were contemporary painters working, that it was a choice. I knew there were people who made pictures as a hobby, and that there were advertising artists, and that there were illustrators who did covers for *Collier's* and *The Saturday Evening Post*, like Norman Rockwell, but I'm not sure I really knew that there were contemporary artists.

I went to art school thinking I would be a commercial artist of some kind, but once there I gravitated toward the fine-arts department. When I came to New York, in the early 1960s, I had graduated from the Cleveland Institute of Art and attended graduate school at Yale. And married my wife [Sylvia Plimack Mangold]. We both came to New York to be painters.

The person I think about the most consistently over the years is probably Barnett Newman. In Newman I saw a sense of architecture in terms of the work, and a sense of the viewer's relation to the work—the viewer standing in front of the work and his particular size and position in relation to the work. That's what I've thought about ever since in terms of my own work.

Almost all of my paintings since 1984 have had a drawn ellipse or ovoid form, and sometimes multiple ellipses within it. I can't tell you why I've consistently done this; I mention it and notice it only now that the new work separates from it. I also have to go back to 1977 or '78 to find paintings of mine within square or rectangular units. From that time up to the present, I have made devised shape an important part of the work.

The new curled-figure paintings make a clear separation from the works of the recent past. Two years ago, in March of 1999, I exhibited two large paintings, one of them over seventeen feet long, the other over twenty-seven feet long. With the exhibition of those works, it felt to me that this series that I had begun in 1996 had come to a close. I found myself in what by now is a familiar position: I work with a certain image/idea for a period of time, maybe two or three years, and I get to a point where I feel the making of more paintings in this series, while still possible, is fruitless. There is nothing left there for me. When I choose to work on an image/idea—I think of image and idea as connected—in multiple ways over time, it is because I somehow find significant interest there: not simply a casual or passing interest, it must hold something for me that I cannot discard.

Years ago, when my wife and I started going to antique shops in the country, we would often deliberate for a long time on whether or not to buy something. A woman proprietor of one such shop told us, "Never buy anything that you can do without." I'm sure we haven't always obeyed this dictum in terms of purchases, but it's a good one for the artist: never paint something that you could just as easily *not* paint. Never follow up an idea that you could turn your back on. I think too much art is made that lacks necessity as a primary ingredient. So the idea/image must have within it

Curled Figure II. 2000. Acrylic and pencil on canvas, 36 x 51" 251

something of compelling interest for me, an interest that is probably inexpressible. It rings the right bells within me. It makes connections, both visual and mental, that are intriguing. Yet this construct remains aloof, separate, intrinsically itself.

One reason I work on a single idea over many works is that the process becomes one for getting to know or understand this interest better. I can't tell you why one idea/image has significant interest over another. I don't believe it's a question of aesthetics—in other words, it's not because one idea looks better. Aesthetics come later in the narrowing or refining of an idea/image. I think instead the choice is entirely personal, coming from within. I follow it intuitively. I am or try to be sensitive to these signals, and in the same way that they can mark the beginning of something, they can imply the end of something.

The present curled-figure paintings and works on paper I began working on early last summer. In some ways, though, I've been thinking about them for a decade. In the "Attic" series of 1990–91, some of the works contain what I call twisted ellipses, a figure-eight form. I wanted to pursue curving arabesque-like figures back then, and I started working with them, but I couldn't form a clear group of paintings, so I put the idea aside, returned to it, put it aside, until I could find a way to use it. In these present works there is both a reaching back into my past work and a moving into something less friendly. They resemble many works that I did in the '70s, a single drawn-line figure on a painted one-color surface.

The figures in these new works are primarily double curls or reverse curls, or you could think of them as double spirals. Unlike ellipses and ovoids, which are complete, fulfilled forms, a spiral starts in the center and revolves outward—energy goes out. In these double spirals, while the outer curls touch the edges of the canvas or paper, they curve inward, internalizing the energy. I think of them as like wires in tension. They're inside this thing, they hit the sides, and they're kind of alive, with a spring. It's a feeling idea that I want the line to have; it doesn't have to do with mathematical proportion.

The lines are at the same time a single figure and a double figure, or a single figure in the process of becoming a double figure. Forms in transition are not a new subject for me. I've many times drawn a circular line that increases or diminishes its radius so that it does not complete itself; that is such a form. It is a circle on the move. Other such forms are the shaped-canvas works that I made in the '70s, where the canvas starts out as a circle on the left and becomes an octagon on the right, or begins as an octagon on the left and becomes a hexagon on the right.

I can almost universally say I never start with a blank canvas. Because shape plays such an important part in my work, I have to figure out the size and proportion ahead of time. I have to figure out what the idea/image is going to look like. I like to say that I'm an intuitive artist but not an improvisational one: I don't step in front of the canvas and begin.

I start out with a white gesso canvas and I draw a line. That takes me a while—the lines are drawn freehand, and there's no mathematical idea determining how they're formed. I just want the curl. I try to make it as smooth and clean as I can, so I keep backing up and looking at it and sitting down and looking at it. If it looks lumpy I go back and change it a little. Eventually I get the drawing to the point where I think that the line is fairly correct. At that point I start painting. I'll roll the coat of paint on and then I'll redraw—if the drawing isn't quite correct, I can adjust it a little. Then I'll paint another coat.

Scrolled or curled-line figures are in use everywhere in our world—in fabrics and in architectural details, for example—as if they held some strange significance for us. They also exist in ancient cultures, as signs and symbols transcending ornament. People ask where I get the ideas for my paintings, and I wish I had a good answer—or maybe I'm glad I don't. I did go back and look in the sketchpads that I work on to see if I could find a page where the discovery occurred, but I had no success.

At one point after I started working on these images, I thought perhaps they were driving me crazy. I don't think it's by accident that we point at our brains and move our fingers round and round to indicate madness. But I think I'm probably as sane as I ever was.

In general terms, all of my work, or at least all of it since 1970, combines a drawn line figure with a painted surface container. The act of drawing within the act of painting seems to hold a deep interest for me; these are two separate but equal activities in my work. In painting I cover the surface efficiently and quickly, most often using a roller and relatively thin acrylic paint. The paint is a film of color rather than a tactile substance; after its application, the surface becomes less tangible rather than more. Then, with a pencil and the act of drawing, I reconfirm the surface as a plane. The drawing reasserts what the painting process dissolves. What absorbs me in painting is this dialogue between thereness and not-thereness.

Mangold in his Washingtonville studio, 2001

Born 1958 in Long Branch, New Jersey. Lives in Los Angeles

CHARLES LONG

Selected Solo Exhibitions
"Charles Long: 100 Lbs. of Clay." Orange County Museum of Art,
 Newport Beach, 2002
"Currents 75: Charles Long." St. Louis Art Museum, 1998
"Charles Long: The Amorphous Body Study Center." Bonakdar Jancou
 Gallery, New York, 1995

Selected Group Exhibitions
"Arte Contemporáneo Internacional." Museo de Arte Moderno,
 Mexico City, 2001
"ART/MUSIC: rock, pop, and techno." Museum of Contemporary Art,
 Sydney, 2001
"MoMA 2000: Open Ends." The Museum of Modern Art, New York,
 2000–2001

My collaboration with Merce Cunningham opened Saturday night. I was surprised when the curtain came up because there was no movement the first twenty seconds, just my set, so the color, scale, and depth were elusive, but then their interplay with dancers brought an intimacy to the project.

Working with Merce was great for this unpredictability. He became aware of my work through my collaboration with Stereolab, "The Amorphous Body Study Center" [1995]. I loved making that project but it took on a life of its own as it was absorbed into the global art machine, which sees it as a funhouse for its pop music, bright plastic colors, and viewer interaction. All of those things were byproducts of my sculptural investigation about the body, autonomy, and connection. "Success" diverted that inquiry but I keep returning to those original questions.

I started out working with popcorn kernels as a model of autonomy and difference. I drew them large, going from one side of the paper to the other, thinking that if I could understand all that unnamable difference, I might somehow redeem it. Like my own subjective predicament, I might transform utter specificity of form into an experience through the act of seeing, drawing, and representing. Then I chose a popcorn kernel with a sense of "overdeterminism," my projection really, and gave it to a jeweler to cast an identical pair. I welded them onto the opposite ends of this wire and bent the wire, trying to get one kernel to stand up to eye level.

By reflecting back to the drawings I discovered a subtle difference between painting and sculpture: like Magritte's subjects, the drawn kernels were free-floating and didn't respond to the gravity in which the image was viewed. If it was held on the wall, you didn't think about the nail that was holding up the image. As a sculptor, I wanted to engage the problem of presenting a model for theoretical play while simultaneously playing with conditions that object and viewer occupy. You have to support yourself. You have to get up and bring yourself here, but you also have to support yourself psychically. You have to deal with your own birth, death, and transition through that. So here in this early work, a popped kernel supported by a rod was a paradigm saying, "I have this efficient means of supporting the unknown." I think one's life, or at least my life as an artist, is that. I just need to support myself sufficiently so that I can have ample room to get way out, to have all my feelings be their own kind of thing.

Next I turned to mold-making, thinking about positive and negative flow. I found an Eames Chair shell, an icon of modernist form where the fluidity of plastics meant that people could ergonomically shape the world to the body, increase efficiency, decrease pain. I observed how this ideology of form also closed off aspects of our being, and this led to a series of works that were hermetic, synthetic, and fetishized. I sat in this chair with a mound of clay between my legs and watched TV while working my hands into the clay mindlessly. Hours later I made a plastic cast of the chair as it flowed into the clay mass, fusing work and pleasure, self and object.

Charles Long exhibition at Tanya Bonakdar Gallery, New York, 1997. Installation view

Self and object are primary subjects of sculpture and I made a hybrid of them by punning "self" into "shelf" in a show I did called "Our Bodies, Our Shelves" [1996], where rubber shelves stretched into loopy wall compositions. I saw them as models of work, pleasure, and death: a form determined by purpose (the shelf) is in support of an undetermined object (the blob) against the consequences of reality (gravity). I was also thinking about the shelf as an ideogram of the body/mind, where the brackets are the legs and the mantle is a body with arms. The ends extend here and there, and then there's this useless blob, somewhere between phallus and breast. Is the blob the mind, the libido, a self that depends on its body, or somebody's body? Were these mind-maps of social bodies? Of how we imagine families or institutions where needs might be in a contest to be met?

I was raised on a bottle. So here's that first need of connection, where I wanted to suck on a nipple and they gave me silicone rubber. This enabled men to establish this connection too. Being part of this brave new world, I found rubber held this connection for me, but it also evokes a body's potential for movement and thus for connecting to another.

In "The Amorphous Body Study Center" I continued my investigation of the material and psychic aspects of sculpture but expanded the notion of autonomy by literally connecting to the viewer as object. *Bubble Gum Station,* for example, is made of pink modeling clay on and under a table that participants sit at and sculpt while listening to music spurting out of headsets. I saw the gum metaphor as the return of the repressed body in the public sphere. But the way the show was received eclipsed my concerns. With my next show I reacted against that metaphor of consumption and made these brown crusty sculptures from the collected public waste of used coffee grounds. Fresh-brewed coffee was served to inspire interpretation and conversation instead of interaction, and the grounds were incorporated into new works.

I had just started a family at the time and was happy to be away from the art world with them. In the mornings I would drink my coffee and do crazy caffeine-inspired outline drawings at the kitchen table and then go to the studio and sculpt from them with our used grounds. The coffee sculptures are about inspiration and defecation, the lightbulb that goes off when you get an idea from caffeine but also the poop it prompts. You're godlike and animallike at the same time. I was sorting through the organization of a life: the separation of the bathroom from the kitchen, the studio from the family, the public from the private. In the show the whole mess hangs together and actually it was one of the most beautiful shows I did. My wife, son, and dog had a lot to do with its development, which was new and wonderful.

When success happened, it screwed me up. I didn't even realize how much until last year, when I canceled all my shows. Better to not make work at all than make work in reaction. I saw this reacting against the audience as the beginning of a perversion in my work. I stopped producing and started reading and teaching. First-day jitters

tempted me to play it cool and teach the perverse body stuff I used to love—David Cronenberg, for example. Instead I went in and showed them Agnes Martin, someone who commands me to sit up straight and really think: Why I am here? What am I good for? My interests moved away from the body as the subject of the mind and conflicted desire and toward something strong, sacred, and an agent of transformation. It's been therapeutic to make visible aberration, desire, and dependency, though indulgent, too. What would it be like to do something beyond that? To question form, consciousness, and the body in a positive way in the context of a society that is suffering quite a bit at the level of the individual? Revolutions in the world begin with the ones we engage within.

Some might indulge this suffering, or don't consider it as such, and enjoy the party. I can't hang at that party anymore. I guess I would mention here that I'm going through an event in my life: my four-year-old son was diagnosed with an inoperable brain tumor three years ago and he's been on chemotherapy. I tried to maintain my career amidst this, but my marriage fell apart, and I fell apart many times. That process of having to deal with the iffyness of his situation, and the incredible devastation that it has caused to my wife's career and my own—well, we look at things differently now.

Everyone has to face fatality. There are few that haven't been touched by the loss of someone close to them in some dreadful event. I'm not special in that. But I do know I'm going through something that puts me in a new reality. Suffering is very transforming, but what's curious to me is discovering ways to embrace life and struggle in the process.

The work I did with Merce is so full of beauty, vitality, and loss. But it doesn't have some larger moralizing tendency. It's just its own thing. It looks very flowerlike to me, and in a funny way—I know this is really terrible of me to say, and very personal—but it feels like flowers for a funeral. For what, for whom? I'm not sure. I'm feeling my way.

Long in his Los Angeles studio, 2003

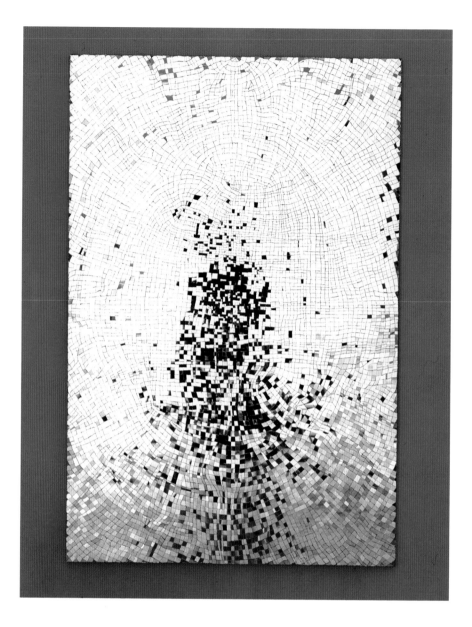

Born 1957 in Spokane, Washington. Lives in New York

JIM HODGES

Selected Solo Exhibitions
"Jim Hodges: colorsound." Addison Gallery of American Art,
 Phillips Academy, Andover, Massachusetts, 2003
"Jim Hodges." Tang Teaching Museum and Art Gallery,
 Skidmore College, Saratoga Springs, New York, 2003 (traveling)
"Jim Hodges." Miami Art Museum, 1999

Selected Group Exhibitions
Whitney Biennial. Whitney Museum of American Art, New York, 2004
"Projects 70: Jim Hodges, Beatriz Milhazes, Faith Ringgold." The Museum
 of Modern Art, New York, 2000
"Regarding Beauty: A View of the Late 20th Century." Hirshhorn Museum
 and Sculpture Garden, Washington, D.C., 1999

When I graduated from Pratt Institute, Brooklyn, I was working as an art preparator in a SoHo gallery. One night I went to an opening at the New Museum of Contemporary Art. I was in line to have my palm read by [the artist] Linda Montano, who, in 1986, did a series of palm-reading performance pieces in the museum's storefront window. There was this wild-looking woman, her name was Elaine Dannheiser, and we hit it off right away. She asked if I was an artist and would I be interested in maybe working for her: she offered studio space to artists in exchange for helping her with her collection. We exchanged numbers. A few weeks later I got a call from her saying that she didn't have any space, but offered "Keep up the good work." A week later she called again and said "I think something came up." She drove me downtown and showed me a huge space in the basement of her foundation—the Dannheiser Foundation—and said "Do you think you can work here?" I said "Sure." So she handed me the keys and showed me the foundation's collection, which was filled with great work. I worked for Elaine for nine years—basically that's where my real education began, where I started unearthing things about myself.

When I got to the space I had somewhat of a crisis: I had gotten my degree in painting but I realized I wasn't enjoying myself trying to paint. I thought "Here I am, set up in this great place—I should really be happy here." I was actually miserable. So I called up a professor of mine back in Spokane and I told him my dilemma. He said, "Well, why do you think you need to be a painter?" Because my passion was drawing, I had just assumed that I was going to be a painter—though painting really held nothing for me, and I certainly wasn't taking it anywhere interesting. He advised, "Just do what you enjoy." It was the best advice I could have received. I put my paint away, bought charcoal and some white paper, and started investigating drawing.

I worked with many different types of materials. Not having much money at the time, I found a roll of tarpaper left by a construction company on the second floor of the building adjacent to my studio. I dragged it inside and started tearing it up, scattering the bits on the floor. Then I took Scotch tape, taped it all together, peeled it up off the floor, flipped it over, and taped it all up again. I hung this piece in the center of the room. it was probably the precursor to a lot of work that followed. The thing that was interesting to me about this material was that the use of the tape was for me like skin. It was my first delving into notions of material as metaphor, in this case a metaphor for immortality via the material's repairing qualities.

In 1990 I received a grant, and with that money I went out west for a month and rented a cabin on an island in Puget Sound. The cabin was inhabited by orb-weaving spiders that wove their webs all over. One morning I woke up and a spider had made his web in the open doorway. I thought to myself, "It's so tragic, this spider's poor choice, how it was doomed." But I liked very much the idea that the thread held a place for a time. I started thinking about combining actual events and holding them down with these web forms.

Somewhere between Here and There. 2001. Mirror on canvas, 6' x 48"

Elaine was a wonderful person and the Dannheiser Foundation was a great space, but in the wintertime my studio was very cold, often too cold to work. I'd end up in coffee shops, where I started to draw flowers on napkins. It was an attempt to record a moment, to make a flower and not judge what it looked like. They were all made from my imagination—I would basically draw what I felt was already waiting for me on the napkin. I made hundreds of these drawings, and when I was invited to do my first one-person show in a gallery, I hung 570 of the napkins on the walls. That was at CRG, when it was up on East 71st Street—a beautiful, intimate little space in the parlor floor of a townhouse, the perfect location for this body of work.

I had been working on a large spider's-web piece, made to cut a space in half from wall to wall. The process was grueling; I would get very tired, so I would have to rest. As I was sitting one day I started pulling silk flowers apart and reassembling them in a kind of frozen animation. I loved what was inside these imitation flowers, and this body of work became a different way of working—the exhale to the inhale. I'm attracted to various materials in the world without necessarily knowing how they're going to end up, or for that matter what the relationship is going to be between them and myself. I would lay the little flower bits on the floor so that they were touching, then take a piece of tracing paper, spraying it first with photo mount, then placing it on top of the flower petals on the floor to pick them up. At this same time I was invited to make a proposal for a collaborative work at the Fabric Workshop [in Philadelphia]. I brought a couple of ideas down. One of them was a flower piece I had sewn by hand—really rough-looking, a poor attempt at a doily. I ended up making ten pieces this way, the first of them at the Fabric Workshop. The largest, *No Betweens*, was made for the 1996 São Paulo Bienal.

In 1998 I was asked to do an exhibition at the Kemper Museum of Contemporary Art, in Kansas City, as well as a workshop with children. "We'll use the process of installing the exhibition as the workshop, and during it we'll make a drawing with the children," I responded. I let the kids choose from 120 colored pencils and then stand anywhere along the wall. Using the colored pencil of their choosing, I would measure them, recording their names, their height, and the date. Over the course of installing, this process would make the drawing. I've made this work, *A Possible Drawing*, four times in four different museums. I think quite possibly it is one of the most happy and joyous experiences I get while working.

In 1996 I felt a need to move on from what I was making and the way in which I was thinking. It had been a difficult period for me—I had lost some friends—and I had reached the limits with particular bodies of work. As I was recording these thoughts in my journal, thinking about wanting a new start, a break from my history, the image of a broken mirror appeared to me. I felt a real sense of liberation. I made works like *No Dust* out of broken mirror. I was attracted to the liveliness of the material: it's not passive, it's totally active, constantly in a state of readiness.

After I broke the mirror, it seemed like I possessed it, that I could do anything I wanted with it.

On a summer day in Maine I happened upon a fabric store. Inspired by all the patterns and colors in the fabrics I saw, I came up with idea of "writing" my auto-biography by using different fabrics to represent personal developments in my life. This "autobiography" would be told through the use of different shirts in a variety of fabrics. Each shirt nestled one inside the other, like those Russian dolls that get smaller and smaller. The smallest shirt in the center was white, next was a baby blue shirt in terrycloth, a fabric I wore as a small baby. The piece comprises seventeen shirts in all, viewed collectively by their collars, much like the rings of a tree.

I work very slowly, and usually have things around for a long time before I understand where they're going, or at least until I have an idea where to take them. Basically I get my instructions from the materials. I follow these instructions and don't question them much. What I really enjoy is the distance between events rather than the closeness of events. If that's fragmented, then that's what it is. I also think presenting these moments is a kind of bringing together. The work is probably always going to move in that way. I only discover these things in retrospect; in the moment that I'm working, I don't really know, I really don't. I just try to let myself be, to do my work. That's the most important thing.

Hodges in his studio, 2003

Born 1959 in Athens, Ohio. Lives in New York

MAYA LIN

Selected Solo Exhibitions
"Between Art and Architecture." Arthur A. Houghton Jr. Gallery, Cooper Union
 School of Art, New York, 2000
"Maya Lin." American Academy in Rome, 1998
"Maya Lin: Topologies." Southeastern Center for Contemporary Art,
 Winston-Salem, North Carolina, 1998 (traveling)

Selected Group Exhibitions
"Maya Lin/ Finn Juhl." The Danish Museum of Decorative Art, Copenhagen, 2003
"U.S. Design: 1975–2000." Denver Art Museum, Colorado, 2003
"llusions of Eden: Visions of the American Heartland." Columbus Museum of
 Art, Ohio, 2000 (traveling)

I installed *Groundswell* at the Wexner Center for the Arts, in Columbus, Ohio, in 1993. It's the first permanent work that the Wexner commissioned. For me it was my first artwork. It sounds sort of funny, but I felt the memorials—the Vietnam Veterans Memorial in Washington, the Civil Rights Memorial [in Montgomery, Alabama]— were hybrid works. They combined art with the functionality of architecture, even though the function was a symbolic one. They exist between the two fields.

The Wexner asked me for a work that would reflect what I'd been doing in my studio. I'd been working with beeswax, lead, and broken glass, and the trouble in the public realm is, how do you propose exposing people to broken glass? I took one look at the Wexner Center and I knew exactly what I wanted to do: create a sculpture out of glass that was accessible visually but not physically. Peter Eisenman, in design-ing the building, combined two grids, and what's left over is what I'd call residual spaces—unplanned exterior spaces that were empty yet highly visible from within the block. I couldn't resist.

Again, staying with the spontaneity of the smaller, studio works, I didn't plan this piece. I didn't draft it; I didn't draw it; I didn't model it. Forty-three tons of glass showed up and I made the piece. I was trying to combine the Eastern and Western aesthetics—the Indian mounds of southeastern Ohio, where I come from, with the raked-sand gardens. The glass was gravity poured. As time goes by, the glass settles and the piece gets shallower, so at the end of each year you repoint it—you take from the bottom and pour it right back on top.

In 1999 I completed the Langston Hughes Library for the Children's Defense Fund, [at Clinton, Tennessee], the site of the writer Alex Haley's old farmstead. The building's an old barn—I slipped a modernist skin under it. The barn itself is from the 1860s, 1870s. I fell in love with it, but what could I do? I'm basically a diehard modernist. My modernism, though, is the modernism of the '50s, a warm modernism, so I inserted a new layer, slipping it in on the barn's interior. Skylights lead you through the space. Then you come up, and there's a layer of glass, a layer of maple, and the whole thing is sheathed in a formaldehyde-free particle board—I love to introduce sustainable, all-natural design materials into my architecture. The tables are made from soy, and the whole place is heated and cooled by using a nearby pond as a heat sink. It's intimate, 2,000 square feet, and it overlooks the pond.

When Marian Wright Edelman brought me in, she asked me to think of two pieces, a library and a chapel. The library came first, and it preserved something old. The chapel faces the same pond, and started as an idea: what could a modernist do on Alex Haley's farm? He had brought many old one-story, one-room log cabins to his property, so everything was wood, using the vernacular architecture of the area; every-thing was based on a barn or log cabin. What could I do? I thought of a boat, because a boat could be both barnlike and modeled. Also the motto of the Children's Defense Fund is, "Dear Lord, be good to me. The sea is so wide and my boat is so small." So

the chapel is boat-shaped. Symbolically, too, you have one stone building (actually concrete block), one wood building (the barn), and between them a trellis. It's made out of wood and it lets the light go through, like the trees in an orchard. Again I love playing with what's inside and what's outside. The size of the chapel is intimate: it's approx. 3,000 square feet, and seats 300 people. Yet the seating under the terrace allows it to double its capacity of people for special occasions.

In 1995 I had a residency at Pilchuck, the glass workshop in Washington State. There were these stones called Pilchuck stones and I started collecting them—by the end of my residency people were leaving them on my table as gifts. I had the glaziers blow every different shape. Now the beauty of glass-blowing is that they turn the glass symmetrically—it's supposed to be dead on. I had them play with asymmetry. When you try to make something natural, there's a fine line when it begins to look *un*natural. I love that line that divides the symmetrical from the asymmetrical, the natural from the ordered.

In 1999 I was brought in to work on a tiny corner of a public park in Grand Rapids. I took one look at the site and said, "I really don't think I do object art, but I've heard the city is redoing the park. If you would be interested in having me go in as the artist and act as a catalyst to reshape the park, I would be very interested." Part of the park had a skating rink, and I don't know why but I was very interested in making a skating rink. I started with the idea of a simple drop of water, and the rings emanating out in a pool. I thought of three points of water: one in ice—the skating rink; one in liquid—a regular fountain; and the third a fountain of mist. So it's solid, liquid, and vapor.

I was brought in as an artist but I ended up putting all my hats on for this one. I brought in my own team, including Quinnell Rothschild, a New York landscape-architecture firm. The true art here for me is the skating rink, where the seating is slightly tapered on all sides. I'm exceedingly interested in the curvature of the earth. We all know that water freezes flat, but could I trick your eye? There's a grade change from one end of the skating rink to other, about eight or nine feet. Could I cheat with the seating, and taper it in a way that would make you feel you were skating on a slightly tilted plane? So on one side the skating rink is above the seating, and the ice drops right over the edge. A railing goes up in the winter. Then many of my artworks deal with time and natural phenomena, so in the rink itself there's a fiber-optic array under the ice showing the array of constellations over Grand Rapids on January 1, 2000. The new millennium begins—it's a specific point in time. The ice refracts light, making the fiber optics more visible. That park was a three-to-five-year process; I was brought in as an artist and then started doing the architecture. The skating rink, the use of time, the tilted plane, to me are the true art of the piece.

I was told in architecture school that I should make a choice. This is graduate school; I'd already won the Vietnam Veterans Memorial when I was an undergrad.

I finished it, went back to Yale, and they thought, "She has all the whatever in the world—why is she blowing it? Why is her process so . . . ?" At one point one critic said my work was too intuitive. Another one said, "You're going to have to make a choice, Maya: either art or architecture." A third one said, "We know you can build models; now give up the models and draw." I'm blind in two dimensions, I can only see in three. They weren't trying to hurt me, they were trying to help me, but I don't think like an architect. I love to build, but my process is much more that of an artist, even though I've never formally trained in art. My dad was Dean of Fine Arts at Ohio University, and I remember watching George Segal cast some of his early pieces at the foundry there; I cast bronzes myself when I was young. My father was a ceramicist and I grew up playing with clay—so what do I always model in? Plasticine. Yet it never occurred to me that that's where my background was. So I went to architecture school, and I couldn't figure out why I was having such a problem. Then about two to three years out, I realized. When I hit *Groundswell*, I said it was my first artwork, because the memorials were these hybrid creatures for me.

I know everything blurs, but at this point my art and my architecture tend to be fairly distinct. I love them both, I wouldn't give up either of them, I never planned to be one or the other—I just couldn't stop doing whatever I did. Artists could graduate from graduate school and be called artists and their work could be called art. Early on, I remember, someone said, "The Vietnam Memorial isn't art, and you're not really an artist." I had to work for another ten years before someone came up and said, "I really liked the artwork you did in Ohio." I'm also now known for these very large-scale outdoor artworks. You might see one here, you might see one there, but it's hard to see them as a whole, as a body of work—it's not like having a traveling show. The discourse that's there is absolutely about landscape, and it always has been about landscape. It's been a real discovery for me to see what my own voice is.

Lin in her studio, 2000

Born 1962 in Boulder, Colorado. Lives in New York **JOHN CURRIN**

Selected Solo Exhibitions
"John Currin: Works on Paper." Des Moines Art Center, 2003 (traveling)
"John Currin." Coorganized by the Museum of Contemporary Art, Chicago,
 and the Serpentine Gallery, London, 2003 (traveling)
"John Currin." Institute of Contemporary Art, London, 1995

Selected Group Exhibitions
"Lily van der Stokker Small Talk." Museum Ludwig, Cologne, 2003
"Drawing Now: Eight Propositions." MoMA QNS, Long Island City, New York, 2002
"Liebe Maler, male mir . . . Dear Painter, paint me . . . Cher Peintre, peins-moi."
 Centre Georges Pompidou, Paris, 2002 (traveling)

JOHN CURRIN April 10, 2002. Studio, Chelsea

My favorite artists have always been Max Beckmann, Picasso, Grünewald, Van Gogh—
those tortured kinds of artist. I used to see myself that way, I don't know why—but I
moved when I was ten from northern California to Stamford, Connecticut, and that
was a rude awakening. So that was the acorn that grew into the oak of my art: being
a depressed teenager was my ace in the hole for a long time. Also I had a long line of
depressing personal relationships. Meeting my wife, Rachel [Feinstein], changed my
life of course, but it also changed my art: it robbed me of the paradigm of the repressed,
vengeful guy. I realized that being a tortured artist was not in my repertoire anymore.
I was happy and content, and I had no concept of what it was like to make art out
of those feelings.

In fact it seemed to me that positive feelings were an unexplored, virgin territory
in contemporary art. There was no way you could have positive feelings about sex, your
past, the world; they were considered odd and ironic. *Girl on a Hill* [1995] in particular
was the beginning of my learning how to use those unfamiliar feelings. I thought,
"Well, it'd be funny to do L.A. girls in front of a sort of peaches-and-cream pastel thing."
It was a simple idea, and I thought, "Oh jeez, I'm doing something stupid," but I ended
up liking these paintings because they weren't based on the tortured-artist thing. It
was important for me to get over that, and to the idea that you can make art just out
of wanting to make something good.

I was interested in genre paintings. A Chardin painting like the one of a boy
building a house of cards is an allegory: it instructs you in how you should look at it.
So I thought, "Well, in my own paintings I need to have the figures absorbed in observ-
ing something." And I thought it might be interesting if, while you were looking at
their faces, they were looking at each other's breasts. I'd already been accused of sex-
ism by this time, in fact it was the way I was always described, though it had never
been my intention; so I thought, "Why not do some kind of incredibly failed version
of smart-ass sexism?" That's one reason why, in *Dogwood* [1997], I was attracted to
the idea of a cartoon of misogyny. The composition is mostly ripped off from Hans
Baldung Grien, who's one of my favorite artists. He was a student of Dürer, and made
some famous drawings of witches, which is what I thought these women would be.

I started selling paintings, and having enough money not to have to take regular
jobs. Looking through old magazines I saw these ads with girls hanging out in their
bedrooms, just whiling away the hours in their underwear, and it felt so familiar: I
thought, "This is what my life's like now." But if I could be an artist and I didn't have
to hang drywall and I was happy with Rachel, what did I have to make art about?
So I came to the end of that contented streak.

The way I got out of it was, I had a dream that I was holding in my hands a kind
of 1930s man-and-wife painting, but both the figures were John F. Kennedy. The weird-
est thing, though, was that the faces were done with an old-fashioned palette knife.
I've always loved Courbet, and a strange thing happens when Courbet uses a palette

knife: there's a destruction of irony and a beginning of irony at the same time. I'd always had a feeling about the palette knife: the effect it makes is partly like one of those dumb Bob Ross paintings of covered bridges, but there's also something intimate and vivid and almost loving about it. You can't make a perfect surface with a palette knife, and it's also almost impossible to use one to connote a social reality; you get a cartoony image. But there's a pathos to it—an easy pathos maybe, but a pathos.

Then there's a painting by Velázquez in the Met of a little girl's head, and I was wondering how he got a certain color, a strange pink that has no yellow—it's like celestial lightness. And I realized he painted in black and white first, then painted in red on top, and the transparency of the red turns it into magic. It isn't magic really, but it seemed to me like a lightning bolt. I realized that this was how I wanted to make art.

Finally, on my honeymoon we went to Venice and Florence and looked at Tintoretto, which confirmed my idea about underpainting as the way to go. I came back and I had no ideas—I was too content. And I was sick of big breasts, sick of that whole thing of being the provocative guy. So just for fun I made a nude with underpainting, *Honeymoon Nude* [1998]. I also made the whole thing up; that was important, not working from life. Obviously those are my own arms—ugly, man's arms—and the breasts are sort of just the idea of breasts, and the body isn't treated pruriently. It's like being married: sex is a different thing. It's just different. It's not lust, it's love.

I've always found paintings of nudes depressing because they can't compete with photographs. The grainiest photograph of some girl, a blurry Polaroid—you'd rather look at that than at the Venus de Milo, because you think "Wow, that's really somebody." But I thought, "As long as I don't try to do what photographs do, which is give you a piece of the true cross—'This camera really was in front of this real naked lady'—if I make the whole thing up, and obviously so, I'll be able to express what I have on my mind," which was love, directed at only one person.

Impressionism had sort of ruined art—it's great painting, but it had become the basic way we think about painting, an idea of performance on canvas. Underpainting got me around that. The whole point of it is that you hide your labor, the viewer doesn't see how long it took. The top layer is rather fresh and the rest of the work is buried. Now look at the feet in *The Old Fence* [1999], and then the head. This painting has no meaning other than the meaning that's buried in the form, which is the only meaning worth anything in art. (I know it's a cliché to say art is what's not expressible in words, but it's true.) The flatness of her arm against her chest, this momentary lapse of form where her arm is kind of embedded like a bas-relief—I think that's a wonderful moment, and unexplainable as meaning. It *has* no meaning.

I had a problem with figurative painting that had no sense of painting's inherent flatness. A kind of winking knowledge of painting's flatness is an aspect of modernism, but in contemporary neo-expressionist-like figurative painting I found a complete

reliance on the spatiality of photography and a total ignorance of flatness. My concern with these paintings was making them flat while making them vivid.

You can ask about figurative paintings, Is the person depicted aware of her status as a depicted person? And I thought it would be strange for realism to arrive at a kind of Italianate, Renaissance idea of depiction, as in a Botticelli, where the goddess is unaware of being depicted because she's divine. It would be strange to paint a real person unaware of her pictorial state in that way. So I painted a group of works having to do with depiction. I hired a model for the first time. I'd never had a studio before that looked so much like a traditional artist's studio; being here, I got this academic feeling.

There's always an anxiety when you paint: "I'm at the hand now. I'll mess it up." You can't mess up a hand, just like you can't mess up a face, because everyone, no matter how naive they are about art, will know that you couldn't do a hand and you couldn't do a face. Everyone knows what those things look like, so you start to feel nervous when you get to them. But that's the cool thing about figuration: everyone feels they have a right to know what it's about.

I like the fact that everyone thinks they know what things look like. If a painting is realistic, everyone thinks it's a good painting.

To me that's an interesting quality. You don't have the modernist pride, and you may have a weird guilt about making figurative art, but you have this almost greater responsibility: your elders, your parents, your clergy, these different types of authority, will make you tell yourself you'd better do it well.

Currin in his studio, 2003

Born 1956 in Santa Monica, California.
Lives in Brooklyn, New York

FRED TOMASELLI

Selected Solo Exhibitions
"Fred Tomaselli." The Fruitmarket Gallery, Edinburgh, 2004
"Fred Tomaselli: Ten-Year Survey." Palm Beach Institute of
 Contemporary Art, 2001 (traveling)
"Fred Tomaselli, The Urge to Be Transported." Center for the Arts
 at Yerba Buena Gardens, San Francisco, 1996 (traveling)

Selected Group Exhibitions
"Painting Pictures." Kunstmuseum Wolfsburg, 2003
Liverpool Biennial. Tate Liverpool, 2002
"Patterns: Between Object and Arabesque." Brandts Klaedefabrik,
 Odense, Denmark, 2001 (traveling)

I grew up in the shadow of Disneyland, where it was normal to look up into the night sky and see Tinkerbell flying around amid the fireworks. This environment informed the dislocation I later felt upon seeing my first real waterfall: I just assumed it was a fabrication, even though I'd hiked half a day to get to it. The only waterfalls I'd ever seen were manmade, and I actually searched for the conduit and pumps that might run it. My mind was blown when I discovered that something so sublime was not artificial. I was a stoner kid, a mall rat, living amidst the theme parks of Southern California, so I guess you could say the idea of reality slippage never seemed abnormal to me. Solid reality was stranger. Maybe it was coming to New York seventeen years ago that gave me the proper perspective to make art about that kind of reality slippage, that dislocation.

I was very influenced early on by a Bruce Nauman retrospective I saw when I was a teenager. No one explained it to me, which was really good. I saw a corollary there to theme parks and Disneyland, except it was a theme park of the irrational. I didn't realize that artists could explode space the way Nauman did; I mean at that time I thought art was Salvador Dalí and Michelangelo. I also saw an amazing James Turrell exhibition around the same time. There was a work that looked to my eyes like a black rectangle painted on the wall, and as I went to touch it, my hand passed into a limitless void. Basically my derision changed to "Wow." That notion of the double take, of thinking you know what you're seeing and then finding out it's something different, taught me a lot, and I try to create that kind of experience in my work. Those shows caused big paradigm shifts in my perception and became emblematic experiences in my life.

In the early '70s, when I was still painting pictures in school, late modernism and the counterculture still felt viable and then, suddenly, they were over: modernism fell apart into postmodernist stasis, and the transcendental hippie stuff collapsed into disco and cocaine. I wasn't quite sure where I wanted to go with this rubble that I had inherited, so I abandoned painting in the '80s to do installation. I worked primarily in installation from approximately 1982 to 1991, making pieces in darkened rooms that utilized the tropes of theme parks: light-trapping corridors, compressed spaces leading into expansive ones. A lot of the work was electronic, and it involved kinesis and light; I was trying to create an immersive environment that would modify the viewers' reality. The theme, more or less, was the mechanics of that perceptual modification.

Eventually I started thinking about the ideal of a painting as a window to another reality. In a historical sense a painting may represent a transcendent or sublime place, and I thought that ideal dovetailed interestingly with some of the rhetoric around psychedelia: perceptual modification, taking a trip to a place of beauty, desire, seduction. I became interested in the idea of a painting as a reality modification device. I was thinking at the same time about drugs, and I wanted to rearrange the use value of the artwork so that it would be equally psychoactive. I began to make works that were

more or less illustrations of these concepts. If I wanted to get my viewers high on paintings, I needed to rearrange the delivery system of the psychoactive material in the work so that instead of going through the bloodstream to affect consciousness it would travel through the eyeballs. It would just be a different route to the brain. I'd given up painting because of the burden of history; after almost ten years of installation, I was finding my way back into it.

Basically we're a culture on drugs. Our realities are being modified in increasingly sophisticated ways. When I first started investigating this idea of immersive reality, there were books, movies, drugs, and theme parks, but now there's a whole host of places we can get lost in. That, increasingly, is the way we live. This condition blurs the boundaries between nature and culture, politics and entertainment.

I've begun to add more paint to my works, but I'm reticent about calling them paintings—it's probably more accurate to call them collages. The works may look like paintings but are in fact made up of photographs, paint, pills, leaves, and other real substances that are then embedded in resin. I try to keep the viewer off-balance about the nature of the elements within the work. A lot of the disks in these pictures may be pills or they may be paint; you have to come close to the work and really look—it's not entirely clear until you do. The resin has a tendency to create a unifying surface that, at a distance, makes the image read as flat. I've been playing with that by working in layers, setting the pills and images at different depths—only about a half-inch difference, but when you get up close to them there's a little back-and-forth, a little shadow play, and a little alteration of the focal point of your eyeballs. I finish the works by sanding and polishing the surfaces, which is followed by an application of TurtleWax. I think it's kind of funny that I wax them like cars or surfboards, since I tend to see my works as transportation vehicles. I want to take the viewer on a trip to the world inside the pictures.

I don't want to talk about seduction and desire and beauty without delivering; I want to hit the viewer in the body. I used to be primarily conceptually driven, but now I tend to believe more in the efficacy of the object and of the image—more in the experience of art. I'm trying to deal with the object-viewer relationship through the body, more or less on a sensual level. Most people listening to a pop song like to listen to the rhythm or melody first and then later might want to listen to the lyrics. I guess that's how I'm starting to think about the conceptual side of my work: it's there, it can add to the appreciation of the art object when you know what it is, but I want the object to be able to survive without the rhetoric. Ultimately ideology is the first thing in art that dies—it's the work's least preservable part. I can't insist on directing people about the meaning of my work. After I'm gone, all that's left is the object, and so I'm throwing my lot increasingly with the object and less with the ideology behind it.

I used to preconceptualize the objects and then execute them; I thought I knew what I wanted to do before I started making the piece. Now I don't always know

exactly what I'm shooting for. The process is increasingly chaotic and there are a lot more chance operations and intuition. This is one of the biggest changes in my working process.

The work has been very influenced by my love of Asian art, specifically Tibetan Tangkas and Indian miniatures. I have a Tangka from the seventeenth century that I look at almost every day, I think it's starting to bleed into my consciousness and affect me in ways that are simultaneously insidious and beautiful. The drawings I did for *Monsters of Paradise* [2001] involved this sort of many-armed Devi destroyer thing, as well as Islamic pattern and Judeo-Christian imagery—specifically Masaccio's *Expulsion from the Garden of Eden*. I'm also very interested in outsider artists like Henry Darger and insider artists like Sol LeWitt, John McCracken, and Ed Ruscha. I've also been very inspired by the work of Bruce Conner and Jess. All those interests and more get to play in my work.

I really feel that the shape of nature is the archetype of beauty. I try to use its shape in my work, with the understanding that all nature is deformed by ideology. Ever since that early waterfall experience, I've looked at landscape as being encoded by culture, and this is the phenomenon at the heart of the American experience. Europeans came here thinking they'd discovered a New Jerusalem and set out to create a paradise on earth. In the process they created some good things and some very bad things. I'm interested in the corollaries between the histories of American utopianism and of modernism.

I guess you could just say that I'm not a purist. I like to create unities between enemies and I don't believe in utopian ideology. I've been exposed to enough crumbled, dead ideologies—I'm skeptical of them but I incorporate the parts of them that I like the best and create hybrids. Maybe "hybrid" is the one word I would use to sum up my entire output. I'm using hybrid media to make works about a hybrid of ideas. Drugs and culture have hybridized my brain and perceptions. So I don't believe in purity, I think it's just a myth. I'm doing the best I can with the world I live in.

Tomaselli in his studio, 2001

Born 1941 in Dublin. Lives in London **MICHAEL CRAIG-MARTIN**

Selected Solo Exhibitions

"Eye of the Storm." Gagosian Gallery, New York, 2003

"Michael Craig-Martin: An Installation." IVAM, Valencia, 2000

"Michael Craig-Martin: A Retrospective 1968–1989." Whitechapel
 Art Gallery, London, 1989–90

Selected Group Exhibitions

"Voilà le monde dans la tête." Musée d'Art Moderne de la Ville de Paris, 2000

"Die scheinbaren Dinge." Haus der Kunst, Munich, 2000

British Representative, Bienal Internacional de São Paulo, 1998

I'm interested in the boundaries between art and other things—design, architecture, technology, advertising—just about anything. I dislike hierarchy, mystification, and jargon. I'm not interested in the irony of postmodernism, or in the idealism of modernism, or in the use of popular imagery that characterized Pop art, or in a conceptual critique of consumerism. I have naturally been aware of all these concerns of contemporary art, however, and have exploited aspects of each as it suited me.

I've never desired any role in art except that of an artist, but I've been fascinated by the roles that revolve around the artist, and when possible, or necessary, I've tried to act them out from the point of view of the artist: teacher, curator, critic, editor, lecturer, collector, exhibition designer, and museum trustee. I've never tried being a dealer, however, but it seems obvious to me that artists should understand through personal experience the activities of those who control so much of what happens to our work.

The first works I showed, in the late '60s, took the form of boxes. I started making similar constructions as a student at Yale, and they constituted my first solo exhibition in England in 1969. I was interested in the idea of an object that had a function, so I made boxes with hinges and handles—things you could move so you'd be able to act on the work. I was resistant to the rule that you're not supposed to touch art, so in my work, if you didn't touch it, it didn't work. I liked the idea of art that you could change, in the sense that you could fold it up into non-art when you didn't wish to have an artwork around.

I spent several years making pieces exploring a variety objects in terms of their functionality—trying to use their normal function as the basis of my work. I used tables, buckets, clipboards, shelves, bottles, and so on. Then in 1973 I made the piece that I have always thought of as the culmination of this first phase of my work. *An oak tree* consists of a glass of water on a glass shelf, always placed high on the wall, and a text in the form of an interview also shown on the wall. In it I claim to have changed the glass of water into an actual oak tree without changing its appearance. In the first exhibition the piece was shown in a large gallery entirely alone.

In *An oak tree* I tried to address a question that preoccupied me and many other artists at the time: is there something, an essential bottom line, that distinguishes a work of art from other things? I'd been playing with the idea of trying to make a work that would be invulnerable to criticism. I decided that meant doing something where the proof that it didn't work would be the same as the proof that it did, and that meant appearing to do nothing at all.

I realized that if I simply called the glass of water *An oak tree* everyone would assume I had simply re-named the object rather than totally changed it. I hoped that writing in the form of an interview would allow me to make clear what I was claiming—and not claiming—in a seemingly casual, humorous, and nondidactic way. In

the exchange of questions and answers I was able to play the roles of artist and critic, believer and skeptic. But I think this means that anyone reading the text becomes implicated in the piece in an unusual way, taking on both these roles too, becoming the artist as well as the viewer.

After *An oak tree,* starting in the mid-'70s I decided to reconstruct for myself a sense of the most basic forms of art: painting and drawing. I wondered, what is the ordinary object in painting? I decided on amateur paintings, done without great ambition or pretension. So I went to Portobello Road and started to buy small modest still life and landscape paintings. I discovered that if I inset them into the upper-left-hand corner of a much larger unpainted canvas with their surface on the same plane as the canvas's surface, I could retain the original painting unaltered while creating a new work with a different and contemporary meaning.

In about 1978 I started doing wall drawings. I wanted to try to find a way of making drawings that were simple but accurate pictures of ordinary manufactured objects, so I started to draw them, one at a time, always on the same-size paper, A4. I wanted these drawings to be impersonal—manufactured-looking, like the objects themselves— so I traced each of them in a thin tape line on a sheet of clear acetate. It soon became obvious that simply overlapping these transparent drawings produced intriguing juxtapositions. So I started to make more complex drawings out of the overlapping images, and then to make slides of these to project and trace with wider tape on the wall.

In a sense I'm still exploring that territory. I still use many of the same images I drew then; I've just added to this vocabulary of pictures and tried to follow the project where it has taken me. I can use the same image to make a drawing on the wall that's eighteen inches high or twenty-five feet high. In general I have made only one drawing of each object. Once I've made a drawing of an object, that's the one I stay with. I can't see a reason to change it, or to do another. Essentially I use them as templates.

I've discovered that although I had a sense that our world is made up of an infinite number of simple commonplace objects, strangely that's not true. They're quite finite. I try never to draw something that you couldn't recognize instantly—I don't want the viewer to wonder, "What's that?" The only object I've drawn many versions of are chairs. I have maybe fifteen of them. Chairs are very surprising: you can have chairs that don't look anything alike, but we all know instantly that they're chairs.

I almost always draw objects in a kind of three-quarter perspective and from slightly above. It's a way of maximizing the sense of three-dimensionality. I'm always trying to give the objects some feeling of occupying space. Because they're drawn from more or less the same point of view, I can put them together coherently, even when they're of entirely different scales. They may look like they're resting on a single plane, but actually each of them contains its own perspective.

One of the things that led me into this work, and gave me confidence about my endeavor, was an article I found by an American philosopher, Robert Sokolowski, who

wrote brilliantly about the nature of "picturing." He pointed out that the capacity to see something, as a picture of something else is only possible because of a capacity in us, not because of a capacity of the picture. If it weren't for our very odd ability to look at something and read it as a picture, the picture wouldn't do that work itself. This was of great importance to me, because I had always thought of the viewer as passive in relation to pictured images. But in fact the audience is in an active engagement: everyone is engaged in making the picture work. Like opening the boxes.

In 1993 I was invited to do an exhibition at the British School in Rome. They sent me pictures of the room, which was striking, with a large stone fireplace—obviously not originally a gallery. So I decided to do several things I had never done in an installation before: to use color and to respond directly to the character of the place. I painted the walls of the room, making a play on the fact that it had served different functions over the years. I painted two of the walls cream and green, institutional colors, and then the other two walls pink, because the room had French doors and I assumed must have been a bedroom at some point. For the institutional reference I used images of handcuffs and for the bedroom I used images of face mirrors. So these two historical readings of the same space were pulling against each other.

This was the first time I'd done anything site-specific and the first time I ever used color. I've treated every installation since as site-specific. Working with color unblocked something for me, and it has become a defining aspect of my work.

The other thing that had a great impact on my work in the mid-'90s was the use of computers. I don't make "computer work" and the computer doesn't produce the

work for me, but it allows me to plan increasingly complex projects in great detail, whether as installations or as paintings. I have scanned or drawn on the computer all the images of objects that I use. I can assemble and organize on a page any number of them at a time, color them, recolor them, alter their size or scale. For installations I can draw the room on the computer, move images on the virtual walls, repeatedly change the color of the walls as well as the images. In the past, I could spend a day making a complicated drawing on acetate. With the computer I can change a drawing in seconds. Now when I'm doing an exhibition I often do 100 different drawings to plan a single room; before I might have done two.

Craig-Martin in his London studio, 2003

Born 1962 in Brooklyn, New York. Lives in New York

GREGORY CREWDSON

Selected Solo Exhibitions
"New Work 6: Gregory Crewdson, Twilight." Aspen Art Museum, 2002
"Gregory Crewdson: Photographs." Organized by SITE Santa Fe,
 New Mexico, in collaboration with Mass MoCA, North Adams,
 Massachusetts, 2001
"Gregory Crewdson." Cleveland Center for Contemporary Art, 1997

Selected Group Exhibitions
"Fantastic." MASS MoCA, North Adams, Massachusetts, 2003
"Moving Pictures." Solomon R. Guggenheim Museum, New York, 2002
"Vision from America: Photographs from the Whitney Museum of
 American Art, 1940–2001." Whitney Museum of American Art,
 New York, 2002

Every artist has a central story to tell, and the difficulty, the impossible task, is trying to present that story in pictures. You'll see certain continuing obsessions or fascinations in my work; I guess most centrally I'm interested in a tension between ordinary iconography and mystery, or what Freud described as "the uncanny." I hope that in all my work there's a sense of the uncanny in its clearest definition, which is unexpectedly finding something terrifying, mysterious, or strange in ordinary life. I want all the artifice in my work to create a fictive world, but I would describe what I've done as a strange kind of psychological realism.

I grew up in a brownstone in Brooklyn. My father was a psychoanalyst, his office was in the basement, and one of my earliest memories is that as a young child, perhaps nine or ten years old, I used to try to hear what was happening beneath the floor. I couldn't hear much of anything, and I really didn't understand my father's work, but I knew that whatever conversations were occurring below the surface were secret, and I would try to visualize what I heard and make pictures from it. That's a very photographic activity, trying to project an image in your mind. My father was an enormous influence in my life as an artist.

As a graduate student at Yale from 1986 to 1988, I worked in a small town called Lee, in Massachusetts, trying to create a body of work that wound up being my thesis project, and using the town as a backdrop to construct my own fictions. I was interested in blurring the lines between the real and the fictive, creating a photographic language that hovered between documentary-style photography and a more cinematic approach. It shows a family who lived in the town. There's a sense of some artificial light; perhaps the boy is watching television. I did all this modestly back then, working alone, though using lights and gels and creating tableaux. But there's always a search beneath the surface of things, a tendency to look behind an ordinary facade to try to find something secret or forbidden.

After leaving graduate school, in 1988, I was faced with the common dilemma of most art students with an MFA: how I am going to continue my life as an artist? How can I support myself? As far as I could see, I had two options. One was to move back to New York, get a job, and somehow do work. That seemed almost impossible at that point; the art world seemed foreign and intimidating. The other option, which was much more interesting, was to go back up to Lee and keep working there. Which was what I did, but it became more and more difficult for me, because I became disenchanted with the project. On some level I was becoming uncomfortable with voyeurism, and with the kind of mythology I was constructing: it was a voyeurism that reversed back on itself and created a subjective myth.

Then something transforming happened. I often begin my photographs with an image in my mind that I then construct in physical form. In this case I was photographing a middle-aged woman lying on her living room floor looking up at the camera. I'd convinced this woman, whom I didn't know very well, that making this picture

Untitled (woman planting in road). 1996. From the "Hover" series. Gelatin silver print, 20 x 24" 279

was a good idea, but there was a weird, psychosexual, Freudian anxiety in play for both of us. We made the picture in the middle of the day, when her husband and children were away. She lay down on the floor. I had the lights set up. And literally as we were making the photograph, as if to confirm my own guilt and confusion, a police car drove up and parked in the driveway. The policeman rang the bell, she got up nervously and answered, and then the policeman actually said, "Are you the photographer I keep hearing about? Photographing in and around the neighborhood over the past year or so?" I confessed that I was. It turned out she was friends with this man. The next thing was really surprising: he said, "Well, I'm a photographer too, and I'd like to show you some of my pictures." He was the forensic photographer for the town of Lee. We went down to the police station, and he showed me these extraordinarily haunting and disturbing pictures—various kinds of evidential photographs of murder scenes and drowning victims. And all he wanted to know was, "How can I make the pictures better? How can I have less grain and a better range of contrast?" But that moment, that exchange, that aesthetic connection—it was a moment of crisis, in a sense; all artists go through them, where one project is over and you need to take a leap and go in a different direction.

So I knew it was time to stop that project, and for some unknowable reason I started making dirt piles in my parents' backyard and photographing them over and over for a period of three months. I didn't know quite what I was doing, but I knew there was some sense of urgency about it. And if that's not strange enough, it's even stranger to know that I never developed a single one of those negatives. Only much later did I make the connection with Richard Dreyfuss's activity in [Steven Spielberg's] *Close Encounters of the Third Kind* [1977]. I think that film is extraordinary: Dreyfuss's character witnesses a series of extraterrestrial events in the night sky over his suburban neighborhood, and in an irrational attempt to make sense of something impossible to understand, he begins building these totemic structures. As he builds them, he says over and over again, "This is important. This means something." This obsessive need to construct something, to try to understand—it's a beautiful metaphor for what the artist does. And it culminates in what I think is one of the great scenes in film history, with Dreyfuss building an enormous totemic structure in his living room. This is so relevant to my work, it describes the various oppositions I'm interested in: a collapsing of interior and exterior space, of domesticity and nature, a rational and an irrational obsessive act, and finally of the normal and the paranormal.

So I built these piles of earth over the course of the summer. In October or November, because of the cold, I wound up bringing my operation into the log cabin's guest bedroom. And over another month or two, I finally understood that I wanted to make these piles into something larger. Using the dioramas at the Museum of National History as an example, I started to construct these detailed worlds. I moved back to New York and began to construct these tableaux in my studio. One of them,

for example, from the "Natural Wonder" series, is a photograph of a seagull seen through a toxic swamp.

At the time, I was becoming more interested in the dynamic, or the polarity, between repulsion and beauty, or repulsion and attraction. And I tried consciously to make the most grotesque object I could: something between a mutated gourd and a corpse, made from Styrofoam and wax, with hair growing out of it and all sorts of unseemly things. It wasn't quite enough for me, so I ordered a thousand meal-worms from a company in Ohio. Again, I was trying to make something beautiful out of the grotesque.

As this project was ending, I was again pushing its limits, and knowing that I was coming to another transition. So working with an artist you might know, Keith Edmier, I made realistic casts of my body parts and presented them in tableaux. In a sense I was referring to Marcel Duchamp's piece *Étant Donnés . . .* [1946–66], but also to those forensic photographs. And in 1996 I went from making these gruesome, claustrophobic, graphic images of my body to trying to do the absolute opposite: I began a series of black and white photographs, called "Hover," instructed by my dreams, photographing in a single neighborhood of the same small town I'd worked in as a student. They're very cinematic, and there's a sense of the world being trans-formed into a miniature. We would build these things, and then I would get in the crane with my eight-by-ten camera and photograph it. It seemed like the most beauti-ful thing in the world to me.

What's interesting for me about these pictures is that they exist as a kind of fiction, but at the same time, in order to make the picture, you actually had to make the scene. In the "Hover" series [1996–97] some-one's obsessively covering the street with sod. So we bought a quarter ton of sod and laid it on the street. All the neighbors came out. At a certain point, I realized I wanted something to counteract what I saw as an optimistic image—after all, this man's trying to make a connection with his neigh-bors—so I asked my assistant to call up the town police and tell them there was somebody covering the street with sod. We had no permits; we got no permission from the town. So the police showed up; the sense of authority is real.

Crewdson on location in Rutland, Vermont, 2003

Born 1940 in Chicago. Lives in New York

ELIZABETH MURRAY

Selected Solo Exhibitions
"Elizabeth Murray Paintings and Works on Paper." Jaffe-Friede &
 Strauss Galleries, Hopkins Center for the Arts, Dartmouth College,
 Hanover, New Hampshire, 2002
"Recent Work by Elizabeth Murray." Wexner Center for the Arts,
 Columbus, Ohio, 1991–92
"Elizabeth Murray: Paintings and Drawings." Dallas Museum of Art,
 1987–88 (traveling)

Selected Group Exhibitions
"Splat Boom Pow! The Influence of Comics in Contemporary Art."
 Contemporary Arts Museum, Houston, 2003 (traveling)
"The American Century: Art & Culture 1900–2000. Part II: 1950–2000."
 Whitney Museum of American Art, New York, 1999–2000
"Sieben Amerikanische Maler." Staatsgalerie Moderner Kunst, Munich, 1991

Most artists have trouble talking about their work. I make the paintings, I don't talk about them—it's really a nonverbal language. I suppose you could compare paintings to music, except music is linear. You start listening, and themes recur and repeat in the same way they do in paintings, but you don't have to deal with music all at once; with a painting you see it all immediately and at one time. Apart from that, I believe the way you experience painting and music is similar. As you look, you begin to see repetition, you begin to see how the arrangements of elements are zones that relate to each other.

My older paintings came farther off the wall than these recent ones, and were more three-dimensional. I got stuck with them in a way that would be hard to articulate: I didn't know where I could take them. I do have a very strong sense that there's more that could be done there, but I don't know if I'm going to be the one who does it. I just arrived at a point where I didn't know what to do. My first instinct was to shrink back, to pull back toward the wall. I just wanted to paint again, and let my arm go anywhere. And with the three-dimensional works, it was harder and harder to paint on them and get a color that expanded out, so that you could feel it as a sensate thing. Then, with reliefs, there are always shadows that have nothing to do with the illusion of the painting. Those are reasons I can tell you about that I know; I think there are other reasons that I don't express that made me feel I needed to make some changes. And that led me, slowly, to these paintings here.

My first response was to start painting. I painted a couple of really big, squarish paintings, and I liked painting them, being able to take a big flat surface and just splash the paint on and let my arm move and develop the painting in that way—so I got that out of my system. But almost immediately I was bored with it, so I basically started to cut out smaller shapes and stick them together. *Back in Town* [1999] is one of the first of these paintings: I took three different shapes and sort of shoved them into each other and made that painting. It was satisfying in the sense that I liked having those separate shapes. Even though they come together, there's something about them wanting to be separate that is extremely satisfying to me. I'm interested by the conflict of getting something to fit together, like putting pieces of a puzzle together. From there, and it wasn't all at once, I took more shapes and had them come together and touch corners.

I also wanted to get away from the cup imagery I've used so much. In *Topple* [1999–2000] I had cut out some shapes, put them together, and made a cup where the center became these circles. The painting sort of meshed, and I could disguise how the shapes came together by using the paint on top—I like thick paint—kind of like icing on a cake. Sometimes I do feel like I'm a baker and I'm just sort of slathering the paint down and taking it off and finding a new way to warp or change the shapes. Anyway, it was from working on that particular cup painting that I literally picked up plywood shapes that were lying around in my studio. I cut them out and I screwed

them together from the back and I glued canvas on them. And that's really what set me off on my most recent paintings.

The big, main shapes in these paintings are worked out in advance. They're put together from behind; I can take them off the wall and make certain changes, but the process of making the shapes is all done in drawings. I start in a little notebook, where I do drawings until I get a set of shapes piling on top of each other that seem exciting or interesting. Next I make big drawings on sheets of paper that then go to the carpenter, who makes wooden forms that I stretch the canvas on. So the boundaries are given, but I can do anything I want inside the shapes. The image and color develop totally in the process that begins when I put the canvas on and put the paint down.

These paintings sometimes feel like constructing fences to me, like a sort of Irish wall of stones where you get to peek through the stones and see little bits of light. Putting them together is kind of like building with blocks, except I do it on paper first. There's actually another aspect to it: I didn't want things to be woven together, I wanted them to kind of butt up against each other. I have no idea why that seemed interesting to me. When I started to make them bigger, clearly it would have been easy to get them to shove into each other or even overlap. But I just didn't want to do that. I wanted to have that problem of having these different shapes and different zones together. I get certain areas to feel right, or maybe one shape to feel right. Once it does, I'll go on to the next. I put them together in this kind of linear way. And once I've got everything in one zone sort of dealt with, I start trying to get different zones to work together. I want these things to resolve in a way that I don't quite understand, and maybe you won't quite understand, but I want them to be resolved. There is a kind of unity that I want with them. I think that when I've felt finished with them, it's happened through color. I wanted this color—it was very clear to me and still is. I want it to be very, very intense.

I've been out to see the "Matisse Picasso" show [at MoMA QNS, Long Island City] twice. It makes you think, How much can you take from one artist? For me it would be Picasso more than Matisse—he'd be one of the first people there in my work. I don't think anybody can look at my work without seeing that to some extent. The other person would be Gorky—I keep a Gorky book in my studio. Actually I keep a lot of books in my studio; another is the book of Picasso's notebooks, *Je suis le cahier: The Sketchbooks of Picasso*. If I get stuck I'll open up the early-Gorky book and look at those things. Philip Guston has certainly been important in my work. But I'm looking at art all the time. And I think you're continually influenced by what you see, whether negatively or positively.

The way I learned to draw was really by looking at comic books. I was allowed to read comic books, and I read everything, from Walt Disney to Bob Kane and Superman and Captain Marvel. I didn't trace them, I copied them. I made my own

comic books. That condensation of space and time and motion was probably the most influential thing that could have happened to me. When you're reading a comic book as a kid, and you're completely involved in it, you're totally immersed. (I'm sure it's similar to video games today.) There's a condensation, a way that time moves through space. It's very different from reading—it's visual, though you read the little bubbles too. I think comics have something to do with why I'm very drawn to motion. There is something about motion in time that I'm after. I'm not exactly sure what it is.

I feel like I take the painting as far as I can take it and then whoever looks at it finishes it in a way. Sometimes it's like an offering, a communication. I feel you can kill it by saying this form symbolizes this and this and this. That could mean it's pretty dead anyway.

The paintings take longer to make now. I have no idea why; that's certainly not something I necessarily want. I don't think it makes the paintings any better than the earlier work at all. To be positive, maybe it's partly because I know more. No, that's not true—it's not that I feel I know more, it's just I want more. I'm not satisfied as easily as I used to be.

Murray in her TriBeCa studio, 2003

Born 1966 in New York. Lives in New York

TOM SACHS

Selected Solo Exhibitions
"Tom Sachs: Disaster." Galerie Thaddaeus Ropac, Paris, 2003
"Tom Sachs: Nutsy's." Bohen Foundation, New York
 (coorganized with Deutsche Bank, Berlin), 2002
"Sony Outsider: Tom Sachs." SITE Santa Fe, 2002

Selected Group Exhibitions
"Mirroring Evil: Nazi Imagery/Recent Art." Jewish Museum, New York, 2002
"My Reality: Contemporary Art and the Culture of Japanese Animation."
 Des Moines Art Center, 2001 (coorganized with Independent Curators
 International; traveling)
"Art at the Edge of the Law." Aldrich Museum of Contemporary Art,
 Ridgefield, Connecticut, 2001

Welcome to Allied Cultural Prosthetics, bringing you tomorrow's problems today. This space was once called the Allied Machinery Exchange. The area around Center Street and Broome was the machinery district of Manhattan for a while, and this was the second-to-last space here to sell machines. I moved to this neighborhood because of all the industrial things here, and as soon as I got here it was all replaced with fake Gucci bags and fashion stuff. I took that as a cue and incorporated those things in my work instead of macho machinery.

I've made a full-scale model of a McDonald's value meal out of Hermès packaging and glue. I've also made a fully functional McDonald's restaurant for your home; it has a grill and a deep-fryer, a soda gun that pumps Coke, a little freezer to store your hamburger meat, a fry-warming tray, and a cash register and paper towels and stuff. Another work is a full-scale guillotine. It's three meters high, it's got a real 150-pound blade, and it'll do a human head. Its full title is *Chanel Guillotine (Breakfast Nook)* [1998], and it's for the urban couple who need both a breakfast nook and a guillotine in their loft. It's got swiveling leather benches and it's like a dining room table.

Tiffany Glock is a model of my own Glock, the same gun the police carry—a compact model for discreet use—but I made it out of Tiffany packaging. Before I could afford my own $600 Austrian plastic nine-millimeter pistol, I made one out of paper. It was a method of creative actualization, like voodoo. *Prada Death Camp* [1999] is a model of a concentration camp made out of a Prada hat box. It's a controversial piece; in the context in which it was intended, it was intended to be about fashion, packaging, and commercialization rather than cheapening or exploiting the horror of the Holocaust.

Uncle Tom's Kitchen [1996] is a set of kitchen tools made out of racist food packaging—Uncle Ben's, Aunt Jemima, Cream of Wheat. All in the tradition of Africans serving white people. And *Sony Outsider (Gaijin)* [1999] is a full-scale model of the atomic bomb dropped on Nagasaki, made out of fiberglass and carbon fiber. It says Sony on the outside because I was trying to push the branding. I'd done all those fashion-icon pieces and I was trying to take it to the next place.

Lav A 2 [1999] is a model of an airplane lavatory in a Boeing 767, with all the parts to make it work but made out of foam core and paper. I resined and fiberglassed the paper in places, though, so it would be waterproof. The detail was crazy: we did 1,200 dots for the Pirelli flooring, all cut out of paper. I got the idea for the piece when I was circling Boston for two hours on a snowy day, and I was just so bored, so I went into the bathroom to do a drawing, and I measured everything. You could hang out in there; in fact it's the only place on an airplane you can be alone. Most of us have a pretty large sense of personal freedom, and on airplanes you're trapped. So I've got a great drawing in my sketchbook of all that. That's just as well, because I tried to get plans from Boeing but they screened me out as an industrial spy.

I made an independent sculpture just about the sink. I isolated it to learn about it. There are a lot of details in something industrial; the components are often isolated so they can be tested individually, so the failures can be confined.

What Would James Brown Do? (W.W.J.B.D.) [1999] is an electric chair with a transformer that would be sufficient to fibrillate the heart. I tried to consult Fred Leuchter, who was sort of the leading authority on execution techniques in America. He refused to consult with me but spent forty-five minutes on the phone explaining—so I got the right transformer, it's a real electric chair in every way. I added a TV because he felt that if the subjects weren't sedated enough it was inhumane—and television's my favorite brand of sedative.

I got my undergraduate degree in '89, and then I never made it to graduate school. First I worked for Frank Gehry for a year, in Santa Monica, making the prototypes of that wooden Knoll furniture that some of you are sitting on. That's where I became a master carpenter—or I should say that's where I mastered the table saw, which is the foundation of modern woodworking, the essential tool. Doing that very technical job for a year gave me the confidence to tackle any technical challenge. It was a job based on wood laminates and very thin veneers, one of the most complex procedures in woodworking, and in the process my skills got very advanced. Technical stuff and building are really satisfying to me. You might not think so because my things look rough, but that's a quality I enjoy.

After working for Frank I came to New York and started my career as a repairman welding iron fire escapes. It didn't really pan out and I got involved with more lucrative stuff: I renovated apartments, did window displays at Barney's, did plumbing, learned elevator repair, things like that. Meanwhile I was building up my shop and my equipment.

I made a Mondrian out of duct tape and plywood. I couldn't afford my own Mondrian so I went to The Museum of Modern Art and measured theirs—this is a precise model of it. I tried to illustrate the cracks, the faults, and the signature, all in duct tape. It was a way of possessing it, like shopping.

Does anyone remember the '80s video-arcade game Defender? Kids I talk to at art schools are too young to remember it, but it was the second-highest-grossing video game of all time, after Pacman, and it was very macho, very difficult to play. I bought a Defender video game on eBay, and then I made two speakers to look like it. It's like a giant pipe organ—two gigantic speakers with 5,000 watts of power pumping out the sound of the video game. It's hooked up to a mixer and a turntable so you can play them together. It's my homage to my youth.

Another piece is a scale model of Le Corbusier's Unité d'Habitation in Marseilles made out of foam core. I don't even know how they can talk about Mies van der Rohe and Le Corbusier in the same sentence: Mies is of course influential and important, but the utopian fantasy, the potential behind Le Corbusier's genius, is so vast. His

designs have so many possibilities for solving the world's housing problems through architecture. I know he's widely misunderstood, and it's his fault; these horrible housing complexes—though their problems have really been more about management and development. There's such great humanity in Le Corbusier's ideas. The potential of modernism has always been exciting to me. Planned obsolescence, and what's wrong with America, are kind of my opposite love and passion. Le Corbusier inspires me with what we can achieve. His work is forever a foil for everything that could have gone right but went wrong with the modern age.

I guess I'm really still a student of architecture. In the twentieth century, I think, the key players are Louis Armstrong and Le Corbusier. People say Picasso, but that's just art; he gets credit for a lot of stuff that was kind of in the air. Of course he's a great artist, but there are many. Duchamp would have happened without Duchamp. I don't think Louis Armstrong would have happened without Louis Armstrong.

So many things are interesting to me. The technology and craft of weapons, their precision, have always been interesting to me; the armor department at the Met has always been my favorite place. Technology has advanced through weapons. The stealth bomber and this great surveillance equipment, Krazy Glue and Velcro and all the NASA stuff, the Saturn 5 moon rocket, which is a thinly cloaked missile—it all comes from military research. From a technological standpoint, weaponry has always been the most advanced, most developed thing. But for me it's not so much about the weapons and their destructive power as about the fact that I can make my own. I can make my own rocket, make my own shotgun, and engage in the process of creating something. It's very similar to making my own airline toilet or my own McDonald's—using readymade, accessible stuff to make things that seem unattainable.

Sachs (left) in his studio, 2003

INDEX OF ARTISTS

THE ICI "NEW YORK STUDIO EVENTS" PARTICIPANTS, 1981–2003

Magdalena Abakanowicz 1993

Vito Acconci 1989

Gregory Amenoff 1988

Laurie Anderson 1981, 1997

Janine Antoni 1999

Polly Apfelbaum 1998

Ida Applebroog 1989

Richard Artschwager 1990

Dotty Attie 1992

Alice Aycock 1984

Donald Baechler 1994

John Baldessari 1997

Stephan Balkenhol 2000

Tina Barney 1993

Jennifer Bartlett 1982, 1995

Vanessa Beecroft 1999

Gretchen Bender 1991

Lynda Benglis 1985

Ashley Bickerton 1991

Ross Bleckner 1988

Mel Bochner 1988

Jonathan Borofsky 1995

Richard Bosman 1989

Louise Bourgeois 1989

Cecily Brown 2001

Trisha Brown 1983

John Cage 1990

Sophie Calle 2001

Peter Campus 1996

Janet Cardiff and
 George Bures Miller 2002

James Casebere 1996

Saint Clair Cemin 1997

Catherine Chalmers 2000

John Chamberlain 1991

Sarah Charlesworth 1995

Louisa Chase 1987

Sandro Chia 1984

Lucinda Childs 1981

Christo and Jeanne-Claude 1981

Chuck Close 1987

Maureen Connor 1996

John Coplans 1995

Petah Coyne 1994

Tony Cragg 1998

Michael Craig-Martin 2003

Gregory Crewdson 2003

John Currin 2002

Richard Deacon 1997

Claudia DeMonte 1981

Lesley Dill 1995

Jim Dine 1990

Mark Dion 2000

Mark di Suvero 1984

Rackstraw Downes 1985

John Duff 1994

Carroll Dunham 1990

Nicole Eisenman 1999

Inka Essenhigh 2002

Heide Fasnacht 1992

Rachel Feinstein 2002

Molissa Fenley and Dancers 1985

Jackie Ferrara 1986

Janet Fish 1990

Joel Fisher 1993

R. M. Fischer 1987

Eric Fischl 1985

Mary Frank 1985, 1995

Hamish Fulton 1994

Adam Fuss 2000

Philip Glass 1982

Leon Golub 1986

Douglas Gordon 1999

April Gornik 1988

Dan Graham 1998

Nancy Graves 1992

Spalding Gray 1984

Gregory Green 2001

Jan Groover 1985

Peter Halley 1987

Jane Hammond 1993

Mary Heilmann 1999

Oliver Herring 1998

Al Held 1986

Jene Highstein 1991

Jim Hodges 2002

Jenny Holzer 1987

Roni Horn 1999

Jacqueline Humphries 2000

Bryan Hunt 1988

Robert Irwin 1992

Alfredo Jaar 1992

Yvonne Jacquette 1985

Neil Jenney 2003

Bill Jensen 1998

Joan Jonas 2003

Bill T. Jones and Arnie Zane 1985

Donald Judd 1993

Ilya Kabakov 1994

Y. Z. Kami 2000

Anish Kapoor 1998

Alex Katz 1984

Mel Kendrick 1988, 1997

Alison Knowles 2000

Komar & Melamid 1986